HOW TO
DRAW & PAINT

HOW TO DRAW & PAINT

CHARTWELL
BOOKS INC.

A QUARTO BOOK

Published by
Chartwell Books Inc
A Division of Book
Sales Inc
110 Enterprise
Avenue
Secaucus, New
Jersey 07094

Copyright © 1981
Quarto Publishing
Limited
First published in
the USA in 1981

ISBN 0 89009 400 4
Library of Congress
Catalog Number 80
70476

This book was
designed and
produced by
Quarto Publishing
Ltd
32 Kingly Court,
London W1

Editorial director
Jeremy Harwood
Art director
Robert Morley
Editors
Victoria Funk
Judy Martin
Art editor
Neville Graham
Designer
Nick Clark
Design Assistants
Martin Chambers
Dennis Thompson
Photographer
David Strickland
Illustrators
Roger Twinn
John Woodcock
Picture research
Linda Proud

Printed in Hong Kong

Contents

Introduction

LEARNING HOW TO draw and paint from the example and work of other artists has a long tradition, stretching back into prehistoric times. The earliest known examples are to be found in the cave paintings of southern France and Spain. The artists involved in making these images of bison and other game certainly learned their craft from example and no one would have been better qualified to give this than their more experienced elders.

The process has continued over the centuries, even though the demands of art have naturally changed. In the Middle Ages, for instance, the Church was the dominant influence on the artist, who spent much of his working life creating images to illustrate Biblical legends. Primitive man, on the other hand, probably painted as a type of magical process, hunting the beasts captured successfully on cave walls as a preparation for the actual events of the hunt. Between these two extremes came many others, from the decoration of buildings to the gratification of aristocratic whims. But, within all these approaches, there is a common core – the interpretation of the visual world.

Learning to see
Painting and drawing are an extension of the art of seeing. It therefore follows that learning to look and see in an aware, intelligent manner is a prerequisite of good picture making. When the first attempts to draw a portrait or paint a still life prove unsatisfactory, this is just as likely to be the result of inadequate initial observation as the result of a lack of knowledge of the actual practical techniques. In any event, the cultivation of a vision of the world about you is a most rewarding and exciting experience, as well as a yardstick against which to measure the success or failure of drawings or paintings. In undertaking the process, you will be in the company of artists throughout the centuries. All of them have learned to interpret the visual world through painstaking looking, as well as through the development of basic technical skills. Study the world about you; observe the relationships of colors and the scale of things one to another – large to small, grand to insignificant. Look also at the way artists of the past saw and painted what they observed.

This process, of necessity, must be a subjective one, even though we are all part of an endless stream of development and much common ground exists from which we can learn. What will be a 'good' picture to one artist will not necessarily be so to another; a careful depiction in great detail of a favourite landscape, for instance, will be beautiful to some, but anathema to others. However, as long as the essential discipline of looking, seeing, and interpreting is observed, the basic foundations are laid for future development. The initial technological steps themselves are not always easy – and certainly can be frustrating – but it is surprising how soon the combination of a cultivated eye and a learning hand make improvements.

The eventual rewards of making telling, well-drawn and constructed drawings and paintings are great. Much pleasure and endless joy to others can ensue; the greater your experience and the wider the range of projects undertaken, the better the results. Another great benefit that springs from picture making is that you soon learn to see the world in different ways from others. The dull, olive green tone of a tree in the foreground, alongside the acid yellow greens of fresh spring foliage, will be seen to contrast well with the sunbathed sea, shimmering turquoise blue in the middle distance. So much more can be gleaned from seeing in this way than by a casual observer.

Learning by example
There is nothing casual, however, in preparing to make such a picture work. In the example above, the artist would distance himself from the subject and study it in terms of form, color, and inter-relationships of shapes and volumes before making even an initial mark on the board or canvas.

It would be obviously foolish to be categorical about what constitutes a sensitive line, or what makes a beautiful color harmony. These are things to be discovered out of the individual qualities of the artist. The work of the great masters of the past naturally shows such individuality and another common way of learning is to study how such artists made their pictures. Try and probe beneath the surface and discover the analytical processes and personal language at work.

Visits to galleries and, if possible, to artists' studios are always helpful. In addition, copying existing works of art can provide an invaluable insight into the mind of the original painter. This system has been used as a method of art education for a very long time. Even well-established artists both in the past and in the present make copies; indeed, the only surviving record of some very early pictures is through the copies made by later artists. Rubens (1577–1640), for instance, copied carefully a Leonardo da Vinci (1452–1519) mural. The original has long since disappeared and the work is known today only through the copy.

Often, the techniques used in the original will reveal themselves to you in making your own version of the painting or drawing. Discovering the way color is balanced, lines are put together across the canvas, perspective is drawn and character delineated will not only add to your experience but reflect back into your own work.

Constructing a picture
When constructing a picture – constructing is the most appropriate word to describe the process – always remember that the single most important factor at the outset is the support you choose, whether it is paper, board, or canvas. The shape is significant because different shapes and proportions engender different emotions and moods. Thus a square will convey stability and solidity, while a long, narrow rectangle will suggest calm. Such horizontal rectangles are referred to as 'landscape' and vertical ones as 'portrait'. These two terms should not be confused with areas of

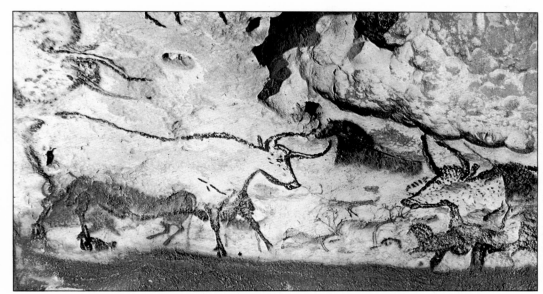

Left: Some of the earliest examples of drawing and painting are found in the caves of southern France. These images of bison and hunters were thought to have magical powers which promised success and prosperity.
Below: Peter Paul Rubens, 'The Judgement of Paris'. The 16th century artist Rubens was a master at rendering the figure and is well known for his fleshy, opulent nudes.

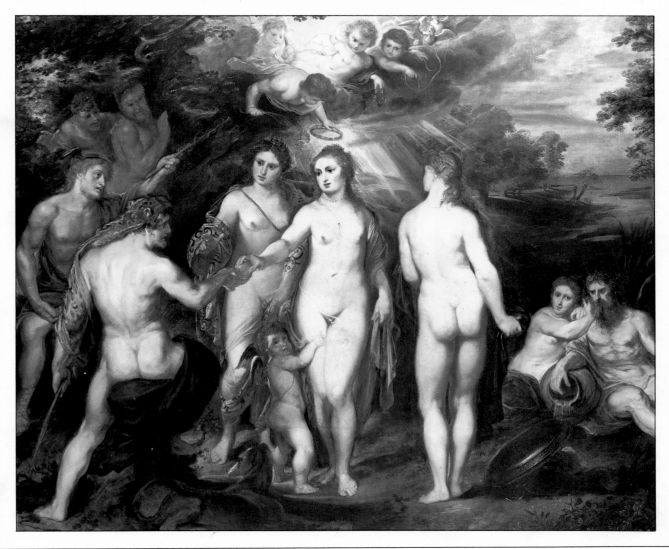

work. Constable (1776–1837), for instance, painted many landscapes on vertical canvases, while Degas (1834–1917) painted portraits on horizontal ones.

The next important consideration is the suitability of the support's surface for the selected medium, technique, and subject. A finely smoothed surface on a stable base, either of wood or millboard, with a prepared priming to allow oil paint to be laid on it is essential for small, detailed paintings. A canvas with a medium coarse texture, stretched on to a stretching frame, will prove suitable for either one of two completely different approaches. The canvas can be used for thinly 'scumbled' areas, which will allow the warp and the weft of the texture to show through, or for larger and broader styles of painting, with plenty of 'fat' in the paint.

The intention of the picture – whether it is to suggest a strong sense of vigour, atmosphere, or great fidelity to the carefully observed subject – must first be decided upon, since the choice of actual working materials stems from it, together with the techniques employed. Remember, for instance, that not all painters use brushes exclusively. The palette knife, rag, and even fingers have long been part of the stock-in-trade of the artist.

When choosing the scale for a painting or drawing, be guided by the demands of the subject. Pencil portraits, for instance, are usually better at, or below, life size; the problems that may be encountered if the scale is increased can be formidable. Again, however, such a general rule can be broken, if the nature of the work demands it.

Every individual demand will conjure up an individual solution – a compound of all that has been learned from observation, experience, and the study of other works. Rough and smooth, tightly finished or very loosely suggested, in pencil, chalk, oil, tempera, watercolor, or pen and ink – the choice is there to be made and the factors governing the decision can be rapidly assessed. Nor should the opportunity for experiment be ignored, even at an initial stage. It is always worth trying a few variations in both techniques and media. For example, try making a still life in color – say, in gouache – and in black-and-white, perhaps using graphite powder and a soft, finely sharpened pencil.

The criterion for anything you may produce should be quality. If color is involved, then it should be harmonious, or disruptive by choice, not by accident. Balance should be aimed for in the design, but it should satisfy the viewer's need for completeness. Areas of relative inactivity can be balanced against small, tightly focused areas, where a great deal is happening. Dimensional suggestion is a further important element. The use of linear perspective and what is called atmosphere, or 'aerial perspective', to create illusions of space will also bring rewards from applied study.

Oil painting

Oil paint is perhaps the commonest and most popular painting medium in current use. Its flexibility and potential range is legion. Brought into use on a wide scale by the Flemish brothers Hubert and Jan Van Eyck in the 15th century, oil paint gradually superseded the less flexible medium of tempera, which had been in common use before.

It was discovered that, when oil was added to the tempera, the result was a richer, brighter effect. The use of the new medium soon spread, particularly in 15th century Venice, where oils were found to be far more suitable for the city's humid atmosphere than tempera had been.

The earliest oil paintings were made on wooden panels with a specially treated surface. This was achieved by coating the panels with several thin skins of size – rabbit-skin glue or a similar product – and then covering them with a ground. Often, gesso was used for the purpose. This consisted of a mixture of size and whiting or chalk. Several coats in total were applied, each individual coat being rubbed smooth before another layer was applied. The finished surface would then be highly polished to render it only slightly absorbent – just enough to allow the paint to bond to it, but not enough to let the color go 'flat'. This term describes what happens when the ground tends to suck the color in, leaving the surface dull. Sometimes, this can be deliberately cultivated as part of a technique, but, in general, it should be avoided – at least in the initial stages – because it is very difficult to control.

From panels to canvas

The original panels, however, soon proved unsuitable for many paintings since their rigidity made them liable to split when subjected to extreme temperature or atmospheric changes. At this point, the idea of painting on canvas – a woven surface made from flax stretched across a frame, originated. The advantages of this new method were immediately apparent as material thus suspended will stretch and shrink within tolerable limits to accommodate the changes the panels rejected.

Initially, the surface was prepared in much the same way that the wooden panels had been. But, before long, variations developed as the result of artistic experiment and demand.

Primers and grounds

It soon became clear to the early oil painters that, while white was a useful background for many subjects, it was not necessarily the most suitable surface for all of them. Accordingly, colored or tinted grounds were soon introduced and the range of options open to painters thus expanded. The painters of 15th century Florence – Botticelli (1444–1510), Michelangelo (1475–1564) and Leonardo da Vinci – worked on a cool green base, the quality of which is reflected in their finished paintings. Because these artists tended to use descriptive local color – that is, the approximate blue for sky, green for grass, pink for flesh and so on – the effect was cool. This added to the overall calmness and dignity of the finished pictures.

The Venetian artists of the same period, on the other hand, used a strong red-brown underpainting with startlingly different results. Painters such as Bellini (1400–70), Titian (c.1487–1576), Giorgione (1477–1510) and Veronese (1528–88) used reflective color, the summary of all the various touches of color which strike the surface of the objects being painted, to arrive at an apparently descriptive color.

The painting technique employed by the Venetians was similarly different from that of their Florentine counterparts since it tended to be less linear. This term is used to describe a work in which the shapes are defined with finite edges – one edge meeting the other – with the objects themselves being filled in with modulated tones of color. In the alternative system, as practiced by the Venetians, the edges tend to run into each other. The lines, far from being precise, are frequently

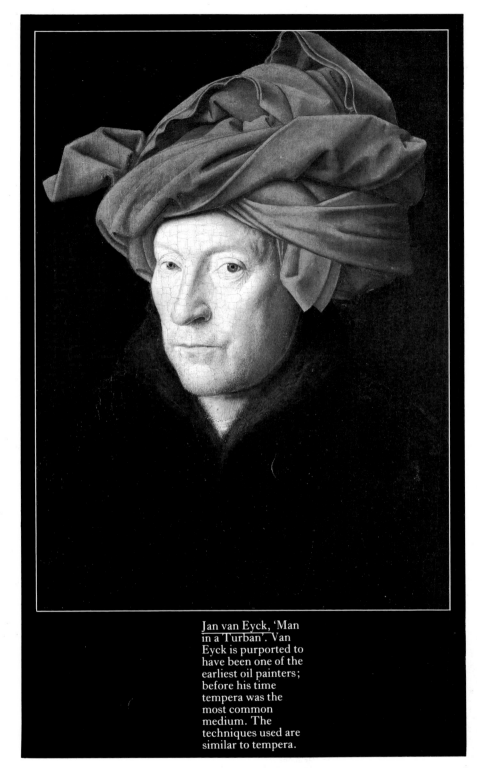

Jan van Eyck, 'Man in a Turban'. Van Eyck is purported to have been one of the earliest oil painters; before his time tempera was the most common medium. The techniques used are similar to tempera.

ing. A battleship grey, for instance, may well create a flat, uninteresting overall mood; a scarlet or crimson will make the work unbearably hot and brash. Often a thin wash of a neutral warm tone, say an earth color, such as raw sienna, will prove highly suitable.

Types and mediums

Oil paint is fundamentally a fusion of powdered pigments derived from both organic and man-made substances. These are mixed with an oil to dilute them to a consistency suitable for painting. The method of manufacture has varied little over the centuries. The grinding and emulsifying of pigment, which was the task of apprentice painters in the Renaissance, is essentially the same process as the one used in the commercial manufacturers of today.

The agent used to adapt the paint from the stiff, pure state in which it leaves the tube to the workable, viable condition needed for actual painting is called the medium. In the case of oil paint, the medium is invariably an oil, more usually a mixture of oils.

The test of time has shown that pure spirits of turpentine is a useful dilutant. However, because turpentine has a different drying rate to the heavier oils used in manufacturing the paint, it evaporates more quickly. It is advisable, therefore, to mix it with another substance to delay the process.

Linseed oil is the most suitable for this. Its use allows much more elasticity in the colors laid on the picture, i prevents cracking and also leaves color values more apparent and fresh. Poppy oil is preferred by some artists, just as stand oil is used if its own particular characteristics of rich and fatty surface marks are required. Some artists, too, like to use turpentine mixed with a varnish, though the latter is usually reserved for glazing the actual picture.

The paints themselves are made in various qualities. Inexpensive paints are usually ground into an oil that is known to darken with time and exposure to light. The fine, expensive, permanent types used by professionals are always ground into the best available oils; they also consist of the finest stable and well-balanced pigments.

The painter's palette

When selecting paints, it is advisable to limit the range of colors on the

broken and ragged. The latter technique is much closer to the way the human retina receives an image; color signals reach the brain and dance back and forth to arrive at a consensus of color.

Colored or tinted canvases are just as useful to the artists of today as they were for the artists who first devised them. They allow artists to keep tight control of the organization of the design and particularly of the tonal structure. This describes the light,

dark, and mid-tone range of colors used within the work. The theoretical extremes of this are black at one end and white at the other, though, in practice, it is likely to be far more subtle.

The tonal structure is an integral part of what is termed 'painting the lights' – that is, working up from a dark ground to the mid-tones and, finally, the highlights. When embarking on this process, remember that certain tones tend to deaden a paint-

palette as many of the more esoteric and arcane formulae are unnecessary. Learning to cope with such a restriction will reap dividends later. The great artists of the past prided themselves on their ability to create a complete range of colors from a very limited palette and there is no reason why contemporary artists should not follow their example.

One suggested palette for painting figures or portraits from life would be flake or titanium white, yellow ochre, light red, terre verte, raw umber, and cobalt blue. By careful mixing and experiment, mixing these colors together in varying proportions will create a great range of shades, all sympathetic to the rippling feeling of live flesh.

It will be noted that no strong color is present in this suggested palette. If, however, it is necessary to intensify a local color, such as lipstick, rouge, or the lighter tone of gold earrings, cadmium red or alizarin crimson can be employed, together with chromium or chrome yellow.

Always feel free to experiment, but bear in mind that the so-called 'fugitive' colors and inflexible ready-made tints should be avoided. Fugitive colors are so-named because they fade when exposed to light; they can also be destroyed chemically when mixed with certain other colors. It is advisable to check the lists supplied by all reputable art stores. These use a coded system to grade paint permanence, based on the durability, reliability and relative instability of the colors. But the best insurance against all possible trouble is to buy the very best that can be afforded in the first place.

Painting techniques

The techniques of oil painting enable a vast range of varied effects and textures to be created. For example scumbling or glazing with the same color can produce quite different effects within the same picture.

In scumbling, thickish paint is rubbed into the surface, with the result that it tends to pick up the texture of the support. Glazing is a technique often incorporated with others and is particularly effective for painting flesh. The system is based on laying skins of color, like washes, over a light ground – frequently white.

Each glaze qualifies earlier ones; the result is rich, transparent, and glowing. Preserving this transparent colour quality is one of the fundamental aims of glazing and it helps if a means can be found to accelerate the drying time. Note, too, that when thin washes of paint are applied, the painting must be laid flat, as otherwise they would drip across the surfaces.

Under no circumstances should a turpentine substitute be used for glazing. Because the molecular structure of the oils used in such substitutes does not marry with those used in the paints, the result can be disastrous. Substitutes should be employed only as solvents to clean brushes, clear palettes, wipe up drops of spilled paint and the like.

Stick to pure distilled spirts of turpentine when actually painting. indeed, the same principle applies – the best possible materials produce the best results.

Acrylics

Acrylics were invented in response to the pressing need for a flexible paint, capable of retaining its brilliance when exposed to the open air. They are made from pigment ground into either an acrylic resin or polyvinyl acetate. The paints dry quickly because they are water-soluble; the factor governing the drying rate is the time it takes the water to evaporate. This means that an artist can repaint or overpaint much more quickly than with oils.

The paints have other advantages as well. They possess great permanence as their chemical structure makes them resist oxidization and decomposition, while each layer bonds permanently to the preceding one.

Sometimes the quick drying time can be a disadvantage. In such cases, a retarding agent can be added to slow down the process and so allow time for adjustments to the painting to be made while the surface is still wet.

Tools and techniques

The nature of acrylics means that a wide range of tools can be used to apply them. Conventional brushes are excellent; working with a palette knife will produce the same striking results as it will with oils. Rags and sponges will work well too. Techniques are similarly varied, the range of options matching the thickness or immediate thinness of the paint being used.

An interesting technique – between traditional watercolor and oil painting – is to glaze over a thick base, which can be either wet or dry. Use a sponge or a rag. Again, the key is to experiment and so discover the best ways of exploiting the true characteristics of the paint. Start with traditional methods, underpainting in thin, flowing washes with a tendency to monochrome, and from this move on to scratching back, glazing over, and blotting.

Watercolor

Watercolor is the most suitable medium for working outside the studio. Its characteristics are quite distinct from those of oils and need careful study in order to exploit them

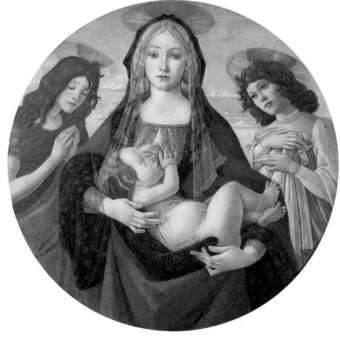

Sandro Botticelli, 'Virgin and Child with St John and Angel'. The artist Botticelli was one of the most influential painters of 15th century Florence and his linear lyricism epitomizes the elegance found in paintings of this period. Madonna paintings were very popular during this time and Botticelli grew prosperous and well-known for paintings similar to the one shown here. The circular shape of the surface adds a feeling of symmetry and peace; however, even without this, the painting would be harmonious and balanced.

Michelangelo
Buonarroti, 'The
Manchester
Madonna'. This
painting is
interesting not only
for its compositional
excellence, but
because it illustrates
15th century
painting techniques.
Note the use of terre
verte for flesh tones.

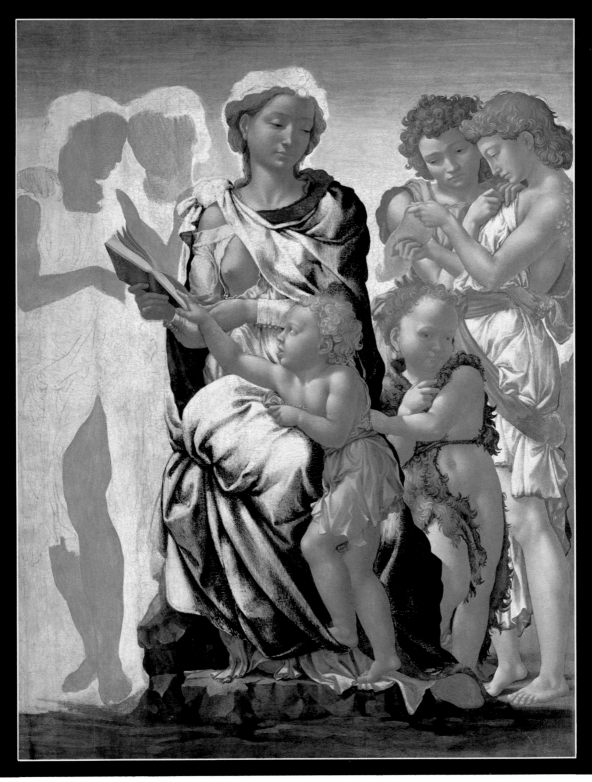

INTRODUCTION

fully. The prime quality of watercolor is its transparency. It makes more use of the support – usually paper of one type and texture or another – by allowing it to shine through the thin, watered paint skins and also to describe the white, or near white, colors in the picture. This contrasts totally with the technique of working 'to the lights' used in oil painting. Because of the need to make decisions before applying the paint, it means that a great deal of discipline and organization is required, as opposed to other methods of painting.

The medium itself is an extremely old one. Frescoes, for example, are actually a form of watercolor, while watercolors on paper were being created long before the medium became popular in the 18th and 19th centuries. Part of this popularity sprang from the introduction of commercial watercolors in the 1700s. The process of manufacture itself is simple; the colors are simply powdered pigments ground in with gum arabic. Since the original method was invented, various other additives have been introduced, but, though these have been found to be effective, the established formula remains the original one.

Nevertheless, the flowering of watercolor remains linked inevitably with the birth of the great watercolorist tradition in 18th century England. Artists such as John Cotman (1782–1842) and William Turner (1775–1851) brought the technique to extremely high levels. One of the more interesting elements is the scale and sense of space they achieved, given the limitation of the size of their canvases.

Most watercolor paintings are small – primarily because of the need for portability, but also due to other factors. The size of a painting is always directly related to the size of the average mark made with the medium in use. With watercolor, because of its relatively rapid drying time and the optimum amount of paint that can be carried by the brush, the commonest size is about 20in (50cm) by 30in (65cm). However, many of the finest examples are considerably smaller than this.

It was the artists of this period, too, who developed the classical watercolour method. This is to stretch the paper first by soaking it in clean water and then, while still wet, taping it firmly to a support, on which it is allowed to dry and tighten. This not only eliminates wrinkles and other surface blemishes; it also lifts off any grease that might be on it, via fingerprints, for instance.

Techniques and toning

Artists of the past decided upon the mood of the scene they were painting in advance and toned their paper accordingly. This general principle is a helpful one to follow, since it serves to blend the various elements of the picture together. If the scene is to be bright, sunlit and cheerful, a very light wash of Naples yellow or yellow ochre could be used; if a heavier, overcast mood is required, a thin wash of Payne's grey or another neutral blue grey could be employed. Through this, any subsequent color will be slightly modified in tone, though not enough to prevent anything left as white appearing as white.

Most artists find the assessment and organization of tone to be the most difficult aspect of watercolor painting and, to cope with the difficulty, resort to many devices, including the squint and the white paper viewfinder. Squinting results in a stronger definition of tonal contrasts, with mid-darks becoming darker and lights remaining strongly light. A viewfinder helps not only in ascertaining the related tones, but also the composition of the picture.

A small rectangle – the same proportion as the picture surface – is cleanly cut out of a sheet of stiff white paper. By holding it at arm's length, or closer, and closing one eye, the range of possibilities of relating objects to the picture edge can be determined. By this means, for instance, a cropped part of a tuft of grass in the foreground can be rapidly contrasted with its effect on the whole picture.

Colors are laid over the carefully organized tonal base from a limited range and in varying densities. A mellow olive green, for example, would cover most of the foliage, creating both a sense of unity and establishing the color idea. Adjustments are always made during the course of work; the answer is not simply to remove an inconvenient tree or reduce the height of a hill to make the scene tell. The whole aim is to organize the colors into an arrangement that is at once atmospheric and descriptive. Indeed, some artists believe that the melting of colors into one another is as important a part of watercolor as the quality of transparency.

Gouache

Gouache, or body color, is included within the broad definition of watercolor. It is a water-based paint, usually made of coarsely ground pigments, but instead of having the distinctively transparent quality of pure watercolor, it is opaque.

Many techniques can be used with gouache, but a number share common ground with watercolor, oils and tempera. It should never be used as a substitute, however, since it possesses its own potential and beauty.

Using gouache on a dampened ground, for instance, creates interesting effects, as it is possible to use overlays to obliterate or qualify earlier marks. Floating semi-transparent details into a picture broadly sketched in colored inks can create a unique atmosphere, with the artist being able to use gouache alongside watercolor to contrast the latter's transparency with solid color touches. Ordinary watercolor mixed with strong opaque white can produce a similar effect.

Tempera

Before the advent of oils, tempera was the main medium for easel pictures – small, compact works in contrast to the huge frescoes decorating the walls of medieval churches. It still enjoys a good deal of popularity, deservedly so for its surface and color qualities are extremely fine. It also has the advantage of being easily produced – a few simple ingredients plus a little labor produce a full range of colors.

The basis of tempera is fresh egg, which is used to emulsify finely ground pigments. Some artists prefer to use only the yolk; others use the whole egg. Oil can also be blended into the simple mixture in order to achieve an additional quality. It is vital that the eggs are completely fresh; any unused mixture must be thrown away at the end of the day. If old yolks are used – even one day later – the paint will go bad. All tools – knives, pestle and mortar, glass sheet and so on – used to produce the paint must be kept scrupulously clean. Failure to do so will encourage moulds to grow on the painted surface.

Different tempera mixtures produce very different effects. Some tempera tends to look flat and gouache-like, while others are much more resonant and brilliant. The purest form is the mixture of egg yolk,

12

pigment, and distilled water; this is permanent, virtually insoluble and inexpensive.

Supports and techniques

Suitable supports include wood and millboard panels. These are especially satisfctory when primed with several coats of gesso and then buffed to produce a highly smoothed surface. The range of techniques that can be employed is very wide indeed, due partly to the rapid drying time. Strangely enough, the home-made variety tends to dry faster than proprietory tubed brands. Skimming color thinly, flooding it in washes, stippling, splattering, glazing are all possibilities.

Tempera's flexibility also makes it suitable for painting a wide range of subjects. There is a long tradition of portrait and figure painting in the medium; it has been used, too, for landscapes, still life, and natural history subjects. The aim should always be to produce the typical tempera qualities of quietness and softness of colour and feeling.

Drawing

The idea conjured up by the word 'drawing' is invariably of pencil marks made on a sheet of white paper. 'Pencil', therefore, is synonymous with drawing in most peoples' minds. That this should be so, although not by any means entirely true, is understandable. For many years pencil has been found to be the most sympathetic and subtly variable instrument for documenting, describing and analysing an image.

The Italian masters of the 15th century were all familiar with silverpoint, a stick of silver sharpened to a point. Silverpoint was used to enable the artist to build up a continuous tone of great sensitivity. In the past, silverpoint drawing was done on a specially prepared sheet of colored paper.

Chalk was also a forerunner of the present day pencil and had greater immediacy and fluency than the quieter quality of silverpoint. Most chalk studies were the raw material for subsequent paintings. Indeed, these studies often remained in a master's studio for years, being used in several works and often inherited by students for use in later pictures.

Silverpoint was suitable for deliberate and careful investigation while chalk increased the range of activity.

Jean August Ingres, 'Pencil Study'. Ingres was extremely adept at simple pencil studies of this sort. Using only a rough outline and areas of shading, Ingres captured his subject with economy.

With chalk the outlines of a proposed composition and the perspective necessary to locate figures within the implied space could be worked out.

Pencil types and supports

Attention should be paid to the broad range of marks available with the pencil from the fine incisive line of a hard lead, to the thick crumbling smudges created by a heavy black lead. Pencils are produced in varying degrees of hardness and a grading system is employed by manufacturers to identify these grades. The 'H' series are the hardest and the range progresses down to the 8B – an extremely soft lead. The combination of different grades of mark within one picture is very effective, as in the combination of detailing with a 4H to broad, richly rendered and freely applied tones with a 4 or 6B.

The range of pencil types does not end there; wax pencils, charcoal pencils, conté crayons and several others all have their own unique qualities to exploit, combine, and experiment with.

The support used for working in

13

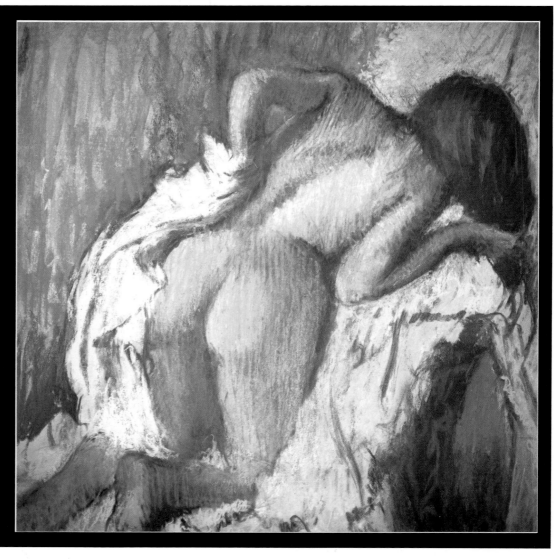

Edgar Degas, 'Woman Drying Herself'. Degas was one of the great innovators and promoters of pastels. He experimented widely with different techniques and developed a 'painting' method which involved spraying the pastel surface with warm water or milk. Degas' use of gesture and color are important aspects to study. He was also one of the first artists to use broken color – strokes of pure color which 'mix' optically. Many of the Impressionists incorporated his discoveries in their work.

pencil is very important since the quality of the drawing will always be dependent upon the texture and tone of the paper or board used. A hard pencil will make a strong dark line on a rough textured paper, just as a soft lead will make a fine and crisp line on a smoother surface.

Drawing techniques and mixed media
The smudge, and tones comprising linear marks rather like those described in the comments on silverpoint drawing, are all part of the range of techniques possible with the pencil.

The pencil is very effective when used in combination with other media – both water and oil based – and can be drawn on to canvas and gesso grounds, as well as paper. A relatively recent development worth exploiting are colored pencils. Used either as full color to describe things as seen, or to introduce color suggestions into a pencil drawing, they are equally effective. Colored pencils are also likely to be affected by the texture of the paper

and so the issue of scale is obviously important.

The drawing process
A sound way to learn to render the form and volume in, say, a figure study, is to work in a pencil with a very hard lead on a large, smoothish piece of paper. By this means, if the paper measures about 20in × 30in (50cm × 65cm), the amount of labour needed to make the marks of, say, a 2H pencil show on the surface, allows the artist to scratch away and correct mistakes without the faults needing the use of an eraser. If erasing can be avoided, one can learn from these corrections, for by seeing the 'false' lines left alongside their more accurate brethren, fewer uncertainties should occur.

Pastels

Pastels share some of the characteristics of both painting and drawing media. The sticks, made from finely

powdered pigment and a surprisingly small amount of gum or resin, have been in use for many years. They produce a characteristic powdery quality, which many artists find extremely attractive.

Because the great majority of pastels have an opaque nature, the papers and boards commonly used with them tend to be toned or colored. Many artists prefer to tone their own surfaces, particularly if textured ones are being used. Their use is often combined with charcoal or black chalk; the latter are harder and so introduce a tough, energetic linear quality, which contrasts well with the soft, blended feeling generally associated with the pure pastel.

Techniques
By experimenting with the widest possible range of marks, surfaces, and techniques, it will become apparent that there is an optimum size, style, and feeling for working in pastel. A warm, hot, or cool-toned paper

or board, for instance, will produce an entirely different mood and spirit in the eventual work. Roughly applying pastel to coarse paper, or finely smoothing pastels to a fine surface, will have similarly differing effects.

One method of working is to use pastel to render the subject to a highly finished state and then to flood water or milk across the surface. This melts the tones together to form a 'painted' finished picture. The technique was employed by Edgar Degas (1834–1917) and others. Degas used pastel throughout his life to produce some of his most celebrated works. From the briefest of sketches to formal compositions, he was a master of the medium.

Another popular and successful method of working in pastel is a technique known as 'working the lights'. In this, the main structures and features of the painting are ticked in on a toned ground in soft pencil and then the light tones and colors are carefully defined, using light pastels. These will be later developed into the middle and dark tones; here, a torchon, a roll of paper used to blend colours together, can be extremely useful.

A knowledge of 'gesture' is as important in pastel as in all other media. As defined in art practice, gesture means the type of marks made by the individual artist on the surface. The gesture can be long and lingering or short and staccato, depending on the medium, the size of the subject, and the subject matter itself. Experience is the key factor; in pastel, the stroke of the broad side of the stick or the softened finger-rubbed mark will both contribute to the quality of the image. The trick is knowing when to use which technique.

Oil pastel

The oil pastel is a relatively recent innovation. This is a stick of color, similar to the traditional pastel, but instead consisting of oil-bound pigment in a solid form. It behaves in a very different way to orthodox pastels and should be exploited for its own distinct characteristics.

Since oil pastels are inclined to be more clumsy than 'pure' pastel, it is best to use them on a small scale. The images they produce are fluid and malleable and, as an ingredient in mixed media painting, they have proved themselves able to create a wide range of effects. One technique is to lay in the broad, general outlines of

composition and color harmonies in oil pastel and then overpaint in gouache. If the oil rejects the gouache, a little soft soap can be added to the paint to enable it to cover the pastels effectively.

An attractive result can be achieved from a technique based upon an old method called 'wash off'. Lay in the broad basic composition and block in the main colors with oil pastels. Work up details in colored inks and gouache, leaving occasional gaps between the features within the piece. When dry, cover the whole work with a coat of white gouache, applying this thickly enough to create a solid sheet of color. of colour.

Carefully spread a further coat of black waterproof India ink over the gouache and allow it to dry completely. Beneath the resulting black surface will be the original design waiting to be revealed. By scraping across the black, inked surface with the flat of a single-edged razor blade, or a similar sharp instrument, the layers beneath will emerge in varying degrees.

Pen and ink

There is a long tradition of pen and ink drawing, its particular incisiveness being found useful for recording fine detail. The studies for the major works executed by Michelangelo and others include a number of pen and ink studies.

With the invention of photo-mechanical methods of printing, the pen and ink drawing has taken on a completely new significance, and we now live in the long shadow of its influence. For the first time, pen and ink is no longer being used for the planning of larger and more significant work, but is used to create the finished work itself.

Prior to the invention of photo-mechanical printing, the draftsman drew the image on to wooden blocks. These were then engraved by superlative craftsmen so well that the resultant woodblock, ready for printing in the books and magazines of the time, almost totally simulated the character of the original drawing. However, because of the timely and costly process of engraving in this way and the necessarily static feeling imparted to the finished work, it was difficult to transmit the calligraphic feel in the original drawing.

Much finer lines, with closer interstices are possible than those seen in such results; melting the edges of lines by drawing on to dampened paper, rubbing the still wet ink to contrast with the sharper drawn lines will create and suggest further possibilities.

Pen types and supports

Pens are made in a wide variety of

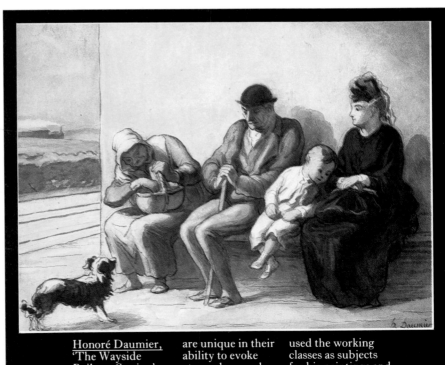

Honoré Daumier, 'The Wayside Railway Station'. Daumier's pictures are unique in their ability to evoke atmosphere and mood. He often used the working classes as subjects for his paintings and drawings.

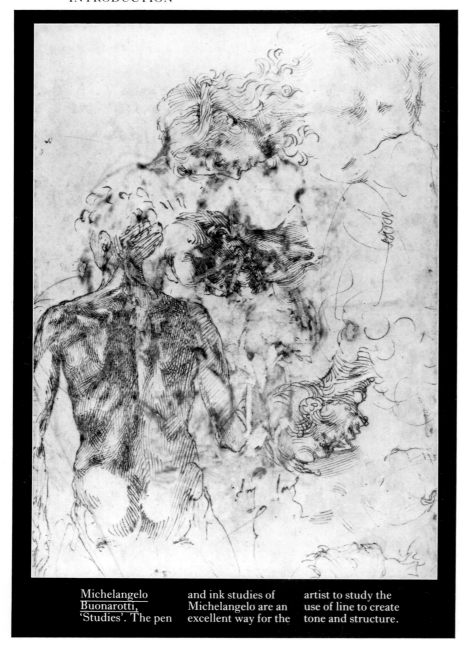

Michelangelo Buonarotti, 'Studies'. The pen and ink studies of Michelangelo are an excellent way for the artist to study the use of line to create tone and structure.

sizes and styles and the supports suitable are of great number. From mapping pens – extremely fine nibs developed for cartographers – to coarse steel, inflexible nibs and variations in between, all are readily available. The making of pens from quills and reeds is well worth persevering with, and varying the size of the nib will result in a great number of variations. Making use of unlikely sources for nibs is not to be discounted. Those made for use in lettering will make a mark fatter, fuller, and more flowing than most of the standard types. Again, the paper used will affect the appearance of the finished piece of work.

The range of supports does not necessarily stop with those available from the artists' supplier. Absorbent surfaces – those treated with size – are sympathetic upon which to make certain images. Wrapping paper, blotting paper and tracing paper take the ink from the pen in entirely different ways.

Techniques

An interesting result can be achieved by making drawings by means of the offset technique. On a sheet of highly sized paper – tracing paper or similar – tick in the main points of the drawing and bring it to a finished stage with pencils. When you consider the picture ready for transfer, hinge the sheet of paper along the long edge to a sheet of blotting or semi-absorbent paper with adhesive tape. Make sure that the original drawing can be folded flat to present the entire drawing image neatly on to the other sheet. Then fold

it back and draw in a small portion over the pencil marks in pen and ink. Follow this by again folding the top sheet down on to the absorbent paper and rub gently over the back in the location of the freshly drawn ink marks, thus transferring it in reverse on to the other surface. Continue this process through until the whole image is transferred.

This technique is of interest not only in its own right but also in combination with others. Traditionally, pen and ink has been used in association with washes of diluted inks and line reinforcing broad masses of simple tones. Splattering tone across and into dry and wet pen and ink lines is one technique, and the use of masking devices to prevent them is another.

Colored inks

As in the case of colored pencils, the range of colored inks is now a part of the artist's repertoire, and a relatively recent phenomena. If used as part of a technique including black and white, these inks are interesting; however, attention should be drawn to the extremely fugitive nature of the color and their tendency to fade with time. Because of this, it is preferable to avoid combining colored inks into pictures to be considered otherwise permanent – e.g., gouache or watercolor.

Mixed media

Whether hatching finely or running lines freely over the page, pen and ink will respond in a great many ways. Mixed with other media, a good deal of invention can take place with colored or black ink on colored grounds; or black lines on a carefully rendered watercolor will bring forth fresh results. Combine several types of nib and brush marks. Don't forget the newer types of pen such as the rapidograph and ballpoint pens.

Erasing

To erase false marks, make sure the ink is dry and scrape gently with a knife or razor to remove the unsuccessful area. By carefully burnishing the erased area, one can render the surface suitable for redrawing.

Composition

The illustrations created by perspective systems are a major factor in constructing a good, sound composition. Composition is the term used to express organization of varied and

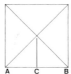 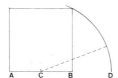 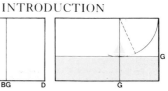

disparate elements within the painting to create legibility and visual interest. The balance and interrelationship of lines, masses, colors, and movement are also aspects of composition.

Over the centuries, the attempt to create standards for the making of art has taken many forms from ideal proportions for drawing the human form, to systematic color patterning.

The 'ideal', as exemplified by the Greeks as the definition of perfect proportion, was based upon a theory known as the Golden Section. This is a mathematical formula by which a line is divided in such a way that the smaller part is to the larger as the larger part is to the whole. The Golden Section was considered to hold balance naturally, entirely satisfying the human eye for symmetry and harmony. Ever since this rule was proposed, geometry has been an important and recurring concept in painting and drawing.

Atmosphere can only be sustained over the whole surface by equal consideration being given to its several parts. The basic types of composition are those based on geometry which have been used for a great many years, both in the simple and more sophisticated forms. For example, often the triangular structure found in early Madonna and Child paintings will be complemented by an inverted or interrelated triangle, sometimes to an astonishingly complex degree.

Piero della Francesca (1410/20–1492) was an Italian artist as interested in mathematics as in art but the complicated compositional structures he used did not detract from the picture's beauty and compassion. Piero is considered one of the world's greatest masters and little effort is needed to see why – not only are the linear interrelationships on the picture surface highly resolved, but color is used both logically and to enhance the aims and intentions of the picture.

These compositions are distinguished by a generally static and classical mood – an inevitable outcome of the systems used. Alternative methods have long been used and the rhythmic composition of a Rubens or Delacroix show some of them in action. In order to suggest movement, or to lead the eye across the picture surface, it is necessary to achieve balance by some other means. The interlocking of the main directional lines into a satisfactory arrangement to tell

The Golden Section. This rule is ascribed to Euclid as the ideal division of a surface. Far left: To find the vertical Section, divide line AB in half to create C. Next, draw a radius from the top right corner to create D. In the next picture, draw in lines to create a rectangle. Point BG is the vertical Section. Far right: To find the horizontal Section, draw a line from the top of the vertical line G to the bottom right corner. Create a radius from the top right corner downward. Where the line and arc intersect is the horizontal Section.

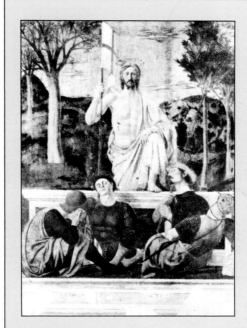

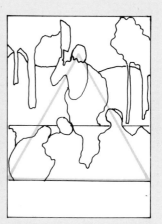

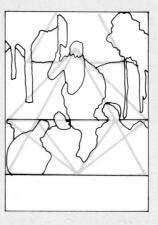

Structure. The 15th century Italian artist Piero della Francesca was as interested in geometry as in painting. Top right: The triangle is the geometric base from which Piero worked. Bottom right: Following this principle, many triangles, can be discovered.

the story use the surface and employ all available space.

The picture space
How often has one seen pictures with the interest focused in the center, leaving corners and outer edges unoccupied, or localized nests of activity with barren and uninteresting deserts of space all around? Poussin, (1594–1665) the French painter, was greatly concerned with the grammar of composition and would invite the viewer to gain by viewing beyond the focal point all parts of the canvas being used.

Dramatic gesture demands balance of an asymmetrical kind. The eye needs to make space for such implied movement, in much the same way that a profile portrait will require more

space between the front of the face and edge, than between the back and parallel edges.

Dramatic impact will be enhanced within the composition by a variety in scale and to this end the exploitation of close and distant viewing, not only tonally as in atmospheric perspective, but as contrasts of size on the surface. The eye of a head in close up will be seen to be approximately the same size as the full figure at a short distance behind. A sea gull in flight above foreground cliffs will occupy the major part of the picture plane. Exploit these contrasts and use them with the other useful contributory parts.

Shape of the support
The shape chosen for the support will determine a good deal of the picture's

overall feeling and the way in which the artist disposes the elements of his subject across this surface will further enhance, extend and amplify this.

Color

It is necessary to study some of the basic theories of picture making and this includes perhaps the most basic, but not necessarily the simplest of all: color. No matter what other features paintings have, the common factor in all is color. Indeed, in the normally sighted human being, what is actually seen is the many and varied sensations of color. The retina of the eye receives sensations from objects which causes a reaction in the appropriate cones. As a result, trees appear green because the cones that have green as their dominant assert themselves and overcome the cones that have other colours. Similarly, the blue of the sky, is caused by the receiving of 'blue' pulses into the retina which immediately triggers a reaction to the blue-stressed cones. In color blindness these cones go wrong and often colors are reversed.

Since this complex act of seeing happens only within the brain, it is correct to deduce that nothing has color in its own right but that color is dependent upon light. In darkened conditions, colors are more difficult to see and define, and in total darkness there can be no color at all. An interesting experiment is that of creating an after-image in the retina demonstrating that it is through the brain that color is seen. Stare at a red patch, then shut your eyes and 'look' at the after-image. The same shape is seen, but in green – the complementary colour of the red patch.

Complementary colors are those at opposite sides of the color wheel. One of these colors, in this case red, reacts through the red cones and the other through the green. Taking complementary colors, we can see that a knowledge of this aspect of color theory is of value when we consider landscape painting.

In an average landscape painting, most areas are of greens of one sort or another. Brilliant, dull, acid; sage, spring, olive or sea, man has created descriptions for various conditions and types of green. If our painting comprises fields, shrubs, trees, and bushes all made up of these various greens, how better to make the harmony complete than by contrasting a

The color wheel. Color has been the subject of study for many hundreds of years ranging from the simple act of observation to highly complex psychophysical theories. In terms of painting and drawing, some of the most important terms include hue, tone, and warm and cool colors. *Hue* is the range seen in the color wheel. The *Tone* refers to the brightness of a color. *Warm and cool* colors describe the orange and blue sections of the color wheel, respectively.

Additive mixture. Red, green and blue are known as additive primaries. When two of these are combined a third color is created which is the complement of the third color.

Subtractive mixture. When two additive colors are combined they create a subtractive color. The colors produced are cyan, yellow, and magenta. When white light is passed through, black is created.

small amount of the opposite, or complementary color, being, in this instance, red. The red will serve to enhance the values of the main body of color – the range of subtly mixed greens. To expand this, since we know that green is a secondary color created from two primary colors (blue and yellow), we can begin to see how this can aid us as well. A similar effect to placing small areas of red beside the green will be created by using blue and yellow in a like manner. By using brilliant Prussian blue and raw umber or raw sienna instead of yellow, an unsuspected green tint will result. Further experimentation will reveal all manner of exciting relationships, not merely of color values – that is 'blueness' or 'redness' – but also of qualities and tones.

Tone and hue
Color has two basic definable qualities: tone and hue. Hue is the 'greenness' of green paint, and tone is its darkness or lightness. Squinting is indispensable in assessing color tones when beginning to work and throughout the painting's development. Expressionistic color as used by 20th century artists such as Matisse and Derain, or the more traditional use as seen in Velazquez (17th century) are worthy of close study. In studying paintings, try always to detach the color element from the whole painting in order to examine it the better.

There is little point in simply copying 'color as seen' without attempting to first organize a scheme. Whether the artist's intention is to shock or to create a mood strictly with a number of tertiary colors, forethought is essential. One method of studying color is to use sheets of specially colored papers, cut out and placed in various shapes and combinations to see what happens when tones are too close or too distant.

Perspective

What is a good picture? There is no simple answer; perhaps one that excites or disturbs, not one necessarily pleasing to the eye, but containing a great deal of visual interest. Not only should the artist be facile in his knowledge and use of the materials, but he or she should be conversant with these other important ingredients of visual communication and, through the fusion of these various elements, achieve his or her ambitions.

In picture making, the elements every artist needs to understand in order to best exploit them include color, composition, and perspective. The fusion of these components with a good basic drawing ability and sound technique give the artist an opportunity to express his personal vision.

These aspects of painting and drawing can be sufficiently learned to allow

One, two, and three point perspective. When two planes are visible, the parallel lines converge at a single vanishing point. When three planes are visible, two points are required. If a cube is seen above or below the horizon line, three points are used.

Seeing. The human eye functions in a highly complex system allowing us to view the world in three dimensions. Distance is formulated by the angle of convergence of the image on the retina. When many objects are viewed, sophisticated computations take place in the brain.

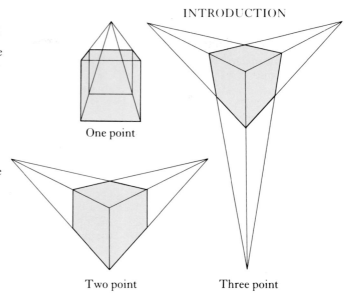

One point

Two point

Three point

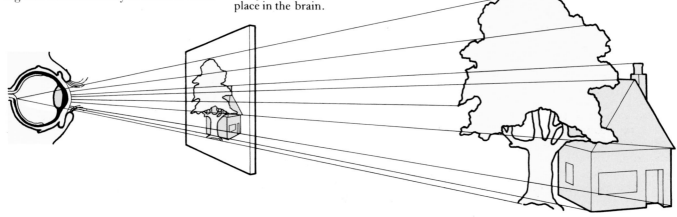

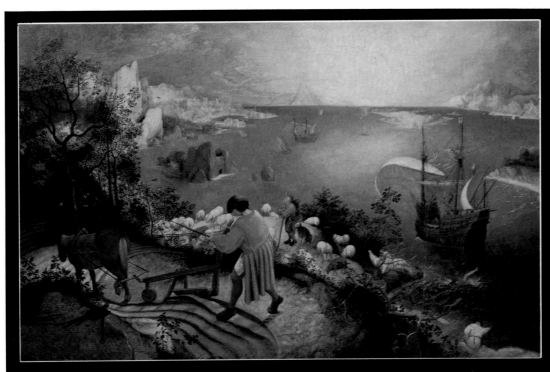

Pieter Bruegel, 'The Fall of Icarus'. The concept of aerial perspective is clearly shown in this painting. Notice how objects close up are precise and detailed and those in the middle and far distance become hazy and less well defined.

19

INTRODUCTION

the original inspiration, no matter how ambitious, to ultimately be resolved. Systematic plotting, allied with an assertion of the artist's intention is the way to achieve good results. No one, however, should expect to always attain their highest levels of work. Being prepared to accept that the 'near

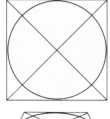

Spherical perspective. Top: If one were to visualize this shape as a teacup seen from the top, as the viewer sits down, the circle becomes an ellipse. To create an ellipse, enclose a circle in a square, bisect it, connect diagonals, and draw ellipse.

Aerial perspective. In general, objects in space diminish in tone as they recede from the viewer and those closest appear darkest. This, however, is not a hard and fast rule as many conditions will affect this principle such as the source of light, the brightness of objects and their reflected light. Tonal variations should be carefully studied rather than preconceived.

Linear and aerial perspective. The combination of linear perspective (the path) and aerial perspective (the diminishing tones of the receding trees) combine to create a sense of depth. Leonardo da Vinci created aerial perspective as a means to describe the different visible tones of objects in space. Objects viewed at a distance will appear to take on a bluish tone due to the scattering of light waves.

miss', the 'brave attempt', or even the outright failure is the sign of a good student. Experience and the ambition to push things a bit beyond one's reach is productive, sound reasoning.

Along with linear perspective, the artist uses aerial or atmospheric perspective. Aerial perspective is that which deals with the reduction and changes of tones and colors due to the distance between them and the viewer. A formula used in the past, e.g., by Pieter Bruegel (*c*.1525–1569) in 'The Fall of Icarus', demonstrates the basic idea of aerial perspective. Objects close-up are seen to be in full tonal and color values; bright, light surfaces facing the light source, and dark in those turned away. Objects

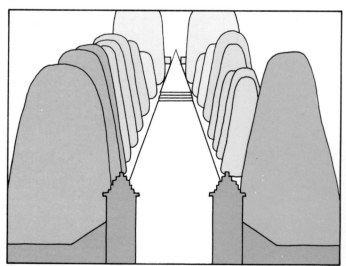

The horizon line. The horizon line is always at eye level. No matter what the size or dimensions of objects, their diagonal lines will all converge on the horizon line.

seen at a short distance, behind these objects, can be seen to have a less well defined distinction between their light and dark sides.

In atmospheric perspective, colors will be seen to have been modified by the atmosphere and to take on a bluish tone. In the middle distance, this is more marked with less subject definition and closer color values, and so on until, in the far distance, only the shape of objects can be discerned and the blue so assertive that things appear to be pure blue. This use of the dark brown foreground, green middle distance, and blue far-distance was in common use in the 17th and 18th centuries. No such rigid formula is to be encouraged, but the use of aerial perspective is essential in the type of work under discussion.

The simplest demonstration of the problems encountered by anyone attempting to transfer a sphere on to a two-dimensional surface is seen in that of two-dimensional projections of the earth. One can begin to see that the point of using such a system of perspective is simply to allow the picture to tell its intended truth. The artist, however, must understand the limitation of such theories well enough to be prepared to depart from the rules as much as needed.

This is of course a direct corollary to the embracing of any scientific method be it of color, perspective, or proportions. They are very useful as servants, potentially disastrous as masters. The one constant criterion in all picture making is the intention and content of the work undertaken; all other considerations are dependent upon this. A good artist is prepared to use all, or none, of these systems towards this end.

To visualize the scale of a painting, when studying the techniques used, each of the pictures shown from pages 36 to 301 are illustrated on a small grid to show their relative size. The maximum size being 39in × 30in (97.5cm × 75cm), each square in the grid represents 3in (7.5cm). The relative size of the painting is indicated by the tinted area.

Materials

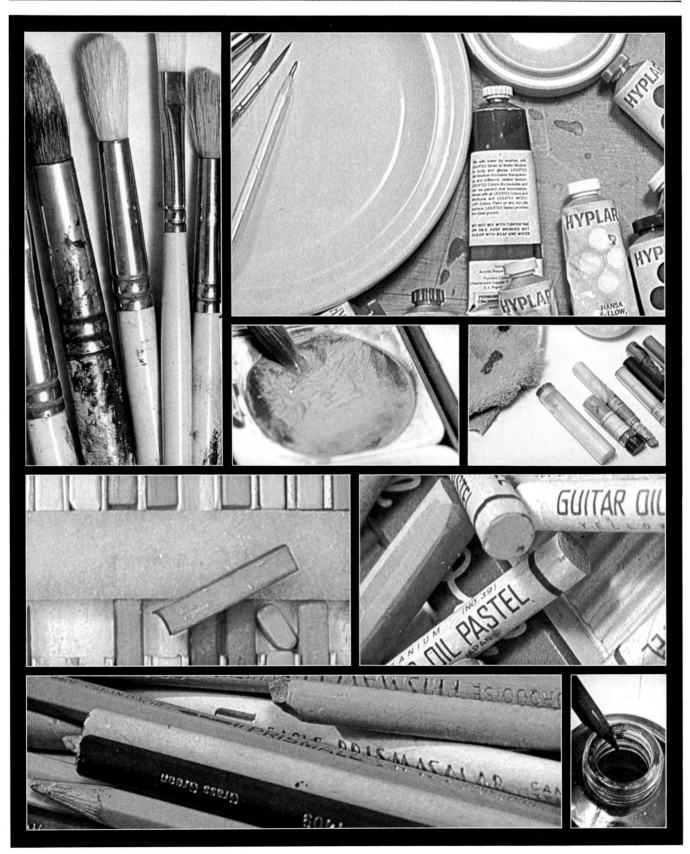

Oil

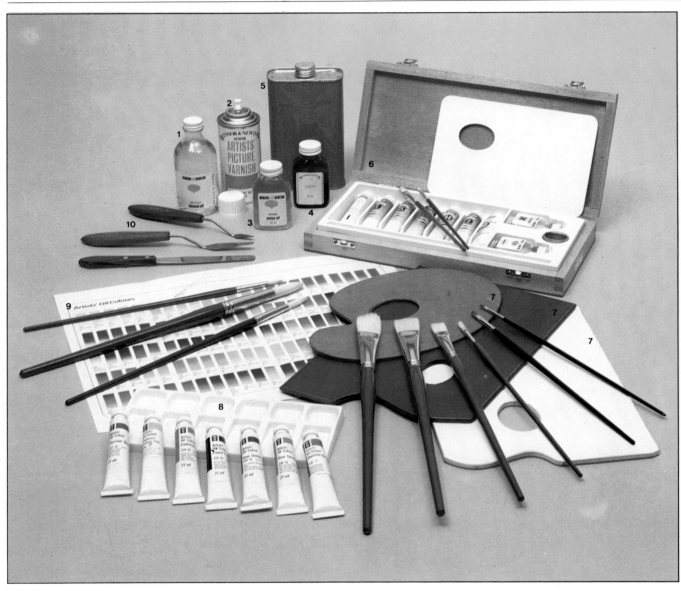

THE EQUIPMENT AVAILABLE to the oil painter is extensive and can therefore be confusing. Initially, the artist should work with as few materials as possible and concentrate on perfecting his technique and understanding of the medium. After a time, it is worthwhile to experiment with a variety of brushes, knives, and mediums, their uses and effects. The basic equipment required by the oil painter should include a small range of oil colors selection of brushes of various shapes and sizes, such as bristle flats and rounds, and smaller sables; a palette knife for mixing and scraping back; distilled turpentine for thinning (not a turpentine substitute); a medium such as linseed or poppy oil; a palette – paper, wood, or glass – and plenty of rags or tissues.

Oil brushes
A great variety of brushes are available to the oil painter. Each type offers a different texture and effect. Some of the most common include (top to bottom): Fan brush for blending; small, medium, and large round bristle brushes for a smooth effect; large, medium, and small flat bristle for covering large areas; fine sable oil painting brush for detail work. The finest brushes should be purchased and cared for accordingly.

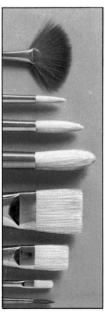

Oil painting materials Shown above are some of the standard equipment needed by the oil painter. (1) Linseed oil is the most popular medium; (2) picture varnish; (3) poppy oil, a slow drying medium; (4) Liquin, a fast drying medium; (5) pure turpentine; (6) an oil painting kit which includes basic colors, mediums, and brushes; (7) palettes – wood, and paper; (8) mixing palette; (9) color charts will show the permanence and impermanence of the various colors; (10) assorted palette knives.

Acrylic

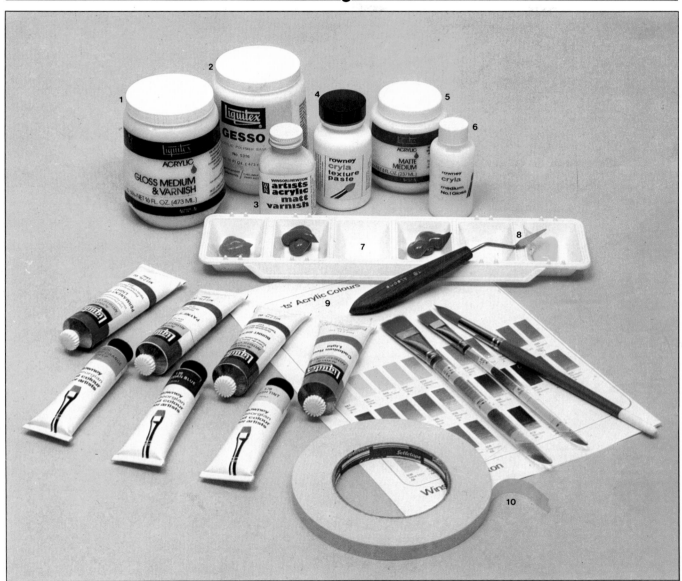

AS WITH OILS, acrylic equipment should be kept to a minimum. Over the years, many mediums and additives have been developed which allow the artist to expand the range of acrylic effects and techniques. All of these are useful, but should be used with care. Many artists enjoy using acrylics not only for their artistic merits, but because they are less messy than oil paints. As acrylics dry to an extremely permanent state, all painting equipment must be cleaned immediately after use. While there are cleaning agents for paint-dried brushes, most better-quality brushes will be ruined if not cleaned immediately. The basic equipment needed should include a selection of colors similar to oils: a palette, mixing dishes; and a selection of brushes.

Acrylic brushes Almost all types of brushes can be used with acrylic paints including bristle and sable. The best, however, are the synthetic type specially created for use with acrylic paints. These include (top to bottom): Medium flat, medium round, large flat.

Acrylic materials Above: A range of mediums are available. These include: (1) Gloss medium which adds gloss to the paint; (2) acrylic gesso for priming (can be used for all painting media); (3) matt varnish; (4) texture paste for rich, impasto effects; (5) matt medium to dull the paint; (6) pure polymer medium to add body. Other equipment includes: (7) Mixing tray; (8) palette knife; (9) color chart; (10) masking tape for masking off areas.

Stretching canvas

1. Loosely join the four pieces of stretcher. If the corners do not mesh easily, knock them slightly with a hammer or fist.

2. To make sure the square or rectangle is even, measure diagonally to opposite corners.

3. Place the frame on a piece of canvas and trim around leaving at least 3in (7.5cm) of overlap.

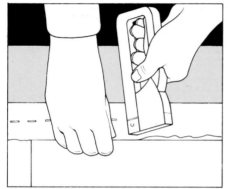

4. Lift the canvas and frame upright. Begin to staple or nail the canvas to the frame from the centre of each strip.

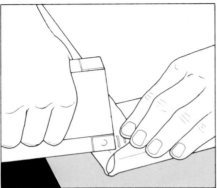

5. Fold in the corners as if wrapping a package and staple down the corners with two or three staples.

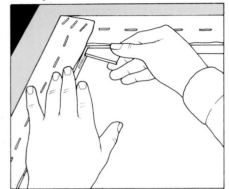

6. Insert wooden pegs in the spaces behind the joints of the stretchers. Knock into place with a hammer.

Applying size/ground

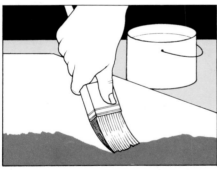

Apply the size to the panel with smooth, consistent strokes. When completely dry, size the back of the support.

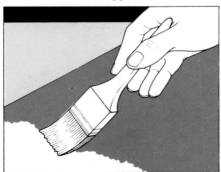

Apply the ground with smooth strokes. Let dry thoroughly and sand lightly with a fine grade sandpaper.

Oil painting fabrics

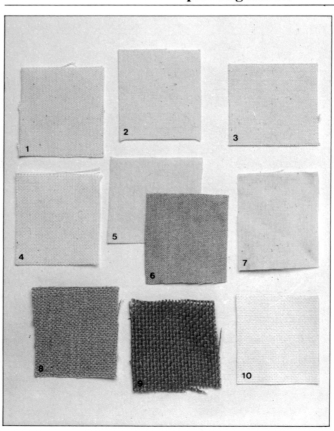

For hundreds of years, oil painters have used various types of fabric for their paintings. Of prime importance is that fabric will alter with atmospheric changes; as well, the minute gaps between the threads allow for thorough drying of the paint. There are many types of fabrics available ranging from very expensive linen and canvas to the popular cotton duck. These are available either unprimed or ready-primed. Some of the most common (left) include: (1) 10 oz cotton duck; (2) 12 oz cotton duck; (3) 15 oz cotton duck; (4) 9 oz cotton duck; (5) embroidery linen; (6) artists' linen; (7) unbleached calico; (8) flax; (9) Hessian; (10) prepared canvas.

Stretching paper

1. To determine the right side of the paper, hold the sheet up to the light; the watermark should read normally.

2. Gently place the paper in either a tray of clean water or under a running tap.

3. Measure lengths of gummed tape equal to the sides of the drawing board to be used.

4. Place tape carefully along the sides of the still damp paper and place on the board.

5. Smooth out the paper from the centre outward and press down the tape.

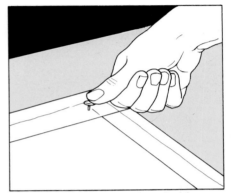

6. Secure the paper to the board with drawing pins placed at the corners. Allow to dry.

Watercolor papers

The number of watercolor paperss available is often confusing; the best method of choosing is by experimenting and talking with art store personnel. It is useful to collect swatch books of different papers available. Some important factors include the weight, texture, and tone of the paper, all of which will affect the finished painting. An alternative to buying tinted paper is to buy white sheets and tint them yourself with a wash of color. When stretching watercolor papers, remember that the weight of the paper will determine the length of soaking time. Some of the most common types are shown, <u>right</u>.

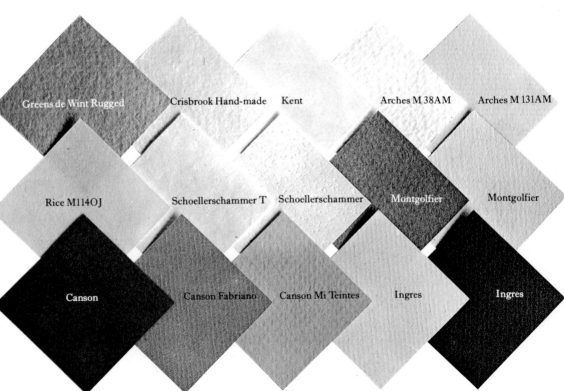

Greens de Wint Rugged

Crisbrook Hand-made

Kent

Arches M 38AM

Arches M 131AM

Rice M114OJ

Schoellerschammer T

Schoellerschammer

Montgolfier

Montgolfier

Canson

Canson Fabriano

Canson Mi Teintes

Ingres

Ingres

Watercolor

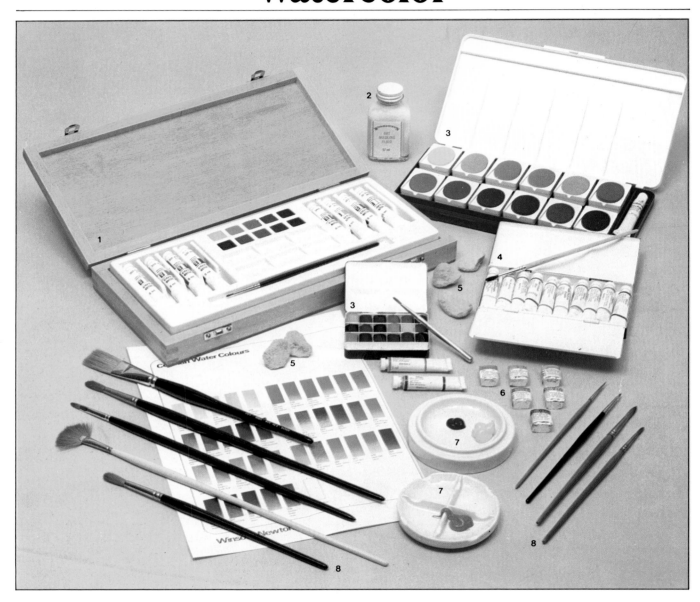

WATERCOLOR PAINTING materials are straightforward and largely determined by the needs of the artist. The paints are available in a variety of types. Tinned and caked watercolors are convenient for working out of doors; tubed colors are also convenient but must be carefully capped after use or will dry out quickly. Watercolor painting kits are also available and range from the simple to the sophisticated. The only other equipment needed is a palette or mixing dishes, small sponges for blotting and blending, and a range of good brushes. The latter are particularly important to the watercolorist as he relies on his brushes to successfully execute the various techniques. The artist should thus purchase only the finest brushes.

Watercolor brushes
Watercolor brushes are an important part of every artist's equipment. Brushes are available in many sizes and are usually of sable, camel, or ox hair. There are also synthetic brushes available. Shown (top to bottom): Nos 2, 4, and 6 camel brushes; no 6 sable; large wash brush; nos 6, 4 flat camel hair; nos 1 and 3 sable.

Watercolor materials The selection of watercolor materials is largely a matter of personal choice: (1) A comprehensive kit will contain all colors and equipment needed; (2) masking fluid is useful for masking off areas not to be painted; (3) tinned watercolors; (4) tubed watercolors; (5) watercolor sponges; (6) watercolor cakes; (7) mixing dishes; (8) assorted brushes.

Gouache

Tempera

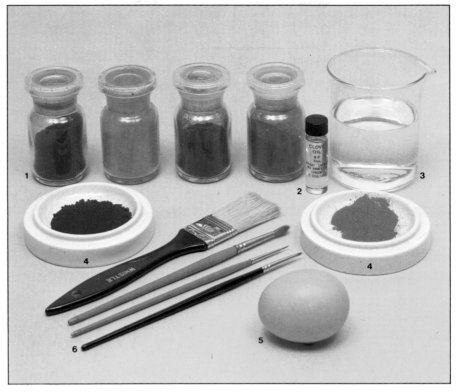

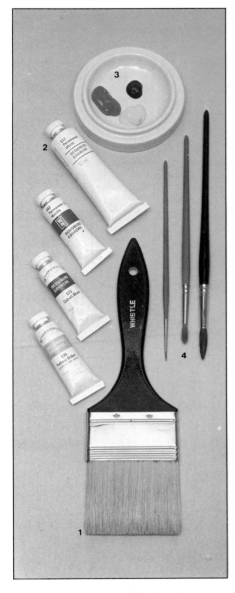

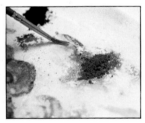

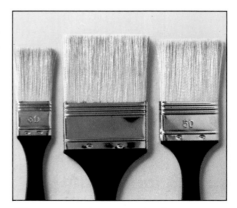

Making tempera
1. Break the yolk of a fresh egg into a jar. Add ½ egg shell of distilled water.

2. Mix thoroughly with brush or spoon to make a creamy texture.

3. Pick up yolk mixture on brush and mix with small amount of dry pigment on palette or mixing dish.

THERE IS OFTEN confusion between the terms 'gouache' and 'poster color'. Poster color is an inferior grade of gouache and is usually sold in large quantities for use in schools. The best type of gouache is designers' gouache which is used especially by designers and illustrators. White designers' gouache is often used with watercolors to lend an opaque quality. White gouache is useful for touching up mistakes on pen and ink and pencil drawings. The basic equipment needed should include a few colors, palette or mixing dishes, sable brushes and, a small decorators' brush.

TEMPERA PAINTING was at its height in the 15th century and recipes from this time often read like magical potions for alchemy. While these are interesting to read, the equipment needed today is very simple and basic. Pure, dry pigments tend to be expensive and hard to obtain but should be acquired if serious tempera work is to be done. A fairly good substitute is tubed watercolors. When mixed with egg, these take on all the qualities of pure tempera lacking only in the richness and translucence obtained with pure pigments. Other equipment: water, eggs, dishes and sable brushes.

All-purpose brushes Detail work is normally done with fine sable watercolor or oil brushes. Wider brushes are useful for priming the surface and covering large areas. The three shown are white bristle: 2½in (6cm), 2in (5cm), 1¼in (3cm). Others include ox, camel, and badger hair.

Gouache materials
(1) A small housepainting brush is useful for blending and spattering; (2) tubed designers' gouache; (3) mixing dishes; (4) sable brushes

Tempera materials
(1) Dry pigments; tubed watercolors may also be used; (2) clove oil will make the paint richer; (3) distilled water; (4) mixing dish; (5) fresh egg; (6) sable brushes.

Preparing a panel

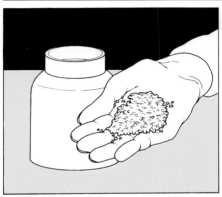

1. Soak a handful of size crystals overnight using 1 part of size to 10 parts of water.

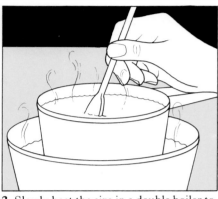

2. Slowly heat the size in a double boiler to dissolve the crystals. Do not let the mixture boil.

3. To give the panel a tooth for the gesso to adhere to, lightly sand with a medium weight sandpaper.

4. Apply size in even strokes across the panel. When completely dry, size the back as well.

5. Mix three parts of Gilder's whiting to 1 part of zinc white.

6. Shake this mixture into a bowl filled with warm size until the size can absorb no more of the mixture.

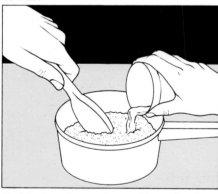

7. Stir the mixture thoroughly to dissolve the whiting.

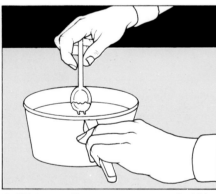

8. With a small spoon, remove any bubbles or lumps in the mixture. Strain the mixture through a muslin cloth.

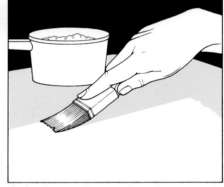

9. Apply gesso in smooth strokes across the panel, in one direction. When dry, work across in the opposite direction.

10. Apply six to eight more coats of gesso in the same way, allowing to dry between coats. Sand the surface between coats.

11. For a fine polish, rub into the surface with a damp linen rag.

Types of panels

Wooden panels were in use as painting surfaces much earlier than fabrics. Panels are suitable when the artist desires a smooth, consistent paint texture, but all must be sized to prevent warping and splitting. Mahogany is the most durable but tends to be expensive. Chipboard is tough and will not require extensive preparation. Plywood should be backed or glued to another piece of wood. Panels can also be sized with a piece of muslin or canvas to give a fabric texture to the painting surface.

Window mounting

1. After measuring the size of the window on a piece of mounting board, lightly prick the intersections with a drawing pin.

2. With a very sharp scalpel or Stanley knife and metal ruler, cut into the board, following the ruled lines.

3. Attach the picture to the back of the mount using either gummed tape or rubber cement.

Mouldings

Mouldings come in a wide assortment and selection is best determined by the subject to be framed. The most common include: (1) box; (2) reverse slope; (3) half round or hockey stick; (4) raised bead and flat; (5) box; (6) planed timber and architrave.

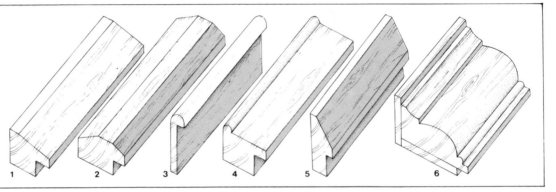

Cutting a miter

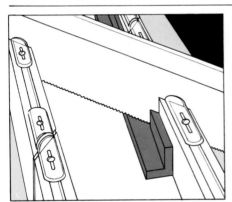

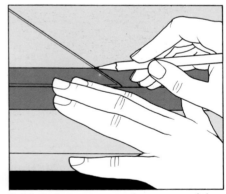

1. Secure the piece of wood to be cut in a miter box.

2. Measure the appropriate length from the inside of the mitred edge.

3. Mark the next cut on the top part of the wood so it will be easily seen while cutting.

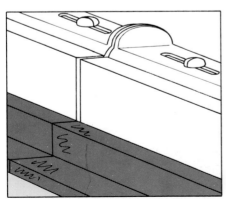

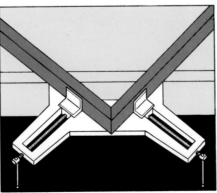

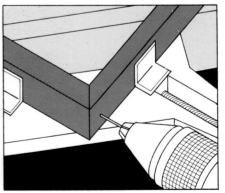

4. Place the wood in the miter box so that the saw will cut precisely through the mark.

5. Using long and short pieces of wood, assemble an 'L' shape in the clamps of the miter box.

6. Drill small holes in for the pins to be inserted to avoid splitting the wood.

Pencil

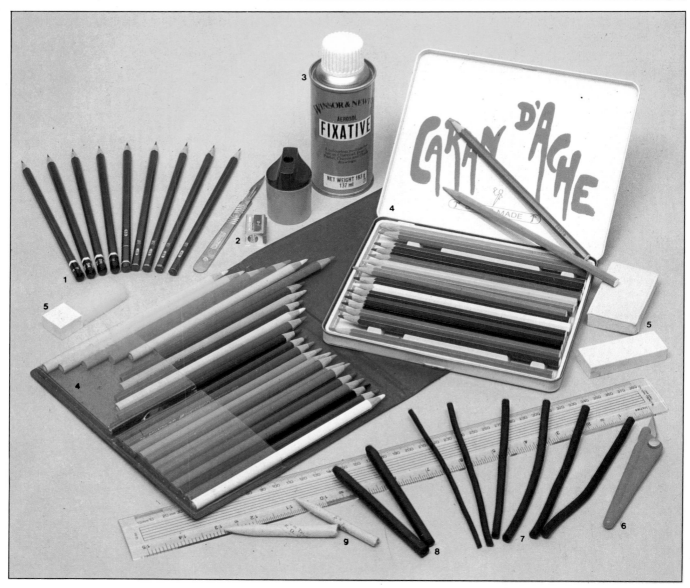

DRAWING PENCILS ARE made from a mixture of graphite and clay, the amount of graphite determining the density and softness of the pencil. To avoid confusion, pencils are assigned letters and numbers indicating their hardness and density. These range from the HB – a hard, light pencil – to the 8B with a very soft, dark mark. Most artists find a small range of pencils covers all of their needs; a light, hard pencil for preliminary sketching and a mixture of soft and dark pencils for shading and toning. Colored pencils are defined purely by their color and are not sold by grades. Drawing charcoal is made into either thin, fragile sticks of willow, or compressed charcoal which makes a hard and dense mark. Other tools include erasers, sharpeners, and fixative.

Drawing materials
A basic collection would include the following: (1) A variety of soft/hard, dark/light grades; (2) scalpel or sharpener; (3) fixative; (4) set of colored pencils; (5) putty and gum erasers; (6) knife; (7) fine and medium willow charcoal; (8) compressed charcoal; (9) torchon.

Auxiliary equipment

The more pencil becomes a part of the artist's repertoire, the more he will naturally know what equipment is required to facilitate the drawing process. Some of these include masking tape, gummed tape or thumbtacks for mounting paper on board and Q-tips and tissues.

Pastel

Pen and ink

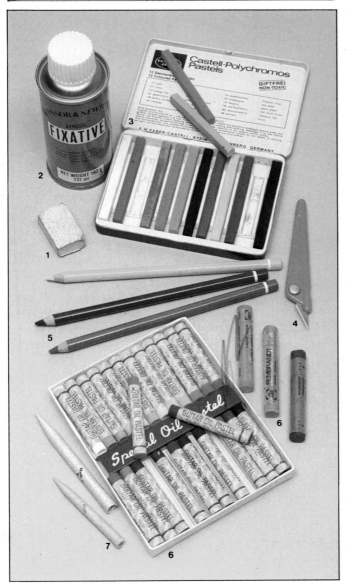

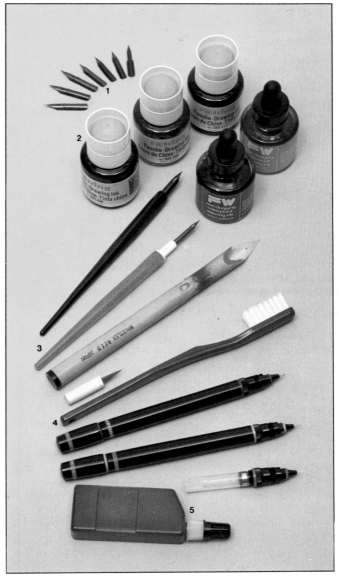

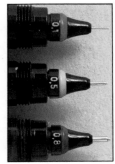

THE SIMPLEST WAY to purchase pastels is in sets which will include all the basic colors required. After familiarizing yourself with the medium, you may wish to purchase individual sticks of color as often one or two colors will run out before the others. Pastels come in two forms – hard and soft. The soft type are extremely fragile and tend to crumble easily; a combination of the two usually yields the best results. Fixative is a must for all pastel work, both to preserve the picture and protect it from damage and smudging. Oil pastels are simply chalks with an oil binder added. As the pigment used is coarser, oil pastels are different from the chalk type.

Pastel materials (1) Putty eraser; (2) fixative; (3) pastels; (4) knife; (5) pencils; (6) oil pastels; (7) torchons.

THE BEST WAY to become familiar with the types of pen and ink equipment available is to purchase one or two dip pen holders and a variety of nibs ranging from fine to broad. These are relatively inexpensive and useful for experimentation. Dip pen ink comes in black and a variety of colors, both waterproof and water-soluble. As the distinction between illustration and drawing becomes less well defined, the materials of the illustrator/artist have become part of the pen and ink artist's repertoire. Rapidograph nibs come in a variety of sizes. Under no circumstances use dip pen ink in the rapidograph; only special rapidograph ink must be used.

Pen and ink materials (1) Pen nibs; (2) inks; (3) dip pens; (4) toothbrush; (5) rapidograph ink.

Dip pen nibs
There are many types of nibs for dip pens ranging from extremely fine to broad; a range of types are useful to keep on hand. Pen nibs are fragile and should be carefully cleaned after use.

Rapidograph nibs
As with dip pens, there are many types of rapidograph nibs which range from the extremely fine-lined 0.1 nib to the broad, 0.8. The nibs are very sensitive and should be cared for accordingly.

Landscape

THE NATURAL ENVIRONMENT of man is bound to be a popular subject used in paintings and drawings. Earlier art, however, tended to stress the narrative elements of the picture and landscape was often relegated to the background. Indeed, so important was the priority given to man and animal that often a landscape was no more than a cypher, meriting no reference at all.

Egyptian artists used reeds and skies, creating an atmosphere in which birds, beasts and fishes could exist. These landscapes are less descriptions of specific places than arrangements of separate landscape elements, cunningly disposed in order to relate as parts of the overall picture. Thus, a clump of bullrushes are placed on the surface at a calculated distance from the birds living and nesting in them.

The growth of landscape

The use of the component parts of landscape to symbolize the environment and the adjustment of the landscape to make it conform to the design needs of the picture has persisted. It would of course be remarkable if trees, hills, shrubs and clouds all perfectly interlocked into foreground, animals, figures and the like. The French 17th century painter Poussin is a fine example of an 'orchestrated' landscapist, with each element playing its part, not merely to establish space for the subject of the painting, but also allowing shapes, colors, and textures to contribute to the painting's overall effect.

From humble beginnings, the landscape came to be used as a major part of the picture and indeed to eventually become the whole of the picture. The painters of Renaissance Italy in depicting Biblical events used the everyday scenes around them for the church-goer to identify with. Because the streets of the cities and the forested hills beyond were an unquestioned part of everyday life, great historic dramas were enacted within these pictures, the better to be understood by the common man.

Since the 17th century, landscape painting has flourished and we now think of several interpreters of the fields, seas, and mountains as amongst the greatest of artists. Atmospheric painters such as William Turner, John Constable, and Edward Hopper employed the principles of both linear and atmospheric perspective, and the engravings of Rembrandt and others show a similar knowledge.

It is advisable to plot with care the composition of your landscape, for certainly anyone painting such a subject, whether from life or from sketches, will have to make adjustments to the natural scene. Nature herself will be perfect when viewed as a landscape, but a piece of it trapped within a rectangle or square as a picture will certainly contain unwanted elements. Be prepared to remove, substitute, or add a tree; feel free to reduce the amount of yellow if it seems to jump out of context, and to mix a range of greens rather than use one basic green, even if such a basic green is modified by other colours. The source of such greens – Prussian blue plus yellow or viridian green – will show if too much of it appears in the same area. Brown and blue will also offer a new green to the palette; always experiment as our demonstrations set out to suggest.

Landscape media

When working in watercolors or gouache, the principle of varying the basic green used is again of great importance. Because these pictures are likely to be small in scale, several important decisions must be taken before committing the paint to paper, especially in watercolor painting. This often demands an analytical attitude, deciding which colors to use in order to simplify things and then modifying one layer with another, as brilliantly exemplified in the pictures of Girtman and Cotman, both 19th century artists.

With gouache, the problems differ for one can overpaint, make adjustments, even pile paint on very thickly for particular effects, as seen in the work of Samuel Palmer (1805–1881).

Pen and ink suits landscape interpretation, as it has a conciseness and fineness of detail that gives the subject a good feeling. Never hesitate

Surface shapes The most common shapes are landscape and portrait. Landscapes need not be horizontal nor portraits vertical.

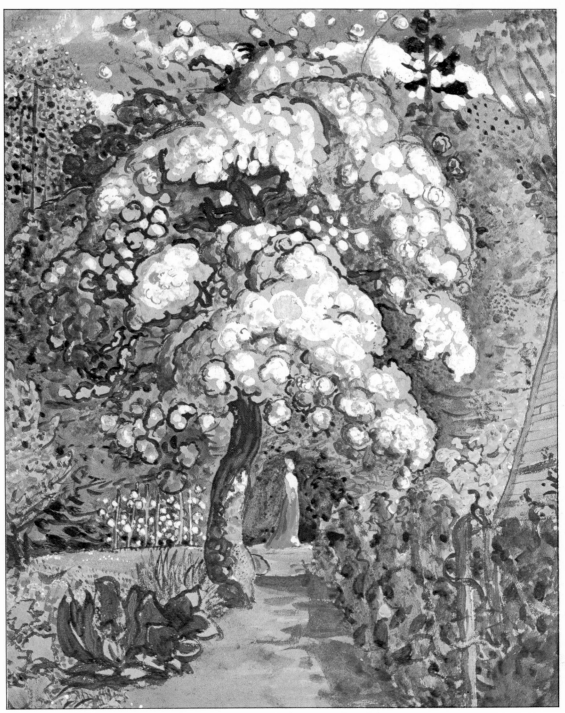

Samuel Palmer, 'In a Shoreham Garden'. This painting is a good example of the unique qualities of gouache used in landscape painting. Note as well the incorporation of the figure in an otherwise purely natural picture showing how landscape and figure subjects can be successfully combined.

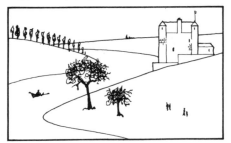

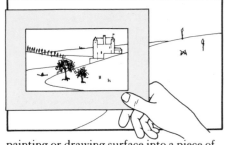

The viewfinder A viewfinder can be a great help in choosing a suitable composition. The viewer is made by cutting a shape similar to that of the painting or drawing surface into a piece of heavy card. By holding the viewfinder at arm's length, the artist can select the view of the scene to be used.

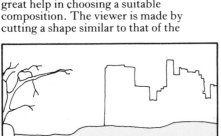

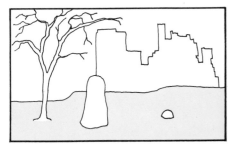

Strengthening composition The composition of a picture is often determined by the goal of the artist. For example, if an accurate rendering of a scene is desired, the artist will move about to find the most interesting point of view. If, however, the artist is more concerned with the painting itself rather than a realistic rendition of the scene, he may use creative license to rearrange objects. Left: The picture is pleasing but uninteresting. Right: Interest is added by moving the tree to the right and introducing another element.

Motion and direction Left: Objects in a landscape are susceptible to the elements of nature and not least of these is wind. When movement is involved, it should be looked for in all objects, not just the obvious. Right: In this picture, the road leads the observer's eye across the picture plane. The idea of leading the eye through the use of direction is an important element in all types of painting and drawing.

The sky In all landscape work, the sky can be used as either a major or minor pictorial element – but it will always influence the rest of the picture. Above: Loose, billowing cloud shapes are emphasized by the straight, hard horizon line. Center: Using a very high horizon line and only a small indication of land, a semi-abstract image is achieved. Right: The sky is an effective backdrop for the sharp outline of the castle, creating a silhouette effect.

to use any outside aid such as the ruler for there is no great achievement in putting unreasonable handicaps in your way and ruled lines will contrast very well with the freely drawn line. Splattering ink, using unlikely instruments – string dipped in ink or the edge of a piece of wood or plastic – will add to the range of textures and therefore to the possibilities.

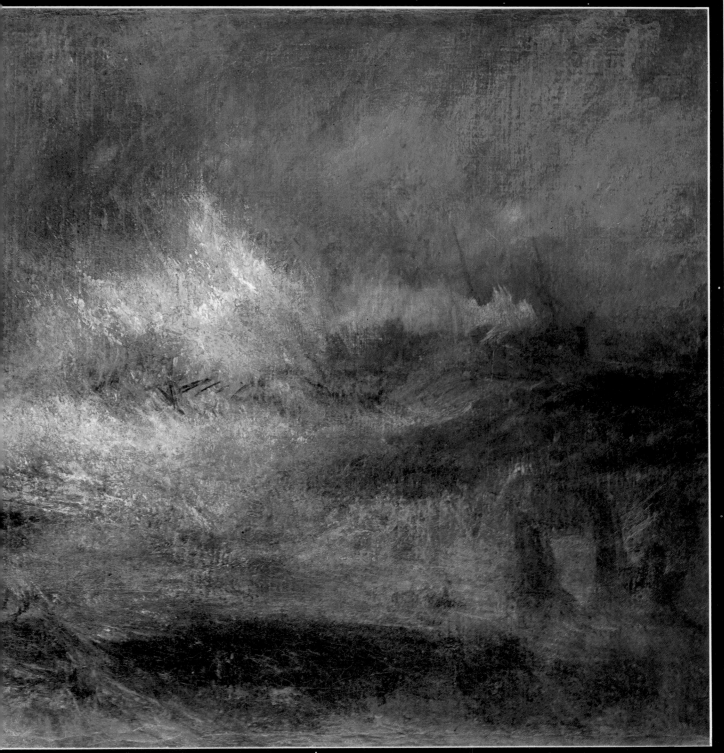

Turner was a master at creating stimulating land and seascapes. In this picture, paint has been heavily impasted to build up rich, subtle tones.

Pencil drawing has been used a great deal for this subject in recent times, and the 20th century artist Paul Hogarth has shown an astonishing freshness and variety of touch in his drawings of buildings, landscapes, and city streets. This is achieved by using a number of pencils and often consolidating the drawing by adding ink to emphasize details.

The sky is a constant element in any landscape interpretation whether drawn or painted. Be aware of it as not merely a backdrop to the scene but as an integral part, able to lend drama through heavy clouds or suggest vastness by being indicated as a simple void. Constable made many small sketches in color of changing skies, cloud masses, etc. and was able to

incorporate things learned from these into his larger pictures. Because the source of light will generally be in the sky, it follows that in most cases it will be the lightest tone in the landscape. However, do not let it disassociate itself from the remainder of the piece but integrate it into your overall scheme by adjusting either it or the land mass.

Oil

THERE ARE VARIOUS ways of undertaking the preparatory stages of an oil painting. Here the composition is roughly outlined using a soft pencil; this method requires a light touch as heavy pressure may dent the canvas and cause the stretched surface to sag. The composition is divided roughly in half, but the artist has taken care to avoid making a completely symmetrical division of the picture plane, as this would interfere with the spatial illusion.

The low wall and brightly lit garden urn on the left of the painting underline the horizontal emphasis but, more importantly, provide a focal point which contrasts with the large expanse of green. The result is to create an overall sense of harmony. The shades of green are varied by the addition of blue, white, yellow and red.

The texture of the surface was enlivened by spattering wet paint from the end of the brush and constantly altering the directions of the brushstrokes. The best way to apply the paint is to vary the techniques; for instance, lay thin glazes over patches of solid color, scrub the paint into the weave of the canvas, and feather the brushstrokes into textured trails.

Materials

Surface
Stretched, primed canvas

Size
39in × 30in (98cm × 75cm)

Tools
1in decorator's brush
Nos 6 and 8 hog bristle brushes
No 8 round sable brush
Wooden artist's palette

Colors
Black Cobalt blue
Burnt sienna Chrome green
Burnt umber White
Cadmium red Yellow ochre
Cadmium yellow

Medium
Turpentine

1. Draw up the composition lightly in pencil. Block in a loose impression of the background shapes with thin paint. Use greens with blue, yellow and red.

2. Continue to develop the shapes, varying the tonal contrasts and breaking up the color masses with linear brushmarks and small patches of different hues.

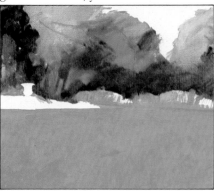

3. Lay in a solid expanse of chrome green across the whole of the foreground, using a 1 in (2.5 cm) decorator's brush.

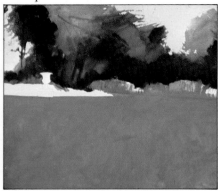

4. Work over the sky and around the forms of the trees with a thick layer of light blue. Draw back into the green shapes with the brush to make the outline more intricate.

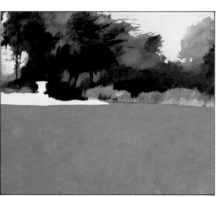

5. Work over the colors with fine linear brushmarks and thin layers of dribbled and spattered paint to increase the variety of tone and texture.

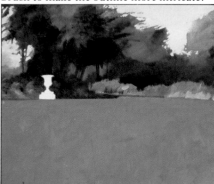

6. Define the shape of the wall with small dabs of brown, red and pink laid against strong black shadows. Blend and soften the color with a dry brush.

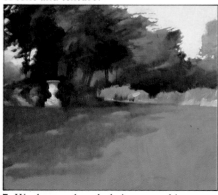

7. Work over the whole image making slight adjustments to the shapes and colors. Bring up the light tones and darken shadows.

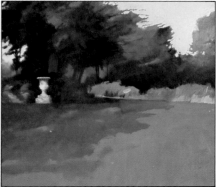

8. Brush in a thick layer of bright green over the right of the foreground, working into the dark shadow area to bring out the illusion of light and shade.

Details of wall · outlining the urn redefining tree outlines

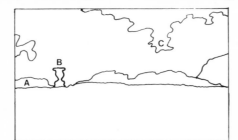

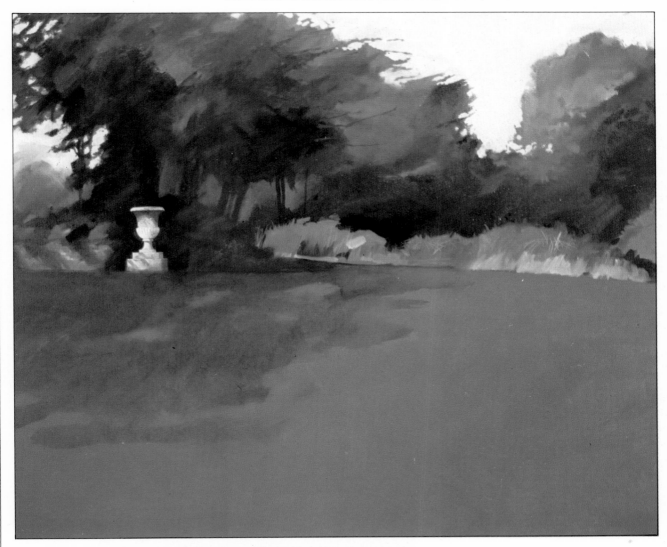

A. With a small sable brush, the artist is here putting in details in the wall. The previous layer was allowed to dry thoroughly before overpainting.

B. With a small bristle brush, the artist is here working carefully around the urn to strengthen outlines.

C. With a small sable brush and a thickish mixture of pale blue paint, the artist works back into the tree shapes.

IN ALL PAINTING and drawing, the artist's decision on what media and techniques he or she uses to create a picture is a highly individual and selective process. The factors involved are a combination of practical skill, an understanding of the media and techniques and, most importantly, how the artist sees the picture in his or her mind's eye.

In this picture the *alla prima* method has been used. This is a quick, direct method of painting which can be used to create a bold and exciting picture in a short period of time. From a rough sketch, the artist works directly on to the surface, as opposed to the traditional method of building up layer upon layer of color, or working from dark to light. In unskilled hands, this sometimes can be risky as in laying down thick, heavy areas of paint, the artist is often simply hoping that the result will reflect the initial intention. When working as heavily as this, the main danger is of either building up the paint surface too quickly or mistakenly putting down wrong colors. However, one of the beauties of oil paint is that it can be easily scraped off and the artist can begin again.

To work with bold color requires a good color sense and a knowledge of how the individual colors interact with one another. Here, the artist has used 'unnatural' colors such as purples, greens, and reds over basic earth tones to both preserve the feeling of the subject and add interest and variety to the painting.

Materials

Surface
Prepared canvas board

Size
24in × 20in (60cm × 50cm)

Tools
Nos 2 and 4 flat bristle brushes
Palette
Palette knife
Rags or tissues
Willow charcoal

Colors
Burnt umber	Permanent magenta
Cadmium red light	Prussian blue
Cadmium yellow light	Raw sienna
Cadmium yellow	Raw umber
Cobalt blue	Yellow ochre
French ultramarine	White

Medium
Turpentine

1. After lightly sketching in the subject with willow charcoal, apply a thin wash of general color areas in cool and warm tones with a No 4 bristle brush.

2. With burnt sienna and cadmium yellow, overlay the roughed-in areas with thick, short strokes of color, using the stroke to define the shapes.

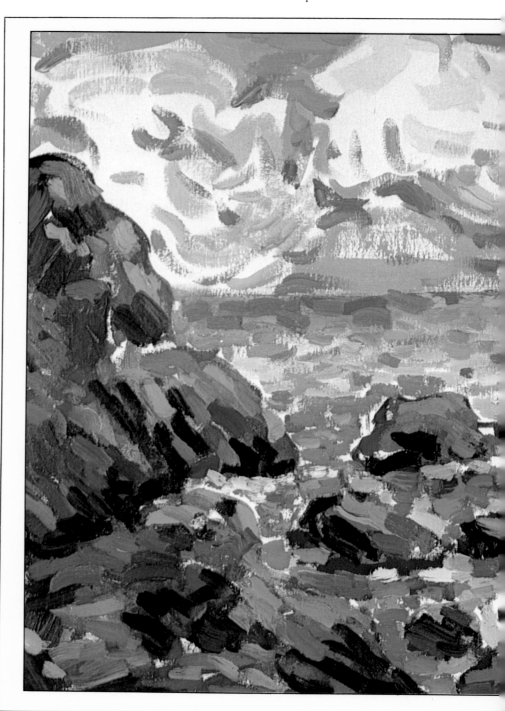

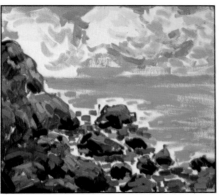

3. Build up the dark tones with Prussian blue and burnt umber and lighter 'dark' tones in green. Add touches of cadmium red as highlight areas.

4. Develop the light areas with cadmium yellow, ochre, red, and purple mixed from ultramarine blue and magenta. Develop water with Prussian blue.

5. Using a No 2 bristle brush, continue to lay in the water highlights in cadmium yellow and white, allowing the underpainting to show through.

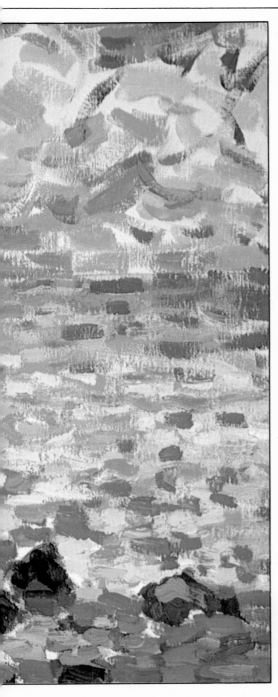

Cloud texture · modelling rocks · water highlights

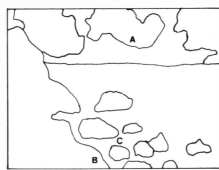

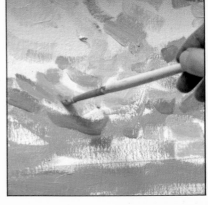

A. The artist is here putting in cloud shapes with a thick, opaque paint mixture and a small bristle brush.

B. Allowing colors to mix directly on the surface, the artist puts in thick strokes of paint in the rocks, allowing previous layers to show through.

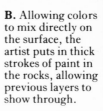

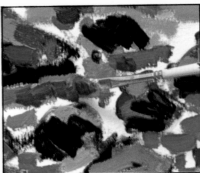

C. With a small bristle brush, various tones are touched into the water area to create a rippled texture.

THE MAIN TECHNIQUE demonstrated in this painting is considered particularly suitable for landscapes involving broad planes of color. The paint is applied thickly with a knife in simple shapes and, as a result, details emerge from the paint surface, rather than being dictated by the structure of the drawing. The composition is built up with overlaid layers of impasto paint giving a craggy, ridged texture. Each individual shape has a ragged edge where small vestiges of previous layers break through the top coat of color. In the final stages the work is coated with very thin, liquid glazes of color. These settle into the pitted impasto to form a veined sheen over the surface, drawing the tones together.

The limited range of color serves to focus attention on the texture of the paint, as does the simplicity of the composition. The balance of tone, color and texture is achieved by continual adjustment of the paint mixtures. The technique must be carefully controlled because the paint is thick and wet – frequent drying out periods may be needed before further layers can be added. Use palette knives to lay in thick paint areas and spread glazes with a clean rag to work the color into the surface.

Materials

Surface
Stretched, primed canvas

Size
12in × 9in (30cm × 22.5cm)

Tools
Palette knives: short trowel, 3in (7.5cm) cranked blade, 3in (7.5cm) straight blade; palette; rags or tissues

Colors
Paint: *Pastels:*
Alizarin crimson Black
Black Cerulean blue
Cerulean blue Ultramarine blue
Payne's grey Yellow ochre
Prussian blue
White

Mediums
Linseed oil
Turpentine

1. Lay a wash of thin grey oil paint over the whole canvas, rubbing it in with a clean rag. Draw up the basic lines of the composition with oil pastels.

2. Apply thick layers of paint with a palette knife, blocking in the shapes with light blues, grey and mauve.

3. Still using the palette knife, build up the textured surface, lightening the tones of the colors. Work in broad, directional sweeps of broken color.

4. Continue to lay in grey and blue tones, varying the direction of the strokes.

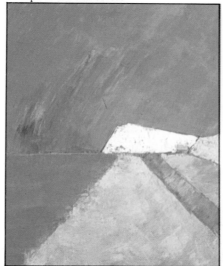

5. Heighten the colors, working over the central shapes with solid white and light greys. Allow the underlayers to show through the thick paint.

6. Adjust the tones over the whole work to warm up the color balance. Even out the colors but keep the thick impasto quality.

Underpainting · painting with palette knife

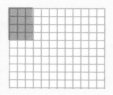

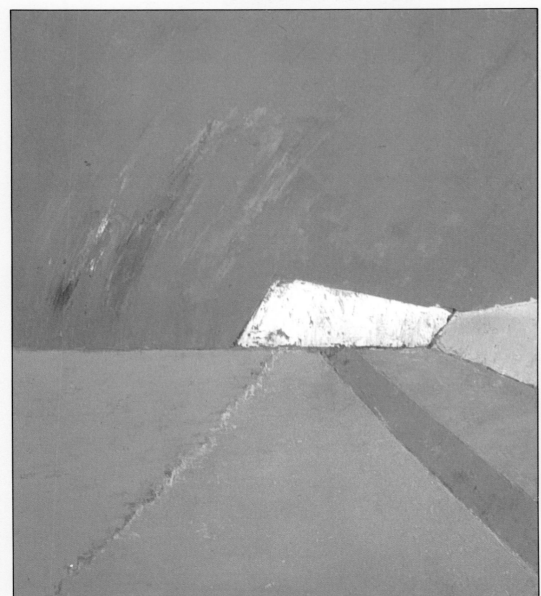

The artist blocks in general color areas with a palette knife, using a thick, opaque mixture of paint.

A thin ground of grey paint and turpentine has been rubbed into the canvas. On top of this the artist puts in the general outlines of the composition in oil pastel.

Draw the knife across the surface, blending the paint well into the canvas with even consistent strokes.

MANY ARTISTS FIND that working from photographs is an acceptable way of creating landscapes. However, there are disadvantages. Although the method enables an artist to increase his or her range of subject matter, it is limiting in terms of a fixed viewpoint and static lighting. The artist can compensate for this by exploiting colors and textures of the painting and by developing aspects of the image which naturally attract attention.

In this painting, the warm glow of light and pattern of trees and flowers have been exaggerated and used as the basis for a more colorful interpretation of the subject. The bright pastel colors of the sky are echoed in the pathway through the center of the picture, while the predominance of green has been enlivened by adding red, forming a contrast of complementary colors.

You can experiment with brushwork, laying the paint on quite thickly; oil paint can be scraped off and the surface reworked if an area of the painting is unsuccessful. Use three or four different brush shapes and sizes and vary the strokes between the tip and flat of the bristles. If necessary, let the painting dry out for a few days before completing the final stages, so that clear colors and clean whites can be laid over the darker tones.

Materials

__Surface__
Prepared canvas board

__Size__
24in × 20in (60cm × 50cm)

__Tools__
2B pencil
Nos 3 and 5 flat bristle brushes
No 1 round bristle brush
No 4 filbert bristle brush
Palette

__Colors__

Alizarin crimson	Cobalt blue
Black	Hooker's green
Cadmium green	Terre verte
Cadmium red	Ultramarine blue
Cadmium yellow	Violet
Chrome orange	White

__Medium__
Turpentine

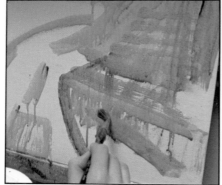

1. After sketching in the composition, with a very thin wash of green and turpentine, quickly block in main shapes with a large, soft sable brush.

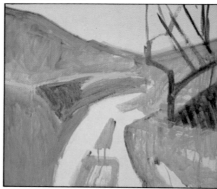

2. Load a bristle brush with cadmium green well thinned with turpentine and scrub in the basic composition, working with black and yellow.

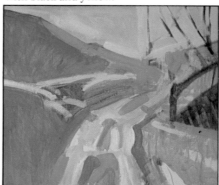

3. Thicken the paint and lighten the tone of the colors, adding cobalt blue and violet to the palette. Work quickly over the painting with broad brushstrokes.

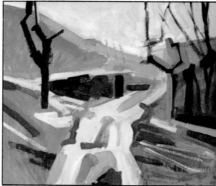

4. Develop the tonal contrast by drawing into the image with black and increasing the range of warm, light colors and mid-toned greens.

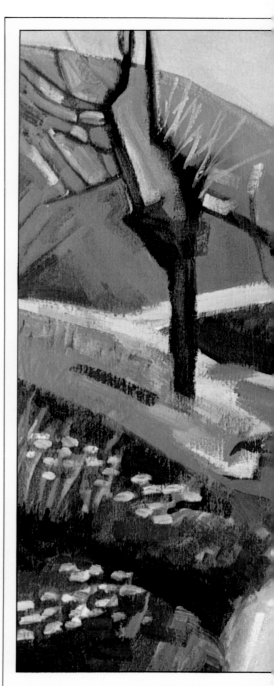

Highlighting · blocking in shapes

With a large bristle brush, the artist blocks in rough shapes of pale blue in the stream with thickish paint.

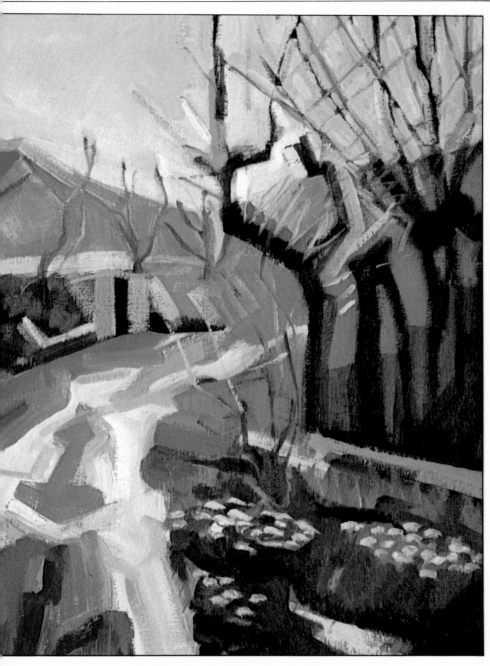

5. Work into the shapes of the trees with red and black and block in thick slabs of green, building up the texture by varying the quality of the brushmarks.

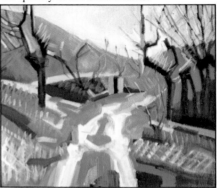

6. Use the point of a fine, round bristle brush to develop the linear structure of the composition and to color details. Paint in dark tones with ultramarine.

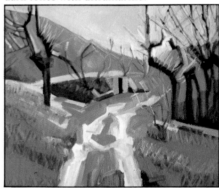

7. Elaborate the texture in the foreground with finely crosshatched brushstrokes of red, green and yellow woven across the previous work.

After drawing in the tree outlines in green, the artist is here working into the white areas between with a pale pink.

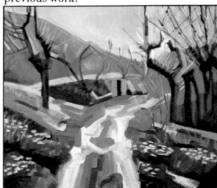

8. Give form and density to the foreground area with streaks and dabs of color. Add depth in the shadows with dark red and blue contrasted with white patterning.

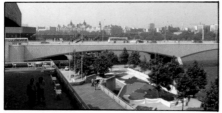

ONE HUNDRED YEARS ago, few artists would consider doing a landscape painting from anything other than the actual subject, *plein air* painting being synonymous with the great artists of the day. Today however, painting out of doors has become something of an anomaly and the artist is often looked upon as an object of curiosity. Most landscape painters learn through experience what is required to adapt themselves and their work to working out of doors. Choose your materials and equipment carefully and plan to be working under poor rather than perfect weather conditions. Do not bring a lot of materials with you; the fewer the better.

In this painting, the artist has purposely chosen a view with an interesting combination of colors and textures. The neutral, earth tones of the buildings work well with the leafy green forms of the trees, the touches of red and yellow are just strong enough to enliven general color areas.

A good point to keep in mind is that when working closely from the subject, it is not necessary to paint or draw exactly what you see before you. In this case the artist has chosen certain objects, shapes, and colors and used them to the advantage of the painting, sometimes exaggerating and sometimes underplaying colors and shapes to make the picture work as a harmonious unit.

Materials

Surface
Card sized with rabbit skin glue

Size
11.5in × 9in (29cm × 22.5cm)

Tools
No 3 bristle brush
Palette

Colors

Aureolin	Chrome green,
Black	Cobalt blue
Cadmium red light	Raw umber
Cadmium red medium	White
Cadmium yellow medium	Yellow ochre

Medium
Linseed oil
Turpentine

1. Working from the center outward, draw in general subject outlines in pale blue with a No 3 bristle brush and begin to apply a thin raw umber tone.

2. Carry this same color outward from the center. Keep the paint consistency thin and work loosely.

Touches of color · scratching back

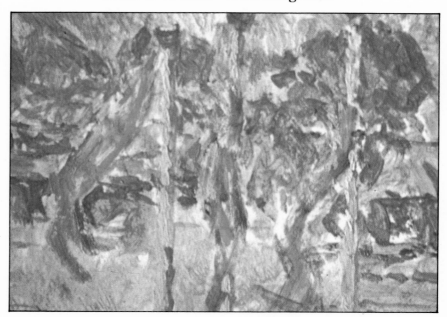

Above: Bright touches of color will often enliven an otherwise monochromatic painting. In this painting, the small red flag shapes add a valuable touch of interest to the finished picture.
Right: By scratching back through the wet paint with the end of a brush, an interesting texture can be obtained.

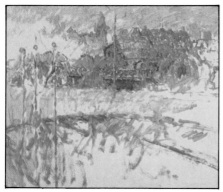

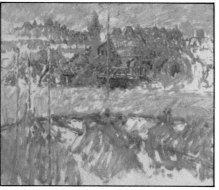

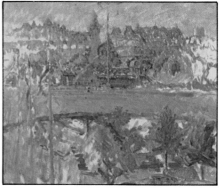

3. Put in basic horizontals and verticals in the blue used for the initial sketch. Carry green and brown tones over the painting. With cadmium red put in the flag shapes.

4. Mix chrome green, cadmium yellow and white. Thin with turpentine and loosely work in the foreground trees.

5. Continue over the painting developing lights and darks. Work back into previously painted areas and develop details.

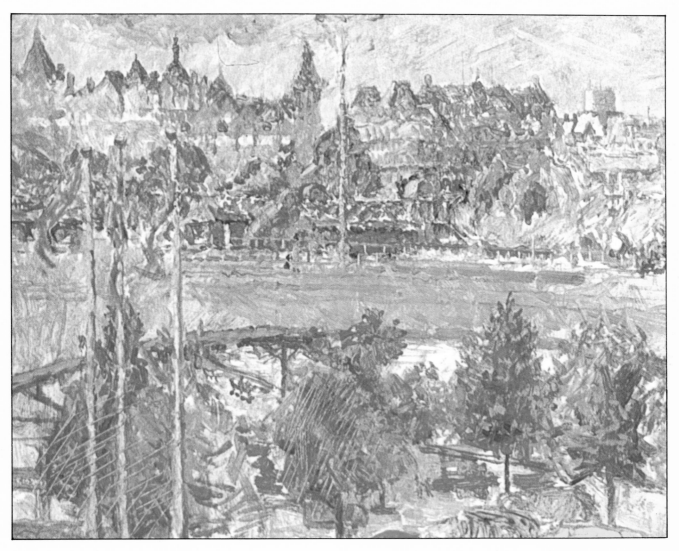

WHETHER PAINTING OR drawing, few artists will work on a picture as a group of individual and independent parts. An artist will rarely begin in one corner and progress across the page, or complete a section without regard for the rest of the picture. There is sound reasoning behind this. While the artist may have a good idea of what the finished picture is to look like, it is impossible to predict exactly the result of each brushstroke and how it will affect the picture as a whole. There is a natural rhythm to painting which involves a constant checking and re-checking of the work – not only in a particular area, but in all areas simultaneously. As small and insignificant as one brushstroke may seem, it is impossible to put down a touch of color without it affecting every other color.

In studying the progression of the work shown here, the rhythm of work becomes clear. The artist mixes a color, applies a few touches, and with that same color moves to another part of the painting. The sky color is used not only in the sky, but in the trees and water as well. The purplish tone used as an underpainting is repeated throughout the painting in various shades and tones.

This is an efficient way of painting as it saves the artist from having to mix and match colors each time they are needed. More importantly, this method gives the picture unity which is not overt or obvious to the viewer. It is also the wisdom behind using a few colors and from those mixing other colors and tones. By limiting the palette to three or four colors, the artist is automatically ensuring that the painting will have harmony.

Materials

Surface
Prepared canvas board

Size
18in × 24in (45cm × 60cm)

Tools
Willow charcoal
Nos 2, 4 flat bristle brushes
Palette knives
Palette

Colors
Alizarin crimson	Cerulean blue
Cadmium red medium	Viridian
Cadmium yellow medium	White

Medium
Turpentine

1. Very lightly rough in the subject with willow charcoal. Block in the general color areas with a No 4 brush using tones of chrome green and violet.

2. With pure cerulean blue and a lighter shade of this (add white), put in water and tree highlights. Use cadmium yellow medium to describe the lighter tones.

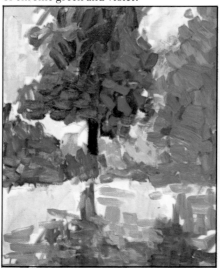

3. With a No 2 brush, mix viridian green and white and develop the tree on the right using short, directional strokes.

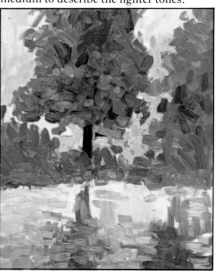

4. Mix alizarin crimson and cadmium red medium and put touches in the green of the trees. Add white to this mixture and put in water highlights.

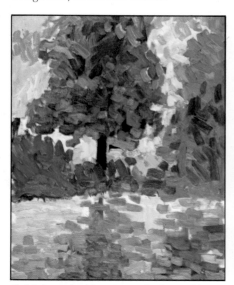

5. Lighten the blue-green shade used in the tree by adding white and carry this over into the water area. Lighten this mixture and block in the cloud shapes.

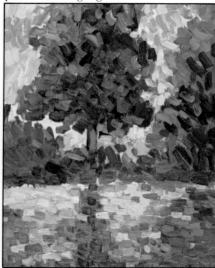

6. With a No 2 brush, mix cadmium yellow light and white and put in the sky tone. Carry this into the water, defining tree and sky reflections.

46

Overpainting · strengthening shapes

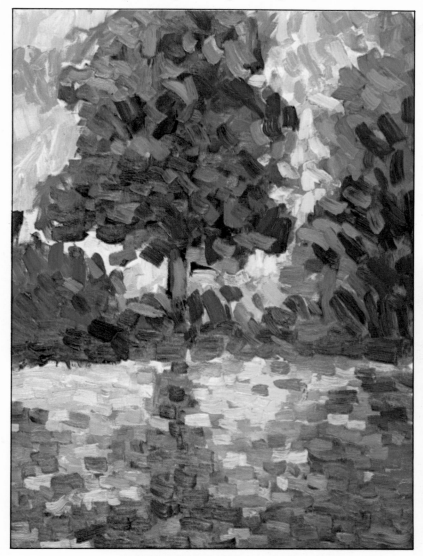

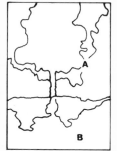

A. To strengthen the contrast between the tree outlines and the sky, the artist is here working with cadmium yellow and a small brush, working around tree shapes.

B. Overlaying the thin underpainting of the shadow areas in the water, the artist lays in short strokes of thick, undiluted paint.

Acrylic

PAINTING OR drawing cityscapes requires a different approach from the more traditional rural landscape picture. The artist may feel overwhelmed by the sheer scope of the subject and, from this incredible amount of information, what should be included in the picture. This is best determined by the goals of the artist and the techniques to be used. Very detailed and meticulous cityscapes, as seen for example in some primitive paintings, are as successful and interesting as more generalized, abstract scenes which include only basic shapes and little detail. One way to tackle the problem is to focus on a small area and include only broad, general areas to give an overall impression.

In the painting shown here, an image has been 'cut out' from a wider perspective. There is no horizontal plane in the immediate foreground and no view of the sky.

Start with a simple impression of geometric planes first outlined with a brush and then blocked in with a thin layer of color. You can then define the complexity of the structure gradually and work with thicker paint in small areas, describing local shapes and colors.

Materials

Surface
Stretched, primed canvas

Size
18in × 22in (45cm × 55cm)

Tools
No 3 and 5 flat bristle brush
Plate or palette

Colors
Black
Burnt sienna Cobalt blue
Burnt umber Hooker's green
Cadmium red medium Yellow ochre
Cadmium yellow medium White

Medium
Water

Blocking in shapes · using masking tape

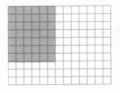

A. Working over the very thin underpainting, the artist begins to block in solid shapes of color with thick paint and small brush.

B. Masking tape may be used to create a clean, sharp edge. Make sure the surface is dry before putting down the tape and then work carefully into and over the tape with thickish paint. Peel off slowly and carefully to avoid smudging.

1. Draw up the general layout of the image in cobalt blue using a No 3 bristle brush. Lay in thin washes of color with a No 5 bristle brush.

2. Work over the whole canvas with a No 8 brush blocking in layers of thin color to show the basic shapes of trees and buildings. Reinforce with the No 3 brush.

3. Develop the structure of the drawing in cadmium red. Apply light washes of burnt umber and black to indicate shadows and depth.

4. Gradually build up the impression of form with small blocks of color, burnt umber, grey and yellow. Work into the trees with brown and green.

5. Continue to develop the form and color, drawing into the image in more detail with a No 3 brush. Thicken the paint and vary the direction of the strokes.

6. Lay in small shapes of color, adjusting the tonal balance to strengthen the qualities of light and shadow over the buildings.

7. Add to the details of the structure in the foreground, drawing the framework of steps and scaffolding in grey and black. Paint with the tip of the No 3 brush.

8. Increase the tonal depth of the colors by painting in shadow areas in burnt sienna and black. Work over the whole image revising shapes and tones.

9. Develop the linear forms in more detail with fine black lines. Strengthen the colors to build up the pattern of light and shade.

ALTHOUGH ACRYLICS ARE a relatively new phenomena in the painting world, their use has spread quickly, since they are flexible enough for use in most traditional types of painting. Their fast drying time and ability to be thinned to a watercolor-like consistency makes them ideal for the classical technique of overlaying thin areas of color one upon the other.

In the time of the Old Masters, almost all painting was done in this way. It is interesting to note that many of the Masters spent a great deal of their painting time developing the underpainting, and then working quickly through the final stages. Thus what is seen by the viewer in a Velazquez or Rubens are simply the last steps the artist took to complete the picture – with an elaborate underpainting lying just beneath the surface.

In this painting, the artist decided upon the mood of the picture before laying in the underpainting. As he wanted the painting to have a peaceful mood of a seascape at dusk, he chose a reddish underpainting, which would work well with the other colors used and give the entire picture a warmish tone. He has also used the traditional method of working from dark to light – slowly building up highlights from a dark base – and from the general to the specific.

Materials

Surface
Prepared canvas board

Size
26in × 24in (65cm × 60cm)

Tools
2B pencil
No 3 synthetic acrylic brush
Nos 2, 3, and 4 bristle brights
Nos 4 and 5 sable rounds
Mixing plates or palette
Jars for medium
Rags or tissues

Colors

Alizarin crimson	Cadmium yellow
Burnt sienna	Cobalt blue
Burnt umber	Pthalo blue
Cadmium green	Ultramarine blue
Cadmium red light	White

Medium
Water

1. Mix a fair amount of burnt sienna and water and apply quickly and loosely with a broad brush. In the foreground, use a drier mixture applied with short strokes.

2. Put in the lighthouse in a thin wash of the same burnt sienna. Cover the ground with a more opaque, darker tone. Mix alizarin crimson and brush in sky tone.

3. Draw in verticals and horizontals of lighthouse and horizon with pencil. Mix chrome green and cadmium yellow medium and lay in small patches of grass.

4. Mix thin wash of ultramarine and lay in the sky color. Letting previous layer dry, build up light foreground area with yellow ochre and white in a vertical direction.

5. Apply a darker wash of blue over the sky. Mix a light tone of white and ochre and put in the sea. Put in strong darks in burnt umber and details in foreground.

6. Apply a very thin wash of pthalo blue for the sea. Overpaint burnt umber areas in chrome green and redefine highlights with yellow ochre and white.

7. Mix alizarin crimson and burnt sienna and carefully put in the lighthouse stripes with a small brush.

8. Put in white highlights in the sea with a small sable brush and pure, undiluted white.

Dry-brush · lighthouse · sanding

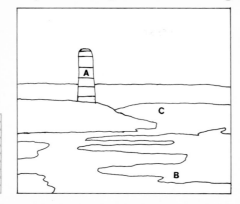

A. Using a broad bristle brush and cadmium red, the stripes in the lighthouse are defined, again allowing the underpainting to come through.

B. With a dry mixture of white and yellow ochre, the artist lets the brush drag across the dry paint surface to create texture.

C. With a piece of fine sandpaper, the artist smooths down the painting surface. This allows for fine, clear details to be put in without the interference of the textured surface.

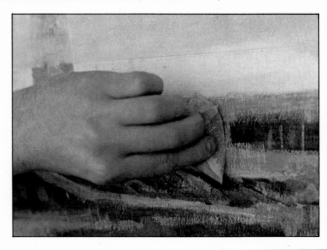

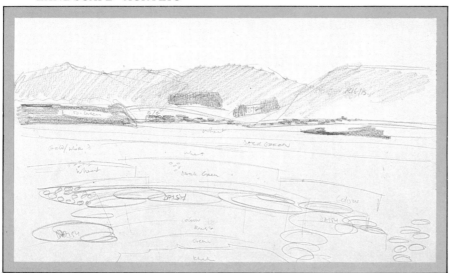

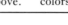

A common practice with landscape artists is to make rough sketches. These include not only the subject but also notes concerning colors and lighting. The painting shown here is based upon the sketch made above. Note how the artist has included information on colors to be used.

MANY LANDSCAPE ARTISTS work out of doors on small pencil or watercolor sketches of the subject and return to the studio, using the drawings as reference material for larger paintings. This is far more convenient than attempting to carry cumbersome equipment from place to place; it also allows the artist to observe the subject closely and gather a great deal of information on form, color, changing light, and so on.

Acrylics were chosen as the medium for this painting in preference to oils because of their efficient covering power and drying speed which enable the painter to build up the composition rapidly with layers of color. There is more freedom than with other media because the opacity of the paint means that highlights and light colors can be applied at any stage over previous layers and a constant revision of tones and colors can be made.

The painting is enlivened by contrasts between detailed, active patches of pattern and strong color in the foreground; large flat areas of reflected light; and the horizontal bands of changing color.

Materials

Surface
Prepared canvas board

Size
24in × 20in (60cm × 50cm)

Tools
Nos 3, 6, 8 flat bristle brushes
No 4 sable brush
Plate or palette
Rags or tissues

Colors

Black	Olive green
Burnt umber	Raw umber
Cadmium yellow	Ultramarine blue
Chrome green	Vermilion
Cobalt blue	Viridian green
Gold ochre	White
Lemon yellow	

Medium
Water

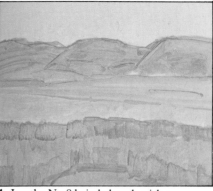

1. Load a No 8 bristle brush with a mixture of gold ochre and raw umber. Work over the whole canvas indicating the basic forms of the landscape.

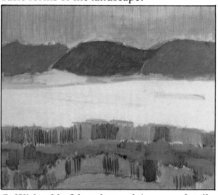

5. With a No 3 brush, work in more detail over the bright foreground colors with fine vertical and horizontal strokes of light and middle-toned greens.

Overlaying · broad areas

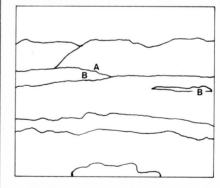

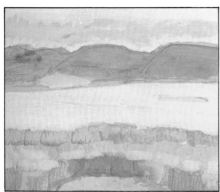

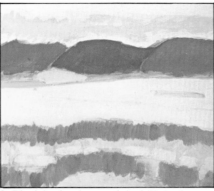

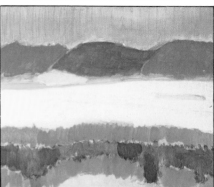

2. When dry, use a No 6 brush to lay in a warm, dark orange in the foreground and olive green above. Apply a thick layer of lemon yellow across the center.

3. Block in the shapes of the hills in the background in a green. Work into the foreground color with bright orange mixed from vermilion and yellow.

4. Using broad brush strokes, apply a light cobalt blue to form the basic tone of the sky, spreading the color with a rag. Work into the orange shapes with vivid green.

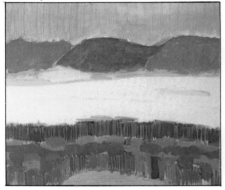

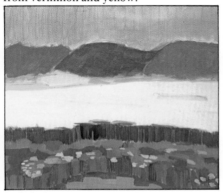

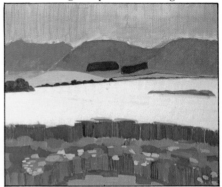

6. Build up the details with a variety of greens and greys, working with thin glazes of color and thick dabs of opaque paint.

7. Lift the tones in the foreground by adding small patches of light green and white applied with a sable brush, but do not cover the other colors completely.

8. Draw up detailed shapes in the background with the No 3 bristle brush using several shades of olive green.

(continued overleaf)

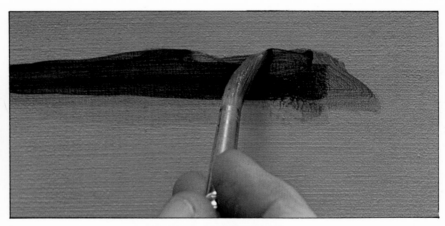

A. After the initial underpainting has been allowed to dry, the artist begins to block in broad areas of green in a thick, opaque paint.

B. Acrylics can be used in the traditional watercolor technique of layering thin washes of color. Here the artist is building up a dark area of chrome green and black by working over a darkish underpainting.

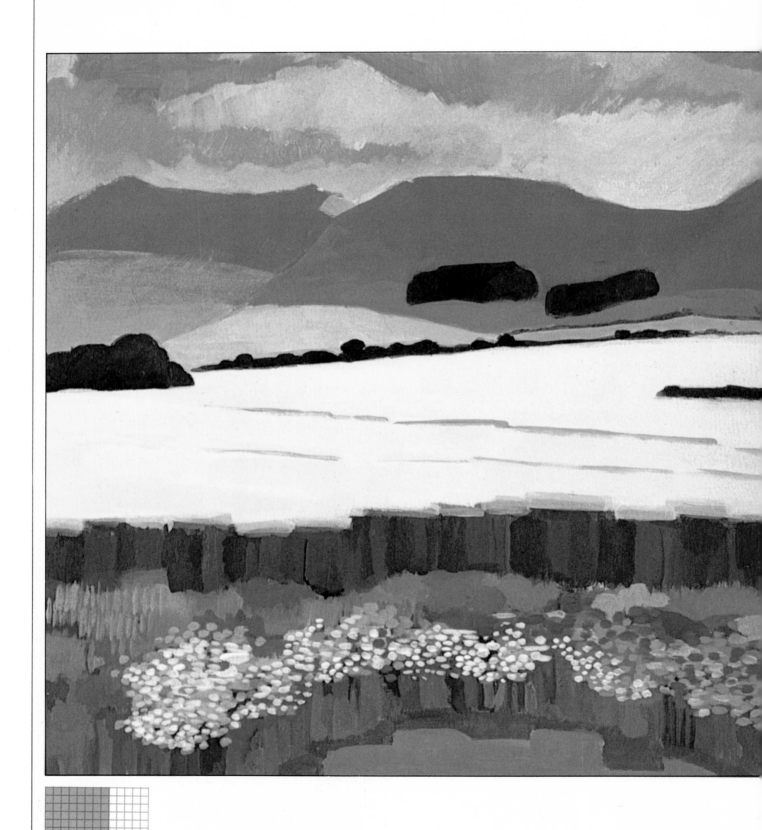

Sky tones · highlights

Showing the effective use of an underpainting to warm subsequent layers of color, the artist blocks in sky tones in light grey allowing the warm yellow underpainting to break through.

Using a vertical scrubbing motion, the artist is here putting in lighter shades of green in the foreground area.

9. Lighten the tone of the sky and link the blue with a pale blue-green in the foreground. Add to the details with light orange, mixing in white to give opacity.

10. With a No 6 brush, scumble a layer of pale yellow across the sky area and work over it with light blue, grey and white, brushing the colors together vigorously.

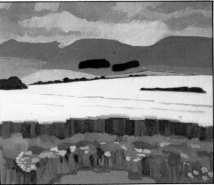

11. Brighten the tone of the central field, laying a thick creamy yellow mixed from ochre, white and a touch of green.

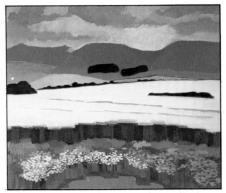

12. Work into the foreground creating an area of small dabs of light green and white paint with the No 4 brush. Apply fine vertical strokes of dark green for contrast.

55

ACRYLIC IS ONE of the most flexible painting mediums in existence today. To make the most of it, the artist should become familiar with all of its many uses. A good way to familiarize yourself with the medium is to create a series of paintings, making a conscious effort to duplicate other media techniques. In this way you will learn what acrylics are capable of and how these techniques and painting methods can be effectively and harmoniously combined in one picture.

In this painting the artist has combined a number of different painting techniques to successfully capture and render the subject. The painting was begun using the traditional oil technique of underpainting. The artist continued to develop the picture using an assortment of brushes and techniques borrowed from other media. The wash, a traditional watercolor technique, was used to exploit the underpainting and create a subtlety of color tone; the paint was often used to 'draw' the subject and define specific areas of interest; in other areas a dryish paint mixture has been dragged across the surface in a texture similar to oil paint. This emphasizes that there are few rules in painting – especially when using acrylics – and that any techniques which serve to express the subject best can be used.

Materials

Surface
Stretched heavy white drawing paper

Size
23.5in × 20.5in (59cm × 51cm)

Tools
2B drawing pencil
No 4 synthetic acrylic brush
No 6 sable watercolour brush
Palette

Colors
Alizarin crimson	Cerulean blue
Black	Chrome green
Burnt sienna	White
Cadmium red medium	Yellow ochre

Medium
Water

1. Having dampened and stretched a piece of paper, lightly sketch in the subject with pencil. Using a No 6 sable brush, lay in a wash of alizarin crimson and burnt sienna.

2. With the same brush, continue to block in the general subject shapes in burnt sienna, using the brush to 'draw' in the shapes. Keep the paint very wet.

3. Add a small amount of cadmium red to the burnt sienna and lay in the roof color. Put in the foreground with chrome green and yellow ochre.

4. Using a No 4 brush and pure chrome green, lay in the darker grass and shrub colors. Put in small touches of color in the tree with a short flicking motion.

5. Add a small amount of black to the chrome green and once dry, lay this over the previous grass and shrub areas. With alizarin crimson block in cloud shapes.

6. Mix white and cerulean blue and describe window shape. Carry the dark green tone into the tree. Mix chrome green and white and dab in grass.

7. Use this same light green to extend lighter grass areas and put in tree highlights. Put wash of burnt sienna in the foreground.

8. Cover foreground with light green tone of dryish consistency, allowing the brown underpainting to show through.

Underpainting

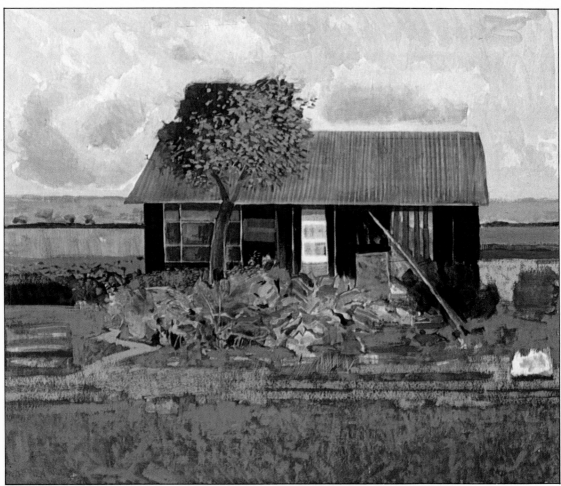

A. With a No 4 synthetic brush, the artist works over the painting laying in general dark areas. The white of the canvas is left bare for highlight areas.

Watercolor

WATERCOLOR IS ONE of the most versatile of drawing media. It can be handled with precision for fine detail work but is also naturally suited to a fluid and spontaneous style. You can exploit random effects in the flow and fall of the paint by spattering color from the end of the brush or blowing the thin, wet washes into irregular rivulets across the paper. Integrate these marks with carefully controlled brushwork to vary the textures in the painting.

The full effect of watercolor depends upon luminous, transparent washes of color built up layer upon layer. As white paint deadens the freshness of color, small areas of highlight are achieved by leaving the white paper bare while light tones are produced by using thin washes of color. Dark tones are slowly brought to a suitable intensity by the use of several successive applications of thin layers of the same color.

The urn shape was initially protected with a layer of masking fluid, painted carefully into the outline. This seals off the paper while the rest of the surface is freely painted over with large brushes and watery paint. When the work is complete and dry you can then rub off the mask and work on shadows and highlights of the shape with a small brush.

Materials

Surface
Heavy stretched paper

Size
23in × 20in (40cm × 50cm)

Tools
2B pencil
No 6 sable round brush
No 10 ox-eye round brush
1in (2.5cm) decorators' brush
Masking fluid

Colors
Burnt umber	Hooker's green
Cadmium red medium	Ivory black
Chrome green	Payne's grey
Cobalt blue	Yellow ochre

1. Sketch in the basic lines of the drawing with a pencil, carefully outlining the shape of the urn. Paint in this shape with masking fluid and let it dry completely.

2. Use a No 10 ox-eye brush to lay a broad light wash of cobalt blue across the top half of the painting and chrome green and Payne's grey across the foreground.

3. Mix a dark, neutral grey and paint wet streaks of color to form the trunks of the trees. Blow the wet paint in strands across the paper making a network of branches.

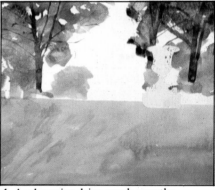

4. As the paint dries, work over the structure with green, grey and umber rolling the brush into the pools of paint and letting the color spread.

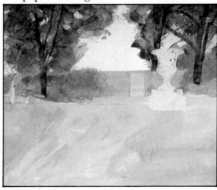

5. Load a decorators' brush with paint and flick tiny spots of colour into the washes. Block in the shape of the wall with a thin layer of red and brown using a No 6 brush.

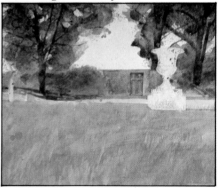

6. Work over the foreground with the decorators' brush loaded with Hooker's green, using a rough, scrubbing motion. Draw in details on the wall.

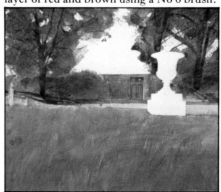

7. Let the painting dry completely. Gently rub away the masking fluid with your finger – make sure all the fluid is off and try not to damage the paper.

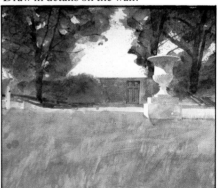

8. Paint in the shadows on the urn in brown and grey, adding a little yellow ochre and light red to warm the tones. Paint the form and stonework.

Masking fluid · spattering · blotting · stippling

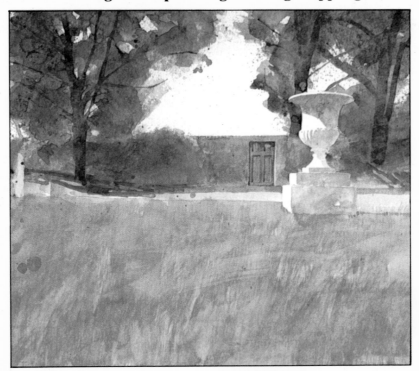

To create a spattered effect, load a large bristle brush with paint and quickly run your finger or a small knife through the hairs.

An alternative to spattering paint is to stipple with the end of a broad bristle brush. Here the artist is using a decorators' brush to lay in small dots of color.

A dense, leafy texture can be achieved by blotting a wet area with a piece of tissue. Do not rub but simply put the tissue down, press, and pick it up to leave small gaps and crevices in the paint surface.

Masking fluid may be used to protect the white paper from the paint. When the painting is completed, rub off the fluid with your finger. If the fluid is put on with a brush, make sure to rinse the brush immediately after use.

THE TECHNIQUES REQUIRED for this type of painting are quite lengthy and it is advisable to practise on scraps of a similar paper before beginning the actual painting.

A large, wet pool of color will dry with a gradated tone and strong, irregular outline. Overlaying a succession of washes produces vivid colors, a patterned network of light and dark tones, and linear detail suggesting the texture of foliage and flowers. You can speed up the drying process with a hairdryer or fan but, since this tends to deaden the color, it is best to let the painting dry naturally.

The image is built up in the traditional watercolor technique of working from light to dark. Start by laying in pale tones in thin, broad washes leaving patches of white paper to form highlight areas. Because the paint is so fluid, only one good-quality, medium-sized sable brush is needed. Make broad sweeps of watery color with the bristles loose or spread, and bring the tip to a point for finer details. Study each shape carefully and draw directly with the brush. Color can be lifted from the surface with a clean, damp Q-tip to lighten the tones. Detailed corrections are difficult with this type of painting, but it is possible to make small corrections by rubbing the surface when completely dried with a fine-grained sandpaper.

Materials

Surface
Stretched white cartridge paper

Size
13in × 8in (32cm × 20cm)

Tools
HB pencil
No 6 round sable brush
Plate or palette
Q-tips

Colors
Alizarin crimson	Emerald green
Black	Prussian blue
Burnt sienna	Scarlet lake
Cadmium yellow	Viridian
Cobalt blue	Yellow ochre

Medium
Water

1. Sketch out the composition very lightly with an HB pencil. Lay washes of thin wet paint to establish basic forms and local colors.

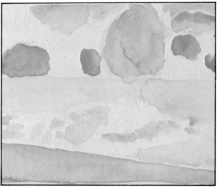

2. Work over the painting again with light washes blocking in more shapes. Let the colors run together in patches to create a soft, fuzzy texture.

Cleaning with knife · sanding · blotting

Where paint has inadvertently splashed on the white surface, the artist can very carefully scratch it off with a knife.

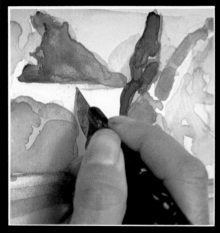

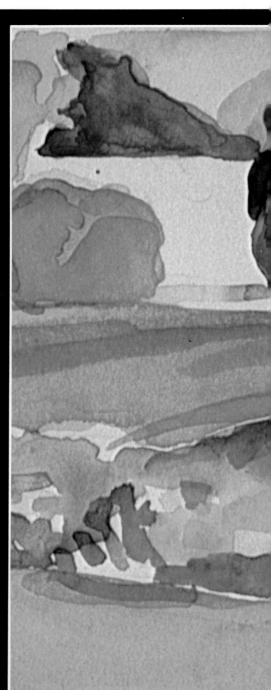

After scraping off spots or splashes, the artist is here very lightly sanding the surface with a fine grade sandpaper. Use a very light touch.

3. Let the painting dry and then apply layers of denser color, gradually building up the forms with thin overlays.

4. Paint in the shadow shapes over the grass with broad streaks of blue and green. Work into the trees with overlapping areas of colour to show the form.

5. Strengthen dark tones in the background with Prussian blue and black. Lay a broad wash of yellow over the grass to lift the tone.

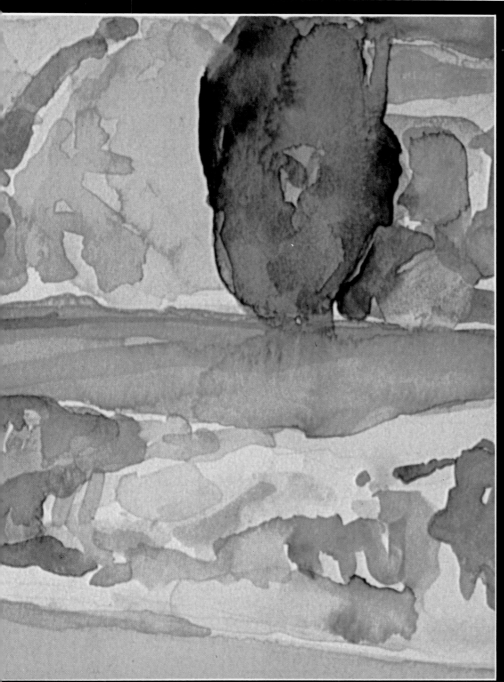

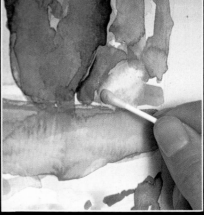

To lighten a tone or stop the paint from bleeding, a Q-tip can be used to blot up excess moisture or color. This can also be used to blend colors.

THE PAINTING SHOWN here captures a sense of distance by showing how the land recedes gradually from the foreground towards the horizon and using the two trees as a central focus. This is achieved by carefully varying color tones – placing strong, warm hues in the foreground and colors which are cooler and less intense in the distance. The impression of receding space is enhanced by the sky gradually lightening and finally rising into a thin strip of white where the paper is left bare.

To keep an overall coherence to the picture, the colors in each area are subtly linked together. For example, the same blue has been used for the linear details in the middle distance as in the shadow areas of the trees. A harmonious balance of warm and cool tones has been applied as seen in the contrast between the warm brown of the foreground, the colder yellow across the center of the painting, and the reddish-brown and blue tones in the trees which deepen the intensity of the green washes.

Materials

Surface
Heavy, stretched paper

Size
16in × 11in (40cm × 27cm)

Tools
Nos 6, 8 sable round brushes
Large sable blending brush

Colors
Burnt umber	Scarlet lake
Emerald green	Ultramarine blue
Gamboge yellow	Viridian
Payne's grey	Yellow ochre
Prussian blue	

Medium
Water

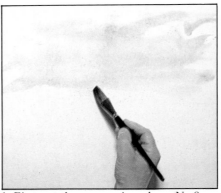

1. First wet the paper using a large No 8 brush dipped in water. Lay in a thin wash of Prussian blue with a No 8 sable brush, working down from the top of the paper.

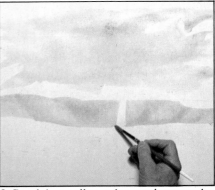

2. Brush in a yellow ochre wash across the centre of the paper, leaving white space along the horizon line and in areas where the main forms will be placed.

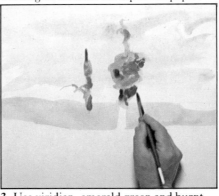

3. Use viridian, emerald green and burnt umber to apply the basic forms of the trees, indicating areas of light and shade.

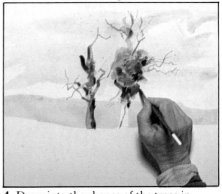

4. Draw into the shapes of the trees in more detail with the point of a No 6 brush. Darken the burnt umber with a little blue and mix yellow into the greens.

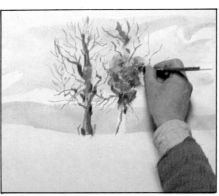

5. Continue to extend the forms and intensify the colors. Fan out the bristles of a No 8 brush between thumb and forefinger to draw feathery texture.

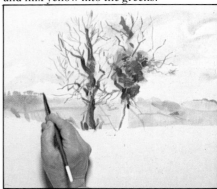

6. Dampen the yellow ochre wash with clean water and draw into it with a mixture of Payne's grey and blue.

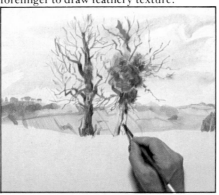

7. Add detail into the grey area with ultramarine, keeping the paint thin and wet. Use the same blue in foliage shadows and contrast with a warm reddish brown.

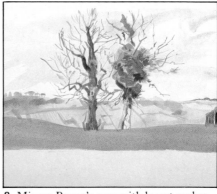

8. Mix up Payne's grey with burnt umber and lay a broad streak of color across the foreground with a No 8 sable brush, working directly onto the dry paper.

Dry-brush · the wash

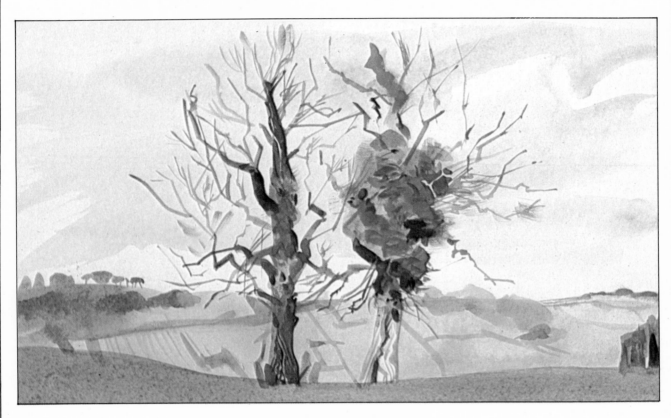

A consistent, even wash can be achieved by mixing a large amount of paint and water in a small dish; dip a large sable brush into this and move across the surface with an even pressure.

To effectively use the dry-brush technique, load a brush with paint, blot on a rag and grasping the brush hairs between the thumb and fingers, flick the brush on the surface to create a feathery texture.

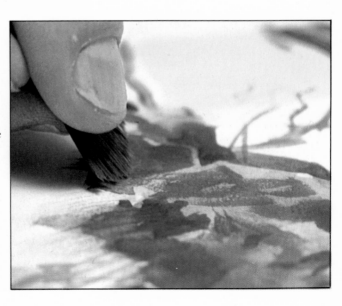

Gouache

THIS PAINTING demonstrates an innovative and imaginative method of combining gouache with another water-based medium – ink – to create an individual and expressive seascape. There is nothing innovative in the use of an underpainting in itself, but it is not generally used with water-based media such as watercolor or gouache due to the inherent transparency of these media. In this instance, the artist has first executed an underpainting in bold, primary colors, which serves to unify the painting and help eliminate the inevitable chalkiness of gouache.

Since the more traditional method of underpainting requires time-consuming layering of color upon color, the use of these bold colors for the underpainting expedites the painting process. In this method, the artist can jump directly from the underpainting to developing the basic structure of the painting without having to wait for previous coats to dry.

While opaque and flat, gouache retains many of the qualities of all water-based paints and can be worked wet-into-wet, spattered, or dry-brushed. The artist has here used a combination of all of these techniques which, when combined with a subtle mixture of color and tone – all of which are enhanced by the initial underpainting – results in an evocative and atmospheric painting.

Materials

Surface
Stretched watercolor paper

Size
19in × 17in (47cm × 42.5cm)

Tools
Nos 4, 6, 10 sable brushes
Palette or mixing plate
Tissues or rags

Colors

Gouache:
Black
Burnt umber
Olive green
Payne's grey
Prussian blue
White

Colored inks:
Black
Blue
Green
Orange
Red

Medium
Water

Underpainting with ink · details

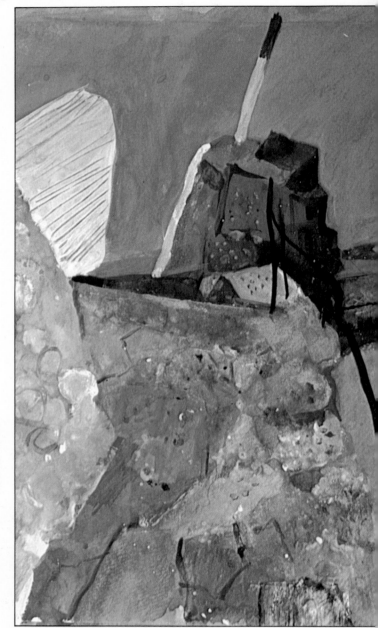

The very bold colors of an underpainting done in colored inks will later be modified by opaque gouache. Here, in the first step, (below) the inks are bleeding into one another.

In the final steps, the artist puts in small details of pure black gouache with a small sable brush.

1. With a No 10 brush, lay down broad areas of red, orange, blue and green ink corresponding to the shapes and color tones of the subject.

2. While still wet, mix a variety of grey tones from white, olive green, and Payne's grey gouache. Very loosely rough in the pier allowing the ink and gouache to bleed.

3. With a No 4 brush, begin to dot in lighter tones of grey and white, once again allowing the colors to bleed together.

4. Cover the orangish underpainting in the foreground with a thin wash of burnt umber.

5. Add a touch of olive green to the white, Payne's grey, and green mixture and with the No 10 brush cover the sky and sea area with broad, loose strokes.

6. Cover the remaining sky area in this same color and let dry. Using pure white gouache, block in white shape to left and small touches of white in the foreground.

7. Add more olive green to the mixture and loosely put in strokes in sea and foreground rocks. Put pure white on a No 4 brush and spatter.

8. With a No 4 brush and black gouache, put in the fine details of the picture.

NO ONE MEDIA can completely capture the diverse and subtle range of colors to be found in nature; the total effect is created by the relationships of all the colors together and the influence of light. Even if a landscape is predominantly green, there are a multitude of tones and hues within the one color to be identified and translated onto the painting surface. A low-key green, for example, may be caused by a subtle cast of blue or red and the painting will be livelier if these contrasts are exploited or exaggerated.

As a general rule, remember that colors in the foreground are the most intense and fade towards the horizon. Within this range there are shifts between warm and cool tones; these help to establish form and position in the overall scheme of the painting.

Only one brush and a limited color range have been used for this painting; the variety of hues and tones is due to careful, observant color mixing. As gouache is thick and opaque, be careful not to overmix the colors. The paint can be laid in thin washes of color or thickly daubed depending on how much water is added.

Materials

Surface
Stretched heavy cartridge paper

Size
14.5in × 18in (36cm × 45cm)

Tools
No 6 round sable brush

Colors
Brilliant green Cobalt blue
Black Scarlet
Cadmium yellow White

Medium
Water

1. Paint in soft shapes to show trees, sky and water using thin washes of blue and green adding white to vary the tone.

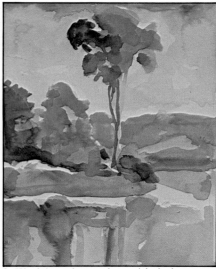

2. Work into these colors with darker tones to establish the basic forms and give the impression of distance.

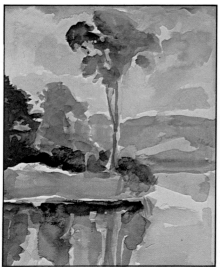

3. With undiluted paint, overpaint the forms in detail, varying the green hues by adding touches of yellow or red. Intensify the colors in the reflections on the water.

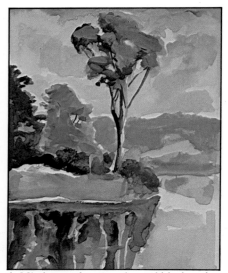

4. Mix brown from scarlet and black and draw up the trunk and branches of the tree. Extend the shape of the tree working with small dabs of red, green and orange.

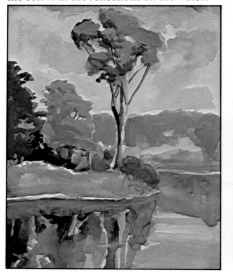

5. Increase the contrast in the light and dark colors over the whole image. Work into the foreground with horizontal and vertical stripes of blended color.

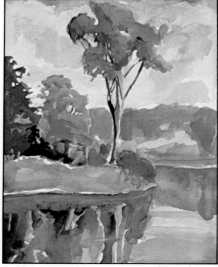

6. Heighten the tones with small patches of thin paint over the sky and trees, mixing white into the colors.

Highlighting

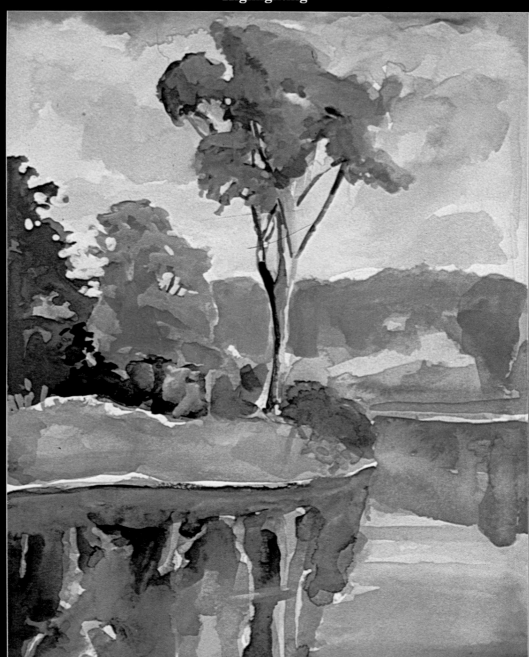

Working over a
partially dry
underpainting, the
artist puts in a
highlight tone.

Pastel

WHILE PASTELS are generally considered a drawing medium, working with them involves both painting and drawing skills. The same principles apply to pastels as to many painting media as seen in the overlaying of colors to create new colors and transparency.

The main difference between using pastel and the usual painting media is that the former cannot be easily erased or corrected. The artist's only recourse to correcting a pastel drawing is to overlay more color. For this reason the picture should be developed through careful and well thought-out layering of tone and color rather than through heavy and dense application of the pastels.

In this picture the artist has used some elements of the pointillist technique without the use of 'points'. Rather, thin strokes of pure color have been laid down beside and on top of one another to give the impression of mixing colors and tones. The picture is based primarily on the use of warm and cool colors – red and blue – and their interaction with one another. By careful use of complementary colors, such as a touch of a reddish tone in a predominantly blue area, a dull and predictable picture is avoided. Close examination of the finished picture reveals that where there is a large area of one color – blue for example – its complement, red, has been added to give the picture unity. The complementary color also 'bounces off' the other warm color areas, unifying the picture as a whole.

Materials

Surface
Heavy weight pastel paper

Size
18.5in × 26in (46cm × 65cm)

Tools
Willow charcoal
Rags or tissues
Fixative

Colors
Blue-green	Light red
Cobalt blue	Light yellow
Crimson	Orange
Dark blue	Pale blue
Dark green	Yellow

1. With broad strokes, lay in the basic warm and cool colors as an underpainting.

2. With heavier, linear strokes, begin to develop darker tones of these general color areas moving over the paper with one color at a time.

3. Begin to lay in lighter, warmer tones of orange, yellow, and red building up the color contrasts of the warm-cool, blue-red motif. Keep the strokes light.

4. Return to the dark colors previously used, heightening shadow areas with a heavier stroke.

5. With cobalt blue, lighten any areas which appear too heavy or dark. Put in the sky with pale blue.

6. Return to the dark blue, red, and green colors to put in the final touches of emphasis and contrast using stroke to give direction and shape.

Overlaying pure color

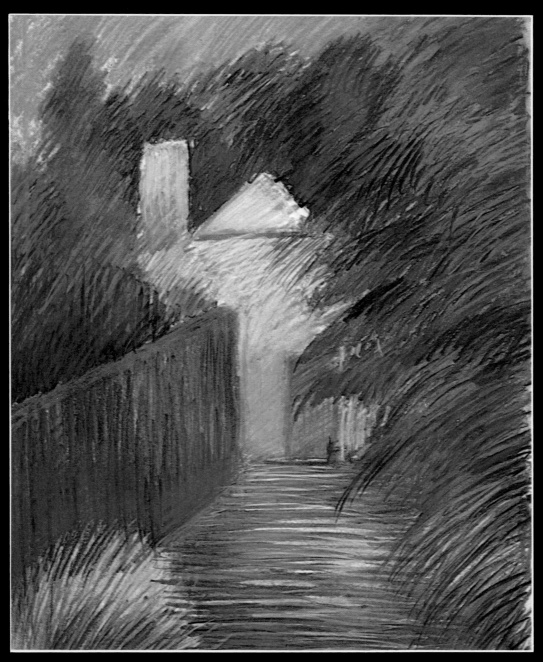

With pastel, the artist produces colors which mix optically on the surface by applying thin lines of pure color one over the other. Here, pale blue strokes are laid over crimson in the wall to create an impression of purple.

WORKING WITH OIL pastels requires a slightly different approach and attitude than using the traditional chalk type of pastel. Unlike chalk pastels, oil pastels can be used as a painting medium. They can be softened and mixed on a palette and then directly applied to the surface with a palette knife; or thinned with turpentine and then wiped onto the surface with a rag. Pastels of any type are difficult to correct, and oil pastels more difficult than most. Without the aid of turpentine, a rag, and some heavy rubbing, the strokes you put down are permanent. For this reason, use a fairly light touch in the preliminary stages of the drawing.

In this painting, the artist has used a variety of techniques to exploit the medium's potential to its fullest and has literally painted with the pastels using all the techniques normally ascribed to traditional oil painting.

Due to their rich and thick texture, another effective technique is to scratch back through the pastel to reveal the original surface color. This can be achieved with any sharp tool to create a variety of lines and tones from a dense crosshatching to a light and flowing line.

Materials

Surface
Stretched, strong cartridge paper

Size
9in × 7in (22cm × 17.5cm)

Tools
2B pencil
Palette knife
Q-tips
Rags or tissues
Pen knife

Oil pastel colors
Black Ultramarine blue
Cerulean blue White
Payne's grey

Medium
Turpentine

1. Make a preliminary sketch in pencil of the main features and compositional structure of the picture.

2. At this point, do not worry about the details of the picture, but loosely rough in the basic sea, sky, and land colors with loose, diagonal strokes.

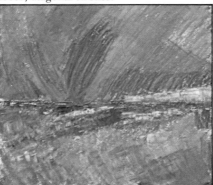

3. Cover this layer with a thick, opaque white and shades of grey. Blend with a palette knife, pressing hard into the surface. Scratch back with edge of knife.

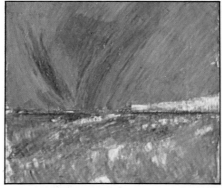

4. Over this, lay in the dark areas of the sky and horizon with ultramarine blue. Create foreground waves with white applied in short strokes.

Using the palette knife · blending

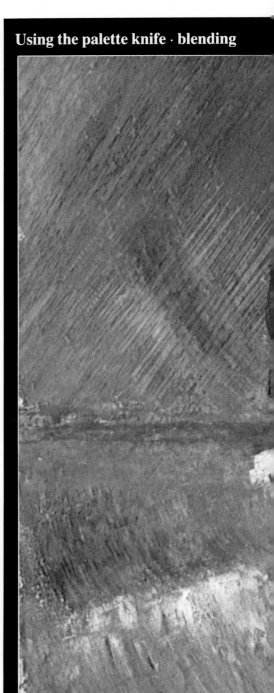

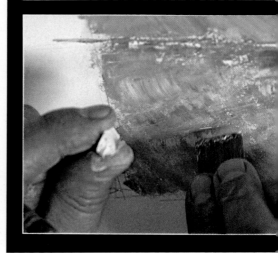

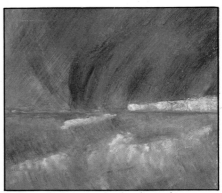

5. Dip a Q-tip in turpentine and blend the pastel over the entire picture surface to cover any remaining white areas.

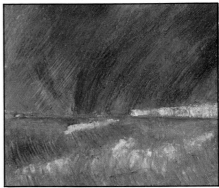

6. Put a darker grey in the sky, using diagonal strokes. Lay in light areas of waves and land with white, or scratch back to white of surface with a knife.

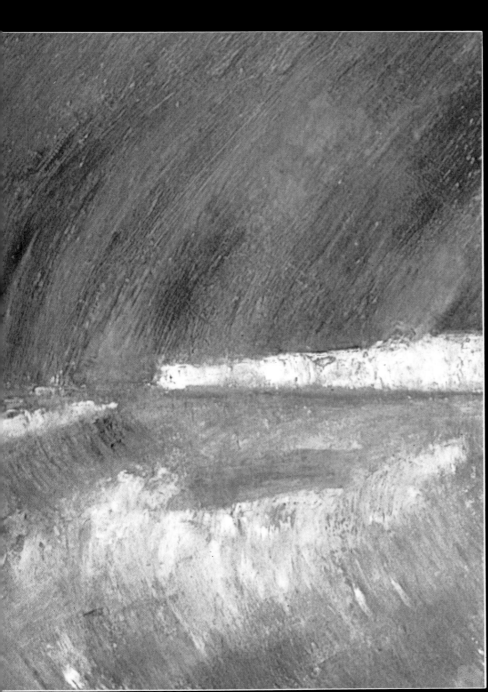

Here the artist is seen pressing small pieces of oil pastel onto the surface with a broad palette knife. The knife, like a brush, can be used to create directional strokes and textures.

With a Q-tip dipped in turpentine, the artist works over the oil pastel surface, blending colours and covering white gaps in the surface.

7. Heighten the contrast in the foreground waves by adding more directional strokes of dark grey.

8. Add deeper blue touches around the white of the wave crests to heighten this contrast.

71

Pencil

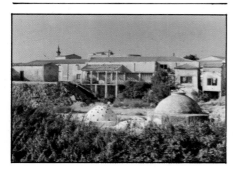

COLORED PENCILS have a special relevance to landscape drawing, especially when the artist wishes to depict the effects of sun and shadow. The variety of lights and darks which can be achieved with colored pencils allows the artist to either work with a very pale and delicate range of colors and tone, or with a very intense and bold palette. When the two are combined – a pale, loose stroke and an intense and colorful area – the effect is balanced yet dynamic. In this case, the combination of architecture and nature is well suited to the medium, and vice versa.

Much like painting media, colored pencils allow the artist to build up layer upon layer of subtle color to create a transparent effect. For instance, crosshatching in different colors – overlaying one area of colored strokes over another color – can create an interesting tone and texture in the picture.

Drawing with colored pencil requires patience and thoroughness. The point of the pencil being relatively small, it is difficult to cover large areas with any evenness of tone and stroke. A smooth, hardish paper or board is normally used with pencil work, however, a roughly textured surface can create interesting white 'gaps' and grainy effects.

Materials

Surface
Stretched, rough drawing paper

Size
30in × 25in (75cm × 62.5cm)

Tools
Eraser
Pencil sharpener or small knife

Colors
Cerulean blue	Light yellow
Chrome green	Medium yellow
Dark brown	Ultramarine blue
Dark green	Yellow ochre

1. After sketching in general shapes with blue pencil, develop general shadow areas with blue and brown pencils.

2. With a pale yellow pencil, begin to put in the lighter areas of the wooden structure. This 'underpainting' will ensure a feeling of bright daylight.

3. Put in dark areas with black and dark brown pencils. Crosshatch using different colors and directional strokes to create color and tone.

4. Work from the centre outward to maintain the picture's focal point. Build up shapes using ultramarine blue for the darker areas.

5. Carry the light yellow and ochre tones into the foreground and palm tree.

6. Build up a strong, detailed drawing of the foreground palm with pale and dark green tones.

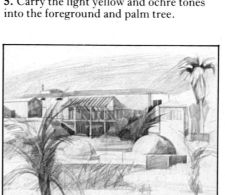

7. Put in very loose strokes of brown in the middle distance. With a strong stroke, develop the green of the foreground palm. Highlight very bright areas with white.

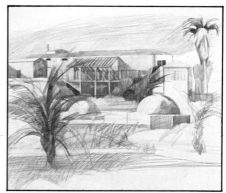

8. Carry loose, blue strokes over the foreground to indicate shadow.

Palm textures · overlaying dark colors · developing shadows

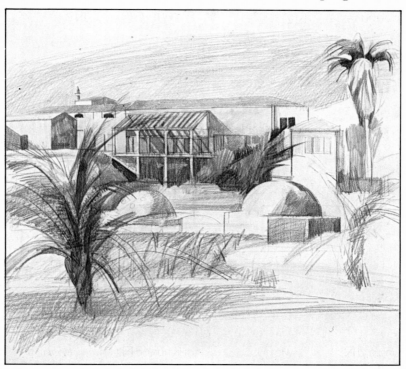

Working around
the shape of the far
dome, the artist
overlays a dark
green area with light
green strokes.

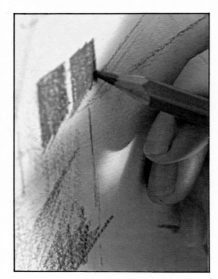

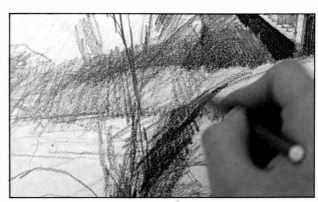

In the initial
steps, the artist
begins to block in
areas of dark color
as in the windows of
the house.

To create the
texture of a palm
tree, the artist
overlays thin strokes
of color.

BECAUSE PAINTING equipment is often difficult and cumbersome to manage out of doors, many landscape artists prefer to do rough sketches which are later used as reference for paintings. However, many landscape drawings are interesting as pictures in their own right.

The drawing shown has many qualities both in terms of pencil technique and subject which are worth noting. Notice that the artist has chosen a strong vertical space in which to draw. This is not typical of most landscape work which is generally done in the 'landscape', or horizontal position. The picture itself, however, is described using horizontal strokes which serves to create an interesting contrast between the shape of the overall image and the image itself.

A putty eraser is very effective in creating highlights. After the general tones have been laid down, the artist can work into the picture erasing out light or highlight areas. These can later be modified by working over again in pencil, or strengthened by further erasing.

Materials

Surface
Cartridge paper

Size
6in × 18in (15cm × 45cm)

Tools
2B, 4B pencils
Putty eraser
Fixative

1. With a 2B pencil, sketch in the perimeter of the drawing and very lightly block in the sky and land shapes.

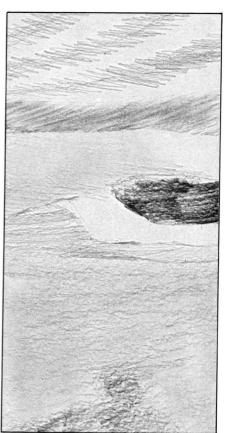

2. With a 4B pencil, block in the foreground tone and work into darker areas. Keep the strokes loose and light.

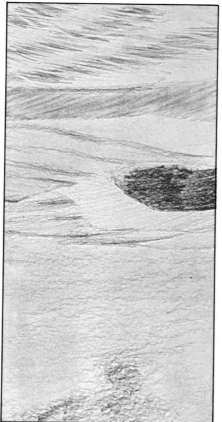

3. Work back into the clouds with the same pencil developing a stronger tone.

4. Using the tip of a putty eraser, work over cloud shapes using the same directional strokes as used with the pencil.

Erasing

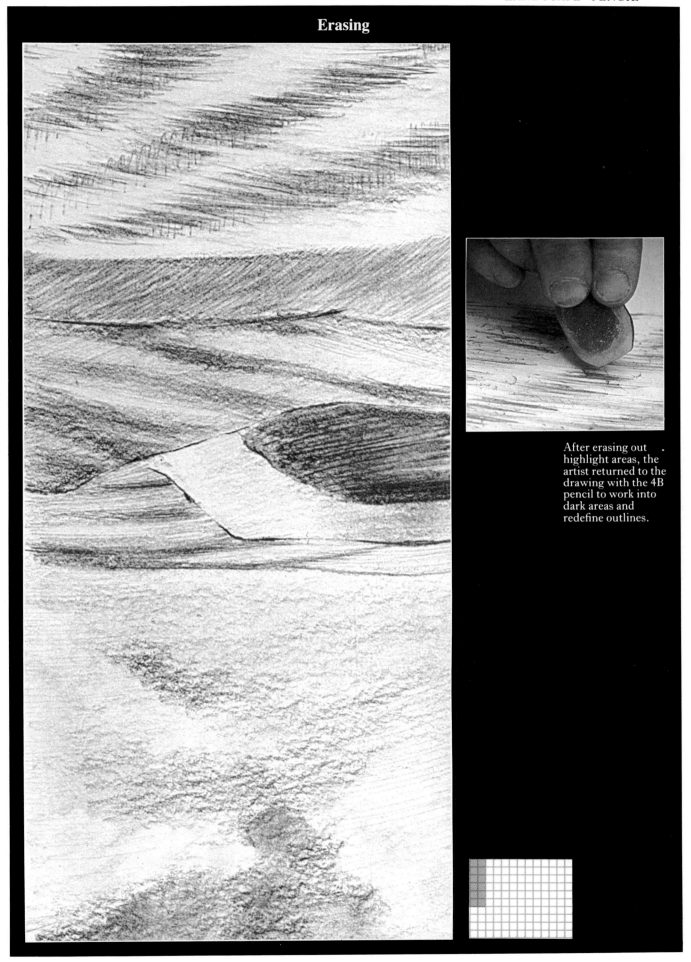

After erasing out highlight areas, the artist returned to the drawing with the 4B pencil to work into dark areas and redefine outlines.

DRAWING IS IN many ways similar to sculpture. The sculptor, while carving out a shape, is always concerned with the space around the shape – the 'holes' which the observer will see through. This is known as negative space; a concept often difficult to grasp but essential to the success of a drawing or painting, especially when the artist wishes to exploit the use of 'white space' or the blank paper.

The drawing shown here is an excellent example of the use of negative and white space. While the artist used the pencils to create an image, he has also used the white of the paper to emphasize shapes and areas between and around the forms. An example is the thin line of red placed diagonally behind the plants. The observer reads this as a 'wall'; no more than this simple line is needed to create the impression of space and depth.

The picture also shows that the entire surface need not be covered to create an effective drawing. If you imagine the picture with all the white areas filled in, you would see that the drawing would lose much of its graphic impact. It takes practice to know when to stop a drawing. Very often the impact of a drawing can be lessened or lost if overworked or carried too far.

Materials

Surface
Smooth, heavy weight drawing paper

Size
23.5in × 17in (59cm × 42cm)

Tools
B, 2B, 4B drawing pencils
Eraser
Ruler

Colors
Black	Dark green
Blue-green	Light green
Dark grey	Red

1. Very lightly sketch in a small area of the subject with a 2B pencil and begin to define leaf shapes and background with dark green and black, pressing firmly.

2. Using a diagonal stroke, carry the dark green color on to the next area, lightly hatching in the area and then reworking. Put in red line with ruler.

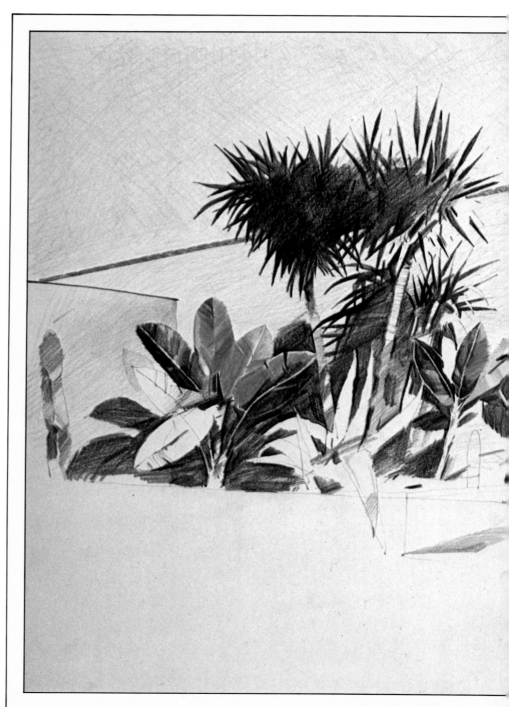

3. Continue to work around this small area, defining the palm leaves in tones of grey and green, first working lightly and then building up heavier, detail areas.

4. Work back into previous areas with black and green pencils, strengthening the darks with a heavy, dense stroke.

5. With blue-green and dark green, begin to put in the cactus shape.

Finished picture · underdrawing

In order to successfully balance the composition of the drawing, in the last step the artist described the palm tree on the far right. Note that only pale colors and a light touch were used; the tree serves to balance the picture but does not overwhelm the left hand side.

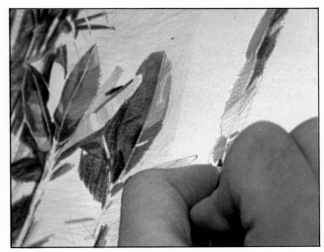

With a light blue pencil, the artist is here putting in the first layer of color which will later be developed by overlaying different colors.

Pen and ink

PEN AND INK has a long tradition in both landscape and architectural drawing. It is especially well suited for the latter as a variety of lines and textures can be created without losing the linear qualities inherent in a cityscape. It is a good medium for working out of doors as well. With pen, pad, and bottle of ink, the artist can situate himself anywhere for either quick sketching or detailed drawing.

Ink is a very flexible medium and can be used in a variety of ways. The usual technique is to use only the pen, nib, and ink; this in itself will provide you with an unlimited choice in terms of line and tone. In this instance, the artist has chosen the traditional use of line for the initial sketch only and has proceeded to develop the picture through the use of innovative and unconventional tools. A thumb can be used to create unusual shadows and textures; the side of a box, when dipped in ink and pressed on to the surface gives an intriguing 'architectural' effect. Spattering the ink with a toothbrush will create a fine mist similar to an aquatint.

If working out of doors there may be many interesting objects around you which can be used in a similar fashion – drawing with a stick, 'printing' with a leaf, dipping some grass in ink and drawing it across the page.

Materials

<u>Surface</u>
Smooth, white cartridge paper

<u>Size</u>
16.5in × 12in (41cm × 30cm)

<u>Tools</u>

Pen holder	Toothbrush
Fine and medium nibs	Small knife
Masking tape	Small box

<u>Colors</u>
Black waterproof India ink

1. Begin by directly sketching in the main verticals and horizontals of the picture with a fine nib.

2. Use the back of the pen to create a thick, emphatic line. The thumb can be used to develop an interesting shadow texture as in the tower.

Finished picture · blotting with finger · spattering

In the last step, the artist put in very faint cloud shapes. This was accomplished by tearing pieces of paper and using their rough edges as a mask over which a fine mist of ink was spattered. Very light lines were then put in to define the shapes. Details were then re-emphasized.

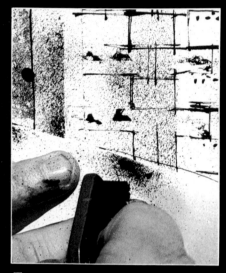

To create a spattered effect, dip a toothbrush in ink and, masking the area not to be spattered with a piece of paper, draw a finger quickly through the brush bristles.

Dipping a finger in ink and blotting it on to the surface creates an interesting texture. In this case, the sharp, crisp lines of the tower work well with the greyish smudges caused by the finger.

3. Use the back of the pen to develop the foreground objects. Dip the end of a small box in ink and press lightly to the surface for a brick-like effect.

4. Build up dark areas by defining geometric shapes and details with a medium nib.

5. Dip a toothbrush in ink and mask the area not to be covered with tape. Run a knife blade quickly over the brush to create spatters.

WHEN USING the traditional pen, nib, and ink it is important to note that it is basically a linear form of rendering. The marks are definite and not easily erased, and 'colors' must be created by hatched and scribbled strokes rather than blending. It is important to understand such characteristics and limitations which will enable you to focus your attention on aspects of the subject which lend themselves to the descriptive qualities of the medium.

When working in pen and ink, look for a subject with a strong, linear emphasis, well-defined motifs and dense pattern or texture. A good range of colored inks is available; there is no need to consider this a primarily monochrome medium. The colors form the intermediary tones between black and the clear white of the paper. Until you feel confident in handling color, however, it may be well to restrict yourself to a few basic tones.

Start by roughing out a simple linear framework for the drawing and then work into each area in detail, gradually building up the overall pattern. Develop a range of marks which correspond to the natural forms and textures without trying to reproduce every shape in detail. As the work progresses, adjust the density of the colors and patterns to achieve a satisfactory tonal balance.

Materials

Surface
White cartridge paper

Size
18.5in × 26in (46cm × 65cm)

Tools
Thick, square-nibbed pen
Fine mapping pen

Colors
April green Deep green
Black Sunshine yellow

1. Draw up the general outline of the image in black ink using a large, broad-nibbed pen. Indicate the main elements with fluid, linear strokes.

2. Work over the whole image again in black starting to define the shapes and forms in detail, using thick and thin nibs.

3. Build up a textured surface to suggest the grass with scratchy, criss-crossed marks, overlaying green and black.

4. Draw into the large tree in black, making heavy shadows with broad pen strokes. Work over the black with green and yellow.

5. Contrast the strong black textures with a thin layer of green crosshatching in the background. Draw with a fine pen using quick, light strokes.

6. Fill in the central area of grass and leaves with a woven pattern of green and black marks. Draw together the separate sections of the image.

Outlining

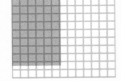

With a broad-nibbed pen, the artist is here putting in the general outlines of the picture. The width of the line is varied by turning the pen while drawing.

FINE, LINEAR DRAWING with pen and ink requires a careful, deliberate approach. Tonal shading must be developed gradually and crosshatching cannot be rapidly blocked in. The crisp, emphatic lines of a pen drawing have no equivalent and it is worthwhile to acquire the skill and patience to handle the pen to produce the dramatic, graphic effects of this medium.

This drawing gives a general impression of a landscape by starting with a loose sketch which outlines shapes and positions of trees and bushes. Each area of hatched lines and irregular, scribbled marks correspond to the basic tonal and textural structure. While the elements are treated separately, the whole image is constantly considered as a whole and brought together in the final stages.

Your technique should be controlled but not rigid – keep the pen well charged with ink and make decisive, fluid strokes. Even if the drawing is quite small, the marks should be as vigorous as possible, since it is texture, not color, which provides visual interest. Keep a lively balance in the tones by working some areas more densely than others and by varying the direction of the strokes and character of the marks.

Materials

Surface
Thick white cartridge paper

Size
12in × 8in (30cm × 20cm)

Tools
HB pencil
Dip pen
Medium nib

Colors
Black waterproof India ink

1. Make a light sketch of the layout with an HB pencil. Start to draw with the pen showing rough outlines and tones.

2. Develop the tones using the large tree as a focal point and working outwards. Build up the texture with fluid scribbled marks and crisp lines.

Crosshatching tones

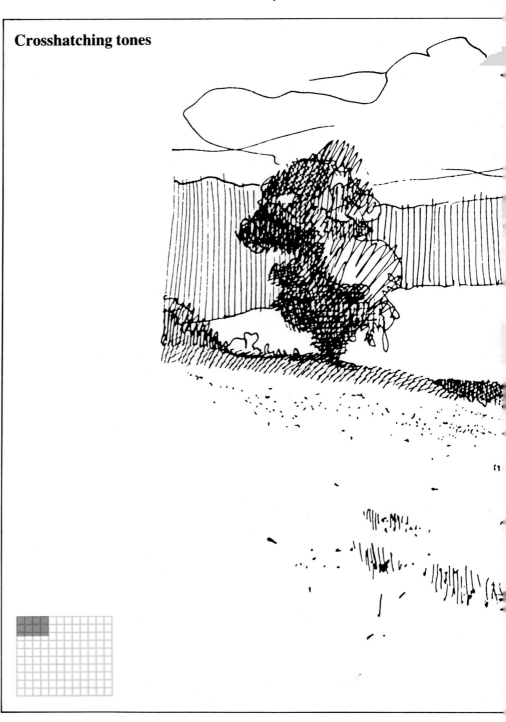

3. Work across the paper sketching in shapes and elaborating forms.

4. Extend the hatched tones, establishing receding planes and overall shape of the image. Develop details in the foreground with small, irregular patterns.

5. Concentrate on details, particularly in the foreground, and work over the outlines of the shapes to soften the contours.

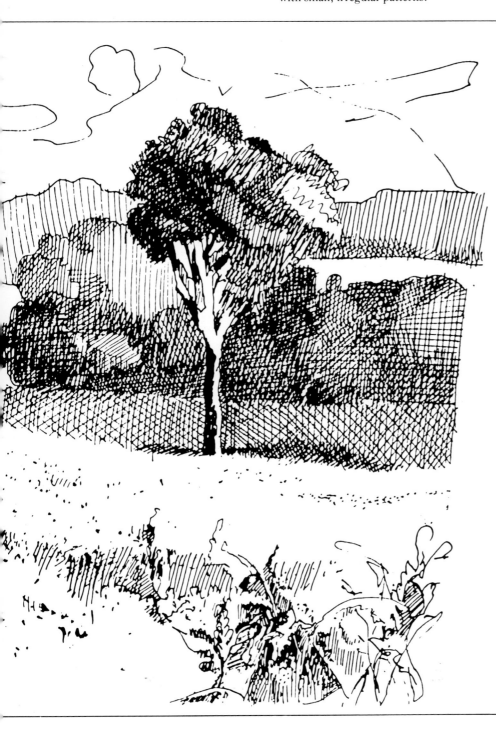

This detail of the shadow area behind the tree shows the artist using crosshatching to develop dense and varied tonal areas.

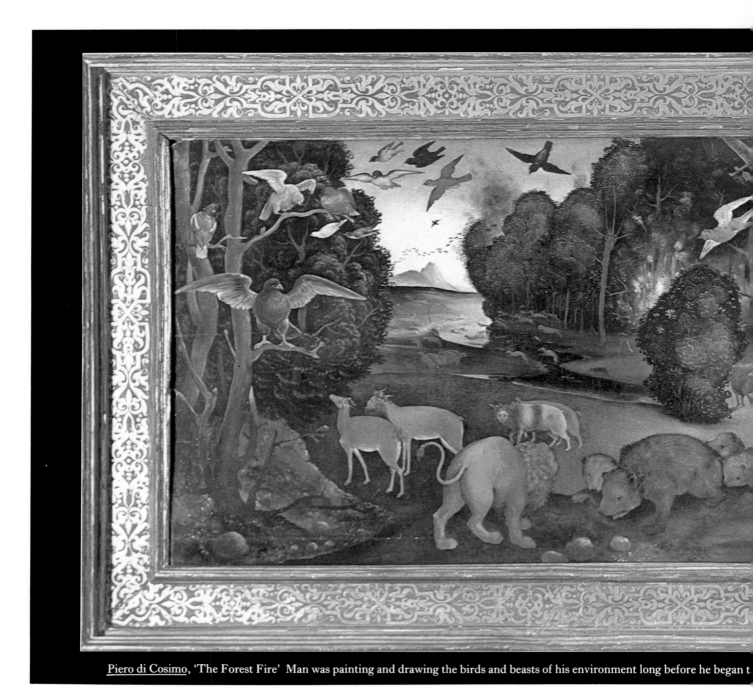

Piero di Cosimo, 'The Forest Fire' Man was painting and drawing the birds and beasts of his environment long before he began t

Nature

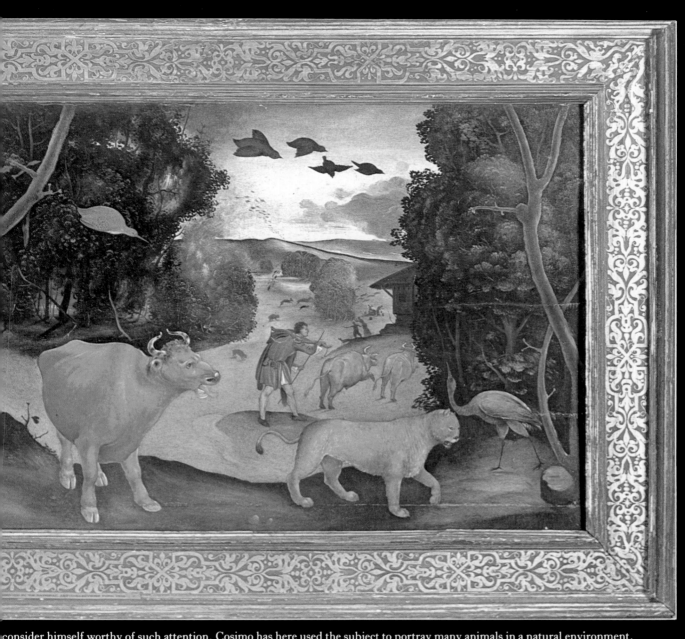

consider himself worthy of such attention. Cosimo has here used the subject to portray many animals in a natural environment.

THE FOUNDATION OF all Western art rests upon the cave paintings of Stone Age man. Drawn, scratched and painted on the dark walls of the caves, they invariably depict the struggle for life and survival of primitive man. The hunt for food was described, man usually triumphing over his prey, be it bison or deer. These pictures were not celebrations of man's prowess and skill, but rather thanksgivings for their continued survival. These images were no doubt made to influence magical sources and thereby ensure success in the true event; a rehearsal for the subsequent performance. Whatever the reasons for their making, the quality of observation in the pictures of the animals is most impressive, and this is a characteristic that has been apparent ever since.

What was true historically is still so, that in general paintings and drawings of birds, animals and fishes are best put into a context, usually their natural habitat. Pisanello (c.1395–1456), an Italian artist, specialized in animal depictions and made fine detailed drawings of working and wild creatures. Dürer, the 16th century German master, surely surprised his audience when he made drawings of elephants and a rhinoceros! The quality of care and study in a picture like Piero Cosimos 'Forest Fire' is truly remarkable.

It is to be recommended that sketch books used in a zoo or wildlife park be used as the raw material for natural history pictures, and the opportunity to study closely any dead beast of the field or sky, whether bought from the poulterer or found by the roadside, should not be missed.

Although George Stubbs (1724–1806), an English painter who specialized in animal and landscape paintings, studied anatomy to very great lengths (even publishing an *Anatomy of the Horse*) such profound knowledge is not essential. Intelligent observation and a basic awareness of structure and limits of movement plus elementary arithmetic, will generally suffice. This is necessary because of the frustration in finding that in the full preoccupation of describing

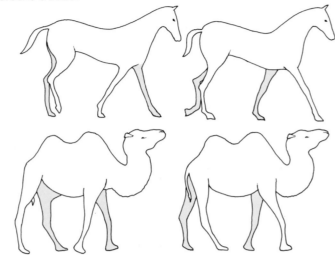

Anatomy An understanding of human and animal anatomy is a great aid for the artist. Here the leg of a human (left) is contrasted with the leg of a horse (right). Note the differences in structure and size.

Movement To accurately capture an animal in motion, the artist should study the pattern of its gait. The horse (top), depending upon its speed, moves with the legs in close conjunction. The camel (bottom) however, will always move with legs on the same side at an equal distance.

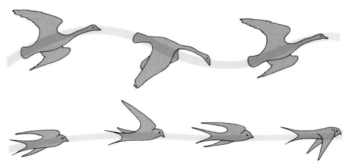

Flight Animals are rarely still and it is to the artist's advantage to study their movements. Above: the flight of a swan (top) is contrasted with that of a swallow (bottom). Note how the head and neck move in relation to the wings and the dipping motion of the swan's flight as opposed to the straight path of the swallow.

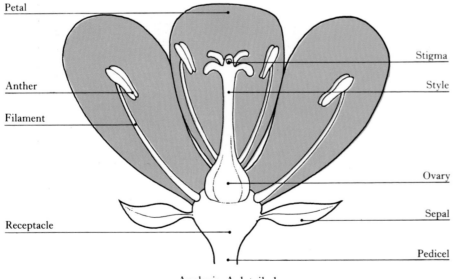

Petal
Anther
Filament
Receptacle
Stigma
Style
Ovary
Sepal
Pedicel

Analysis A detailed study of a flower is a useful exercise for the artist in gaining discipline and improved seeing.

colour, texture, and the other features of a prime specimen, one feather too many – maybe even one fin too few – may inadvertently result.

An excellent way to gain knowledge and confidence is to locate a museum with a collection of stuffed creatures. These are often mounted as tableaux with the young following the parent, or the bird of prey suspended above a suitable habitat. This information can supplement the zoo sketchbook and provide a sound base upon which to create pictures.

Much very good natural history work dealing with animal life has a spirit and vitality reflecting outdoor life in general, but other examples are mainly concerned with the intricacies and finer points of the subject. Such types of work often use natural history objects such as shells, stones, pieces of tree bark and things of that character. This will give the opportunity to exploit the contrasting of textures and colour.

In general, it is as well to consider the descriptive color of the items used in the group or scene. Most animals, eggshells, fishes, etc. have survival reasons for their coloration; camouflage, as used in wartime, is an art adapted from the animal kingdom. Color contrasts are also unique, as seen in the cock pheasant who has such strong, brightly colored feathers so as to be attractive to the hen. Indeed, in the world of birds, the difference between functional color in the male and female is very marked indeed.

Watercolor and gouache are very suitable for making notes or developing pictures of natural subjects. There are many fine examples to see from Dürer to Holman Hunt. Study the way an artist will flood basic tones and colors before finding details in more solid color. Observe the choice of background color and whether it is dark enough to give a strong feeling of the shape of the beast, or subtle enough to allow for feathers or fur to melt into it and so suggest the natural environment.

A technique that has proved useful when working in the field is to use a basic range of oils, say yellow ochre, burnt sienna, Payne's grey, cobalt blue, and a bottle of turpentine. Or, to make drawings, only a few clean rags, very soft black pencils and a small collection of oil pastels are needed. Study the movement of the creatures to be drawn in detail; if it is a tiger

Dürer, 'The Hare'.
In this exceptional
watercolor painting,
Dürer has success
fully rendered an
animal at rest.

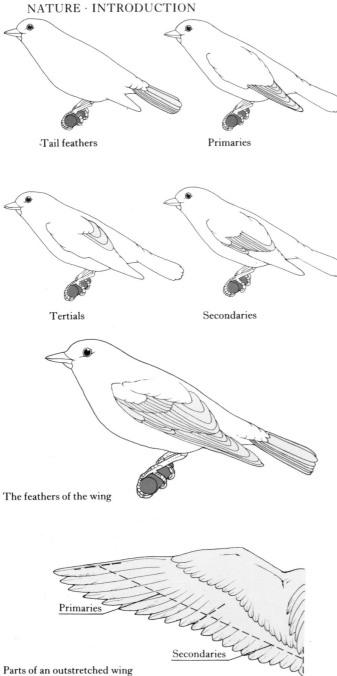

Tail feathers

Primaries

Tertials

Secondaries

The feathers of the wing

Primaries

Secondaries

Parts of an outstretched wing

walking up and down its enclosure, for instance, see at which point in his perambulations the pose is repeated. When you feel that you have engraved the main rhythms in your mind, take a little paint from a tube, dilute this with turpentine and rub on to the paper defining the general shape and color of the animal with the rag. Correct this by adding more smears of paint and when this underpainting looks convincing, draw in with black pencil all the main lines. By adding details with pencil and the oil pastels, the drawing will quickly take shape. With practice this will prove a very useful means of making notes and recording movements.

Birds A thorough study of the anatomy and physical makeup of animals and birds will provide very useful information for drawing and painting them. In almost all animals, every part serves a purpose and it is important that the artist be aware of these aspects.
Above: The layers of a bird's wing are analysed. These are similar to the human hand and arm.

Holman Hunt, 'The Dovecot'. A painting which incorporates a thorou

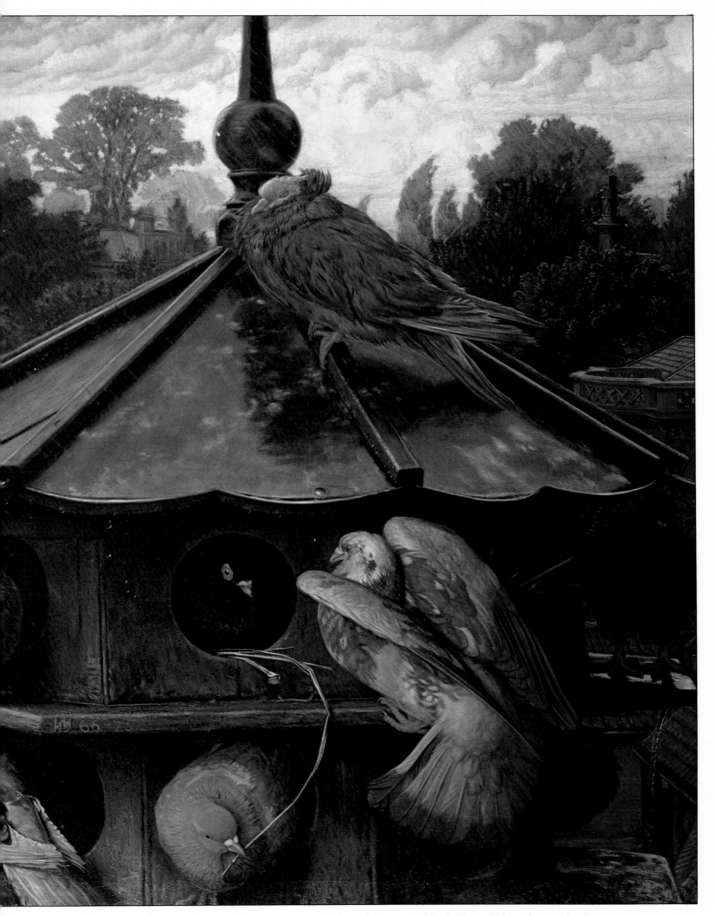

erstanding of the structure of the bird. When used in an atmospheric environment, this yields a subtle and evocative image.

Oil

WHILE THE ARTIST may use a natural history subject to successfully capture the essential characteristics of the subject, it may also be used as a vehicle for creating a dramatic picture.

In this painting, the background colors are part of the range used to paint the animals. Although this provides a close harmony in the whole image, the tones must be handled carefully, or the figures will merge into the background. The dark colors of the animals are a rich texture compared with the solid black behind. The flat pink color of the floor is modified and enlivened with a pattern of shadowy color.

Oil paint is a particularly suitable medium for this subject, as it can be blended and streaked to create an impression of soft fur. It is important to study the color carefully. Dark brown fur will have tints and lights which can be used to enrich the painting.

As a starting point, sketch out the forms loosely with a broad bristle brush but allow the overall shapes to emerge gradually in patches of color, treating each shape as a solid mass.

Materials

Surface
9oz cotton duck stretched and primed

Size
30in × 30in (75cm × 75cm)

Tools
Nos 3 and 6 flat bristle brushes
No 8 round sable brush
1in (2.5cm) decorators' brush
Wooden studio palette
1in (2.5cm) masking tape

Colors

Black	Cadmium yellow
Burnt sienna	Cobalt blue
Burnt umber	Raw sienna
Cadmium red	White

Medium
Turpentine

1. Draw up the outline of the animal with a dark brown mixed from raw umber and black. Use a bristle brush and work freely to lay in the shapes.

2. Start to work into the head, sketching in the features with the tip of the brush and blocking in the colors of skin and fur.

Working from sketch · blocking in tones · face details

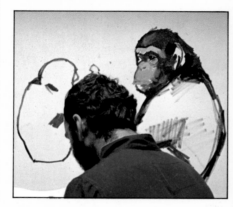

When painting or drawing animals, it is usually easier for the artist to make rough sketches from the live subject which are later used as reference for the finished work. Here the artist is working from a sketch pad.

After the artist has roughed in the general shapes and positions of the animals, he begins to develop the faces. Using a large brush and color mixtures thinned with turpentine, he blocks in general color areas, scrubbing the paint into the surface and allowing these tones to blend with the black underpainting.

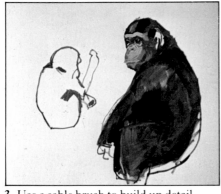

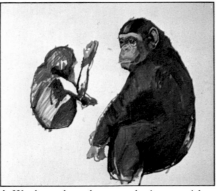

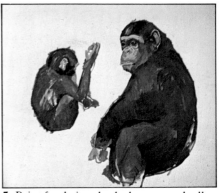

3. Use a sable brush to build up detail, developing the tonal structure of the head. Block in the whole shape of the body loosely with thin paint and a large brush.

4. Work up the color over the image with pinks and browns, strengthening the dark tones. Lay a thin layer of paint over the shape of the second animal.

5. Paint freely into both shapes, gradually improving the details of the form and at the same time intensifying the tonal contrasts. *(continued overleaf)*

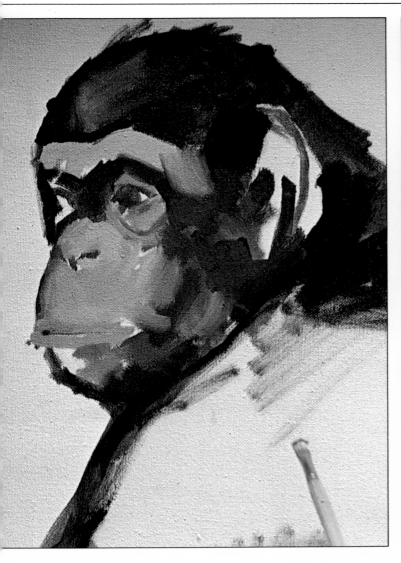

Working over the damp under-painting, the artist begins to develop the details of the animal's face. Using a small sable brush and a thick paint mixture, he works over the initial black underpainting, darkening and refining. It is better to work over a damp surface as errors can be either scraped off or blended into the wet surface.

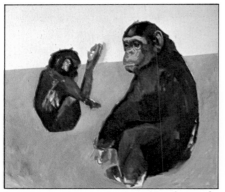

6. Fill in background color with a layer of thin paint. Use masking tape to make a straight line across the canvas and paint into the outlines to correct the shapes.

7. Dab in a multi-coloured texture over the plain area of floor, overlaying dots of red, pink, blue and yellow.

8. Scumble a thin layer of color over the patterning and thicken it gradually so that some areas of colored dots show through. Brush in solid black across background.

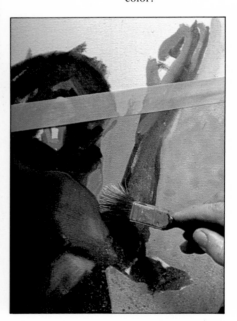

Spattering · putting in background

After the stippled background has been allowed to dry, the artist works with a decorators' brush, loosely blocking in color.

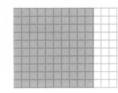

Right: An interesting paint texture can be created by spattering and stippling with a paint brush. The brush should be fairly large, stiff, and dry. The paint consistency is determined by the density of tone desired: the thicker the paint, the stronger the tone and larger the spatter. Above: The overall effect of the surface can be seen in detail. By overlaying a number of colors, from a distance the area will appear to blend into a continuous tone.

9. Draw back into the details of the face with a fine brush, adjusting the shapes and colors. Enrich the black and brown of the fur to give it texture and sheen.

10. Mask off the black background and work across with another layer of color to intensify the dark tone.

11. Draw up light brown shapes on the pink floor to suggest cast shadows. Finish off with white highlights in the fur.

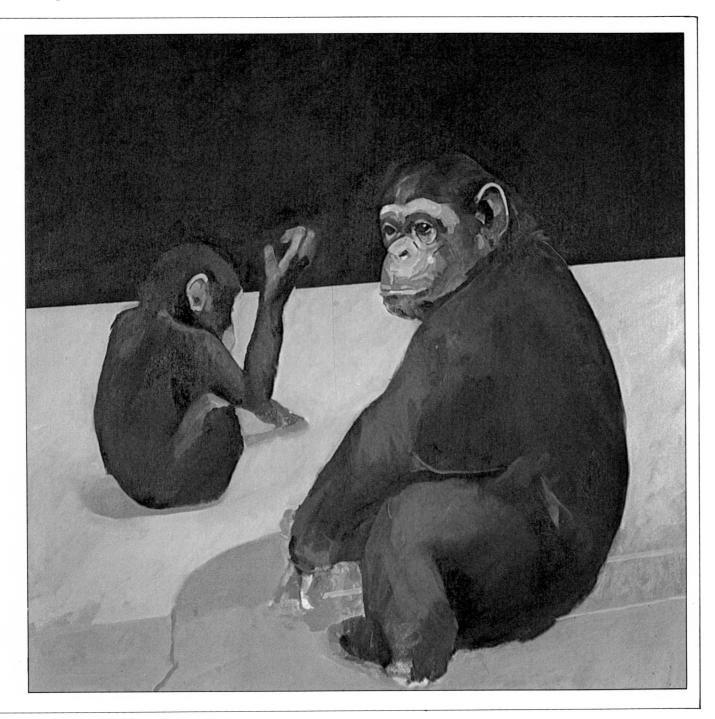

TAKE TIME setting up a still life as the arrangement of the subject is entirely within your control. Move the objects around and consider the overall appearance from different viewpoints. Remember that the full freshness of flowers will not last long and natural light will change gradually during a day's work. Be prepared to work quickly and observe the subject extremely closely throughout the painting process.

Oil paint is the best medium for this type of subject. It keeps its true color as it dries, unlike watercolor which loses brilliance. It also mixes more subtly than acrylics so it is the most suitable medium to describe the range of vivid color and veiled, shadowy hues in the subject.

To establish the basic shapes and tones the composition is first drawn up in monochrome with layers of thin paint. The color is then built up gradually over the underpainting, initially modified by the tonal drawing and gaining full clarity in the final stages. Working quickly in oils means laying the paint wet-into-wet so brushmarks must be light but confident in order to apply colors directly without mixing them on the canvas. Thicken the paint slightly at each stage, adding gel medium where necessary. To make corrections, lift the paint carefully with a clean rag and rework the shapes. Check the drawing and color values continually as the painting evolves.

Materials

Surface
Prepared canvas board

Size
16in × 20in (40cm × 50cm)

Tools
Nos 3 and 6 flat bristle brushes
No 5 filbert
Sheet of glass or palette
Rags

Colors

Alizarin crimson	Permanent rose
Cadmium lemon	Prussian blue
Chrome oxide	Ultramarine blue
Chrome yellow	Vermilion
Cobalt blue	Viridian

Mediums
Rectified spirits of turpentine
Linseed oil
Gel medium

1. Use a flat bristle brush and cobalt blue paint to sketch in the basic lines of the composition. Thin the paint with turpentine and block in broad areas.

2. Strengthen dark tones with alizarin crimson, forming a purple cast over the blue. Draw into the pattern of shapes in more detail.

4. Work on the flowers, drawing in small shapes of red, pink and white. Vary the tone and density of the colors to suggest the form.

5. Refine the drawing with the tip of the brush and lay blocks of color with the bristles flat on the canvas.

7. Brighten the color of the leaves with light green, giving them more definition against the background. Lighten the table top with a layer of warm brown.

8. Brush over the background with a thin layer of blue mixed with a little red. Work over the blues in the foreground with a full range of light and dark tones.

3. Work into the foliage and jar with patches of green, mixing in touches of yellow and crimson. Paint in the background with brown and grey.

6. Bring up the tones of the white and pink flowers, applying the paint more thickly. Add details to the greens in the jar, mixing in yellow and white to vary the colors.

9. Apply small dabs of light color to the flowers, showing the forms in more detail. Work into the leaves behind with yellow and white, bringing out the shapes clearly.

Developing flower shapes

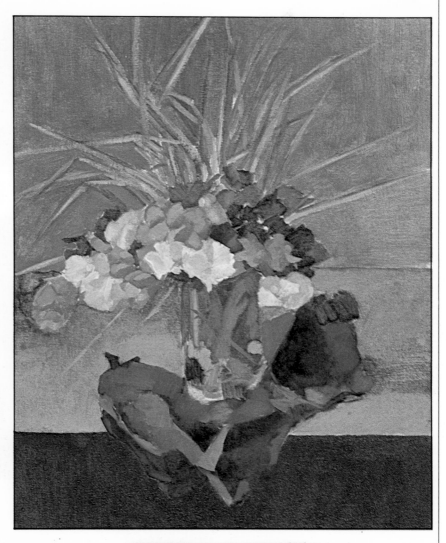

After the initial underpainting is completed in blues and greens, the artist blocks in flower shapes in a thin wash of red.

Working back into the flowers with a small bristle brush to heighten dark and light contrasts.

PAINTING OR drawing animals can be very different from working from the human figure. Because animals are rarely still, drawing or painting them is often an excellent exercise in learning how to work quickly to capture their essential characteristics. If, however, this proves impossible, photographs or pictures can be used as reference material instead of a live subject.

To translate the animal's movement into the painting, pick out characteristic curves and angles in the body and legs. Watch the animal carefully as it moves, looking for repeated movements. Utilize the texture of your brushstrokes to describe thick fur, feathers, or other textures and lay in small touches of color in the earth tones to enliven the overall image. Keep the background simple to focus attention on the color and patterns within the animal.

It can be interesting to use more than one animal in a painting, as the artist can then show more than one position, movement, or type of behaviour. Again, photographs, other pictures or rough sketches made 'on location' can be used as a base, with the various animals or positions of the same animal being combined into the final picture.

Materials

Surface
Prepared canvas board

Size
20in × 24in (50cm × 60cm)

Tools
Willow charcoal
Nos 5 and 7 flat bristle brushes
No 5 filbert bristle brush
Sheet of glass or palette
Tissue or rag

Colors

Black	Cadmium yellow
Burnt sienna	Gold ochre
Burnt umber	Ultramarine blue
Cadmium red	Yellow ochre

Medium
Turpentine

1. Draw up the outline shape in charcoal. Block in basic areas of tone with yellow ochre and blue-black.

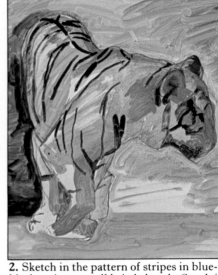

2. Sketch in the pattern of stripes in blue-black, using a small bristle brush. Scrub in thin layers of color over the whole picture.

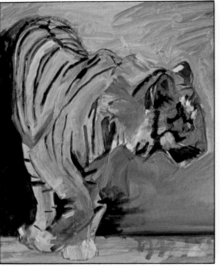

3. Work quickly over the shape of the animal with yellow, burnt sienna and white laying color into the black pattern. Angle the brush marks to accentuate form.

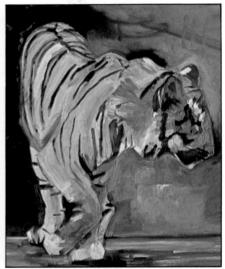

4. Adjust the proportions of the drawing and the division of the picture plane. Strengthen the blacks and heighten the colors, adding touches of red and blue.

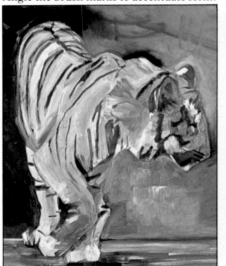

5. Develop the tonal range in the background, spreading the paint with a rag. Work with black and brown to make a dense area of shadow.

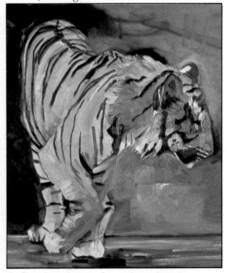

6. Continue to work up the colors, dabbing in the shapes with a bristle brush, well loaded with paint to make a rich texture.

Blocking in background · lightening

The artist rubs
the background
color into the
surface with a tissue
or piece of rag, to
lighten the tone and
pick up excess
moisture.

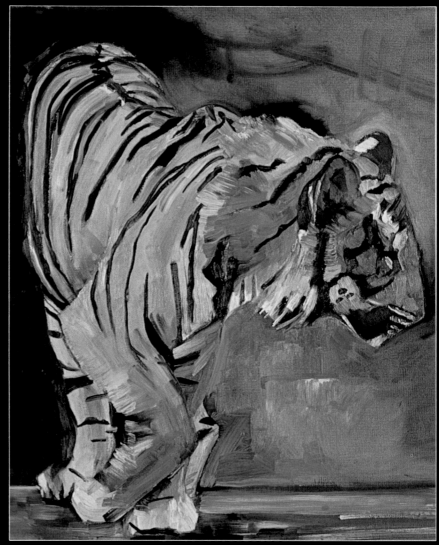

Using a thin
wash of yellow ochre
and black thinned
with turpentine, the
artist very loosely
blocks in the
background area,
scrubbing the paint
into the surface.

ONCE THE form and proportions of this painting were established in the initial drawing, the formal qualities of design, color, and texture became the major areas of interest. A study of the progress of this painting shows that the artist has made continual adjustments to the tones and colors, developing the image from a basic overall view rather than copying directly.

The paint surface is built up layer upon layer, with thin glazes first rubbed into the surface of the board. Thick impasto is applied with brushes and palette knives in craggy blocks of broken color or smooth opaque sweeps. Although the range of color is deliberately limited to exploit the tonal scale, the greys are varied across a wide range which contrast warm yellow hues and neutral or cool bluish tones. Areas of strong color, such as the pinks and reds of the pig's head, are established with the initial glazing then gradually covered and reglazed in the final stages.

The painting should be left to dry out at intervals as if the oil is laid on very thickly the paint will crack as it dries. The surface must be dry before the glazes are applied or the colors will merge and the clear sheen of the thin color will be lost.

Materials

Surface
Prepared canvas board

Size
24in × 20in (60cm × 50cm)

Tools
No 7 sable round brush
No 8 flat bristle brush
No 16 flat ox-ear brush
Assorted palette knives
Palette

Colors
Alizarin crimson Ivory black
Burnt sienna Payne's grey
Cadmium yellow Prussian blue
Carmine White
Cerulean blue Prussian blue oil pastel

Mediums
Linseed oil
Turpentine

1. Draw the composition with Prussian blue oil pastel. Work over the drawing and block in tones with thinned Payne's grey with a No 16 brush.

2. Wash in layers of thin color – carmine and burnt sienna – over the table, the pig's head and the background, using the No 16 brush.

3. Mix cool, warm and neutral greys and spread thick paint over the background walls with palette knives and brushes. Work under the pig's head with white.

4. Work over the whole painting with impastoed layers of solid, textured color. Develop the form of the pig's head with pink, grey and white using a No 8 brush.

5. Continue to build up the layers of paint adjusting the tones of each shape until the whole surface is covered in cool and warm greys.

6. With a No 7 brush, draw into the pig's head with thick black lines and lighten the tone with palette knife and white paint. Rework the background tones.

7. Work over the forms with thin glazes of yellow-brown and dark grey, spread with rags.

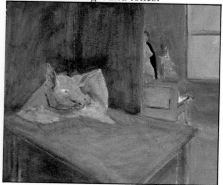

8. Darken the tone of the whole work with thin layers of liquid glazes made from paint and linseed oil. Lay in bright pink and yellow tones over the pig's head.

Blocking in shapes · developing details

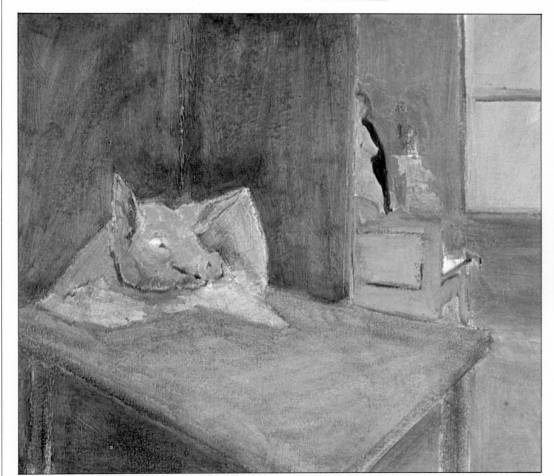

With a small bristle brush and ochre paint, the artist is here touching in the figure in the background.

Working with a large sable brush and thinned paint, the artist blocks in general color tones, rubbing the paint into the surface.

After the reddish underpainting has been allowed to dry, the artist begins to develop the pig's head in broad strokes of pale pinks and greys.

When the artist has modelled the head to satisfaction, a small sable brush and dark paint are used to put back in outlines and details.

Acrylic

ILLUSTRATING ACRYLIC'S flexibility and adaptability, the artist has here used a combination of traditional watercolor and oil painting techniques. Stretched watercolor paper can be used with acrylics, as can sable watercolor brushes. The method used is very much a traditional oil painting technique; the artist uses an underpainting from which to create colors and tones.

The major advantage in using acrylics lies in the fact that the artist need not work from dark to light, but can constantly alter and work from both light to dark and dark to light. In some areas the artist has used traditional watercolor techniques such as the wash. By adding white to a color rather than thinning it opacity can be attained and the brush and paint maneuvered for detail work.

Materials

Surface
Heavy watercolor paper stretched on board

Size
18in × 14in (45cm × 35cm)

Tools
Nos 2 and 6 sable watercolour brushes
Palette or dishes
Rags
2B pencil

Colors

Black	Gold ochre
Burnt sienna	Lemon yellow
Cadmium yellow medium	Raw umber
Cadmium yellow pale	Vermilion
Chrome green	White

Medium
Water

1. Stretch a piece of watercolor paper and after lightly roughing in the subject, apply a thin wash of gold ochre around the subject with a No 6 brush.

2. Using chrome green, begin to lay in the general leaf color varying the tone by making the paint more or less transparent.

3. Mixing vermilion and burnt sienna, describe the branch. Mix lemon yellow and vermilion and put in the apples. Add umber to ochre and block in shadow area.

4. Mix white with gold ochre and block in the area of the background not in shadow. Mix a small amount of black with chrome green and darken the leaf tones.

5. To create lighter leaf tones, mix white, yellow ochre and green. Use pure vermilion to put in darker fruit tones.

6. Mix gold ochre and raw umber to strengthen the shadow area under the branch. Work over existing leaf tones with a darker, more opaque green.

7. Mix chrome green, yellow and white and with a No 2 brush define leaf details, using the underpainting to create the veins in the leaves.

8. Using the same ochre and umber mixture, heighten the shadow under the branch. Thin with water to make a variety of tones rather than adding white.

Developing and refining leaves

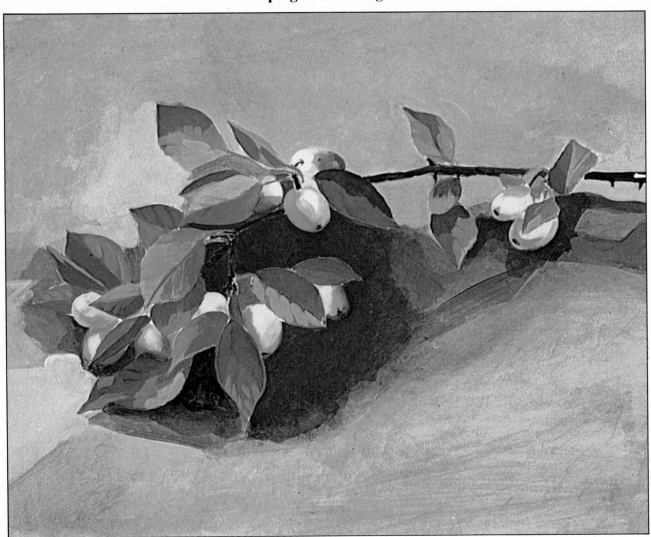

After putting in the background color, the artist blocks in the leaves with a fine sable brush.

With a mixture of chrome green and white and a small brush, the artist cleans up outlines of the leaves.

THE COMPLEX COLORING of zebras is the basic structure for a semi-abstract composition in this painting. The formal qualities of the pattern which include minimal color and high tonal contrasts were selected from black and white photographs which served to emphasize the two-dimensionality of the design.

The forms create a rhythmic framework of light and dark shapes designed to cut across the picture plane in a complex, irregular structure. To vary the color scheme, a warm yellow ochre and cool cobalt blue are mixed into the basic whites and greys. Broad blocks of color surrounding the forms do not indicate a particular environment but are used as a feature of the overall composition.

You will need to make continual adjustments to the colors to arrive at a satisfactory arrangement of the tones. This can be done directly on the canvas, as acrylic paint dries rapidly enough to make overpainting immediately possible. Never try to scrape off partially dry acrylic, however, as it dries with a thick rubbery skin which tears away from the surface. Simply allow the paint to dry and cover any errors with another layer of color.

Materials

Surface
Prepared canvas board

Size
18in × 16in (45cm × 40cm)

Tools
Nos 3, 5 flat bristle brushes
No 10 flat synthetic brush
No 6 round sable brush
Palette or plate

Colors
Black	Vermilion
Cobalt blue	White
Payne's grey	Yellow ochre
Raw umber	

Medium
Water

1. Establish the structure of the composition drawing in simple outline shapes with black paint and a No 5 brush.

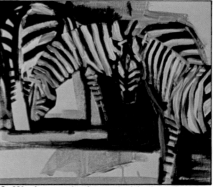

2. Work over the forms in black and white constructing the pattern of the stripes and block in broad areas of background tone with a No 10 brush.

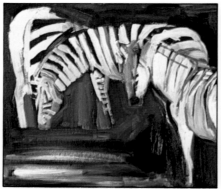

3. With a No 5 brush, develop tones using yellow ochre as an intermediate color. Keep to simple shapes, varying the brushstrokes to make thin and thick lines.

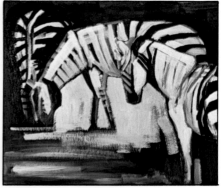

4. Make alterations to the shapes by outlining in red with a No 6 brush. Strengthen the contrast of light and dark, working across the forms.

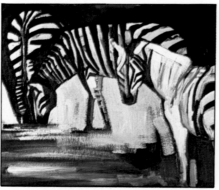

5. Redraft the pattern of lines using the No 6 brush for fine lines and the No 3 brush for thick black strokes.

6. Build up variations in the light tones, adding a little cobalt blue to the greys to offset the yellow and pure white. Extend the pattern across the whole image.

7. Work on the background tones, trying out different combinations of light and dark tones.

8. Block in background and foreground shapes with thick color, using the warm-toned yellow to highlight the black and white.

Developing light areas

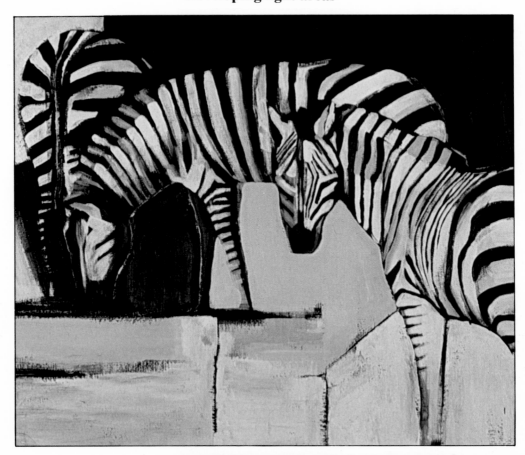

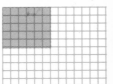

After the initial shapes and outlines of the zebras have been described, the artist here works back into the lighter areas with a small brush and pure white paint.

Watercolor

THE WATERCOLOR techniques used for this painting are particularly well suited to the subject. A combination of loose transparent strokes with opaque white gouache produce an interesting contrast in both texture and tone.

The techniques used – working wet-in-wet and dry-brush – require that the painting be executed quickly and confidently. The process involves working from dark to light and from the general to the particular.

Tinted paper was chosen since it has a unifying and reinforcing effect on the painting. When the color of the paper is used as a 'color' within the subject, as demonstrated in the head of the bird, the contrast in color and texture both heighten the interest in the subject and link it to its environment.

The method of painting is largely intuitive: you should try and let the painting develop independently and take advantage of the various movements of the paint on the surface. A careful combination of control and a willingness to take chances is required and you should learn to take advantage of 'accidents' and use them to express the unique qualities of the picture.

Materials

Surface
Heavy watercolor paper stretched on board

Size
15in × 22in (37.5cm × 55cm)

Tools
Board
Gummed tape
Nos 1 and 2 sable watercolor brushes
Tissues or rags

Colors
Alizarin crimson Payne's grey
Cadmium red medium Prussian blue

Medium
Water

1. With a 2B pencil, lightly sketch in the subject. With a No 2 sable brush, lay in a thin wash of burnt umber, blue, and alizarin crimson to define the shape of the bird.

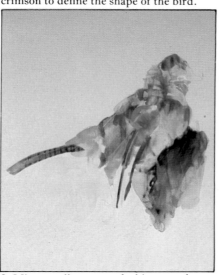

2. Mix a small amount of white gouache with blue and lay this over the undercolors, thinning with water. Put in dark areas with Payne's grey.

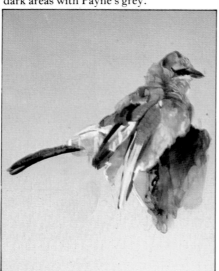

3. With a No 1 brush, mix white gouache with blue and touch in feathers with a light, directional stroke. Add more blue and describe feather texture in the wing.

Underpainting· feathering with brush tip

(**A**, above) The artist puts in a cool underpainting with a wet wash and large sable brush.

(**B**, above) Using the dry-brush technique, the artist describes a feather texture in the neck.

(**C**, below) With a small sable brush and pure white, detail highlights are put in, the final stage.

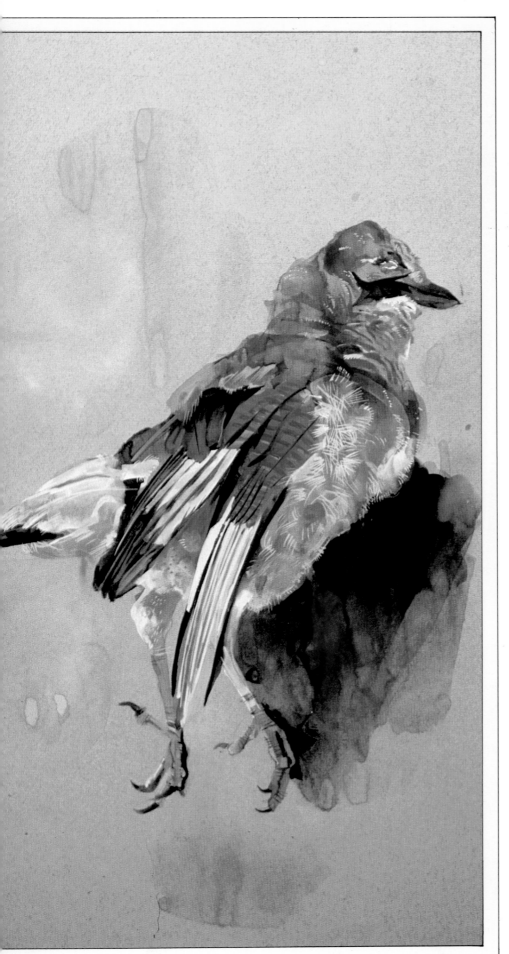

4. With the same brush mix an opaque mixture of Payne's grey and blue and carefully put in dark details of the wings, tail, and head.

5. With a clean, dry No 1 brush pick up a small amount of white gouache. Feather this onto the bird's breast and throat in a quick, flicking motion.

6. With a very thin wash of white gouache mixed with blue, quickly rough in the shadow area around the bird.

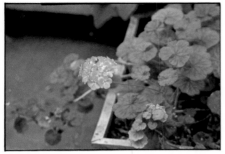

WATERCOLOR USES transparency to create both color and tone. For this reason white is not normally a part of the watercolorist's palette and thus the artist must rely on the various techniques and color mixes to achieve a successful picture. In this painting the variety of techniques illustrate the flexibility of the medium, as well as the skill required to use it to its best potential.

The demands of using watercolor require that the artist be able to anticipate what will happen in advance of putting the paint on the surface. This can be a hit or miss effort, especially when applying loose washes of color or letting colors bleed into one another. The artist has a certain amount of control over where and how the paint is applied, but once the brush touches the paper there is much that can happen which the artist will not be able to predict.

In this case, while care was taken to capture a true representation of the subject, the background was described in a more or less *ad hoc* manner, allowing paint and water to mix with no attempt to control its movement on the surface.

Materials

Surface
Stretched watercolor paper

Size
23in × 18in (57cm × 45cm)

Tools
Nos 2, 6, 10 sable brushes
1½ (3.75cm) housepainting brush
Palette

Colors
Black | Payne's grey
Cadmium green | Vermilion
Cerulean blue | Yellow ochre

Medium
Water

1. Mix a very wet wash of cadmium green and water and loosely define the leaf shapes with a No 6 brush.

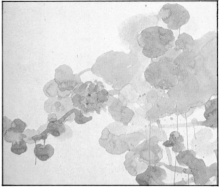

2. With a small amount of cerulean blue and a No 2 brush, put in the dark areas of the flowers. Mix green and yellow ochre and lay in the dark areas of the leaves.

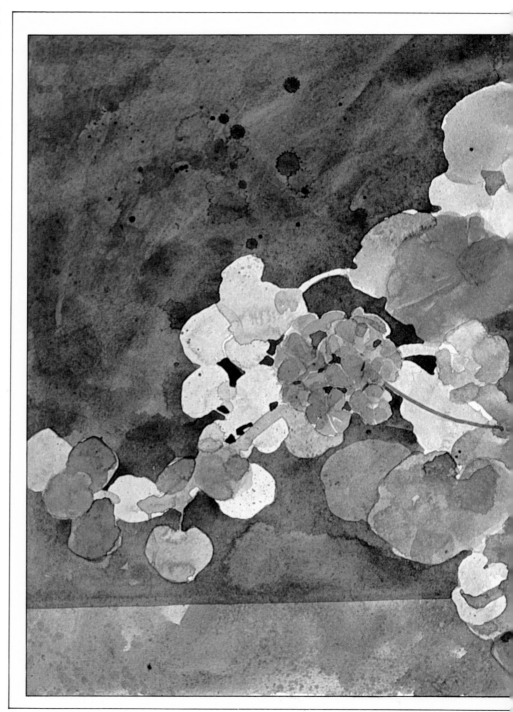

3. Mix a large, wet amount of Payne's grey, cerulean blue, and water. With a No 10 brush, put in the background. Keep the paint very wet as you work.

4. With a No 2 brush, develop dark tones of the leaves by mixing Payne's grey with green. Again, keep the mixture wet and let colours bleed into one another.

5. With a No 2 brush, apply details of stems and veins in pure Payne's grey.

Finished picture · creating leaf shapes · overpainting flowers

To bring the picture together and make it more interesting, in the final stages the artist concentrated on darkening and strengthening the overall image. The background was brought down to describe the foreground plane, and leaves and flowers were touched up with stronger tones.

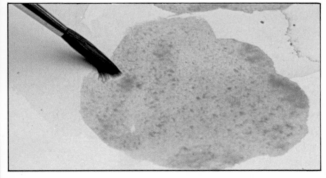

With a very wet wash of water and green, the artist describes the general leaf shapes. The wet paint is pulled out of these areas in thin strands to create the stems of the leaves.

With a small sable brush the artist is here touching in areas of deep red over the lighter underpainting. From a distance, this will give the flowers depth and texture.

ANY WATERCOLOR study of this kind is an exercise in drawing with color. In both objects, by carefully copying each detail of color and texture, the whole impression of the form slowly emerges. The shell is delicately tinged with red, yellow, and grey and the subtle tonal changes which occur as the light falls over the undulating surface are subtly indicated.

Lay in broad washes of basic color to show the simple form and contour of the objects. Pick out linear details such as the network of triangular shapes on the pine cone, drawing with the point of a small sable brush. Use thin washes of color to describe the pools of shadow and natural tints of the shell. Keep the paint smooth and liquid but do not overload the brush – the color should flow freely but not flood the drawing. The work should be dried before fine lines are added otherwise they will fan out and lose precision. Brush wet washes of color together to blend the hues and make the paint spread into soft, blurred shapes of variegated tone. Mix up a subtle range of browns and greys to vary the dark tones and drop in touches of pure color to highlight the surface patterns.

Materials

Surface
Thick cartridge paper

Size
13in × 15in (32cm × 37.5cm)

Tools
Nos 4, 8 sable round brushes
Palette

Colors
Black	Gamboge yellow
Burnt sienna	Payne's grey
Burnt umber	Scarlet lake
Cobalt blue	

Medium
Water

1. Draw the shape of the pine cone with the tip of a No 4 brush and lay in a light wash of burnt umber. Vary the tone with touches of Payne's grey.

2. Work lightly over the shape of the shell following the local color. Pick out small surface details on both objects.

3. Develop the texture and pattern in each shape, drawing fine lines and small patches of color with the point of the brush in dark tones of grey and brown.

4. Strengthen the dark tone inside the mouth of the shell and continue to work over the pine cone, using the direction of the brushmarks to describe the forms.

5. Lay thin washes of grey, brown and red into the shape of the shell with a No 8 brush.

6. Work over both objects with line and wash until the patterns are complete.

Pine cone details · shell tones

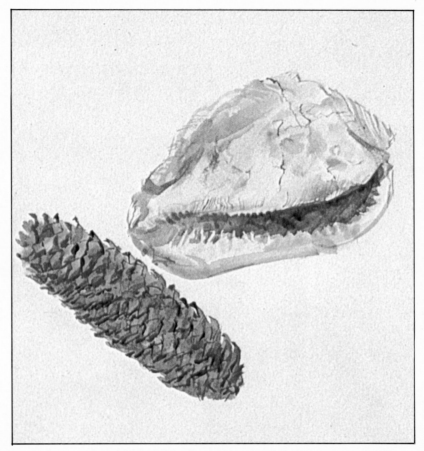

With a very faint mixture of water and paint, the subtle tones within the shell are brushed in.

With a very fine sable brush and burnt umber, the artist describes the details of the pine cone over the dry underpainting.

Pine cone details · shell tones

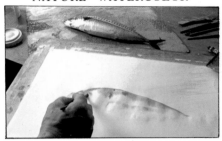

WATERCOLOR IS AT its best when used for subjects requiring sensitivity and delicacy. In this case, the use of watercolor goes far in developing an appropriate aqueous and 'watery' image.

The techniques used by the watercolorist are many and not a few are invented on the spot as the artist is working. There is no formula for creating a successful watercolor painting; however, the better acquainted the artist is with the nature of the medium, the more he will be able to pick and choose – and invent – the techniques most suitable to create an interesting and expressive picture.

In developing this picture, the artist has depended largely on two methods of painting. In some areas he has used the classical wet-into-wet technique – that is, flooding one area of color into another while still wet; in other areas he has laid down a small area of color and then flooded this with water. The combination of the two from the earlier techniques makes the finished painting more interesting than if it were limited to one type only. It is the combination of broad, loose areas of pale color contrasted with smaller, tighter areas of dark detail which give the subject its mystery and interest. Without this contrast and harmonious balance between loose and tight, dark and light, the picture would not be so successful in holding the observer's attention or capturing the essence of the subject.

Materials

__Surface__
Heavy watercolor paper stretched on board

__Size__
22in × 15in (55cm × 37.5cm)

__Tools__
Nos 2 and 6 sable watercolor brushes
Tissues or rags

__Colors__

Alizarin crimson	Payne's grey
Cadmium red medium	Prussian blue

__Medium__
Water

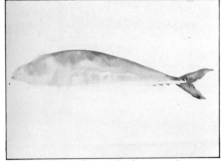

1. On a piece of stretched paper, dampen the shape of the fish with water. With a small sable brush put in a thin wash of blue and purple. Flood with brush and water.

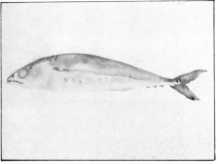

2. Redampen the area to be worked on. With a fine brush and dryish paint, put in the head and spine details in Payne's grey letting this bleed into the other colors.

Wet-in-wet · dark details the wash

With a fine sable brush, the artist puts in fine lines of color over slightly damp paper.

Putting in dark details in the head with a dryish paint mixture. The color is then flooded with water and a clean brush to make it bleed.

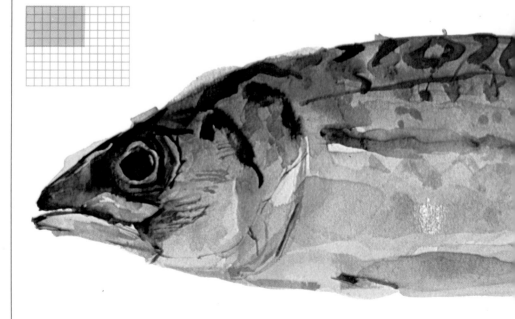

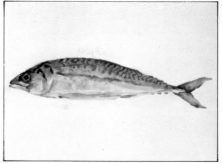

3. After allowing the previous layer to dry slightly, use a stronger and darker mixture of Payne's grey to further define the head.

4. Mix a thin wash of purple and yellow and apply lightly over the body of the fish. Blot with tissue if too wet.

5. Using the deep Payne's grey mixture and a small brush, put in the pattern on the back and heighten tail details.

Working over dark areas with a thin wash of color. When a wet layer is applied over a dried area, a transparent effect is achieved allowing the first color to blend and show through the second.

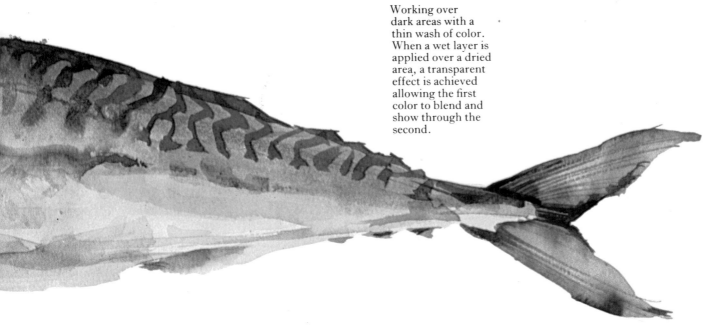

Tempera

THE ORTHODOX tempera painter uses only the finest ground pigments, fresh hen's eggs, expensive and finely crafted brushes, and a surface polished to a marble-like finish. There are many artists however who use shorter and less expensive methods and obtain very satisfactory results. For example, with tubed watercolors and egg yolk, it is simple to create a successful tempera painting in as little time as it takes to do a drawing or watercolor painting.

Egg yolk is a viscous, sticky medium and behaves similarly when brushed on to a surface. Because it dries quickly, the artist must work quickly to avoid the brush dragging and pulling up the painted surface.

Although tempera dries quickly – quickly enough to cause problems – it will not dry to an impenetrable state immediately. Once partially dry, the artist can draw into the surface with a sharp tool, scratching back the paint to the surface. He can then either leave this clean or overpaint in thin glazes. This method of laying down paint, scratching back, and overlaying more paint can be continued almost indefinitely, varying the tone and modifying drawn lines or area of color.

Materials

Surface
Primed hardboard

Size
5.5in × 7in (14cm × 17.5cm)

Tools
No 2 sable watercolor brush
Plate or palette

Colors
Cadmium red light Viridian
Cerulean blue Yellow ochre
Chrome green

Mediums
Egg yolk
Water

1. Dip a No 2 brush into egg yolk and mix with viridian and chrome green. Quickly block in the leaf shapes using a downward stroke. Leave flower areas untouched.

2. Mix chrome green and yellow ochre with the egg and block in the leaf shapes. With only chrome green, draw in outlines and stems.

3. Using the same green, block in major dark areas with a light, vertical stroke. Allow to dry until sticky to the touch.

Finished picture detail

As a final step, the artist puts in thin streaks of pure cerulean blue to enliven the predominantly green surface.

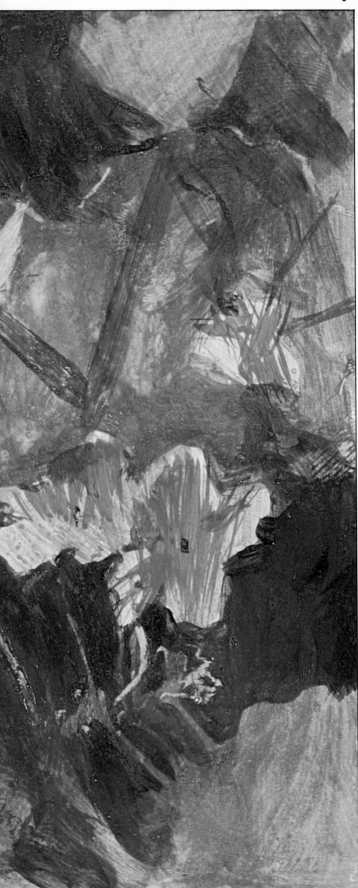

Finished picture detail

As a final step, the artist puts in thin streaks of pure cerulean blue to enliven the predominantly green surface.

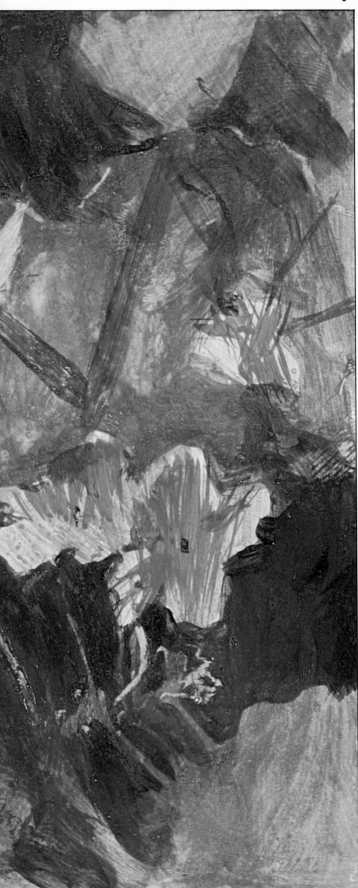

4. With a knife or sharp tool, scratch through the paint surface drawing in the leaf outlines and hatch in small areas of highlight in the leaves.

5. With cadmium red and yolk, block in the flowers. When partly dry, scratch back the surface of the leaves in broad areas. Overlay with a wash of green and yolk.

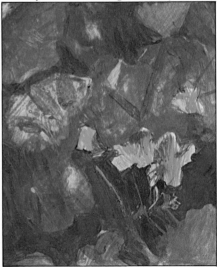

6. With a deeper red, define flower shadows and with cerulean blue, put in the fine lines of blue in the darker shadow areas for contrast.

Gouache

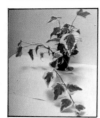

BECAUSE OF their varied textures, colors, and shapes, plants can be an interesting subject for a painting.

To make an effective color study of one plant, arrange it in a well-lit position, preferably against a plain background. Sit far enough away to be able to see the whole form, as otherwise the shapes may become distorted in the drawing. You can move to take a closer look at the details whenever necessary. First draw the whole plant in outline and then start to apply colors. A successful rendering depends upon careful observation of the color relationships as a whole – each hue and tone is modified by its surroundings. Be prepared to make continual alterations to the colors and shapes.

In this example the initial drawing was made in charcoal. The soft, dusty black creates a strong structure for the work and is easy to correct or overpaint. Keep the charcoal drawing clean, or the fine black powder will mix into the paint and deaden the colors. Lay in thin colors at the start to establish general tones and then work over each shape to revise the colors and build up the pattern.

Materials

Surface
Stretched white cartridge paper

Size
15in × 19in (37.5cm × 47cm)

Tools
No 6 round sable brush
Willow charcoal
Plate or palette

Colors
Black	Olive green
Cadmium yellow medium	Raw umber
Cyprus green	Scarlet lake
May green	White

Medium
Water

1. Draw up the outline with charcoal showing the shapes of the leaves and the stalks. Work freely, correcting where necessary by rubbing lightly over the lines.

2. Brush away excess charcoal dust from the surface of the drawing and with a No 6 brush work into the leaves to show the green patterning.

3. Fill in the whole shape of each leaf. Draw the stalks of the plant in red using the tip of the brush.

4. Revise the drawing with charcoal and paint over alterations with white. Continue to develop the colors, putting in a darker tone behind the leaves.

5. Build up the image piece by piece with applied color, gradually adding to the detail and refining the shapes.

6. Adjust the tones of the colors to draw out the natural contrasts. Complete each shape before moving onto the next.

Beginning to work · refining leaf shapes

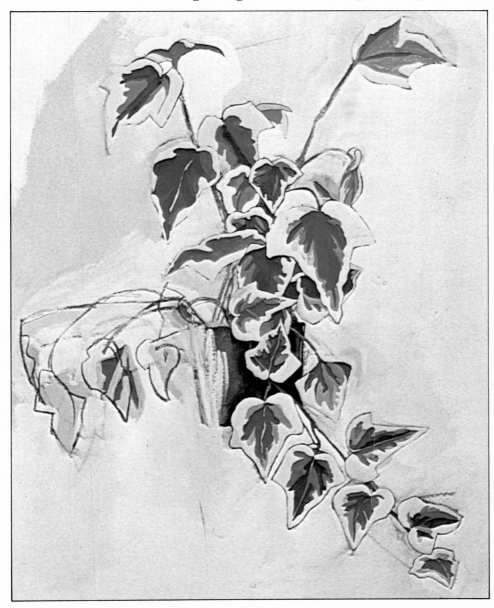

Working with a small sable brush and pale green, the artist works directly over the sketch, blocking in tones.

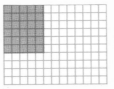

After the dark green of the leaves has dried, an opaque pale green is blocked in around these shapes.

Pastel

IN TERMS OF color, shape, and gesture, the subject for this picture is well suited to a pastel drawing as bold colors and sharp, gestural strokes are few of the many potential uses of pastel. Of course the technique used will determine the end result; if this picture had been executed with heavy blending, smudging and subtle color the results would be quite different.

The colors used are basically complementary: red, orange and pink; blue, purple and green. It is worth remembering that color is created by light, and color will always reflect and bounce off neighboring colors. The artist has exploited this by using a complementary color within a predominant color area. Thus there are touches of red in the purple flowers, and touches of purple in the red and orange flowers. The dark blue used to describe the stems and shadow areas works as a contrast to both the purple, blue, and red, intensifying and adding depth to the overall picture.

The composition was purposely arranged to give a feeling of closeness. The white of the paper works in stark contrast to the densely clustered stems and flowers in the bottom left corner and the directional strokes serve to lead the eye upward and across the page.

Materials

Surface
Pastel paper

Size
16in × 20in (40cm × 50cm)

Tools
Tissue or rag
Willow charcoal
Fixative

Colors
Blue-green	Orange
Cadmium red medium	Pale blue
Cadmium yellow medium	Pink
Cobalt blue	Prussian blue
Dark green	White
Light green	

1. After roughing in the flower shapes with charcoal, lightly sketch in the flowers in pink, red, and purple and the stems in light and dark greens.

2. With a small piece of tissue, blend the color tones of the flowers. With pale blue, work back into the purple flowers describing the petals with sharp strokes.

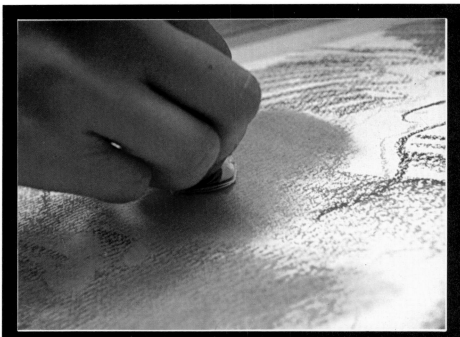

A method of blending is to use a small piece of tissue. Unlike a finger, the tissue will both blend colors and pick up the pastel, thus lightening the tone.

Pastel marks can either be left as clean strokes or blended into subtle gradations of tone and color. Here the artist is blending within the flowers, mixing the orange and pink.

Using the tip of a pastel, the artist describes stem and leaf shapes with a quick, loose motion.

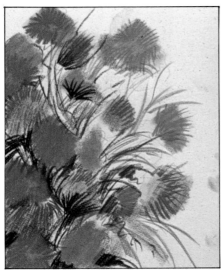 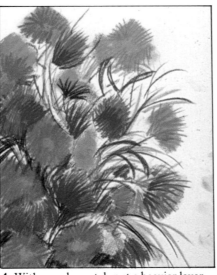

3. With cadmium red and orange, emphasize the petal shapes with sharp strokes. With dark blue, define stems with the same sharp, directional strokes.

4. With purple pastel, put a heavier layer down within the blue flowers. Use the same color to put in additional leaf and stem shapes with a loose stroke.

5. Returning to the flowers, apply deeper tones with more pressure. Add touches of red to the purple flowers. Create flower centers with yellow in the pink flowers.

Finished picture blending · stem and leaf shapes

To finish the picture (<u>right</u>), the artist continued to develop strong dark areas with blue. As a final step, a tissue was used to pick up loose color and blend into the right hand corner.

PERFECTING THE techniques needed to draw effectively in pastel takes time. As pastels are loose and powdery, the sticks must be carefully manipulated to achieve any degree of precision. If you work on tinted paper, the light tones may be handled as positive, strong colors while the tint adds depth to the overall tone of the work.

Outlines, where used, should be light and sketchy, merely providing a guideline to be eventually overlaid by areas of color. Spray the drawing with fixative whenever necessary to keep the colors bright and stable. Overlay layers of color with light strokes of the pastels to create soft, intermediary tones.

Materials

Surface
Blue pastel paper

Size
11in × 15in (27cm × 37cm)

Tools
Fixative

Colors
Black	Orange
Cobalt blue	Pink
Dark and light green	White
Dark and light red	Yellow

1. Loosely sketch in the basic position of the bird with red and orange pastels. Draw the crest of the head in white.

2. Work over the drawing with vigorous, scribbled marks, contrasting the orange and red of the bird against green and yellow in the background.

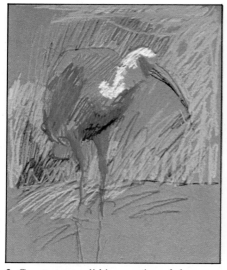

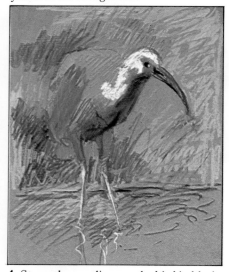

3. Construct a solid impression of shape, drawing into the form with white and black. Work into the background with light tones.

4. Strengthen outlines on the bird in black and lay in a dark green behind. Add small details in blue and white.

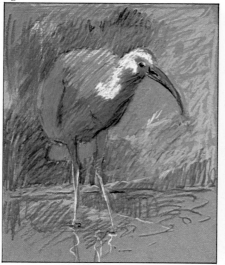

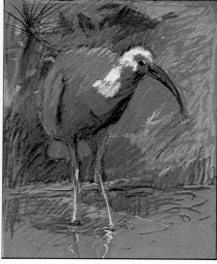

5. Strengthen the colour over the whole image, showing shadows and highlights. Overlay scribbled patches of different colors.

6. Spray the drawing with fixative and let it dry. Reinforce the red shapes, giving the form more definition. Work up linear details in the background.

Developing general shapes and tones · highlighting

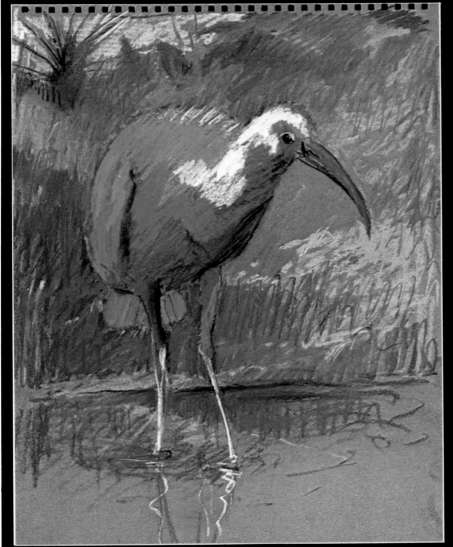

Here the artist begins to block in the color of the bird with a very loose, scribbling motion.

With pale yellow, the artist moves across the picture putting in loose lines of highlight.

Pencil

WASH AND LINE illustrates the ability of mixed media to capture an image both simply and directly. By a skillfull use of line and carefully placed touches of wash, the artist is able to reduce the subject to its bare essentials, creating a picture which is fresh and simple in style.

How to decide upon the ratio of line to wash, and vice versa, takes practice and a keen eye. There are no hard and fast rules but, in general, it is best to keep the image as clear and uncluttered as possible. The temptation to cover the surface with many colors and techniques is a common one; it takes practice, restraint, and a critical eye to put into the picture only what is absolutely essential to best express the subject.

A good reason for resisting the temptation to cover the page is that often the plain white surface can emphasize a line or dab of color far more than any techniques or additional colors can. It is the use of contrast – the broad white or tinted paper contrasting with the sharp edge of a line or subtle wash of color – which serves to emphasize and draw attention to the image. The emptiness and cleanness of a few well-chosen lines and dots of color, when combined with the untouched surface can create an image of eye-catching simplicity.

Materials

Surface
Thick cartridge paper

Size
26in × 18in (65cm × 45cm)

Tools
4B pencil
Putty eraser

Colors
Gold ochre watercolor

Medium
Water

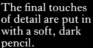

The final touches of detail are put in with a soft, dark pencil.

1. Begin by putting a small amount of gold ochre directly on to a small piece of rag.

2. Rub the gold ochre on to the surface to create general color areas. Use your finger or fingers to draw with the paint and create feathered textures similar to fur.

Feathering · drawing in shapes · details

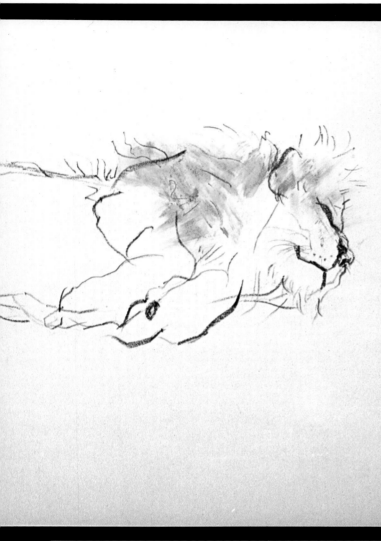

With a dense stroke, the artist is here seen working over the yellow wash to put in the general shape of the lion.

A feathered texture can be achieved by using the fingers to lightly touch the paint on to the surface. Do not use too much paint on the rag and do not dilute with turpentine.

3. With a soft, dark pencil, begin to describe the lion's head over the gold ochre paint. Vary the thickness and width of the line.

4. With the same pencil, continue down the body of the lion with a light, flowing stroke.

5. Reinforce outlines with more pressure. Put in dark details in the head and feet.

A SKULL is a good subject for a pencil drawing as it has a fluid and well-defined outline. The overall structure however is quite complex, containing a variety of linear and tonal details. The smooth, rounded dome of the skull demands subtle changes of tone which contrast with the dense, black shadows in the sockets of the eyes, nose and mouth.

The forms are represented by overlaid layers of shading and crosshatching married with crisp lines outlining the shapes and describing small fissures in the surface. Allow the image to emerge gradually by first developing the structure as a broad view of the whole shape and then breaking down each area to show details.

Arrange the subject carefully when you start a drawing to make sure it presents an interesting view which shows clearly the qualities to be described by the drawing medium. Use an HB pencil in the early stages moving on to a softer 2B to reinforce the lines and dark tones. If you work slowly and logically over the form it may not be necessary to use an eraser, but be prepared to make continual minor adjustments as the drawing develops. Vary the direction of the hatched lines to correspond to the network of curves and cavities. In this case, other bones have been drawn in to establish a horizontal plane and so the shape is not isolated.

Materials

Surface
Thick cartridge paper

Size
18in × 20in (45cm × 50cm)

Tools
HB and 2B pencils
Putty eraser
Fixative

1. Use an HB pencil to sketch in the outline of the skull and the sockets of the eyes and nose. Work loosely with line and light hatching, strengthening the shape.

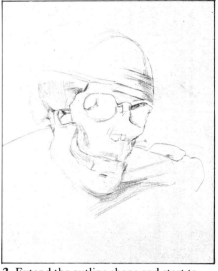

2. Extend the outline shape and start to hatch in dark shadows, working the pencil in different directions to intensify the tones.

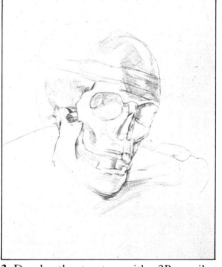

3. Develop the structure with a 2B pencil. Work over the whole drawing blocking in small shapes and improving the definition of the contours.

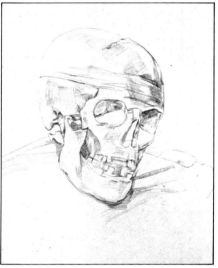

4. Continue to build up the form in more detail, drawing small shapes of the teeth and jaw socket. Use an eraser where necessary to make corrections.

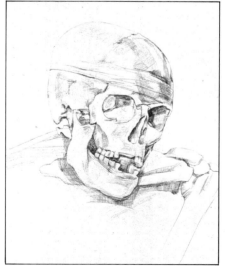

5. Strengthen the outlines and work over dark tones with crosshatched lines to give depth and bring out the full volume of the form.

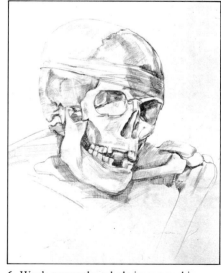

6. Work across the whole image making minor adjustments in the tonal balance and reinforcing the lines where appropriate to clarify the overall structure.

Crosshatching the eye area

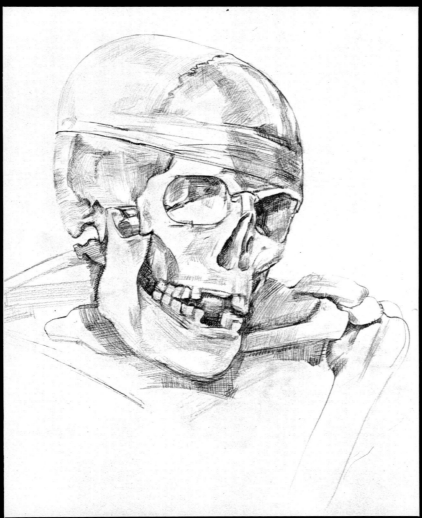

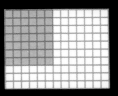

The artist is seen here working into the eye cavity with a soft, dark pencil. Note the use of crosshatching to create depth. The darker the hatching, the more the shape will appear to recede.

Crosshatching the eye area

WILLOW CHARCOAL IS often used for preliminary sketches for paintings but it is also an exciting medium in its own right. The most enjoyable aspect of drawing with willow charcoal is its responsiveness to touch and stroke. Another important feature is that it is easily erased – the artist can put down very intense, black areas and either lighten or remove these entirely with a putty eraser or tissue. The line achieved with willow charcoal is soft and fluid but by no means weak. A wide variety of tones and textures can be achieved through the use of line, tone, blending, and erasing.

The picture here is a good example of the various techniques available. The artist has relied purely on tone, texture, and stroke to give the animal weight and to distinguish it from its surroundings. The elephant is described in soft, blended tones, while the background is created with bold, directional strokes each offsetting the other.

The picture developed through a constant movement between dark and light areas and lines. A dark area is put in, lightened, and then the artist again returned to the dark areas. As seen in the steps, there was a constant progression from light to dark and back again, but within this there was a constant adjustment and readjustment of shadow and highlight, soft and bold, blended areas and linear strokes.

Materials

Surface
Rough drawing paper

Size
23.5in × 22in (59cm × 55cm)

Tools
2B pencil
Medium and light willow charcoal
Putty eraser
Tissues
Fixative

1. After putting in the general shape and composition of the drawing in light pencil, redraw the outline of the animal and background with fine willow charcoal.

2. Using the side of a piece of light charcoal, rough in shadow areas of animal. With a piece of medium charcoal, quickly sketch in the background.

Erasing highlights · laying in tones

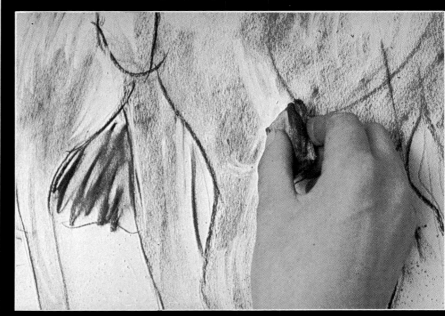

In the first few steps, broad areas of tone are laid down using the side of the charcoal.

A putty eraser may be used to create highlights. Here the artist is erasing back through the charcoal, blocking in light areas.

3. With medium charcoal, work back into the shadow areas of the elephant in loose strokes. Blend area around eye with finger. With putty eraser, erase highlights.

4. Develop darks in background by putting down strokes and blending. Rework outline of elephant. Blend shadow areas beneath with tissue or finger.

5. With heavy, gestural strokes, put in background. Strengthen darks in elephant and blend. Use putty eraser to clean up whites and highlight areas.

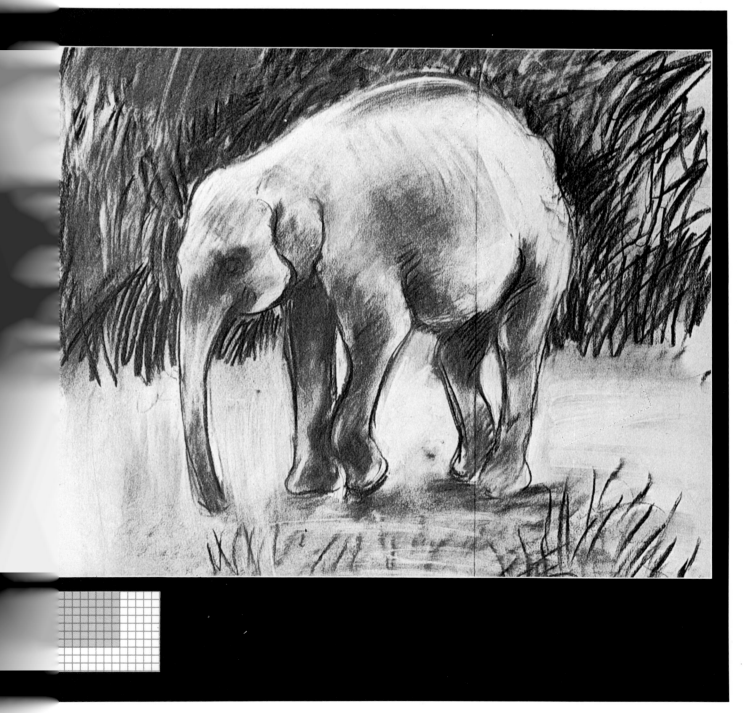

Pen and ink

THE LOOSE LINE and confident strokes which experienced pen and ink artists achieve are acquired more by a relaxed attitude than superior drawing talents. More than any other medium, if the artist is worried about his strokes, the pen and ink drawing will immediately reveal his concern; the artist must make a conscious effort to overcome a desire to control or inhibit the line of the pen and the flow of the ink.

The artist has here achieved an informal sketch with little detail or careful rendering. The strokes are loose, flowing, casual. While there are many artists who consider any form of correction wrong, it is perfectly acceptable to correct a pen and ink drawing, as the artist has done here, with white gouache. On the other hand, as it is impossible to draw over lumps of white paint without interrupting the flow of the line, massive correcting may destroy the naturalness of the picture.

Materials

Surface
Smooth cartridge paper

Size
6.5in × 9in (16cm × 22cm)

Tools
2B pencil
Dip pen
Medium nib
No 2 sable brush

Colors
Black waterproof India ink
White designer's gouache

Medium
Water

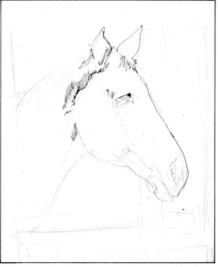

1. With a 2B pencil, roughly sketch in the horse's head and area to be worked within.

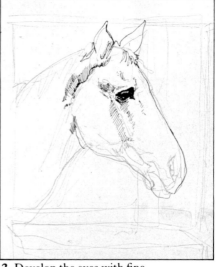

2. Develop the eyes with fine crosshatching. If any area of the drawing becomes too dense, it may be corrected with a small sable brush and gouache.

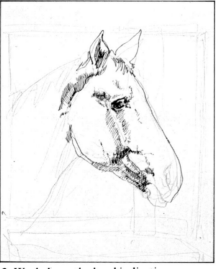

3. Work down the head indicating musculature with a light, diagonal stroke.

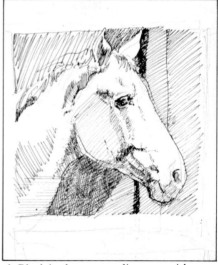

4. Block in the surrounding area with broad, dark strokes. To create a darker tone, work back over these strokes in another direction.

5. Put in the darkest areas with a scribbling motion and plenty of ink. Redefine the outlines of the head with a dense, dark line.

6. Work back into the head and surrounding area with crosshatching to create darker tones and shadow areas.

Beginning details · correcting

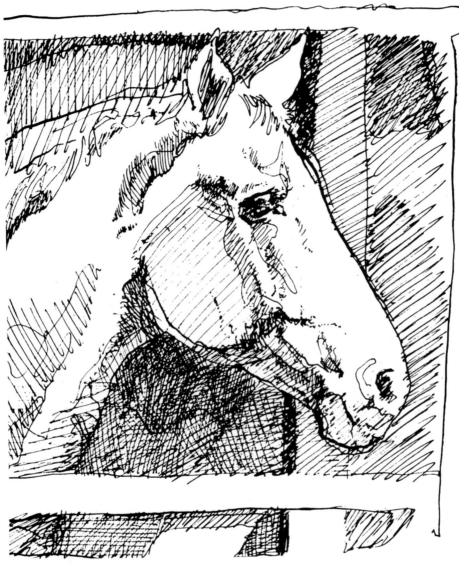

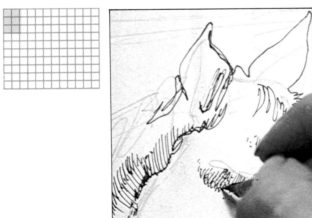

With a very fine nib, the artist puts in details around the eye.

Small areas of ink can be corrected by using a small brush and white designers' gouache. This can be used for small corrections only.

PEN AND INK is considered best suited for tight detail work and densely cross-hatched drawing; however, it is just as possible to use it for loose and informal work. When what are often considered 'mistakes' – such as blending, running, smudging and blotting – are incorporated into the technique, a pen and ink drawing can take on new meaning.

In the drawing here, the artist has taken advantage of all these factors and incorporated them without losing either the strength of the drawing or the subject. Little attempt has been made to control the line of the pen – something many artists struggle hard to achieve – but, instead, the artist has let the nib catch and jump across the page without interference. While working, the artist's eye rarely left the subject; there was a direct line between what was seen and what appeared on the paper, resulting in a series of lines and marks which possibly suggest the subject better than careful and analytical rendering would have.

When the artist's goal is to capture the essence of the subject rather than creating a nice drawing, the attempt to control will hinder rather than help. In which case it is much better to assume an open attitude and allow the hand to follow the eye naturally and without interference.

Materials

Surface
Stretched white cartridge paper

Size
14in × 19.5in (35cm × 49cm)

Tools
No 2 sable brush
Dip pen
Medium nib

Colors
April green
Black
Blue
Red

Medium
Water

Using side of the pen · finishing details

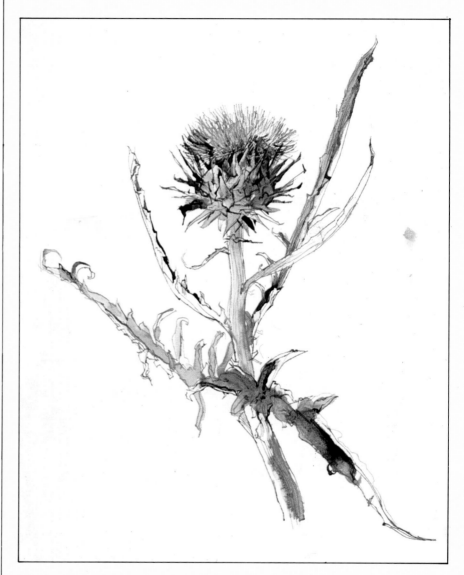

Although a medium nib is being used, a thick line is produced by turning the pen on its side and pulling it across the surface.

1. To dilute the color, dip the pen in water and then green ink and begin to describe the general outline of the plant. Repeat with red and black inks.

2. Move down the thistle with green ink letting the pen create a rough outline. Do not attempt a careful rendering but let it drag across the paper.

3. Dip the pen in water and then blue ink. Begin to put in the flower shape with quick, directional strokes. Dip the pen in black ink and redraw the outline.

4. Continue with the black ink working back over the lines previously drawn in green. Again, do not attempt a smooth line but let the nib catch on the paper.

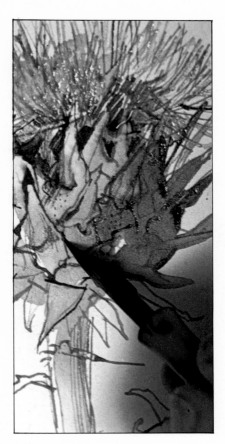

The artist is here describing the final details of the thistle over the light green wash. An irregular, jagged line is achieved by loading the nib with ink and letting it drag across the surface.

5. When the drawing is partially dry, mix a light wash of green and water and with a No 2 sable brush quickly block in the general color areas.

6. Dilute blue ink and work into the flower with the same brush. With a clean dry brush and pure undiluted ink, put in the leaf shapes.

Still life

STILL LIFE PAINTING has been the sole preoccupation of several important artists throughout the centuries and virtually the sole interest of a smaller number. On many occasions a school of artists has earned a reputation solely on the high quality of its still life pictures. Still life can be any one of a variety of things from a group of objects related to each other by association, as in a collection of objects used in hunting or cooking, to a series of apparently disparate items placed on a surface or across several surfaces. Often stories are told by still lifes, which appear as foreground or background accompanying a figure or maybe more than one figure. Otherwise, the set-up might well be simply one affording the artist the opportunity to exploit formal niceties, such as colour relationships, textural rendering, or compositions of a particular kind.

Masters of the still life

The brilliant use of still life objects in the early paintings of the 17th century artist Velazquez are as strong in form and structure as they are in the faithful rendering of color and texture. A glazed pot shimmers in the sunlight as the figure holding it almost breathes the air about him. Chardin, an 18th century French artist, painted intimate interiors reflecting daily events of little consequence in themselves, but lovingly depicted. The demands for both a rural element and the picturesque no doubt were factors in persuading these artists to cherish and cultivate such skills.

Notable for the full union of figure with still life painting are several Dutch painters of the 18th century, particularly Jan Vermeer (1632–1675). These pictures have a strong narrative element, almost elusive in their description and suggestion of a specific event; the artist painting a portrait, the girl having a music lesson, and such subjects, all of which demand that the setting, far from being staged as though in the proscenium arch on a stage, is casual and everyday. To render convincing contexts, Vermeer spent time on careful,

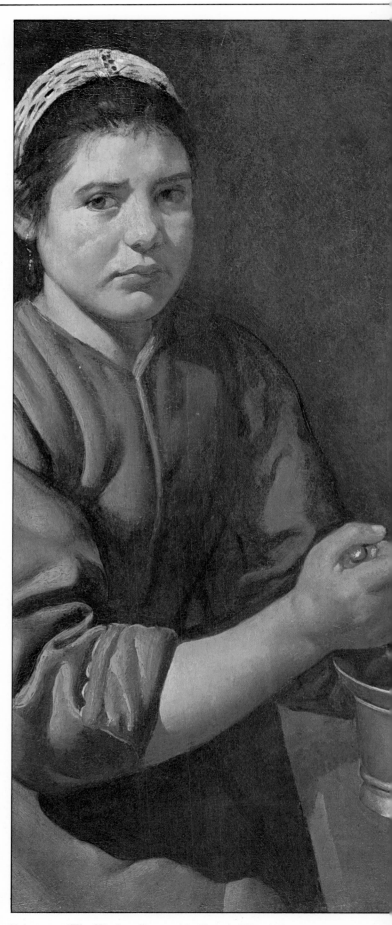

Velazquez, 'The Kitchen Scene with Christ'. The skill with which Velazque

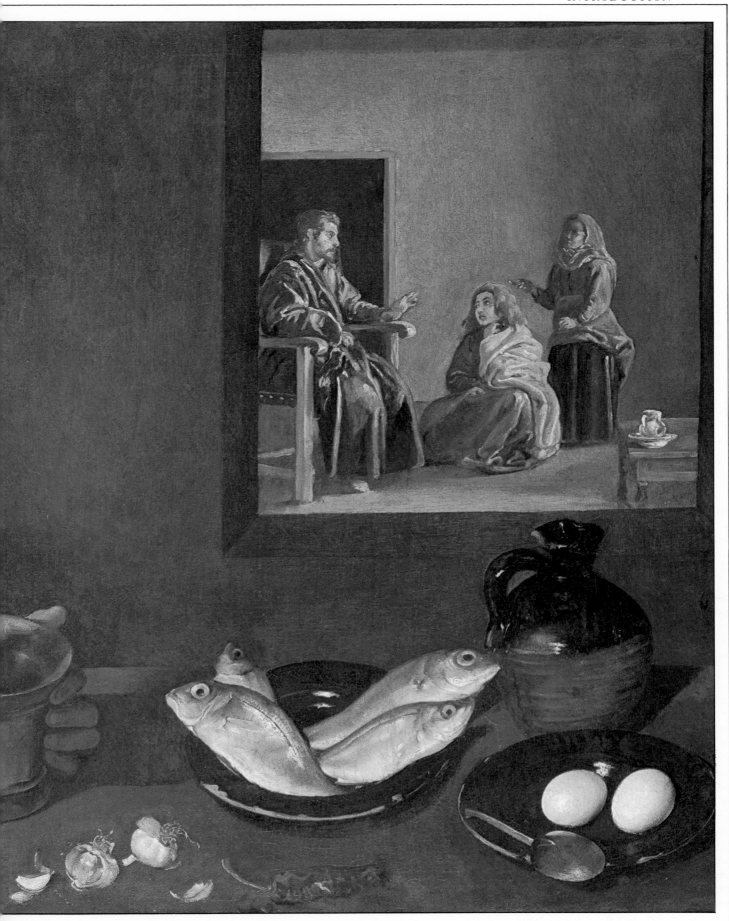

as able to render both still life and figures is apparent in this painting. Note how objects are treated with as much care as the figures.

closely observed interiors and the objects within them. He was a master at rendering the texture of crisp cotton or the languid, weighty drop of silk. Pewter or silver take on a verisimilitude to the appearance of the original; convincing and yet unmistakably painted. The good artist would never let illusion or reality detach him from the so-called 'formal values' of enjoying the picture surface.

A fine exponent of the still life was the 19th century artist Paul Cézanne, a great painter and innovator whose system of working required long periods of readjustment and reworking, overpainting and corrections. The still life group was thus an obvious subject, allowing him to carry on his trials and experiments without the problems of movement. Color was used to organize and unify the design, and the space was carefully composed so that the eye travelled across, through, beyond, around and below the picture surface.

Arranging the still life
The first consideration when making a still life picture is, of course, the group to be painted or drawn. Care should always be taken to make the arrangement as telling as possible. This does not necessarily mean that it must be full of objects and rhythmic interest, as it may be that an astringent, simple, carefully organized group will possibly hold your interest the better.

Taking the trouble to rearrange the elements several times always repays the painter; taking a different viewpoint or altering the color balance is better done before committing paint to surface, rather than abandoning a half-finished picture.

A few diagrams to demonstrate alternative compositions should be undertaken, and, if one chooses, make a painting of a casual arrangement, such as a table top littered with assorted objects. Edit the final choice by cutting a rectangle to the same proportion to your support in a sheet of stiff white paper and frame the group with it. By holding the frame close to the eye a completely different composition can be seen than that viewed by holding it at arm's length. Experiment with this so that the dialogue between yourself and the subject is allowed full rein. It might well be that by this means one can discover a much better alternative and as well allows unsuspected interpretations by cropping objects or putting things into the fore-

Paul Cézanne, 'Still Life with Teapot'. Cézanne used the still life as a means of experimenting with and expressing his innovative concepts of space and depth. The still life has often been used in such a way since objects are easily arranged to suit the artist's needs. The Cubists carried this idea to its extreme with their revolutionary shattering of space and dimension.

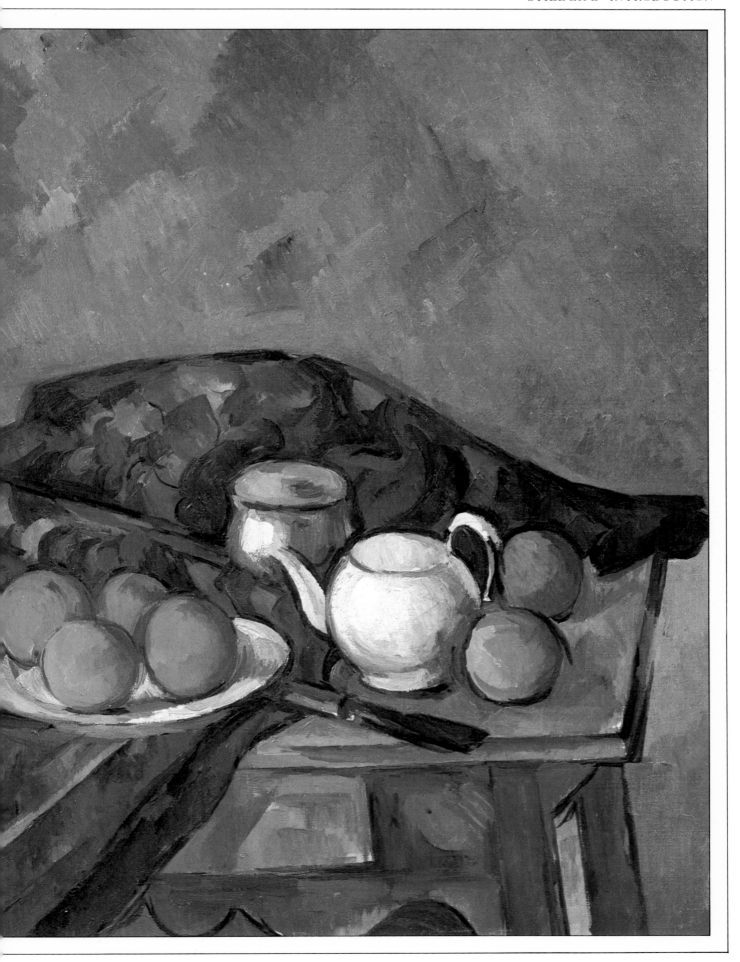

Arranging the still life

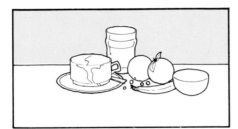

Placement The placement of objects in the picture plane is determined by the emphasis desired by the artist. Left: Objects are centerd to allow the artist to

explore their unique and individual qualities. Center: When objects are moved away from the center, interest is created by surrounding the objects with empty space

which tends to emphasize, rather than diminish their importance. Right: If too much or too little of the object is shown, the picture can become uninteresting.

Arranging objects The still life can be conveniently altered and rearranged to suit the needs of the artist. Left: Objects have been chosen for their contrasting shapes

and the plant in the foreground adds visual interest. Center: A bottle replaces the teapot adding a strong vertical element. The plant is moved further right and

downward to allow for the eye to focus on the objects. Right: The plant is included in the group of objects to add contrast in shape and texture.

Drapery Fabrics and drapery are often included in the still life because they offer an interesting textural contrast to the other objects included. For example, a piece of rough sacking is a good counterpoint to

either the smooth surface of glass or pottery. Left: Drapery can be used to partially obscure the still life group. Center: The fabric has here been arranged to create a visual direction in the picture;

the observer's eye moves from the top, down and around the objects. Right: Placing the fabric in the background can emphasize the still life group.

The figure in still life Left: A picture can contain any number of elements, related or unrelated, and need not be restricted to the traditional still life, portrait, or figure themes. Combining the still life with either a figure or portrait can be extremely interesting and was often used by the masters as a means of demonstrating their skill in all types of subject matter.

ground or lowering eye levels. When the final decision has been taken on the design, color and other components of the group, and the various alternatives have been fully considered, then painting can commence.

Painting techniques

The painting of still life can entail broad generalizations marked in with thin paint with strongly marked details of texture, light and color over-

laid; or, especially in watercolor, the quiet selection of tones and color analysed and interpreted in thin, clear washes. Some artists prefer to sketch the main forms in lightly before beginning to paint, others will pour paint on and manipulate it into a scheme. In this, as in so much else, personal experiment will be needed. With practice, the artist will devise the most comfortable and successful process of working.

In pen and ink, still life might prove an interesting subject to interpret in coloured inks rather than simply black and white. Using washes of diluted inks alongside the lines can link up the various parts, especially if those parts are widely spread. Mixing media, perhaps even introducing collage (the application of cut paper to the picture surface) will introduce a fresh approach and suggest further developments.

Vincent Van Gogh,
'Chair and Pipe'.
The still life need
not include only
traditional elements
such as fruit,
flowers, or dishes.
Simple, everyday
objects can be the
subjects for a strong
and interesting
picture.

Oil

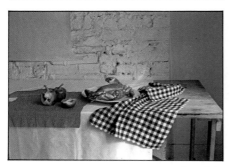

IT IS INTERESTING to note in this painting that although the subject is a 'portrait' of peppers and a crab, the theme of the painting is predominantly non-objective. In fact, it is not so much the crab and peppers which determine the strength of the picture but their surroundings which, through the use of color, shape and texture, draws the viewer's attention into the center of the painting.

The environment is made up of flat shapes and planes described in neutral and earth tones which contrast with the roundness of the peppers and crab. Within the wall there are soft, blended tones and strokes which heighten the distinct lines and tones in the subject. The busyness of the checks in the cloth create a visual interest and, again, draw the viewer's eye into the center of the painting while the red cloth creates tension and contrast with the peppers and the stark white background. Note that the red used in the cloth is of a value purposely chosen to avoid overwhelming the rest of the picture with its 'redness' or contrasting too sharply with the green of the peppers.

Materials

Surface
Stretched, primed canvas

Size
35in × 30in (87.5cm × 75cm)

Tools
2B pencil
No 2 sable oil brush
Nos 4, 6 flat bristle brushes
Masking tape

Colors
Black	Cadmium yellow
Burnt sienna	Chrome green
Burnt umber	White
Cadmium red	Yellow ochre

Medium
Turpentine

1. With a 2B pencil, lightly put in the shapes and general composition of the painting.

2. Mix white and black and with a No 6 brush block in flat areas of color. With a a No 4 brush and more white, rough in outlines and shadows in the brick wall.

Details · describing cloth · masking tape

Masking tape is put down over the dried surface; when the shape has been blocked in, the tape is gently pulled away leaving a clean edge.

With a small sable brush, the artist works carefully into the shapes using smooth, consistent strokes.

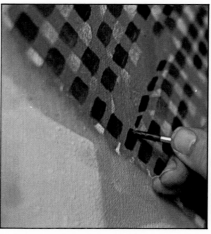

Working over shadow areas in the checked cloth, the artist blocks in squares of pure black with a small sable brush.

6. With black and white, mix shades of grey. Using the No 2 sable brush, paint in squares of cloth using the white of canvas for white squares and light grey for shadow.

7. Work back into the checked cloth with a darker grey and black to strengthen light and dark contrasts.

3. With a No 2 brush and burnt sienna begin to develop the crab. In cadmium red, begin to define the red cloth.

4. Mix chrome green and yellow and with the No 2 brush outline the peppers and put in light areas of color.

5. Mix umber, ochre, and white and block in the table with a No 6 brush. Add a touch of black to cadmium red and develop cloth shadows.

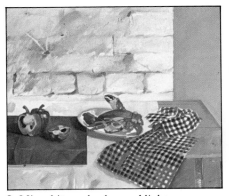

8. Mix white and ochre and lighten background bricks. Use the same grey tone as in the cloth to redefine brick outlines and shadows.

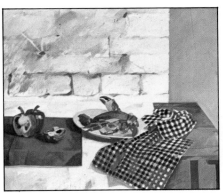

9. Mask the edge of the red cloth with tape and paint over this to create a clean, distinct edge.

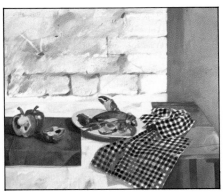

10. With the No 2 sable brush and burnt umber, put in horizontal lines in the table and strengthen the shadow area in the table leg.

137

ACRYLICS WERE USED for the underpainting of this picture as they dry much faster than oils and allow the artist to begin to work in oils almost immediately. Note, however, that this process cannot be reversed and oils should not be used as an underpainting for acrylics.

The artist first tinted the canvas with a thin wash of acrylic paint because it is easier to see subtle color tones – especially white – when working on a non-white surface. A purple underpainting was used as a complement to the warm yellows and ochres which, when the underpainting shows through, creates the greenish tone of the finished work.

The color mixtures in this painting are both subtle and sophisticated. While this requires a good sense of color, all were created from the basic colors included in every artist's palette. Unity was achieved throughout the painting by adding small touches of a complementary color to the paint mixtures, such as adding yellow ochre to a predominantly purple tone or cerulean blue to a predominantly orange tone.

Materials

Surface
Stretched and primed canvas

Size
36in × 30in (90cm × 75cm)

Tools
Nos 4, 6 flat bristle brushes
No 2 round sable watercolor brush
Masking tape
Plates or palette
Newspaper or absorbent paper

Acrylic and oil colors

Black	Cobalt blue
Burnt umber	Cobalt purple
Cadmium red medium	Pthalo crimson
Cadmium yellow medium	White
Cerulean blue	Yellow ochre

Mediums
Turpentine
Poppy seed oil
Water

It is important to note that the artist altered the subject halfway through the painting process by exchanging the black boxes and neutral material for a yellow box and green fabric. This was done largely for compositional and interest reasons. The still life artist should feel free to rearrange or alter the subject to suit the painting or drawing.

1. Using acrylic paint, mix a wash of cobalt blue and burnt umber and block in the main outlines and shadow areas with a No 6 bristle brush.

3. Mix black and cobalt blue and put in dark shapes with a No 4 brush. Mix cerulean blue, yellow and white and block in the background.

5. To the above mixture add a small amount of white and cerulean blue. With a No 4 brush begin to describe the highlight areas of the face.

7. Add burnt umber to this mixture and lay in shadow on table. Lighten with white and put in highlight in cloth. Mix cerulean, yellow and put in background.

2. Use thinned pthalo crimson to block in the turban and background. Add cobalt purple for bluish areas. Mix cadmium red and yellow and block in the face and table.

4. With cerulean blue and white, put in light shape on left with a No 6 brush. Mix cadmium red, yellow ochre, and white and block in the light areas beside the head.

6. Mix white, cobalt blue and a small touch of black oil paint and block in the table shape. Add more black to make a darker tone; yellow ochre for warmer areas.

8. Carry the same background tone into the left foreground with a thinner wash of color.

(continued overleaf)

Underpainting · blocking in

A. With a large brush and thinned acrylic paints, the artist blocks in general color areas scrubbing the paint well into the surface.

B. Once the acrylic underpainting has dried, broad areas of thick, opaque acrylic paint are blocked in.

9. Rework this entire area by painting over previous colors and shapes. Add black to greyish mixture and redefine box shapes with a No 4 brush.

10. Mix white, yellow ochre and a small amount of cerulean blue. With a No 2 sable brush, work in the face highlights with directional strokes.

11. With a thin mixture of permanent magenta and cobalt blue, darken the turban. Carry background color around cast to work around the head.

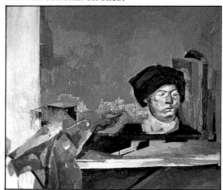

12. With the same brush and black paint, redraw the box shapes and outlines.

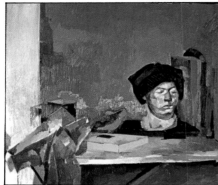

13. With cadmium yellow medium, put in box with a No 4 brush. Use masking tape to create a sharp, clean edge. Using the same yellow, blend into the table area.

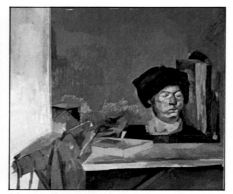

14. Using the background tone with cerulean blue added, block in cloth shape to left. Mix white and cerulean blue and apply to the left hand area in even strokes.

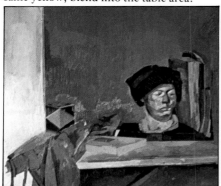

15. Mix yellow ochre, burnt umber and white and put in highlights of books to right of case with a No 4 brush. Use same tone for box at left.

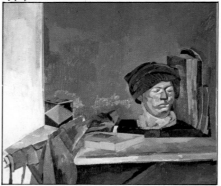

16. Add pthalo crimson to white mixture and put in warm tones of face and cloth with a No 2 sable brush.

Masking tape · blotting · highlights

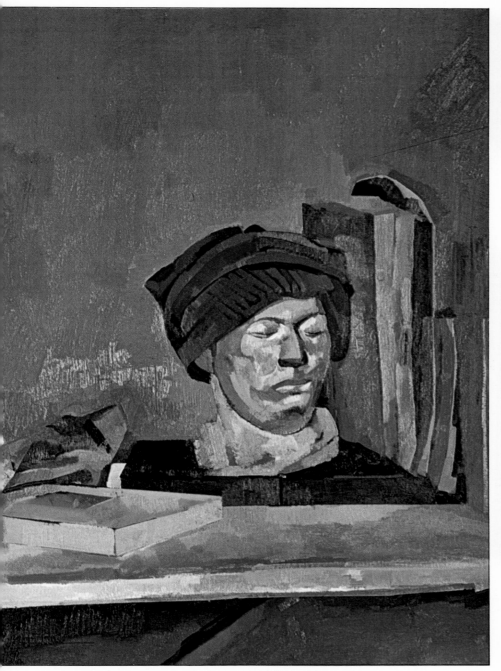

If the paint surface should become too wet to work on, a piece of newspaper can be laid over it, gently pressed with the hand, and slowly peeled off. This should not be attempted if the paint is very thick.

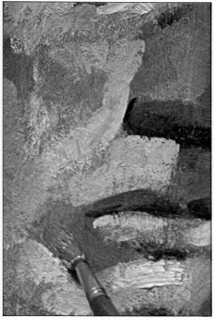

With a small sable brush the artist blocks in highlight and shadow areas in the cast. Note the use of the brushstroke to define structure.

Masking tape is a useful tool for creating clean, sharp lines and edges. Here the artist blocks in the box shapes over the tape. The tape is then carefully pulled off the surface.

A PREDOMINANTLY white painting will exercise all of the painter's skills. Preconceived ideas of the effects of color and light must be abandoned in favor of careful and thorough observation. This is thus an excellent way of training your eyes to see the many subtle tones and shades of color which exist in what is commonly believed to be a 'noncolor'.

One way of confronting the problem is to look at the subject in terms of warm and cool color areas. In this painting the white and grey tones are roughly divided between those created from the addition of blue – the cool tones – and those created by the addition of yellow – the warm tones. Until the middle steps of the painting, these warm and cool tones are exaggerated to allow the artist to correct or revise the tones as needed. In the last steps, the entire painting is gradually lightened to allow the subtle color variations to be revealed.

A wide range of marks are achieved by the confident handling of the bristle brushes. The artist has used both the tip and length of the brushes to vary the strokes and textures of the painting.

Materials

Surface
Prepared canvas board

Size
24in × 28in (70cm × 60cm)

Tools
Nos 3, 6 flat bristle brushes
Palette

Colors
Black
Chrome yellow
Cobalt blue
Raw umber
White

Medium
Turpentine

1. Mix a dark grey by adding a little blue to black and white. Thin the paint well with turpentine and sketch in the main areas of the composition with a No 6 brush.

3. Block in thin layers of paint to show the tonal changes across the image. Start to work over the drawing with thick patches of a lighter blue-grey.

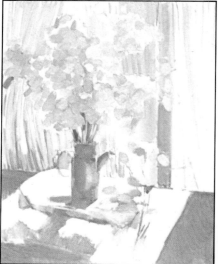

5. Extend the range of tones and build up the complexity of detail. Lighten the colors across the whole image with small dabs and strokes of thick paint.

2. Work over the drawing with the tip and flat of the brush, gradually increasing the detail. Aim for a loosely drawn impression of the whole subject.

4. With a range of warm and cool greys varied with blue and yellow mixtures, lay in shapes of solid color.

6. Use the tip of the No 3 brush to draw into the shapes, emphasizing the linear structure and delicacy of the colors.

Outlining · underpainting

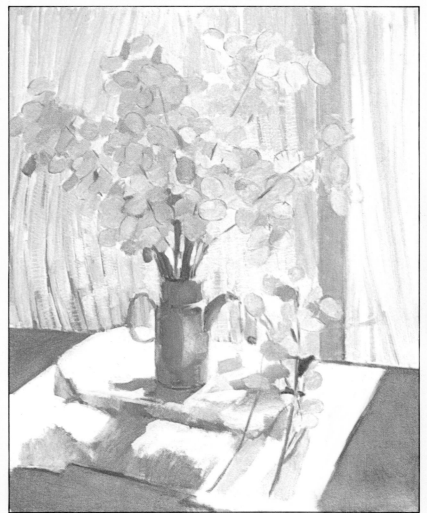

The thinned paint is rubbed into the surface – much like a charcoal drawing – to create a variety of tones. This underpainting will be used throughout the painting process to guide the artist in mixing the various shades and hues of white.

The artist is here using the tip of the brush and a very thin grey paint to draw in the basic shapes and composition of the picture.

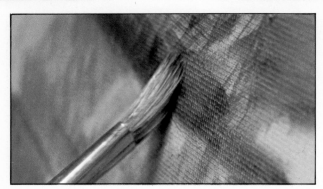

Acrylic

OF THE MANY media and mixed media available to the artist, a prime factor should be which media will most successfully capture the subject. If the painting illustrated were executed in watercolour or pastel rather than acrylic paint, the final effect would be much different. In this case, acrylics were chosen because of the bold colour scheme of the subject. Unlike other painting media, acrylics have an inherent brilliance and brightness which makes them particularly well suited for describing subjects which demand a bold use of color.

In this painting, the aim of the artist was to create a composition using the classical triangle with the wine bottle as a focal point. One of the demands of the still life is that the various objects be arranged in such a way as to avoid flatness in the painting. A mixture of different sizes, shapes, and textures ensures that the finished painting will successfully avoid this problem.

Materials

Surface
Stretched watercolor paper

Size
18in × 14in (45cm × 35cm)

Tools
HB pencil
No 6 flat bristle brush
Nos 2, 4, 6 sable watercolor brushes
Palette

Colors

Alizarin crimson	Hansa orange
Black	Hooker's green
Burnt sienna	Pthalo green
Burnt umber	Violet
Cadmium red medium	White
Cadmium yellow medium	Yellow ochre

Medium
Water

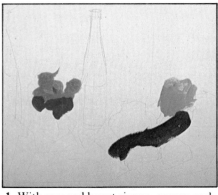

1. With raw and burnt sienna, orange and red, block in shapes in pure color using a No 6 bristle brush

5. Continue across the paper putting in the background. Add a small amount of yellow to the mixture to vary the tone of the green.

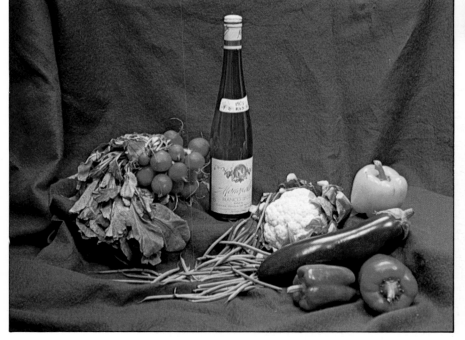

For this painting, the consistency of the paint was kept fairly thick and juicy. By adding a matt or gloss medium, the texture may be further altered.

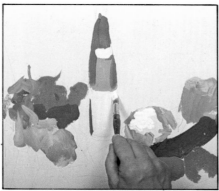

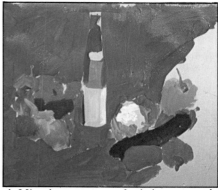

2. Describe green shapes with Hooker's and pthalo green with a No 6 watercolor brush. Vary tones by adding white.

3. Using the same brush and pure white paint, block in the pure white highlight areas of the bottle and cauliflower.

4. Mix a large amount of pthalo green and white and using the No 6 bristle brush, block in the entire background with consistent strokes.

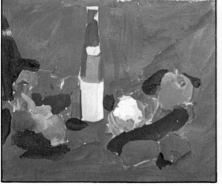

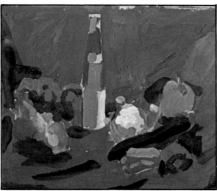

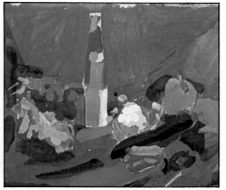

6. Using Hooker's green and a No 4 brush, block in the dark green shadow areas of the background, keeping the paint fairly wet.

7. Add a small amount of burnt sienna to the Hooker's green, and put in shadow areas of foreground.

8. Mix pthalo green and white and with the No 4 brush, describe light areas of the foreground cloth.

(continued overleaf)

Paint consistency · describing shapes · overpainting

The shape of the eggplant is initially described with broad strokes of light and dark tone.

Shapes of the objects are described with a thinnish mixture of paint and water.

Once the underpainting has dried thoroughly, a thick layer of paint is laid down.

145

Detailing and highlights

Highlights within
the bunch of
radishes are created
by using a strong
red.

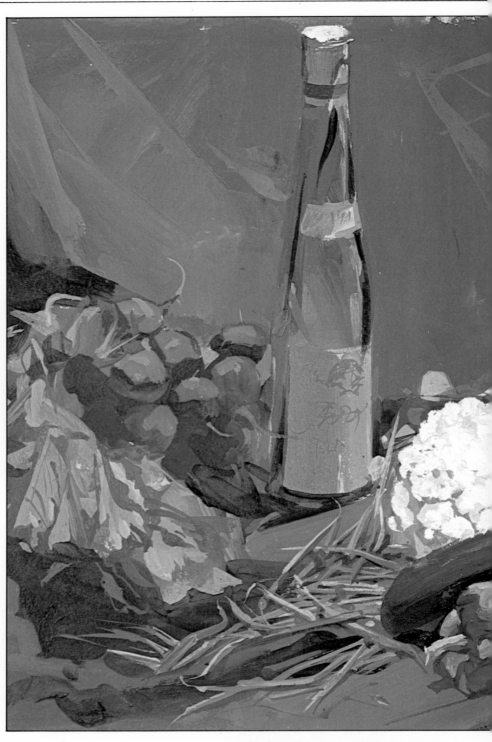

A juicy mixture of
white and yellow
ochre is used to
describe cauliflower
florets.

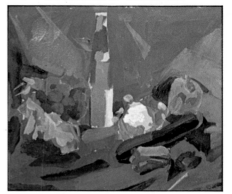

9. Carry this same light green tone into the background area.

Using a pale green tone similar to that in the background, the artist here puts in the finishing touches on the eggplant.

Highlights can be created by using pure white paint directly from the tube.

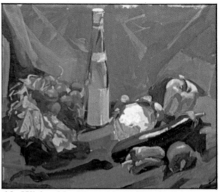

10. With a No 2 brush and Hooker's green, put in the dark shadow areas of the green vegetables. With the same brush and pure white, put in highlights.

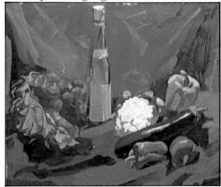

11. With pure white and the No 2 brush, block in cauliflower. Put in strong highlights in white in the bottle.

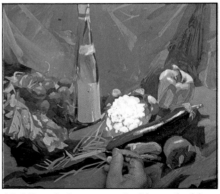

12. Mix pthalo green and white and with the same brush, put in the beans with fluid, even strokes.

147

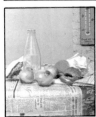

ALTHOUGH ACRYLIC paints were used for this painting, the method is an extremely old oil technique used by the masters for hundreds of years. Through sophisticated means of investigation, art historians have been able to cut through the hundreds of years of wear and tear inflicted upon these paintings, down to the original surface. In so doing, the actual progression of the painting has been revealed. The masters would first develop an extensive underpainting – sometimes as detailed and carefully rendered as the finished painting. The dark underpainting meant that the artist was required to work from dark to light, rather than vice versa. Layer upon layer of thin washes of color were put one upon the other, slowly building up a translucent and shimmering surface. This was a slow and painstaking process, made much more efficient by the introduction of acrylic paints in this century.

Using this traditional method, the artist has here worked on a tinted ground, painting from dark to light with very thin layers of color. The dark underpainting ensures a unity in the painting as it permeates all subsequent layers of paint giving an overall warmth.

Before beginning to paint, the artist carefully arranged the subject and then drew a comprehensive sketch of what the painting would consist of. This allowed him to complete the picture rapidly once begun, as all preliminary planning and decision-making had been finished beforehand.

Materials

Surface
Prepared canvas board

Size
16in × 20in (40cm × 50cm)

Tools
2B pencil
Nos 2, 4, 10 sable round oil brushes
Rags or tissues
Plates or palette

Colors
Black
Burnt umber
Cadmium yellow light
White
Yellow ochre

Medium
Water

1. After the underpainting has dried, sketch in the subject with a 2B pencil. Work over this with thin black paint and a No 2 brush.

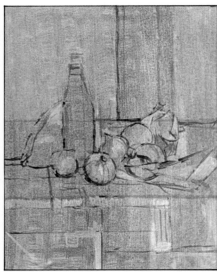

2. With a thin mixture of white and water, block in the lightest areas of the painting with a No 10 brush. Blend with a brush, finger, or rag.

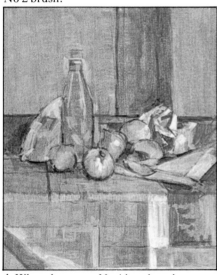

4. When dry, use a No 4 brush and pure white working over the entire surface, blocking in strong highlight areas.

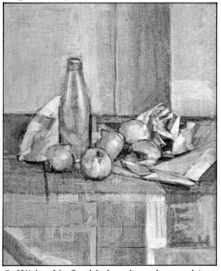

5. With a No 2 sable brush, redraw subject outlines in black thinned with water.

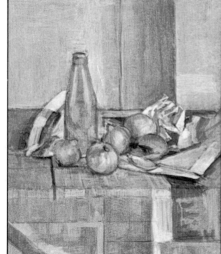

7. With a thinnish mixture of black and water, strengthen shadow areas around onions and table.

8. Apply a thin wash of white and yellow ochre over the foreground table area and background with a No 10 brush. Work well into the surface.

3. Darken the umber tone by adding more paint and start to put in the darkest areas of the painting working the paint well into the surface.

6. Mix white, cadmium yellow and water and with the No 2 brush put in the highlight areas of the onions. With pure white put in cloth highlights.

9. Mix white and black in a lightish tone and rework highlights and reflections in the bottle with a No 2 brush.

Washes of color · highlighting

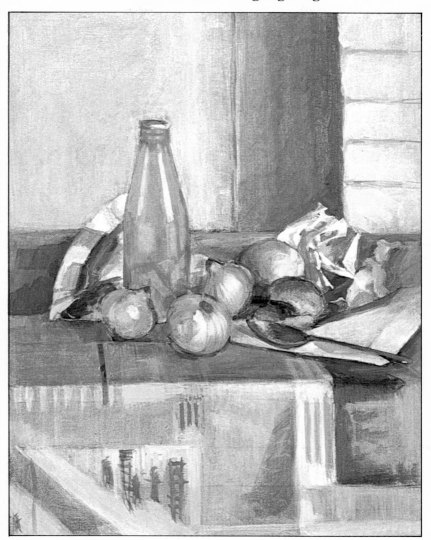

After the underpainting has dried thoroughly, the artist blocks in broad areas of white thinned with water.

With a thin wash of yellow ochre and water, the artist is here blocking in the yellow tone of the onions.

With a fine brush and white paint, the artist develops the texture of the paper beside the milk bottle.

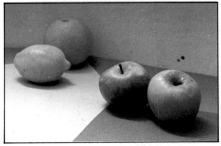

THIS STILL LIFE was deliberately arranged as a study of warm and cool color contrasts and is composed of simple, strong shapes. Each object has a predominant color 'temperature' to show fresh, cool color against a glowing hot tone. This mutually-enhancing use of complementary color is heightened by small touches of shadow which, again, are treated as color contrasts rather than dark tones.

As it is difficult to determine the effects of color relationships in advance, the artist must work by a continual process of adjustment, watching the development of the painting as carefully as he observes the subject.

The acrylic paint is applied thickly, layer upon layer. Overpaint in broad areas of color leaving small broken shapes of underpainting showing through. The overall effect will be lessened if the paint is too thin, so add only enough water to make it workable and use flat brushes to obtain an even, opaque surface.

Materials

Surface
Prepared canvas board

Size
16in × 14in (40cm × 35cm)

Tools
Nos 2, 3, 5 flat bristle brushes
No 6 flat synthetic brush
Plate or palette

Colors

Alizarin crimson	Chrome green
Black	Chrome orange
Cadmium lemon	Cobalt blue
Cadmium red	Ultramarine blue
Cadmium yellow	Violet

Medium
Water

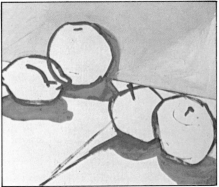

1. Outline the shapes of the fruit and paper in red with a bristle brush and lay in shadows. Work over the background with a light grey tone.

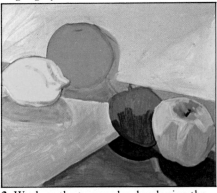

3. Work on the two apples developing the tonal structure to show the rounded forms. Darken the tone of the shadows with a strong blue-black.

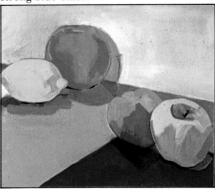

5. Exaggerate the colors to develop the interplay of complementary hues, showing shadows and highlights as bright, pure color.

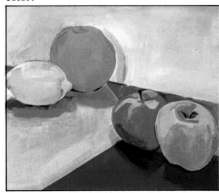

7. Treat the red apple with touches of blue shadow to show the contours. Lighten the tones of the green apple and the foreground and background colors.

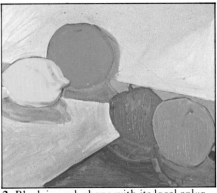

2. Block in each shape with its local color in a thick, flat layer and brush.

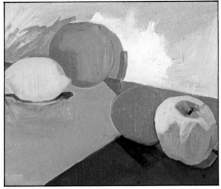

4. Put in red and green tones in the orange and build up the contrast of color over all the shapes. Lighten the blues and purples of the table top and the background tone.

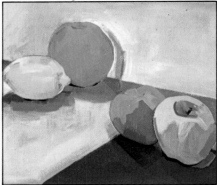

6. Work over the orange and lemon with flat areas of local color leavingg blue, green, and violet shadows to describe the rounded forms and the fall of light.

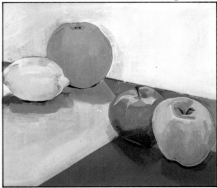

8. Add small details in the shapes and colors over the whole image, adjusting the contrasts and refining the outlines.

Outlining in red · background · blocking in shapes

The artist first describes outlines and shadow areas in a strong red tone. Red was chosen as a complement to the final colors used.

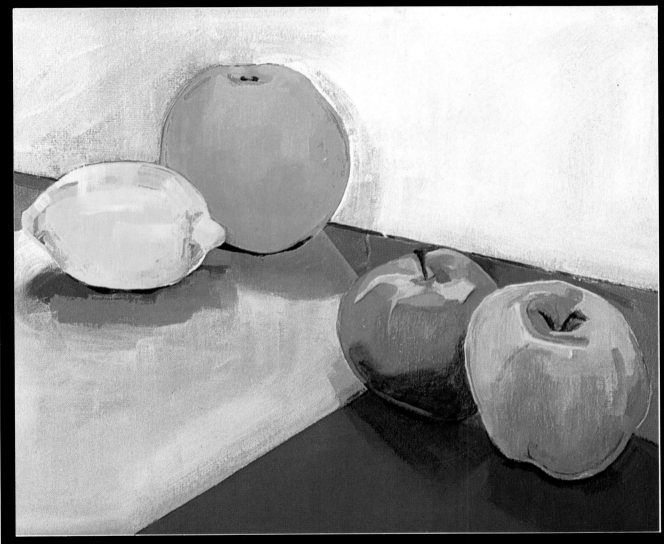

Working around the outlines of the fruit, the artist is here blocking in the background.

With a thick, well-mixed orange tone, the artist blocks in the main color areas.

Watercolor

THE STRUCTURE OF this painting depends upon the development of negative shapes, that is, the spaces between the objects rather than the objects themselves. The image is built up as a jigsaw pattern of small patches of color which are brought together in the final stages of the painting. This is a useful approach in any media; however, with watercolor, you must be precise from the start as it is too transparent to be heavily corrected.

The painting is small and loosely described and thus you will not need a large range of brushes or colors. Lay in broad washes of color with a loaded brush, letting the bristles spread; draw the hairs to a fine point to describe small shapes and linear details. The whole painting should be allowed to dry frequently so the layers of color stay clear and separate, building up gradually to their full intensity. Balance the contrast of warm and cool tones with the hot reds and yellows of the chairs standing out from the cooler tones of the green and blue background.

Dark patches of color can be lightened by gently rubbing over them with a clean, wet Q-tip, but try to keep corrections to a minimum or the surface may be damaged. When the image is completely dry, work over the shapes with colored pencils. This modifies the colors and adds a grainy texture to the flat washes.

Materials

Surface
Stretched cartridge paper

Size
14in × 11.5in (35cm × 29cm)

Tools
HB pencil
Nos 3, 6 round sable brushes

Colors
Burnt sienna	Ultramarine
Cadmium yellow medium	Violet
Emerald green	Yellow ochre
Prussian blue	

Medium
Water

1. Very lightly draw up the shapes with an HB pencil. Work into the background with washes of burnt sienna, Prussian blue, yellow ochre and violet with a No 6 brush.

2. Move across the painting laying in patches of thin color. Add emerald green and viridian to the range of colors.

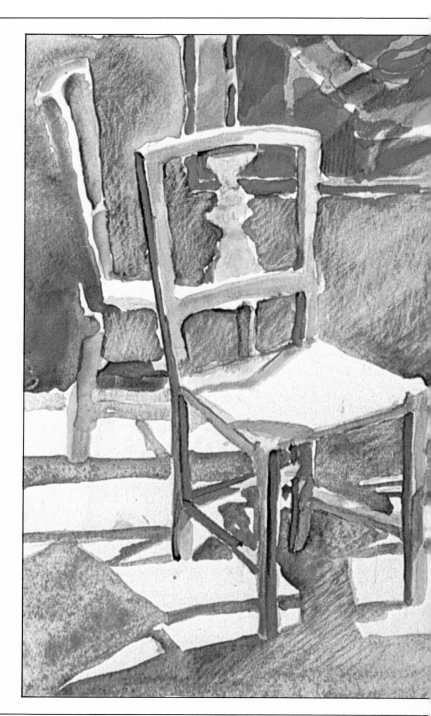

3. Develop color contrasts by working into the shape of the chairs with yellow, red and orange and intensifying the blue and green of the background.

4. Give the shadows on the chairs and floor depth with touches of blue and violet.

5. Draw into the shapes with the tip of the No 3 brush to clarify linear structure. Darken the background to heighten the outline of the chairs.

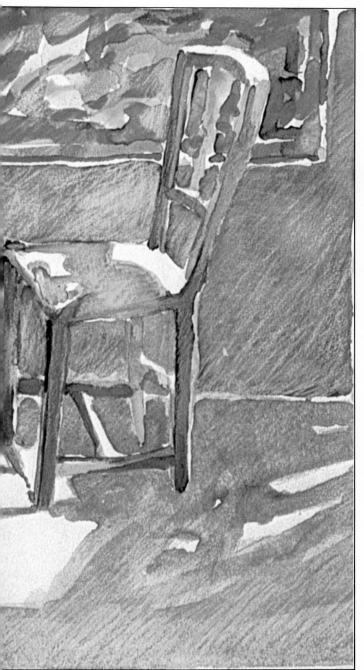

Describing shapes · colored pencils

Here the chair shapes are created by the artist by describing the space around the shapes and leaving the paper bare to describe the chairs.

After the painting is thoroughly dry, colored pencils are used to strengthen shadows and color tones. Do not press too hard as the paper will be fragile due to the paint layer.

THE FRESHNESS of watercolor depends upon the gradual building up from light to dark and any attempt to create highlights or pale tones in the final stages of the painting will alter the entire character of the medium. Accuracy is thus all-important in the initial structuring of the composition. White shapes must be precise and clean, created 'negatively' by careful drawing of surrounding color areas.

A light pencil sketch will help to establish the correct proportions, but complex shapes are outlined directly with a fine sable brush. Block in solid colors quickly or a hard line will appear around the edges of the shapes. Use large brushes to work into the foreground and background and lightly spatter paint dripped from the end of a large brush to create a mottled texture.

A limited range of color was used, mixing in black to create dark tones and varying greys with small touches of red and blue. Dry the painting frequently so that colors remain separate and the full range of tone and texture emerges through overlaid washes.

Materials

Surface
Stretched cartridge paper

Size
16in × 22.5in (40cm × 57cm)

Tools
Nos 2, 5 sable round watercolor brushes
No 12 ox-ear flat brush
1in (2.5cm) decorators' brush

Colors

Black	Payne's grey
Burnt sienna	Ultramarine
Burnt umber	Vermilion
Cobalt blue	Yellow ochre

Medium
Water

1. Draw the basic shapes of the objects in outline with a pencil. Mix a very thin wash of Payne's grey and block in the whole of the background.

2. Paint in the local colors of the objects building up the paint in thin layers and leaving white space to show highlights and small details. Keep each color separate.

3. Mix a light brown from red and black and work over the red, showing folds and creases in the fabric and dark shadows. Lay a wash of brown across foreground.

4. Work up shadows in the blue in the same way using a mixture of blue and black. Move over the whole painting putting in dark tones.

5. Strengthen all the colors, breaking up the shapes into small tonal areas. Bring out textural details by overlaying washes and spattering the paint lightly.

6. Intensify the dark brown in the foreground and use the same brown to indicate shadow on the wall behind. Vary the strength of the color.

Negative shapes · spattering

A good example of the use of negative shapes. Here the artist creates the white lines in the jacket by describing the red areas around them rather than by painting the lines.

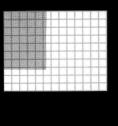

Spattering to create texture. Using a decorator's brush, the artist holds the brush above the paper and taps it lightly to create a tonal effect.

THE ARTIST can learn as much, if not more, from working with a limited palette and simple subject as he can from using many colors and a complicated subject.

This type of painting can be more difficult than painting on a large or complex scale as the artist is required to study carefully the subject in order to see minute variations in shape, tone, and color. You will discover that shadows are not merely areas of grey, but include very slight color differentiations and barely perceptible variations in tone. You will see how a simple piece of lettuce – which most people would describe as 'leafy green' – is in reality made up of many colors, tiny veins of light, and reflections.

An interesting experiment is to make the subject larger than real life. This type of work takes great concentration but the rewards are many. You will find that when you move on to more complex subjects, you will use what you have learned while working in detail on simple subjects.

Materials

Surface
Watercolor pad

Size
10in × 12in (25cm × 30cm)

Tools
No 2 sable watercolor brush
Plate or palette

Colors
Light red
Ultramarine blue
Viridian green
Yellow ochre

Medium
Water

1. Draw in the design with a No 2 sable brush and ultramarine blue.

2. Using just enough water to keep the paint flowing, develop a small area of the picture and then carry this color over to a new area.

Finished picture · outlining · working in new area

To finish off the picture (right), the artist laid a blue wash around the left side, running over and into the lettuce shape. This served to heighten blue tones within the lettuce and contrast with the red outside.

With a fine point sable brush, the artist begins by working over the preliminary pencil sketch with a thin wash of blue.

3. Using varying tones of yellow ochre, light red, viridian, and blue, work over the entire picture. Work back and forth between new and old areas.

4. Working into the outlined area with a wash of greens, develop a contrast between the lettuce and other leaves with different shades of green.

5. Strengthen outlines in blue and red. The red outline contrasts with the predominant blues and greens of the subject. Leave the white of the paper.

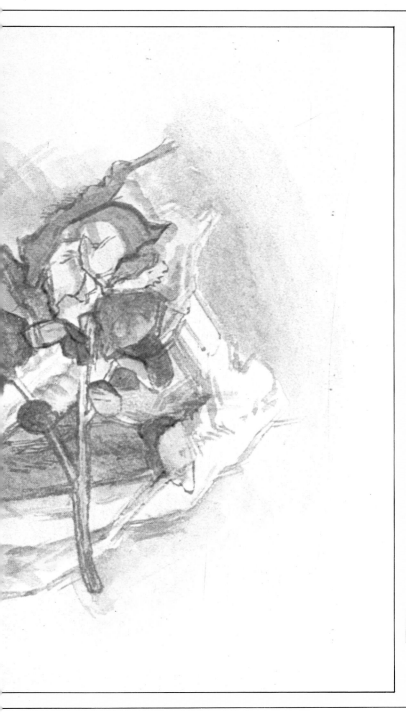

The artist worked in small areas, one at a time. Here the completed area can be seen and the artist is now describing the blue outline for the next area to be painted.

IT IS NOT always necessary to go to great lengths to assemble a still life as a small, ordinary object such as a teabag offers a complex structure and intricate range of tones and colors. As well, practice in quick watercolor studies develops keen perception and skills in drawing and painting which are a sound basis for work in any medium.

Here watercolor is used for a study which is essentially direct and immediate. The painting is rapidly completed, building up the form with a combination of line and thin washes of paint; the subject emerges through a careful interpretation of tiny shapes of color and tone.

In small paintings of this kind, the paint should be wet but not overly so, ensuring that the marks are easy and fluid but controlled. The final effect is achieved by constantly checking lines and shapes; working wash over line; and drawing back into the washes. A limited range of color is used to create a variety of tones, demonstrating the rich versatility and potential of watercolors.

Materials

Surface
Cartridge paper

Size
7in × 10in (17cm × 25cm)

Tools
No 2 round watercolor brush

Colors
Black	Prussian blue
Cobalt blue	Viridian
Light red	Yellow ochre

Medium
Water

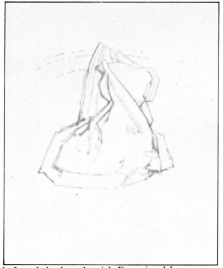

1. Load the brush with Prussian blue paint, well thinned with water. Draw the outline of the shape and details of the form with the point of the brush.

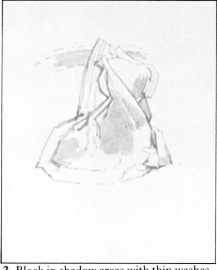

2. Block in shadow areas with thin washes of cobalt blue. The color should not be too too strong as this is the basis of a series of overlaid layers of paint.

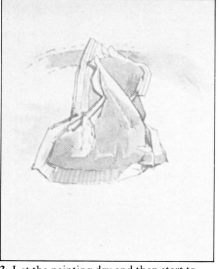

3. Let the painting dry and then start to define the shapes with washes of light red. Overlay red on blue to bring out the form.

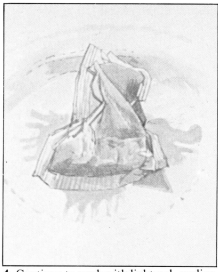

4. Continue to work with light red, cooling the tone where necessary with yellow ochre. Add definition to the shadows with blue washes in and around the outlines.

5. Draw into the washes of paint with a stronger tone of light red to describe creases in the surface. Indicate the shape of the plate with a light wash of viridian.

6. Where the color is too strong, lighten with a brush dipped in clean water. When the surface is dry, draw up the outlines again in blue with the point of the brush.

Initial washes · redefining outlines

After the initial outlines have been described, the artist begins to put in a very thin wash of color using the tip of the brush.

The blue outline is used over and over again in the painting process to strengthen shape and contrast.

Gouache

GOUACHE IS a water-based paint but thicker and more opaque than water-color. The colors are clear and bright; mixed with white they create sparkling pastel tints. Use thick paint straight from the tube to overlay strong colors, or thin it with water to flood in light washes.

At first glance this painting may appear to be carefully detailed and realistic but, as the steps show, the technique is fluid and informal. The first step, for example, is not a meticulous drawing but a mass of vivid, liquid pools of color suggesting basic forms. As the paint is laid on in layers of loose streaks and patches, the impression of solidity and texture gradually emerges. Each object is described by carefully studying the subject colors and translating these into the painting.

In general, the technique used for this painting was to thicken the paint slightly with each application; but thin washes are laid in the final stage to indicate textures and shadows. The combination of thin washes with flat, opaque patches of color is most effective in capturing the reflective surface of the bottle and glass.

Materials

Surface
Stretched cartridge paper

Size
12.5in × 17in (31cm × 45cm)

Tools
No 12 flat ox-ear brush
Nos 5, 8 round sable brushes
Plate or palette

Colors
Burnt umber Sap green
Cadmium yellow Yellow ochre
Magenta White

Medium
Water

1. With a No 8 sable brush lay in the basic shapes of the objects with thin, wet paint. Use burnt umber, sap green, magenta and yellow and let the color flow together.

2. With a No 5 brush, put in yellow ochre around the shapes and into the foreground. Work over the bottle and loaf of bread, painting in shadow details.

3. Indicate shadows in the background with a thin layer of green. Apply small patches of solid color to show form and surface texture in each object.

4. With a No 12 brush, block in small dabs and streaks of color, developing the tones and textures.

5. Intensify the contrast of light and dark with white highlights and brown shadows with the No 5 brush. Work into the background with white.

6. Work over the foreground and background with light tones of pink and yellow, keeping the paint thin. Spatter brown and black over the loaf.

Painting wet-in wet · overpainting dry surface · using paint from tube

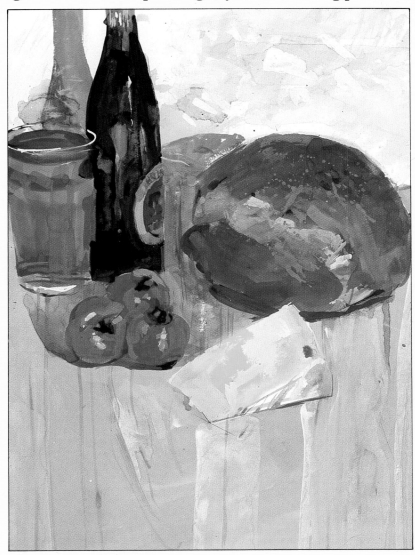

A. After dampening the paper in the shape of the object with water, the artist lays in a wash of color, allowing it to bleed over the damp area.

C. Using paint directly from the tube and a large brush well loaded with water, the background is blocked in.

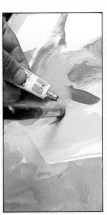

B. Over the dry underpainting, the artist here blocks in the label on the bottle with dryish paint.

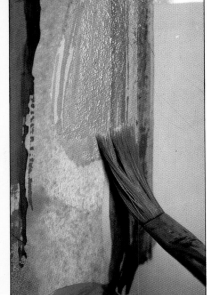

Tempera

WITH A small surface and tempera paints, the artist can create a finished painting in a very short period of time. While the medium can be used with virtually any sized surface or type of subject, it is particularly well suited to small working areas and finely detailed work. To create this picture, the artist worked on a small piece of hardboard, with the finished work resembling a miniature or enamelled tile.

The scratching-back technique can give a tempera painting textural interest. Although tempera dries to a sticky state fairly quickly, it remains workable for a short period of time. Scratching-back the surface with a sharp object to the original color of the paper or board and either leaving it or reglazing it will add luminosity and allow the artist to develop fine details. This process can be carried on almost indefinitely.

Pure, dry pigments can be very expensive, especially the inorganic colors such as the blues and reds, but it is worth acquiring some and experimenting with the true tempera technique. On the other hand, it is perfectly acceptable to use commercial watercolors in tubes and mix these with a yolk medium for a less expensive method of tempera painting.

Materials

Surface
Primed hardboard

Size
6in × 7.5in (15cm × 19cm)

Tools
HB pencil
Nos 2, 4 sable watercolor brushes
Knife or scalpel

Dry pigment colors
Black

Burnt umber	Cobalt blue
Cadmium green	Yellow ochre
Cadmium red	

Mediums
Egg yolk
Water

1. With fine sandpaper, sand a primed board until smooth. Put in the initial sketch with an HB pencil and sand again.

2. With a No 2 sable brush, mix egg yolk with yellow ochre and put in the skull with short, vertical strokes. Do the same in cadmium red for the flowers.

3. Mix cerulean blue and yolk and, with a No 4 brush, put in the background. Add a touch of black and put in the shadow areas of the table.

4. With more cerulean blue, block in the vase. Develop the shadows of the skull in burnt umber.

5. Mix black and cerulean blue in a darker tone and work back into the shadow areas with the No 2 brush.

6. With a sharp tool, scratch back the paint surface in the highlight areas, hatching with the point. Brush burrs of paint away with a rag or tissue.

Creating texture and tone

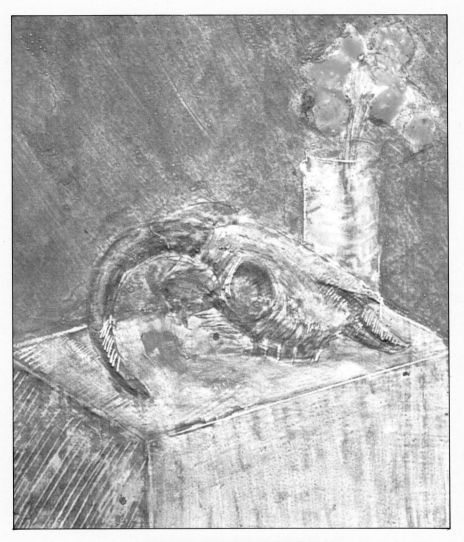

To create an interesting textural effect, the artist is here seen scratching through the paint layer with a sharp knife. Fine lines can be drawn through the paint and crosshatched to create texture and tone. The paint surface should be tacky, not dry.

Pastel

THE STILL life can be an excellent way for the artist to explore various media and experiment with different ways of seeing. The choice of objects and their arrangement is virtually infinite; the artist can pick and choose and arrange his subject to suit every need.

In this pastel, the artist chose to work with simple objects and a few bold colors. While this may at first seem the easier course to take – as opposed to complex subject matter and color schemes – to work with a few primary colors and a simple subject can often be a very difficult task. The main problem in working with bold colors is how to control their intensities so that one does not overpower the other. Although tones and hues may be altered and adjusted by blending, to retain the freshness and vibrancy of the individual colors demands that the artist carefully balance and weigh individual color areas. One way to ensure a balanced picture is to introduce a complementary color into a general color area. Thus in this picture there are small strokes of red within predominantly blue areas, and vice versa. This will also help to give the picture unity, as the observer's eye will pick up the individual colors as it moves around the picture.

Materials

Surface
Pastel paper

Size
18.5in × 26in (46cm × 65cm)

Tools
HB pencil or willow charcoal
Tissues or rags
Fixative

Colors
Blue-green	Pale blue
Cobalt blue	Pink
Red	Prussian blue
Green	Yellow
Orange	

After the initial areas of color have been laid down, the artist works back over these to strengthen tones.

Overlaying thin strokes of pure color will create an optical color mixture on the drawing surface.

1. After lightly sketching the subject in with pencil, use the side of the chalk to put in the main color areas in blue, green, and orange.

2. Using the end of the chalk, begin to work up stronger colors with sharp, directional strokes.

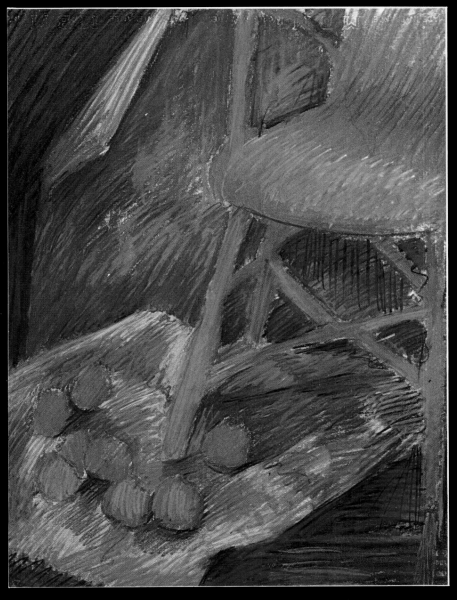

Finished picture · strengthening tones · mixing color · textures

The finished picture shows a skilful handling of strong primary colors to create a balanced and dynamic image. Compositionally, the use of forceful diagonals adds to the overall vitality of the picture.

The surface texture is clearly seen in this picture; dense areas of color are mixed with white gaps in the paper to create a gradated effect.

3. Begin to describe lights and darks in green areas by using various tones of green. Carry the red tone into the blue of the backdrop.

4. Intensify dark areas with dark green, Prussian blue, and dark red.

5. With pale blue, work into the foreground area as a highlight and tone down the background with the same color.

ARTISTS WHO experiment with oil pastels quickly grasp their potential for producing strong, brilliant pictures. They are an extremely flexible medium and can be used either like traditional chalk pastels in thin layers of color, or painted on to the surface by softening them with turpentine and applying them with a palette knife.

The picture shown here illustrates the intensity and brilliance characteristic of oil pastels in creating an interesting and dramatic picture. They are best suited to bold, colorful work, although it is just as possible to work with subtle overlays of color. There is a possibility of the surface being built up too quickly, but the artist can always scratch back into the pastel with a sharp tool to either clean up the surface or draw in fine lines of detail.

The composition of this drawing is particularly striking in its use of strong shapes, colors, and the clean white space of the paper. The lack of any additional background information in no way detracts from the forcefulness of the image and, if anything, causes the subject to stand out in bold relief.

Materials

Surface
Rough, heavyweight drawing paper

Size
21in × 23in (52cm × 57.5cm)

Tools
HB pencil

Colors

Black	Medium red
Dark blue	Pink
Green	Yellow

1. Lightly sketch in the subject with an HB pencil.

2. With a medium red pastel, work over the jacket outlines and block in red with light, broad strokes.

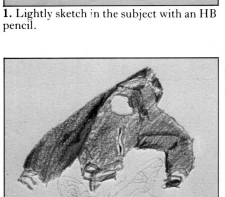

3. With dark blue, rough in the shadow areas with light strokes.

4. With a medium yellow, put in the trim on the jacket. With the same red as before, put in the red of the shoes. Do the same with a green pastel.

5. With medium yellow, block in the rest of the shoe color, pressing the pastel hard into the surface.

6. Work back into the jacket with the medium red, bearing hard against the surface. Rework the shadow areas with the same pressure.

7. Continue the previous step until the entire jacket area is covered.

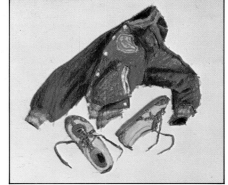

8. Work over the red in the jacket with deep blue, strengthening shadow areas. With a pink pastel, put in highlights in the jacket.

166

Color areas · developing the picture

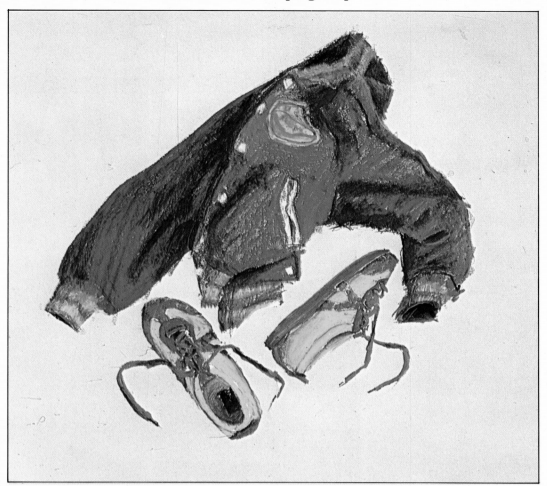

The artist begins by roughing in the basic color areas using a light, sweeping motion.

With each subsequent layer of color, the pastel is pressed more firmly on to the surface to fill the tiny white gaps in the paper grain.

A STILL LIFE need not consist only of the usual subjects such as fruits, glasses and drapery. It is possible to take very ordinary, everyday objects and interpret them in such a way as to create an interesting and stimulating image.

The picture shown here is a good example of the artist taking a subject and, through the use of exaggeration, innovation and careful observation, creating an individual interpretation of a basically commonplace object. The subject was chosen for its lack of color. On first glance, the viewer sees only tones of grey and white; however, on careful observation it becomes apparent that within these general color areas are myriads of subtle colors and tones. Very slight and subtle color variations were discovered within the subject which were emphasized and exaggerated, Thus, where the white of the tiles turns into a coolish blue, the artist described this in much stronger blues and purples; where the tone turns warmer and pinker, a strong orange or red are used.

This method of drawing – exaggerating what is seen – not only helps the artist understand color. It also trains the eye to look for hidden tones and subtle nuances of hue.

Materials

Surface
Blue pastel paper

Size
18.5in × 26in (46cm × 65cm)

Tools
HB pencil
Tissues or rags
Fixative

Colors
Blue-green	Light orange
Cadmium red	Light yellow
Cerulean blue	Orange
Cobalt blue	Pale blue
Light green	Prussian blue

1. After sketching in the subject roughly in pencil, use the side of the pastel to put in broad color areas of white, yellow, and cerulean blue.

2. Blend these areas with a small piece of tissue. With orange, overlay the warmer color areas. With red chalk, draw in the outlines of the tiles in the floor and wall.

3. Using pale blue and light green, begin to develop the cooler, shadow areas in the tiles. Carry red and orange tones over the rest of the picture.

Developing details

4. Lay in red, pink and orange over blue areas to create purplish tones. Begin to put in warm tile colors in yellow and orange.

Here the artist uses the end of a piece of red pastel to describe the red line above the tiles. A combination of such techniques – strong linear strokes and soft blending – add interest to the overall image.

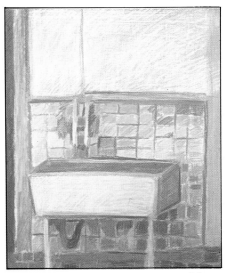

5. Put in pale green strip on right and in the tiles. Strengthen red and blue strips to the left.

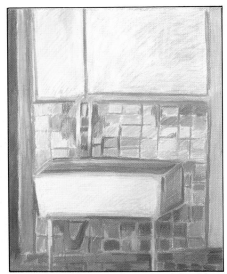

6. Overlay white area above the sink with light orange and yellow and blend with fingers or tissue.

Pencil

A STILL LIFE arrangement can be an excellent vehicle for the study of color, shape, and structure. The still life may take any form from the traditional subject of fruit and flowers to a jumble of objects randomly selected from whatever is at hand. Choose objects which offer an interesting pattern of forms; develop contrasts and harmonies in the range of colors and between geometric and irregular shapes.

The final effect of this drawing is created by successive overlaying of lines in different colors, woven together to create a range of subtle hues. Each layer is described by lightly hatching and crosshatching to gradually build up the overall effect. Blue and purple form rich, deep shadows in the yellows; a light layer of red over yellow warms up the basic color without overpowering its character.

Materials

__Surface__
Cartridge paper

__Size__
23in × 23in (57cm × 57cm)

__Tools__
HB pencil

__Colored pencils__

Black	Purple
Burnt sienna	Scarlet
Burnt umber	Ultramarine blue
Cobalt blue	Yellow
Grey	Yellow ochre

Finished picture · describing details · overlaying color

The finished picture (right) illustrates how colored pencil may be used to create a subtle, atmospheric image. The combination of soft tones with a strong composition create a balanced and interesting image.

Subtle color tones are created by overlaying light strokes of color. Here the artist works over a shadow area with a light yellow pencil.

Small detail areas are described with a dark pencil. This is sharpened to a fine point.

1. Lay in a block of light blue shading behind the hat, varying the direction of the pencil strokes. Use the same blue for shadows on and around the hat.

2. Strengthen and broaden the background color. Develop the shadows and pattern details of the hat. Draw in the shape of the boxes with yellow and red pencils.

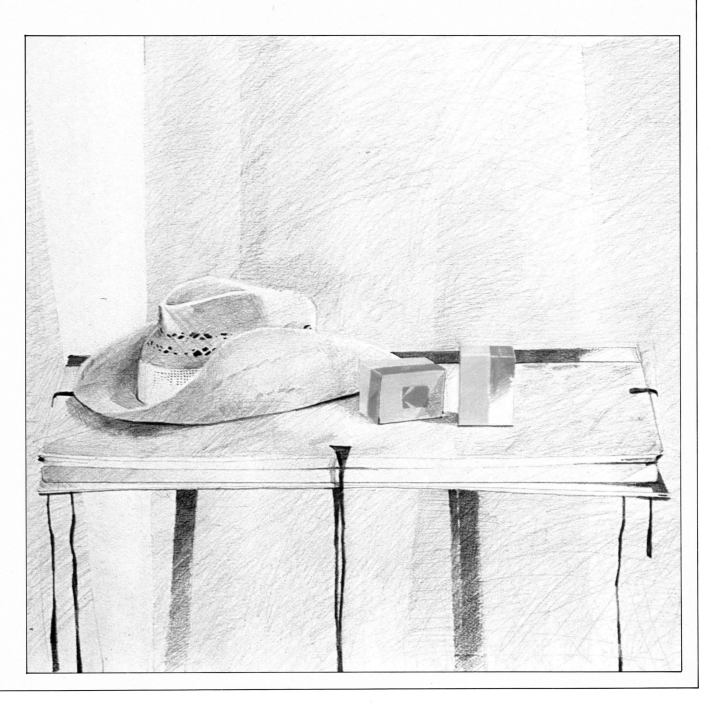

3. Build up the colors with contrasts of tone. Use purple in shadows under the hat, and darken blues to make the objects stand out from the background.

4. Outline the portfolio and sketchbook in black. Strengthen the bright colors against the neutral greys.

5. Lay in the rest of the background area in blue and vary the tones by heavily reworking. Build up details of line and tone with black and yellow ochre.

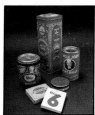

MANY OF THE products of graphic designers are the inspiration for still life paintings. There are any number of designs and patterns, bright colors and vivid images, all deliberately designed to be eye-catching, which the artist can exploit to create a stunning painting or drawing.

Any technique which aims to reproduce a detailed surface pattern demands patience and precision. Because the colors used in packaging tend to be intense and artificial, the bright colors of colored pencils are well suited to this type of subject matter.

The colors are solidly blocked in with heavy shading with patterns following curves, angles, and reflections of the objects. These factors all serve to modify the shapes and tones.

Because the image is complex, it is best to draw every detail first with an ordinary pencil. Graphite pencil is more easily erased than colored pencil, so all corrections can be made before the color is applied. Keep the outlines light, and follow them closely when blocking in the color.

Materials

Surface
Cartridge paper

Size
20in × 24in (50cm × 60cm)

Tools
HB pencil
Putty eraser

Colors

Black	Purple
Dark green	Scarlet
Emerald green	Yellow
Magenta	Yellow ochre

1. Draw up the still life in outline with an HB pencil. Work on each shape in detail to show the surface designs.

3. Continue to build up the color, working with solid shapes and heavy lines.

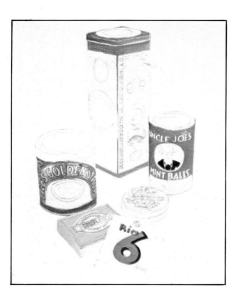

5. Gradually extend the color across the drawing. Describe the patterns exactly as they appear on each object.

2. Start to work into one shape in color. Thicken the outline of the lettering with a black pencil and shade in the colored patterns with green and yellow-brown.

4. Work over another shape with thick red, following the pencil outlines precisely and shading in all directions.

6. Draw into each shape in the drawing in turn, developing the color and completing the patterning.

Shadow areas

Using a sharpened pencil, the artist works back into color areas to create darker tones. The shape of the tins is largely created by this gradation of tone.

THIS PICTURE illustrates how willow charcoal, although a fragile medium, can create a very dramatic finished drawing. The drawing process was one of working up dark areas and then modifying them with a putty eraser to achieve a balance between light and shadow. There is a constant movement between the building up of dark areas, lightening them, and then working back into the shadow areas – and then repeating the entire process.

In all drawing media, and particularly with charcoal, it is to your advantage to experiment with the various textures and tones the medium is capable of producing. From a very fine, fluid line to a heavy and dense black, charcoal is flexible enough to fulfil every creative need. Because it is so easily erased, artists feel comfortable with willow charcoal. Where it can be difficult to lay down strong paint colours, with charcoal the artist can let his imagination run free without fear of spoiling a picture, as any mistake is easily corrected or altered.

Materials

Surface
Cartridge paper

Size
20in × 24in (50cm × 60cm)

Tools
Light and medium willow charcoal
Putty eraser
Tissues
Fixative

1. With the end of a piece of light charcoal, rough in the general shapes. Using the side of the stick, begin to block in the various shadow areas.

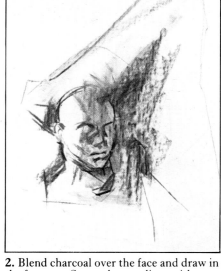

2. Blend charcoal over the face and draw in the features. Strengthen outlines with a heavy line.

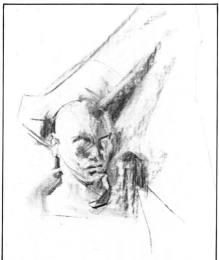

3. With a putty eraser, erase out highlight areas in cast and fabric.

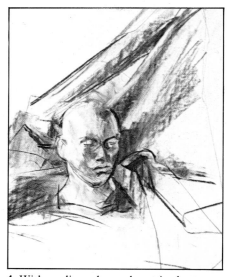

4. With medium charcoal, put in shape and shadows in the fabric and the area around the head. Draw in the outline of the fabric and the table.

5. Work back into the head using the side of a piece of light charcoal. Blend with a piece of rag or a finger.

6. Blend the background shadow. With the putty eraser, lighten all shadows by lightly drawing the eraser across the surface.

Finished picture · facial details · using a putty eraser

The attractive qualities of using willow charcoal are shown in the finished picture. By a skilful handling of tone and texture, the artist has produced an unusual still life. Note in particular the combination of different textures and shapes to add visual interest.

Here the artist puts in dark facial details using the tip of the charcoal.

By using a putty eraser, the artist can erase back through the charcoal layer to create highlights and subtle tones of grey.

Pen and ink

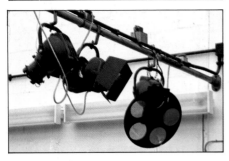

1. Sketch in the outline of the shapes with a pencil to establish the basic positions. Using this drawing as a guide, work with a thick-nibbed pen to define the main shapes.

2. Work boldly in line, drawing into the objects in more detail.

PEN AND INK is a bold, direct drawing medium and therefore demands a degree of confidence in its user. The drawing must be clearly defined through careful observation of the subject and strong interpretation on to the drawing surface. Describe the shapes and contours of each object and use surface detail only where it clarifies and adds texture to the form.

The composition can be sketched out lightly in pencil at the start to establish proportions and relationships of the objects. This should only be a light guideline since the aim is not to trace over the pencil drawing with ink, but to fulfil the medium's potential through direct drawing. Vary the line quality by using thick and thin nibs and so distinguish between solid, hard-edged objects and fine, linear details.

Any initial errors in the drawing can provide a structure on which to more boldly and accurately develop the image. Unwanted marks can be removed by painting over them with a thin layer of white gouache. When this is dry, the shapes can be redrawn in ink. The paint must be applied sparingly as the ink will not work over thick paint and the drawing loses vitality if corrections are too heavy.

Materials

Surface
Thick cartridge paper

Size
25in × 18in (62cm × 45cm)

Tools
Pen holder
Large, square nib
Small mapping pen
No 5 round sable brush

Colors
Black waterproof India ink
White designers' gouache

Medium
Water

With a fine nibbed pen, the artist works back over the initial pen sketch, darkening and broadening outlines.

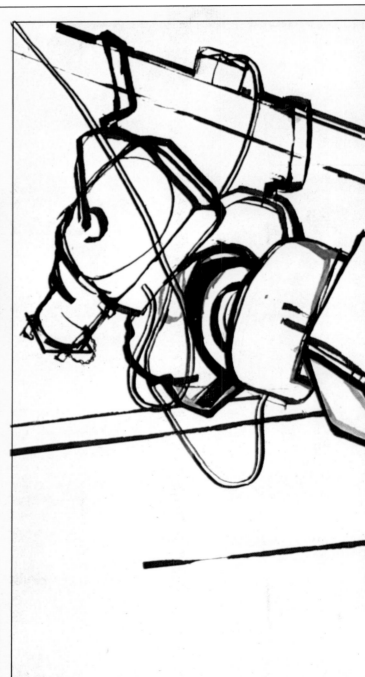

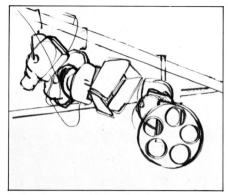

3. Continue to add detail and correct the basic shapes, building up a dense network of lines. Use a fine mapping pen to vary the texture.

4. Take out incorrect li[n]... them over with white gou[ache]... paint thin so that ink can [be]... later on during the drawing...

Rede[r]...

White designer's gouache is mixed with a small amount of water in a dish. With a small sable brush, the artist paints out unwanted lines of ink. Once thoroughly dry, the gouache can be worked over again with the pen.

m × 58cm)

lder
Small nib
No 2 sable brush
Palette

Ink colors
Black waterproof India ink
Burnt sienna
Red

Medium
Water

put in the outline, varying the
ving the pen both quickly and
p a brush in water and let the
bleed into that wet area.

2. Carry the outline further down using
red ink. Begin to create shadow textures
within the boot with the same red, applied
in directional strokes.

3. Mix a small amount of red and burnt
sienna and work into the other boot. With
pen and black ink, rework the outline of
the boot allowing the ink to run.

4. With mixture of red and black ink,
crosshatch in the remaining white area of
the right boot, leaving parts of the surface
untouched to create laces and holes.

5. Using the pen and black ink, work back
into the shoe with crosshatching strokes to
create the area around the laces.

6. Using the back of the pen dipped in the
black ink, roughly describe the sole of the
boots.

Finished picture · preliminary wash · back of pen · negative space and line

The artists completed the picture by laying a darker wash over shadow areas in the left shoe.

The preliminary wash is put in and will later be worked over with pen and ink.

Using negative space to describe shape, the artist uses a hatched tone to create a white area.

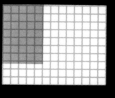

By turning the pen on its back, the artist is able to create a rough, jagged line.

ALTHOUGH THE rapidograph is used largely by the commercial artist, it has gained popularity with the fine artist as well.

As a drawing tool, the instrument has advantages and disadvantages. On the positive side, the artist need not constantly stop to dip the pen in ink, as the reservoir inside the rapidograph provides a constant source. The rapidograph line tends to be more consistent and even than the traditional pen and ink, and less apt to blot. On the negative side, the rapidograph can be finicky and temperamental. The pen must be kept in a near-upright position while drawing and frequently shaken to keep the ink flowing. The line produced is fine and descriptive, but the artist must first acquire a sensitive touch to obtain this effect.

While the drawing illustrated could have been produced with the traditional pen, ink and nib, only a rapidograph could achieve the smooth, consistent line work as seen in the seat of the chair.

The subject was modelled by the use of hatching and crosshatching many fine lines to give the impression of depth and contour. To create deep, dark shadows, the artist put layers of strokes one over the other. Note that where line was used within the coat, it was softened and blurred by the use of crosshatching.

Materials

Surface
Cartridge paper

Size
11in × 14.5in (27cm × 36cm)

Tools
Rapidograph
Medium nib pen
HB pencil

Colors
Black rapidograph ink

1. With an HB pencil, lightly sketch in the subject. Use a rapidograph and black ink to develop shadow tones with hatching and crosshatching.

3. With a light line, put in the shape of the chair seat. With light, loose strokes, hatch in tone of the chair seat, crosshatching to create the shadow area.

5. Put in the background shadow with broad, diagonal lines, crosshatching lightly to create darker tones.

2. Continue the outline downward using a light touch. Work into the line with hatching to create an impression of shadows and folds.

4. Develop darker areas with very fine hatching strokes. Strengthen dark outlines within the shadow areas.

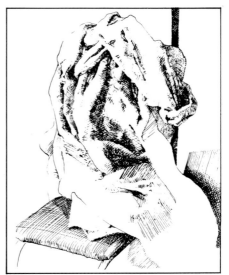

6. Continue to create background shadow area by crosshatching. Vary the direction of the line within these areas.

Creating tone

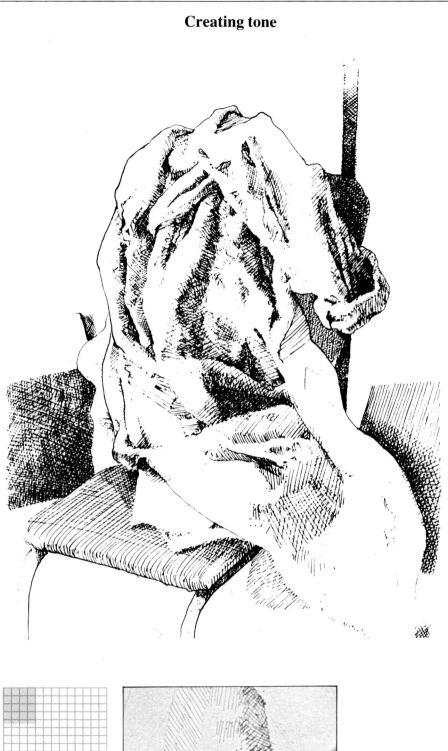

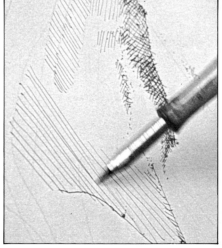

With a fine-nibbed pen, the artist blocks in light strokes of ink. These can either be left as they are to create a soft grey tone or worked over with diagonal crosshatching to create a denser shadow area.

Figure

THE IDEALIZATION OF man has long been a preoccupation of art as has the description of man's miseries: the Greek sculptors with their 'perfect form' or the agonies endured by Goya's subjects; Boucher's plump, seductive women, or the tense and anxious characters in a Giacometti. Nude or clothed, alone or in groups, the figure has always been a vehicle for expression, whether of tender compassion, or bitterness and anger. Every picture which includes the human form invariably carries within it a dimension beyond other types of art, a comment or reflection upon the character of the individual or on the condition of man. It need not be deliberate, indeed, it often is not, but it *is* inescapable. Man describing man always involves visual interpretation and this can be used to the artist's advantage.

The Egyptians used the human form as symbols in the religious and social organization of their society. For centuries there was virtually no change in these figurative symbols which were instantly recognizable and unmistakable. The concept of foreshortening, which assumes a knowledge of perspective, escaped these early artists. Thus limbs were de-scribed as if seen in profile so that legs and feet appear in side view, attached to a frontal view of the torso. Heads turn to show a profile because this is the most characteristic shape.

The differences between Egyptian and Greek art were the result of fundamental philosophical and political divisions. The great advance in the depiction of the human form came with the Renaissance, and particularly with the close study of human anatomy. Figures were to become used in a thousand ways for as many different reasons; religious themes remained for centuries but, in due time, more secular needs were also met. The 17th century painter Rubens was a master at rendering the fleshy nudes fashionable in his day and indeed he ran a workshop/studio which produced large scenes of classical and other subjects, with many a nude cavorting. The 19th century painter Fragonard dealt with the themes dear to the heart of the French courtiers – the shimmering world of high life at court. William Etty (1787–1849) was an English artist who painted virtually nothing but the figure, the fleshy surfaces of his nudes cunningly rendered. Into the 19th century the paintings of Courbet, magnificent in their compos-

<u>Proportions</u> The figures show a comparison of the male and female form, front and back. Comparative anatomy is an important aspect of all figure work, and by contrasting the male and female forms, a better understanding of each can be gained. Note the downward slope of the female shoulder, lower waistline and broader hips. The rear view shows the female to have a lower center of gravity than the male. All of these aspects influence the human body regardless of its size or position.

<u>Male and female</u> The human figure represented by a triangle. In the male, broad shoulders narrow to the hips. In the female, shoulders broaden to the hips.

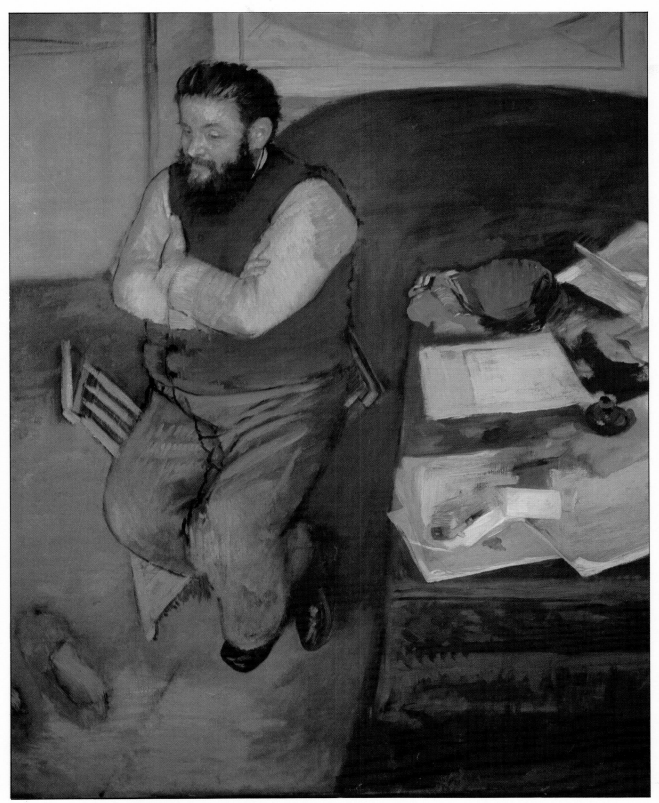

Edgar Degas, 'Portrait of Diego Martelli'. The placement of the figure in the picture plane is an important element in figure work. Note in this painting Degas' skilful balancing of the figure with other objects as well as areas of strong highlight and shadow.

Charles Keene, 'Artist Sketching'. Pen and ink has been a traditional favorite of the figure artist. Keene was a master at doing quick, informal sketches which nevertheless caught the full impact of the subject.

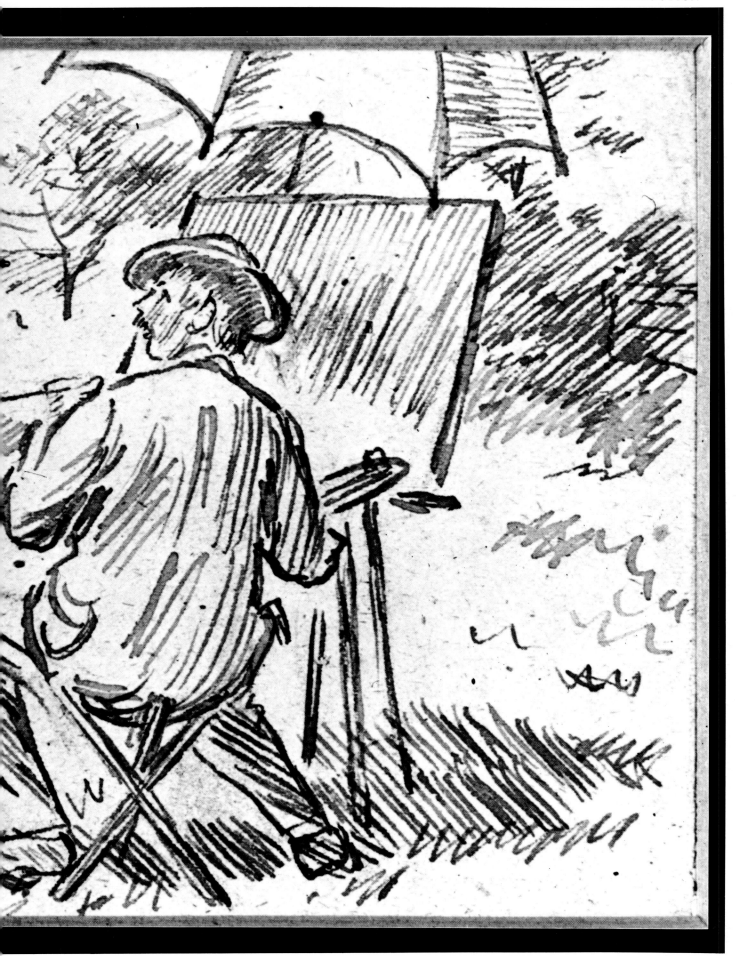

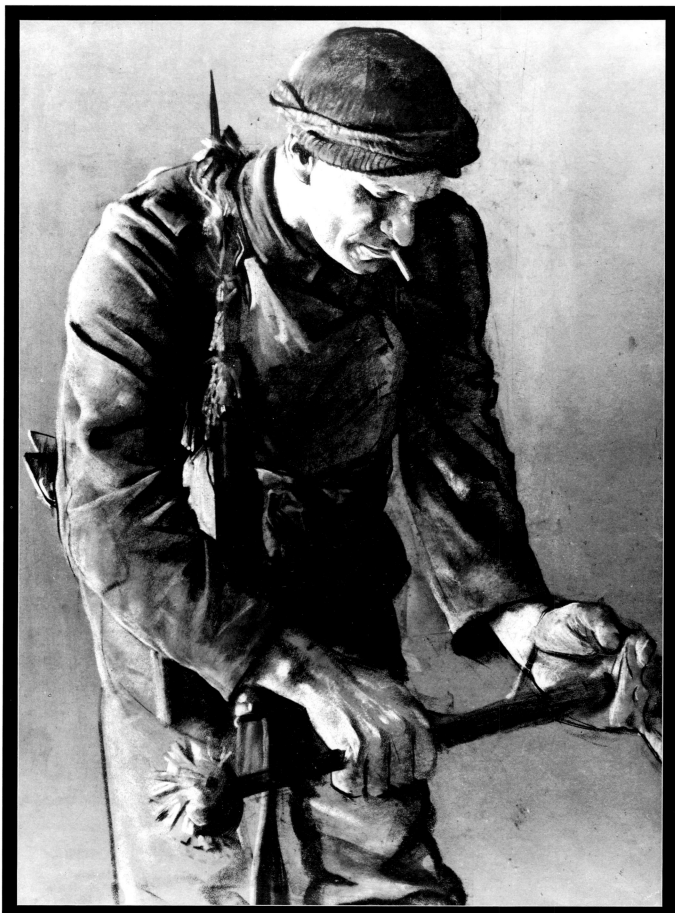

Edward Kennington, 'Raider with a Cosh'. Pastels allow the figure artist to employ a number of techniques which facilitate and enhance the drawing process. Note in this drawing the textures created by either rough strokes or smooth blending.

ition and structure, contain supreme examples of figure painting, as do those of Millet.

Painting and drawing the figure

The practical problems of figure painting and drawing are in some ways similar to those of portraiture, but include other aspects as well. When studying works in galleries, always look to find the individual ways used to relate the figures, both to each other and to the background. Consider how the feeling you have for the subject can best be expressed through color – stark and harsh, or of a languid, linear quality. Note the way Ingres used colour to inspire life into his pictures or the seductive flow in a Modigliani nude; observe the nudes in paint and pastel by Degas, with their energy and liveliness.

Make sure that in selecting subjects and ideas for compositions, you are convinced about the content, for example, whether it is contemporary or classical in theme. Nothing shows more clearly than the uncommitted idea, forced out of the artist and on to the canvas. Diebenkorn, a contemporary American artist, is a good example of a figure painter with a convincing ring to the content of his works.

The palettes recommended for portrait painting will also be found suitable for painting nudes, and the techniques of generalized underpainting brought to a finer focus via scumbling and glazing, for example, will prove useful in both cases. Our demonstrations show how these methods can be used, and experimenting with them in personal ways will prove invaluable. When using pencil, try varying both pencil quality and paper surface. A hard lead on medium textured paper will allow for a good range of marks, but remember that the scale of the work will alter the overall view. Pen and ink techniques abound. See how a simple, precise line or a hatched tone of black lines best relate the story you wish to tell. Smudging or applying washes to pen and ink figure drawings can increase the subtleties and allow for greater definition. Mixed media pictures involving single figures or groups of figures should be ventured; pencil will do some things that pen or paint cannot, and as well, the reverse holds true. As always, the best way of learning is through experimentation. There are few rules, and these should be approached only as guidelines.

15 years old

9 years old

1 year old

Age and size The human is measured in heads. As the body grows in height, the proportions change accordingly. Left: The child of 1 year is 4 heads high. Center: The 9 year old is 6 heads. Far left: the 15 year old is 7 heads high.

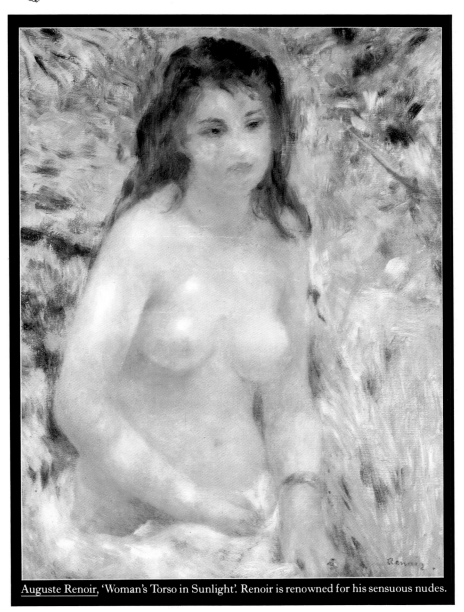

Auguste Renoir, 'Woman's Torso in Sunlight'. Renoir is renowned for his sensuous nudes.

Oil

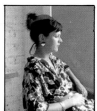

ONE OF the beauties of working in acrylics is that the artist can use them as a short-cut for the underpainting of oils without losing any of the brilliance of traditional oil underpainting. The artist can work quickly to block in general shapes and tones as a rough version to work from, or he can develop the underpainting to a nearly complete state and then finish off in oils. While at first glance this painting may seem to involve sophisticated color mixes and brushwork, most of the subtlety of tone and coloring is derived from the underpainting and the layering of thin washes of color one upon the other.

It is important to remember that the underpainting, whether executed in oil or acrylic, will have a strong effect on the finished picture. This is logical when you consider that the majority of drawings and paintings are done on white canvas to allow the pure, true brilliance of the color – regardless of media – to come through. No matter how thick, or opaque the paint mixture, the underpainting will affect the tones with subtle hints of color. The glass behind the figure is a good example of this, as nearly all the layers of color are in some way apparent in the finished picture.

Materials

Surface
Stretched and primed canvas

Size
27in × 30in (67cm × 75cm)

Tools
Nos 4, 6, and 10 flat bristle brushes
No 4 round sable brush
Palette

Colors
Acrylic:	Oils:
Cadmium red	Alizarin crimson
Cadmium yellow	Black
Hansa yellow	Cadmium red light
Mars black	Cadmium yellow
Pthalo green	Raw umber
Titanium white	Ultramarine blue
Ultramarine blue	White

Mediums
Water
Turpentine
Copal oil

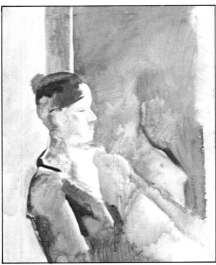

1. With acrylic colors cadmium red, pthalo green and hansa yellow, apply the underpainting in a wet wash with a No 10 brush. Lay in general shadows.

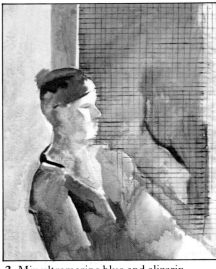

2. Mix ultramarine blue and alizarin crimson and with a sable brush and ruler, put in the grid on the door.

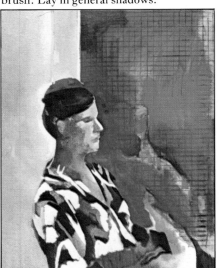

6. Mix white and blue and with a No 6 brush work into the background area. With white and burnt umber, put in the woodwork and window.

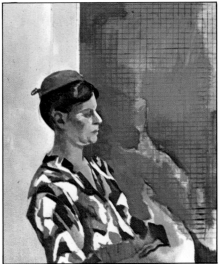

7. With a No 4 brush mix oil colours cadmium red, yellow and a little blue for flesh tones. Mix black and blue and block in the hair. Use red for flowers.

Drawing the grid · blocking in hair · details

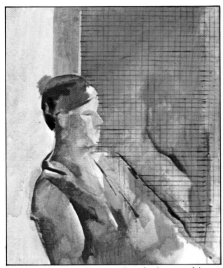

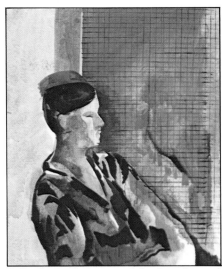

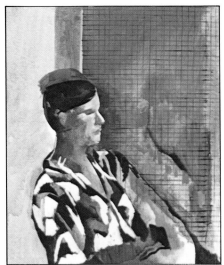

3. Mix hansa yellow and cadmium red in a wet wash and with the No 10 brush, cover door and flesh areas. Outline the figure with a small brush and burnt umber.

4. Put in the dark areas of the dress in a mixture of black and ultramarine blue. With an opaque orange, put in the reflections in the door and blend.

5. Mix a thin wash of orange and water and glaze over the face. With opaque white and a No 4 sable brush, block in the highlights in the face and blend lightly.

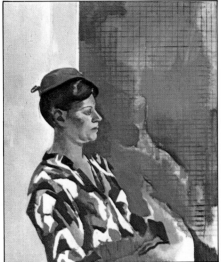

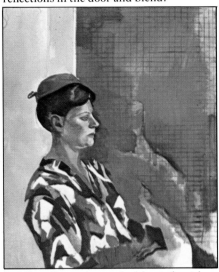

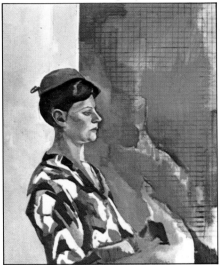

8. With a No 4 sable brush and pale blue, put in the hair highlights. Define the profile with burnt umber. Add touches of blue around the eyes for shadow areas.

9. Mix yellow ochre and white and put in warm highlight tones of the face. Blend a very light tone into the jawline. Add red and carry down the neck and chest.

10. Mix a pale tone from blue, white and umber and rub into the background. Heighten the reflection colors in the glass and blend. *(continued overleaf)*

After the underpainting has dried thoroughly, the grid on the door is drawn in using a ruler, fine pointed sable brush, and dark paint. Allowing the brush to drag across the rough canvas varies the tone of the line.

Working back into the cool underpainting of the face, the artist is here blocking in the hair and shadow areas with a thin wash of blue-black acrylic paint.

With a small brush and dark paint, the artist works over the dried underpainting indicating folds in the fabric and dress patterns.

Redefining grid · highlighting · refining profile

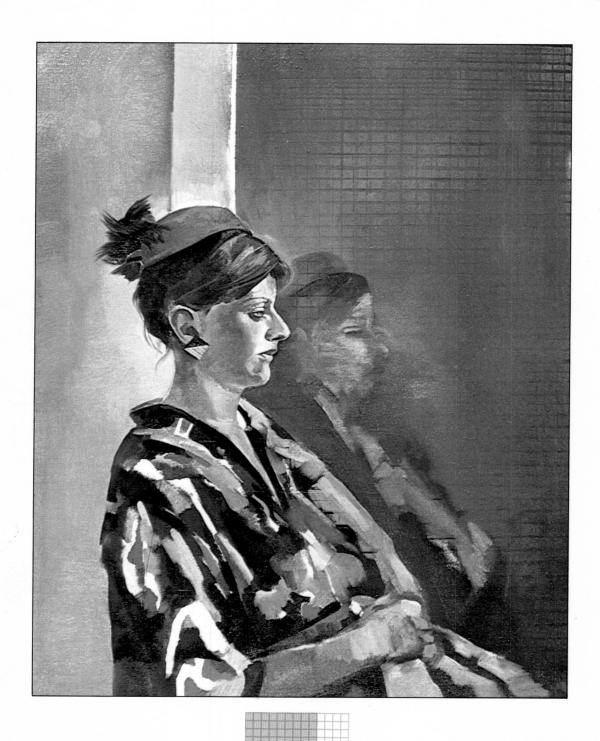

With a small
sable brush and a
light tone of grey,
the artist puts in
hair highlights using
light quick strokes.

The original lines
of the grid are
redefined mid-way
through the painting
process.

Again using the
small sable brush
and opaque black
paint, the profile of
the sitter is cleaned
up and further
strengthened.

11. With the No 4 sable brush and a blue-
black paint mixture, redefine the grid in
the door with the ruler. Mix orange and
water and glaze over the face.

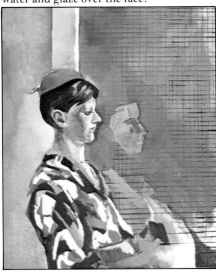

13. With the same flesh tone, add a touch
of green and lightly describe reflections in
the mirror. Mix white, black, and blue and
work over the light area behind the figure.

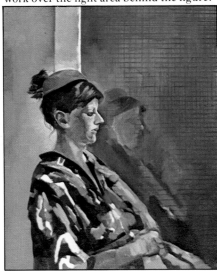

15. Put in the reflection of the hat with
cadmium red. With white and yellow
ochre, put in arm highlights

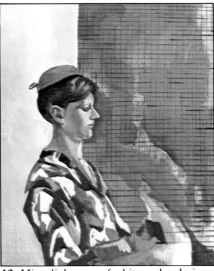

12. Mix a light tone of white and cadmium
red and work back into the face,
strengthening highlights with a small
brush.

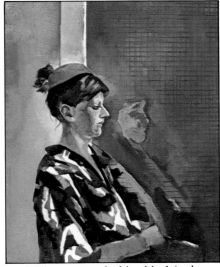

14. With orange and white, block in the
arm. Work back into the reflections
heightening light areas. Then, with black
and blue, strengthen reflections

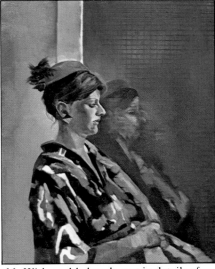

16. With a sable brush, put in details of
hair and feather in hat. Strengthen
highlight reflections in mirror with white
and orange mixture.

IN THIS painting the artist has let his imagination determine the techniques used. Rather than simply copying what was in front of him, elements of the subject have been used to create an interesting and atmospheric picture. While the artist used the subject largely for the preliminary stages of the painting, there was constant reference made to the model in the course of the work. Although the colors chosen are different from the actual subject, the artist used the general tones, highlights, and shadow areas within the model as reference and inspiration.

The painting was begun using the traditional technique of spreading a thin wash of color and turpentine over the surface to determine general tones and overall composition. It is interesting to note that the artist used brushes only for small areas of detail; the main body of the painting was executed with various shaped and sized palette knives. These allow a thick, opaque, juicy mixture of paint to be laid down and are especially useful for covering large areas. While it is difficult to render fine details with palette knives, the texture they create plus the broad planes of color can add a new dimension to an otherwise traditional technique.

Materials

Surface
Linen canvas, stretched and primed

Size
24in × 30in (60cm × 75cm)

Tools
Nos 4 and 8 flat bristle brushes
Assorted palette knives
Palette

Colors
Black	Gold ochre
Cadmium red medium	Lead white
Cerulean blue	Terre verte
Cobalt blue	Yellow ochre

Mediums
Turpentine
Linseed oil

1. With a No 8 brush, block in color areas with cerulean blue and light grey in a thin wash. Draw in the subject in pencil and blend colors with a small rag.

2. Use willow charcoal to reinforce outlines. Add more cerulean blue to color areas and blend. Put down charcoal and blend with turpentine and rag.

3. Mix cerulean blue and white and with a small palette knife lay in the figure and bed. Mix white, cerulean blue and black and describe the background and floor.

4. Add terre verte and block in the floor with a palette knife covering the surface. Work back into the walls, covering them thoroughly with the knife.

5. With pure white, brush in the figure and bed with a No 4 brush, covering the previous blue layer.

6. With a small palette knife, blend the rug out of the floor area. Lay in shadow areas with a darker floor tone and brush.

Finished picture · blocking in color · using palette knife · background area

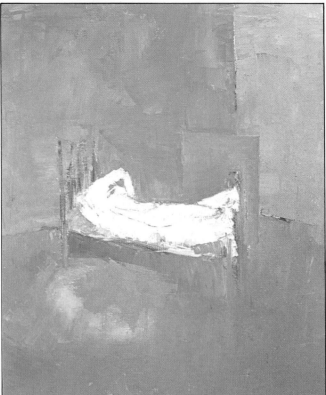

The finished picture shows an interesting and innovative use of composition and technique. In particular this painting illustrates how a non-traditional approach to figure painting can yield interesting results.

After the initial sketch has been described in charcoal, the artist begins to block in broad areas of color. The paint is allowed to bleed into the charcoal drawing. If this is not desirable, first dust the drawing lightly with a rag.

Using a Mahl stick and thin palette knife, the artist is here shown developing the background area.

With a broad palette knife and a rich paint mixture, the artist puts in a layer of grey to describe the floor area.

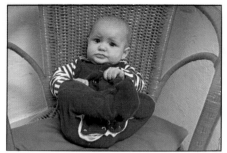

FIGURE PAINTING is a highly individual process. There must be rapport between artist and sitter, or the painting will fail to capture the characteristics of both. It is important to remember that, while the artist is attempting to capture a superficial likeness, he is also trying to portray the essence, or personality, of the sitter as well. These aspects of portraiture should always determine the techniques used.

In this painting the artist has relied more on instinct than analysis and planning. This method requires self-confidence; it is not easy to boldly lay in free strokes without some anxiety over the outcome. With oil, however, if the artist lays down the wrong colour or shape, this can be easily scraped away and worked over.

The composition of this work is one of its outstanding features. The boldness of the colors and strokes and the oddly shaped chair arms serve to subtly emphasize the smallness of the figure without overpowering it and draw the eye inward.

By changing the background from white to taupe the artist has allowed the highlights and features of the child's face to come forward. The loose, white stroke at the bottom of the child's feet is repeated in the sleeves, and the odd shape emphasizes the natural liveliness of the subject.

Materials

Surface
Stretched and primed canvas

Size
18in × 20in (45cm × 50cm)

Tools
Nos 4 and 6 bristle brushes
No 2 sable brush
Palette

Colors

Burnt sienna	New blue
Cadmium green	Scarlet lake
Cadmium red deep	White
Chrome green	Yellow ochre

Mediums
Turpentine
Linseed oil

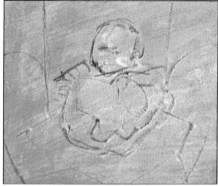

1. Mix burnt sienna and turpentine and with a small rag, rub into the surface. Dip a small No 2 sable brush in blue for outlines of figure and background.

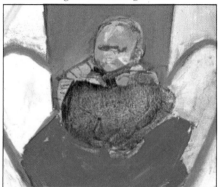

3. Using cadmium green, block in chair seat with a No 6 brush. Put in arms of chair in red with a No 4 brush. Block in white background and blend.

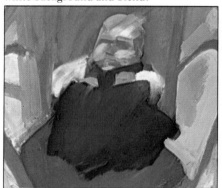

5. With the same colour used for the face, put in the shadow of the chair. Mix white with cadmium red and put in chair highlights and blend with brush or rag.

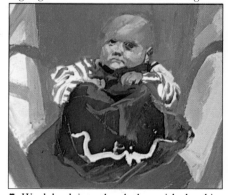

7. Work back into the clothes with the skin tone, indicating highlights. Add touches of red to the face and details in a greenish tone with a small brush.

2. With a No 4 bristle brush, block in the background with a thin wash of cadmium red. Thin blue and put in clothes. Use red and ochre for face.

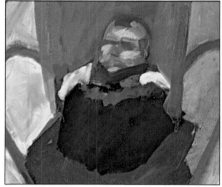

4. Block in blue clothes in ultramarine. Use same white as for background to describe the arms. Rework the face with a mixture of ochre, white, and cadmium red.

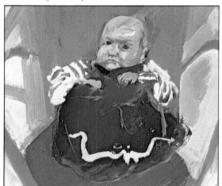

6. With a very loose stroke, put in white pattern at bottom of figure. With another brush, put in sleeve details with ultramarine blue and define features.

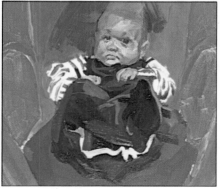

8. Mix burnt sienna, white, and red and cover the background. Use the same color in the face to strengthen shadow areas.

Finished picture · chair arms · facial details · blending with fingers

Besides employing a unique painting technique, the finished painting shows how much an interesting composition can add to any image. Especially in pictures of this type where the goal is to draw the viewer's eyes into the subject, attention should be paid to the placement of the figure.

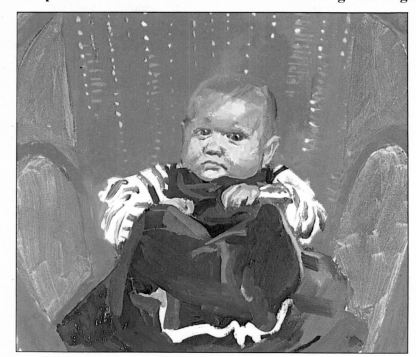

Fingers are often useful tools for creating an interesting texture and stroke. After applying paint directly from the tube the artist here smooths out the color with a finger.

With a fine sable brush, the artist works back into the face to describe details. If the paint surface is still wet, these small lines of color can then be blended with a clean, dry brush.

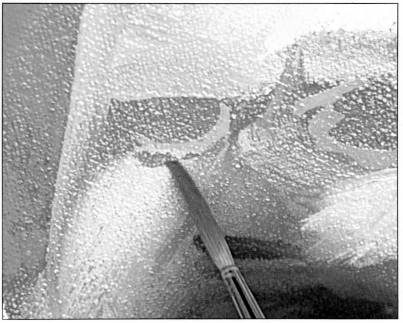

Working over the dry underpainting, the artist blocks in the arms of the chair beside the child's right elbow.

195

THE TECHNIQUE USED in this painting is a unique one which combines a number of extremely old painting methods. Fresco, tempera, and miniature painting techniques are all used, the results showing the inherent beauty of all of them. The basic technique is known as 'wet white'.

Because the artist must work in concentrated areas of detail – much like doing a needlepoint – this technique requires patience and a steady hand. It is a slow process and only very small areas can be covered at a time – thus its similarity to Renaissance fresco painting where only one area of a wall was worked on in the course of a day. The artist first mixes flake white and copal varnish, and applies a small amount to the surface. With a very fine sable brush and a touch of oil color thinned with turpentine, he then stipples a small area of color on to the white. The white/varnish mixture has the effect of bringing forth a jewel-like quality in the paint, which lends translucence and depth to the overall effect.

Until the paint dries, the area worked on is flexible and movable. It can be altered, corrected or worked on until the paint dries – approximately a day. If the artist is dissatisfied with the results, he can overpaint, but this must be done while the paint is wet.

Materials

Surface
Primed hardboard

Size
12in (30cm) diameter

Tools
Nos 2 and 4 sable brushes
Palette or plate

Colors
Alizarin crimson Cerulean blue
Cadmium green Cobalt blue
Cadmium red Flake white
Cadmium yellow

Mediums
Copal oil varnish
Turpentine

Finished picture
overpainting with white · pure color strokes · brushstrokes

The special technique used to create this picture is best understood through the use of close-up shots of the work. For this reason, the picture has not been presented in steps.

A thin layer of flake white and copal varnish are laid down over the transferred drawing. While still wet, using a fine sable brush and ultramarine blue, the artist stipples in dots of paint, following the pencil outline.

Rather than mixing colors separately on a palette, this technique involves creating colors and tones directly on the surface by overlaying thin strokes of pure color.

This detail shows the particular brushstrokes required when using the 'wet white' technique. Note in particular the small touches of complementary color applied with small, light touches over the green underpainting to create depth.

PRECISION AND METHOD are the keywords for the technique used in this painting. Each area is painted in some detail so that the whole image gradually emerges piece by piece. At each new stage, the previous work is adjusted to ensure that the color and tonal relationships of the whole image are balanced

The range of color is limited and the palette consists primarily of earth colors. Cool grey shadows contrast with warm tones within the figure and these warm tones are enlivened by touches of vermilion. The dark greys in the chair and background wall are mixed from black and white, with the addition of ultramarine.

Use masking tape to establish clean outlines. Lay broad strips along the straight lines and define curves with narrow tape which can be manipulated into irregular shapes. Rub down the edges of the tape firmly before you paint over it and lay in areas of flat colour with large bristle brushes. Pull off the tape slowly and carefully to leave a clean, sharp edge.

1. Lightly outline the composition with an HB pencil. With a No 8 sable brush, work into the face and hair with black and mixtures of sienna, vermilion, and white.

2. With a No 7 brush, block in flesh tones over the forehead and black and burnt umber in the hair. Work on details around eyes and nose with light browns.

6. Paint in the dark shadows on the chair with a mixture of burnt umber and black. Mask off the lines of the floor and chair legs with tape and block in dark brown.

7. Develop the background using masking tape to make straight lines. Fill in the shapes with yellow ochre and a dark red-brown directly behind the figure.

Materials

Surface
Stretched and primed cotton duck

Size
39in × 30in (98 cm × 76cm)

Tools
HB Pencil
No 8 round sable brush
Nos 3, 7 flat bristle brush
Palette
1in (2.5cm), ¼in (.62cm) masking tape

Colors
Black	Vermilion
Burnt sienna	White
Burnt umber	Yellow ochre
Raw umber	

Medium
Turpentine

Masking tape · background · face and chair details

Masking tape can be useful for creating sharp, clean edges (below). When working with irregular shapes, use a narrow tape which can be manipulated into curves.

With a small brush, the artist blocks in the background area around the figure.

3. Build up the shape of the face with light pink tones and brown shadows, blending the colors together. Emphasize the mouth and nose with vermilion and white.

4. Work over the body putting in lines of shadow with burnt umber and blending flesh tones into the shapes. Draw up the hands and block in solid color.

5. Use a No 7 bristle brush to lay in broad areas of tone in the legs. Adjust colors over the entire figure and add strong white highlights.

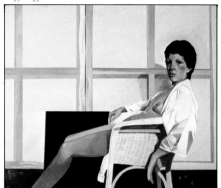

8. Work over the rest of the background with a warm, pale beige, thinly shadowed with grey. Paint a thick layer of light grey over the chair and wall to right.

9. Work back over the head of the figure with a No 3 brush. Lay in a thin grey shape behind the model to depict shadow.

10. Brush in folds and creases on the jacket in black and blend with thick white paint to make mid-toned greys. Build up the woven pattern of the chair in white.

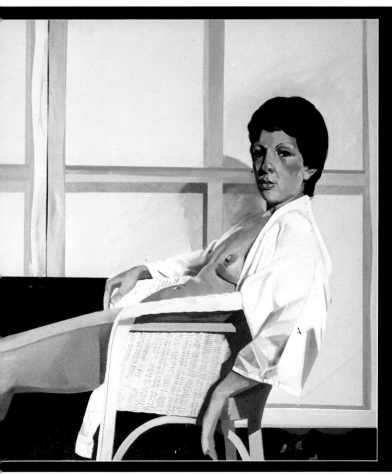

With a fine sable brush, the artist begins to develop small areas of detail around the eyes.

Once the surface is thoroughly dry, the artist returns to put in the fine weave of the chair with a small pointed sable brush and pure white paint.

WHILE MOST of the activity in this painting centers around the figure and the chair as the central objects, the surrounding area also plays a crucial part in the success of the work as a whole.

By following through the steps, the method used by the artist becomes clear. Whether working on shadow areas or highlights, figure or background, blending and softening or defining and accentuating, the painting evolves through the constant and deliberate interplay of colors between figure and background. In looking carefully at the finished painting, you will see that all the colors used in the background are also contained in the figure. The broad planes of color describing floor and walls all move toward the figure, where they are concentrated, emphasized and modulated. The artist worked over the entire surface simultaneously; the figure was never altered without changing the environment, and vice versa.

The geometric shapes of the background – the strong verticals, horizontals and diagonals – emphasize the softness of the figure as a soft, malleable feature in a world of planes and edges. The warm tones in the figure and chair serve to separate it from its environment, which is predominantly cool and impersonal.

Materials

Surface
Prepared canvas board

Size
18in × 24in (45cm × 60cm)

Tools
No 10 round sable brush
No 4 flat bristle brush
Palette

Colors

Alizarin crimson	Chrome oxide
Burnt sienna	Raw sienna
Burnt umber	Ultramarine blue
Cadmium red	Yellow ochre

Mediums
Linseed oil
Turpentine

1. Mix burnt sienna and white. With a No 10 sable brush, block in the figure. With burnt umber, block in the ground area.

2. Add white to the burnt umber and start to block in the area surrounding the figure. Using the same mixture, begin to develop shadow areas within the figure.

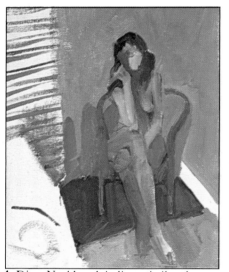

4. Dip a No 4 brush in linseed oil and blend the previous color areas within the figure. Cover the remaining background area in green mixture.

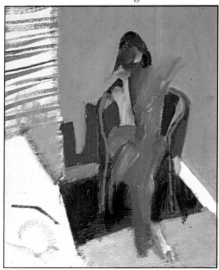

5. Apply cadmium red directly from tube on to chair. Mix green and ochre and blend with rag or finger. Use a lighter tone of same in the background.

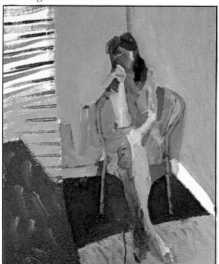

7. Mix alizarin crimson, blue and white and rework shadow areas in figure and background. Carry this into the foreground with a flicking motion.

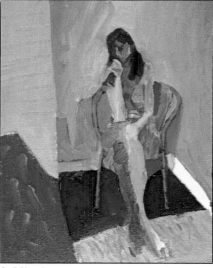

8. Mix chrome green, white, and a touch of red and block in shape on the right. Carry this into the background. Lighten with white and use for highlights.

3. Mix chrome green and white and put in background. Apply cadmium red medium for the chair: white and ochre for highlights, and burnt umber for hair.

6. Mix red and white and put in the chair highlights. Carry this into the figure for highlight areas. Use pure burnt sienna to describe shape at left.

9. Develop final details of painting with white and yellow ochre. Mix white and umber for face features. With chrome green and yellow put in strip on left.

Blotting with tissue

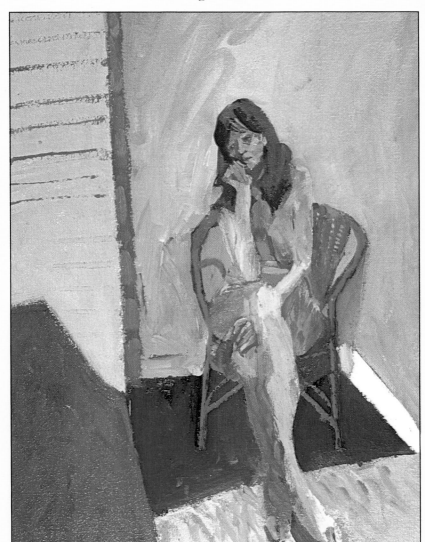

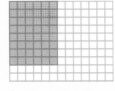

If the paint surface becomes too wet, excess moisture can be blotted up with a small piece of tissue. Do not rub into the surface but simply press the tissue down lightly.

IN ORDER to bring out the full tonal qualities of the subject, here the artist has used a narrow range of colors, relying on strong light and dark contrasts to disrupt what would otherwise be a predictable harmony. The result is a powerful image in which the figure is clearly recognizable, but with an element of abstraction in the pattern of the shadow and the broad planes of color.

The pattern of shapes in a painting is a crucial factor, so you should map out the composition carefully at the start. Follow the outlines as you apply the paint but keep the brushwork loose and vigorous. Thin the paint with turpentine and use long-handled bristle brushes in fluid strokes, gradually tightening up the image as the painting develops.

Color must be used carefully to differentiate the dark tones as otherwise the shapes will merge together. Enrich the heavy shadows by adding blue or brown to black paint. Adjust light tones continuously until you are satisfied with the result. Note that here the light yellow has been made more vivid in the final stage and extended over the orange shape to cool the contrast. None of the highlights are made from pure white and the intensity of the image is maintained through the relationship of the colors and the tones rather than through light and dark areas.

Materials

Surface
Stretched and primed cotton duck

Size
36in × 30in (90cm × 76cm)

Tools
No 6 flat bristle brushes
No 6 round sable brush
1in (2.5cm) decorators' brush
Palette

Colors

Black	Raw umber
Burnt sienna	Ultramarine blue
Burnt umber	Vermilion
Cadmium yellow	Yellow ochre

Medium
Turpentine

1. Sketch in the outlines with an HB pencil and then draw with a No 6 sable and black paint, using line and small areas of tone to establish the basic structure.

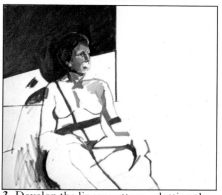

3. Develop the linear pattern, plotting the contour of the figure and shadows. Work into the face in more detail and block in a solid background tone.

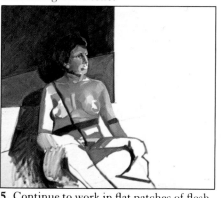

5. Continue to work in flat patches of flesh tones, brushing the colors together. Lay in reddish-brown behind the figure and dark blue shadows with a No 6 bristle.

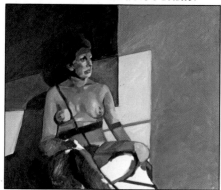

7. Work over the lower half of the figure with loose brushstrokes in dark brown tones. Contrast the shadows with a light yellow tone showing the fall of light.

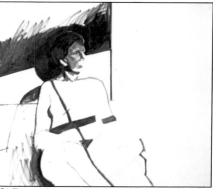

2. Draw up the central shadow across the figure with burnt sienna. Work into the flesh tones on the face and lay in the dark shadow behind the head.

4. Using mixtures of burnt sienna and white with red and yellow, develop tones within the figure.

6. Mix yellow ochre with raw umber and use a No 6 brush to block in the right-hand side of the background. Cover the white space, scrubbing into the canvas.

8. Enrich the foreground colour with a solid shape of bright orange and warm tones in the legs, covering the remaining canvas. *(continued overleaf)*

Shadow areas · eye highlights · flesh tones

The shadow area beside the head is created with a dark tone thinned with turpentine. This is later covered over with a thicker layer of paint. The painting should develop through many thin layers of overpainting rather than a few thick layers.

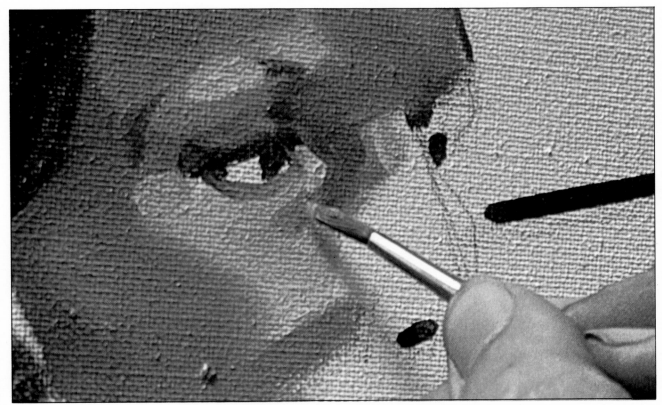

With a fine sable brush, the artist puts in highlight areas around the eye.

A mid-toned flesh color is blended into a shadow and highlight area. The paint is first laid down and then blended by using a clean, dry brush.

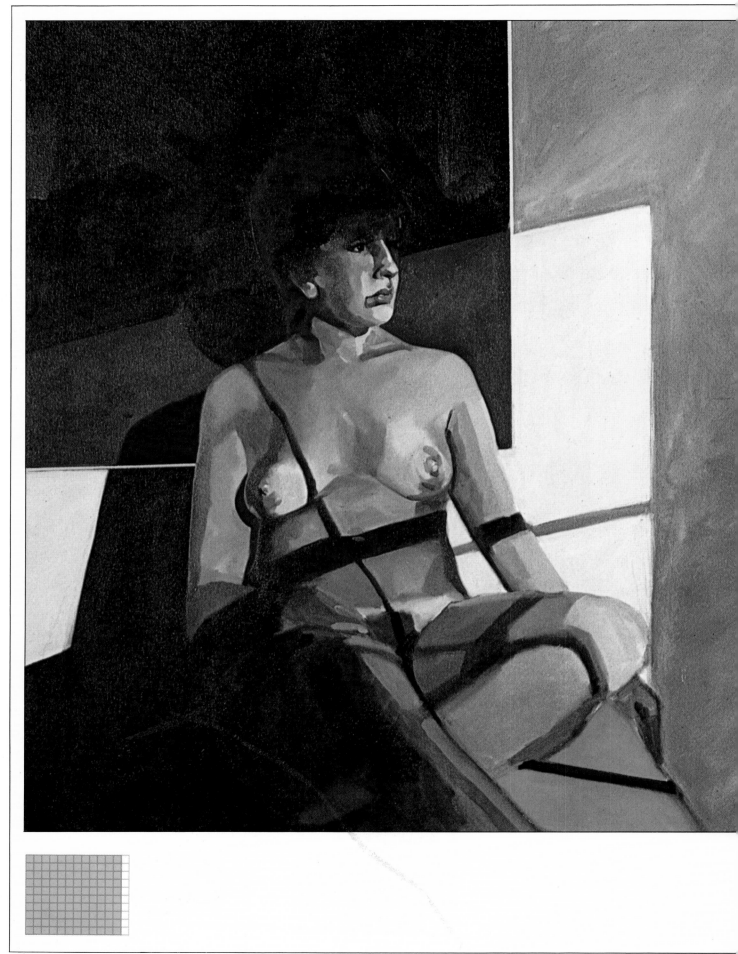

Figure shadows and blending

9. Revise the skin tones in the upper part of the figure, smoothly blending the color.

Shadow areas in the torso are described with a medium-sized sable brush. This color area is next blended into surrounding colors.

10. Continue to work over the whole image making adjustments in the color values. Lay in a dark blue-black shadow down the right leg of the figure.

11. Lighten the tones across the central section of the painting and even out patches of loosely worked color, blending them into smooth, fluid shapes.

12. Break down the foreground shapes to show the pattern of cast shadow over the legs. Strengthen dark tones with black and dark blue.

Acrylic

THE ARRANGEMENT OF a posed figure is important in that it is a means of providing the artist with a range of information from which a personal view can be formed. The artist should consider how to place the model, what kind of furniture and props to use, the direction and fall of the light, and the overall pattern of shapes and colors. In this case a mirror has been placed behind the model to give a back view of the pose and lighten the background tones.

Once the painting is started there is no need to adhere rigidly to every detail; let the work develop freely so your own particular interest in the subject can emerge.

The texture and strong color of acrylic paints provides good covering power and each layer can be built up rapidly without colors bleeding through from underneath. As the paint dries it forms a tough, erasery skin which cannot be scraped back or wiped off, so alterations must be made by overpainting with solid, opaque color.

Materials

Surface
Prepared canvas board

Size
24in × 20in (60cm × 50cm)

Tools
No 5 flat bristle brush
No 6 round sable brush
Palette

Colors
Alizarin crimson Monastral blue
Black Vermilion
Cadmium yellow medium Violet
Chrome green White

Medium
Water

Preliminary colors · reinforcing outlines

Once the underpainting has dried thoroughly, the artist blocks in predominant color areas with a thick, opaque paint mixture.

After the tones of the figure have been laid in with a thin wash, the outlines are reinforced with a small brush and black paint.

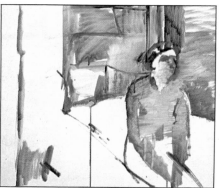

1. Using red, yellow and blue, draw up the basic outline of the composition with a No 5 brush. Apply broad areas of tone and colour with thin, wet paint.

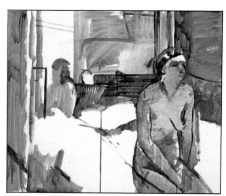

2. Add more detail to the structure of the drawing and break down tones into a more complex pattern.

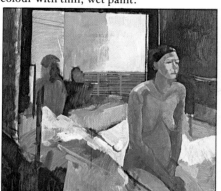

6. Lay in a thin wash of red paint over the figure to warm up the colors. Draw up the face in detail and apply highlights with pinks and yellows.

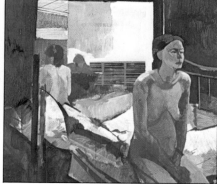

7. Rework the figure with a No 8 sable brush, heightening the color and developing the forms. Paint details of the bed and drapery, blocking in darkest tones.

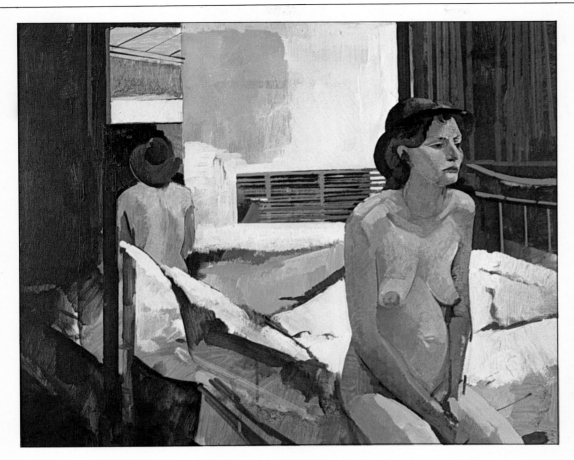

3. Work over the composition with line and thin washes of paint.

4. Apply the paint more thickly, using pinks and browns to build up the shape of the figure. Lay in a dark tone behind the head and shoulder.

5. Darken the background tone over the whole painting and contrast this with strong areas of white highlight.

8. Contrast light and dark tones in the figure showing the play of light over the form. Use light pinks and yellows to highlight against dark red and purple.

9. Work up the detail in the background showing the form and texture of the objects.

10. Use the final stages of the painting to make any alterations that come to mind. Use thick paint to lay in fresh detail or paint out shapes.

FIGURE painting is one of the major aspects of basic training in art schools. This is largely because it is a very flexible vehicle for the study of form and color. Many artists will work from one particular model over a period of time, as the range of paintings and drawings depicting different poses and elements can be almost infinite.

The primary factor in this composition is the luminous quality of the colors and tones. The model posed in a glass-walled studio on a bright, sunny day. The direct light gave a warm glow to the flesh tones of the figure. This warmth is represented at first in the painting with intense pinks and reds, but the full glowing effect becomes apparent as the colors are lightened and given a strong yellow cast. The shadows on the figure are painted mainly with dark green. This produces a more vibrant effect against the warm colors and forms a pictorial link with the heavy mass of green in the background foliage.

The essential factor is the relationship of all the colors together rather than any attempt to match each tone separately with its original in the subject. It is therefore best to stand back from the painting at each new stage to check the overall effect.

Materials

Surface
Stretched and primed cotton duck

Size
24in × 30in (60cm × 75cm)

Tools
Nos 3, and 11 flat bristle brushes

Colors

Black	Hooker's green
Burnt sienna	Lemon yellow
Burnt umber	Pthalo crimson
Cadmium red medium	Ultramarine
Cadmium yellow medium	White
Chrome green	

Medium
Water

Outlining · underpainting warm tones

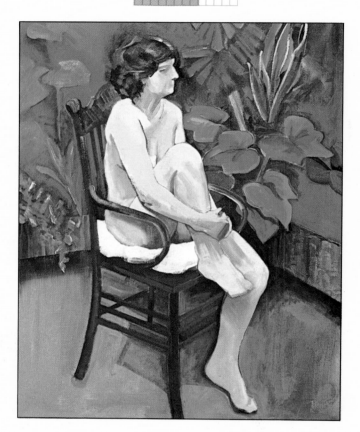

Figure outlines are sketched in with a bold red before blocking in predominant color tones. The outlines are later covered over; however, the red continues to permeate successive layers, warming tones.

Blocking in an underpainting of warm pinks and oranges. This layer is later used for warm highlight areas or covered over with cool tones of green and blue.

1. Use a No 3 bristle brush, well loaded with cadmium red to draw in the outline of the figure. Correct the shape and work over the alterations in white if necessary.

2. Mix yellow, red and white and block in the flesh tones. Lay in a dark green behind the figure to form the basic background.

3. Lay in thin layers of color covering more of the canvas. Continue to work on the figure with pinks and browns and use green for the shadows.

4. Use a No 11 brush to cover the whole background with a thin wash of green. Describe the foliage shapes in yellow and add details to the chair.

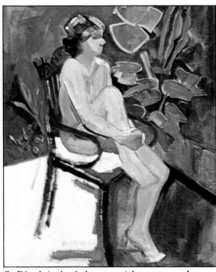

5. Block in leaf shapes with green and yellow mixtures, working into the shadows with black and burnt sienna.

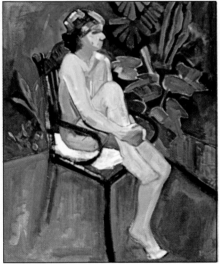

6. Work around the figure covering all the remaining white space and elaborating background forms. Lighten the floor color with blue-grey.

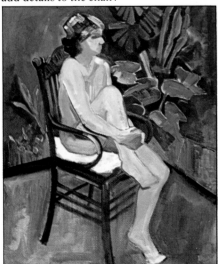

7. Draw the chair in more detail with burnt umber, adding highlights in white and dark tones in black.

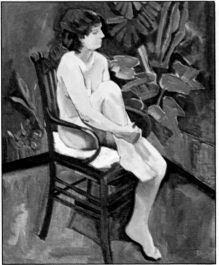

8. Work over the figure using a light flesh tone and put in shadows in green. Describe the shadow under the chair with a thin layer of black.

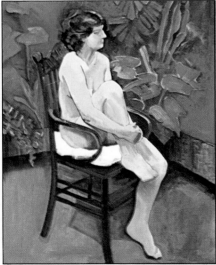

9. Rework parts of the figure as needed, refining the shapes and emphasizing tonal contrast. Bring up the white of the cushion with thick paint.

PAINTING CAN BE a matter of moment-by-moment decision: not all studies need be meticulously planned. In this picture some of the forms, and indeed the structure of the composition as a whole, underwent radical changes as the work progressed. The drawing was continuously redrafted with whole figures as well as small details vanishing under a layer of paint and re-emerging at a later stage. The overall structure was completely altered when the flat, distant horizon line was cut short by the tall block of buildings. The artist chose to do this to close off the picture space and force the observer's eye into the cluster of figures in the mid- and foreground areas.

The painting was constructed from a number of photographs, with the artist taking single figures and groups from different sources to create a composite image. Thus the artist felt complete freedom to experiment and develop the structure in any way which interested him.

Making such alterations in a painting is not unusual and the development of a quick-drying paint such as acrylic has given artists a great deal of freedom in this respect.

Paint out the forms with a solid layer of color and draw them again in outline with the point of the brush. As you become more confident you may prefer to rework directly in color over previous shapes.

Materials

Surface
Prepared canvas board

Size
28in × 24in (70cm × 60cm)

Tools
No 8 sable round brush
Nos 4 and 6 round bristle brushes
Palette

Colors
Black	Cadmium yellow
Burnt sienna	Cobalt blue
Cadmium green	Ultramarine blue
Cadmium lemon	Viridian
Cadmium orange	White
Cadmium red medium	Yellow ochre

Mediums
Water
Acrylic matt medium

1. Start to block in figures with dryish paint, drawing the brush lightly across the surface of the canvas board.

2. Scrub over the sky with ultramarine and the beach with warm oranges and yellows. Draw over the colors with fine black lines.

6. Adjust the drawing freely, working over the shapes to try out different compositional arrangements.

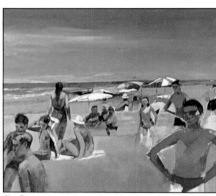

7. Concentrate on developing details in one group of figures, gradually improving the modelling of the forms and tones.

When the underpainting has completely dried, the artist blocks in strong highlight areas with pure white and a small brush.

Working from dark to light, the artist begins to lay in light flesh tones over the dark, warm underpainting.

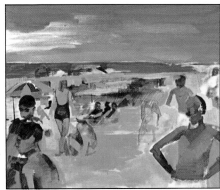

3. Work into the figures on the right side with orange, brown, and black.

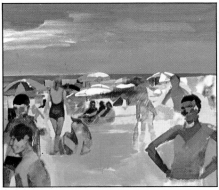

4. Lighten the tone of the sky and at the same time lower the horizon line. Work into the foreground with pale tones and white, adding small details.

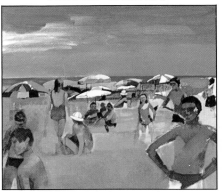

5. Continue to develop the figures and main shapes with fine black outlines and blocks of strong, light color.

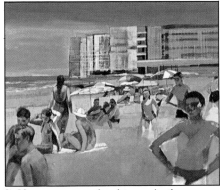

8. If necessary, make changes in the composition. Here the painting has been strengthened by the addition of a group of buildings.

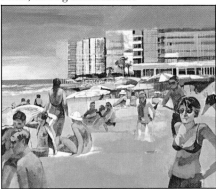

9. Rework the figures in the foreground building up the contrast of light and dark colors. Block out shapes with a layer of thin, pale orange.

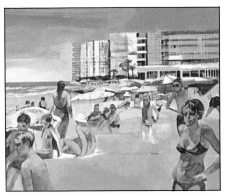

10. Lay in glazes of red over the flesh tones. Develop the shadows with black and grey.

Finished picture · highlights · dark to light

The artist continued to make radical changes in the painting until the very end. This is clearly seen in the figure in the foreground right; the change of position and addition of the yellow jacket add liveliness and interest to the picture.

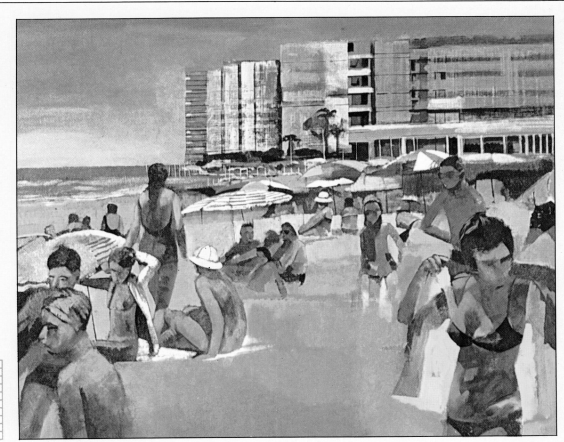

MANY ARTISTS CHOOSE to paint the figure in isolation – without background or props – the better to concentrate on the form, shape, and colour of the model. However, it is important for artists to also consider using the environment around the model to emphasize the figure and create an interesting image. As seen in this painting, not only is the figure itself successfully described, but the area outside the figure is given equal attention as well, which heightens the impact of the picture as a whole.

The painting has successfully captured a strong impression of light and shadow and revolves around a theme of contrasts – the geometric lines and planes of the environment and the cold, bright light coming through the window. This contrasts with the warm, soft figure. The everyday world beyond the window heightens the intimacy of the subject and setting within and creates a visually stimulating idea.

Materials

Surface
Tinted watercolor paper

Size
24in × 26in (62cm × 65cm)

Tools
Nos 2 and 4 sable watercolor brushes
Rags or tissues
Palette

Colors
Black	Chrome green
Burnt sienna	White
Cadmium red	Yellow ochre
Cadmium yellow	

Medium
Water

Finished picture · underpainting · using masking tape

To finish the picture, the artist cleaned up broad areas of color and strengthened the view outside the window. Note as well that the picture was cropped (above), thus strengthening the composition and focus of the image.

Besides creating sharp, straight edges, masking tape can be used as a mask to describe irregular shapes and patterns. Here the artist paints over two pieces of torn tape to create the rough edge of the window.

Shadow areas within the figure are blocked in directly with burnt sienna. The color and shape is later modified by overpainting with warmer, lighter flesh tones.

1. In thick, opaque white, block in highlight areas with a No 4 brush. Add black to the white and put in shadow areas.

2. Mix chrome green and cadmium yellow pale and block in shape of window. In burnt sienna, block in the shadow area of the figure.

3. With a deeper grey mixture, put in verticals and horizontals. Mix white and yellow and put in figure highlights.

4. Using a No 2 sable brush, work back into the figure with the dark grey tones. Mix cadmium red and white and block in the figure.

5. In dark grey, block in the dark shadow area behind the figure. With cadmium red, put in bus outside of the window.

6. In loose strokes add touches of detail outside the window.

213

Watercolor

IN THIS PAINTING, strong patterns of light and shade introduce an abstract element to an otherwise straightforward pose. The tone and color contrasts form an intricate network of shapes which are emphasized to build up the image piece by piece. The figure is basically composed of warm tones of orange, yellow, and brown and are given extra brilliance by the cool, dark blues of surrounding colors. These colors are linked across the image with the warm mauve and intense blue-purple in the shadows of the figure and the background. The strong green of the floor is an unexpected departure from the overall color scheme and provides a lively base for the composition.

The painting technique is fluid and vigorous. Large pools of color are laid down to establish the general shapes, which are then broken down by successive applications of smaller patches of wet color. Use round sable brushes with a relaxed, flowing stroke; a great part of the appeal of the image is that no shape is absolutely precise. To make the most of the colors, dry the painting frequently so that the effect of the overlapping washes is not diffused.

Materials

Surface
Stretched cartridge paper

Size
9.5in × 15in (24cm × 37cm)

Tools
No 5 sable round brush
Colored pencils 2B pencil

Colors

Burnt umber	Scarlet lake
Cadmium yellow	Ultramarine blue
Cobalt blue	*Pencils*
Emerald green	Blue
Orange	Orange
Purple	Purple
Magenta	

Medium
Water

1. Sketch in a rough guideline for the painting with a 2B pencil. Lay in shadows with thin washes of paint using warm colors.

2. Work into the figure with yellow and violet developing the pattern of light and shade. Put in the floor with a wash of emerald green, blues and purples.

3. Build up the contrast of warm and cool tones in the figure, blocking in small patches of color to describe shadows.

4. Mix the paint with less water to intensify the dark tones. Break down the large shapes to show details such as facial features and the fingers on the hand.

5. Work over the skin tones with small shapes of burnt sienna and burnt umber. Overlap the colors and drop in touches of blue to vary the dark tones.

6. When the paint is dry, work over the forms with colored pencils, modifying the shapes and tones.

Lifting color with tissue · overlaying with colored pencils

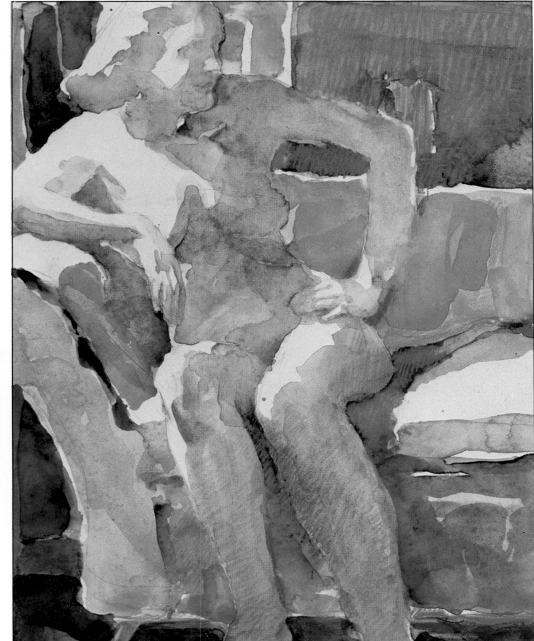

To lighten a color tone, a small piece of tissue can be used to lift the paint. Do not rub into the surface but simply blot with the tissue.

After the painting has dried, colored pencils may be used to create subtle overlays of color. Here the artist strengthen shadow areas in the legs using a blue pencil over a warm color area.

WATERCOLOR IS AN excellent medium for painting a nude, as its delicacy and transparency are particularly suited to the task of building up subtle variations of flesh tones. Color is gradually intensified and broken down into smaller areas with light tones created by the bare white surface of the paper.

To create a balanced composition, the figure has been placed to one side of the paper with the head turned to look across the picture space. The dark, heavy background area adds emphasis to light colors and details within the figure. The model's hat gives a splash of bright color against the subtle flesh tones and cool blue and grey of the surrounding area.

The success of this type of painting depends upon accurate, direct drawing with a good sable brush. Work on each form separately to build up details and make adjustments in the final stages to unify the overall effect. Each shape should be carefully observed and then precisely applied. Keep the paint thin and light as it is difficult to lift off color which has been applied too thickly. It is advisable to dry the painting frequently by either letting the moisture evaporate naturally, fanning the picture, or using a hair dryer so the colors do not mix and become muddy. Brushes should be kept clean and water pots refilled at regular intervals during the work.

Materials

Surface
Stretched watercolor paper

Size
20in × 16in (50cm × 40cm)

Tools
Nos 3 and 6 sable round brushes
No 10 flat ox-ear brush
1in (2.5cm) decorators' brush

Colors
Black	Cobalt blue
Burnt sienna	Light red
Cadmium red	Payne's grey
Cadmium yellow	Scarlet lake

Medium
Water

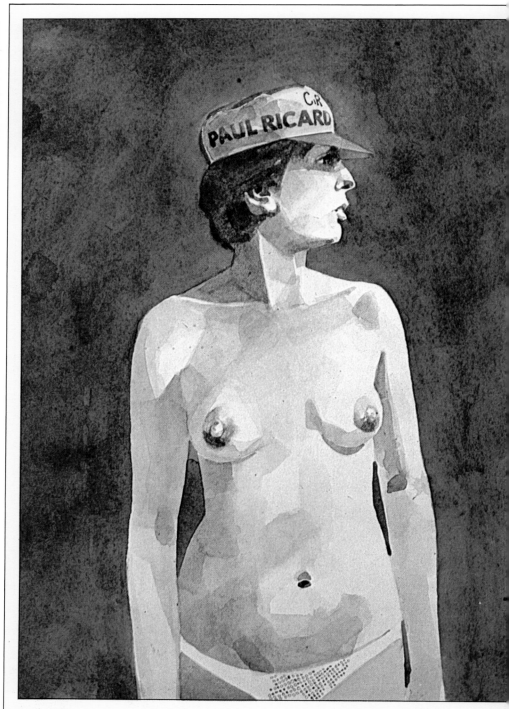

Detailing with pencil

A fine-pointed, dark pencil is here being used to create texture and pattern in the model's pants.

1. Lightly pencil in the outline of the figure and with a No 3 brush paint in the darkest details with black. Lay in a very thin wash of light red with a No 10 brush.

2. Paint in small areas of bright pattern on the cap, keeping the colors clean and distinct. With a No 3 brush and black, brush into the cap to indicate shadows.

3. Gradually build up skin tones with thin washes of paint, varying the color mixtures and overlaying washes.

4. Use a large No 6 brush to apply a wash of color across the background, with a mixture of cobalt blue and Payne's grey. Follow the outline of the figure carefully.

5. Strengthen the shadows in the figure, preserving highlights and light tones. Lay light washes of scarlet lake.

6. Intensify the background color, adding a little black to the blue and grey mixture.

7. Adjust the tones of the figure against the dark background, bringing up details of the features and adding small shapes of dark color to show strong shadows.

8. Work over the whole image to define the full volume of the head and body, using thin washes of black and red to sharpen detail and enliven color.

THE ATMOSPHERIC MOOD of this picture was achieved through the subtle overlaying of washes of color and a dramatic use of light and shadow.

Within the figure, this method of painting mimics the actual physical makeup of the human body. The 'color' of human flesh is created by the many thousands of small arteries and veins carrying blood and oxygen and layer upon layer of tissue and pigment as well. Flesh tone is a translucent 'color' created by these many layers. All of these elements could be thought of as the 'underpainting' of the human figure by which are created what we call the 'flesh tones'.

It is important to bear in mind that the initial washes of color, no matter how often covered over, will influence the final picture. In this case, the artist used a warm, light tone for the underpainting of the figure knowing that this would keep the figure warm in tone, regardless of the colors put down over this initial layer. The white area falling across the figure creates a dramatic contrast to the general dark and sombre tone of the rest of the picture. The square of white in the background is linked with this white area, joining foreground and background and providing unity.

Materials

Surface
Stretched watercolor paper

Size
21.5in × 14in (53cm × 35cm)

Tools
Nos 4 and 12 sable watercolor brushes
Palette

Colors
Alizarin crimson	Indigo
Burnt umber	Payne's grey
Cadmium lemon	Prussian blue
Cadmium scarlet	Rose madder
Chrome green	Yellow ochre

Medium
Water

1. Sketch in figure in outline. Dampen background area and spread wet mixture of indigo and cadmium yellow. Mix cadmium and yellow and put in figure.

2. When dry, mix wash of water and Payne's grey and put in bed. Strengthen tone of paint by adding more grey to create dark shadow areas.

3. Mix Payne's grey and cadmium red light in wet wash and put in floor with a No 12 brush, keeping the tone consistent.

4. After figure has dried, put in a light wash of rose madder with a No 4 brush letting brush and paint describe the subtler flesh tones.

5. Add more red to flesh tone and put in striped shadow area across figure.

6. Create darker flesh tone by adding a touch of burnt umber. With Payne's grey, describe shadow area in bed and window. Put wash of yellow over figure.

7. Mix a dark shade of chrome green and flood in over the background color with the No 12 brush.

8. With a dark mixture of Payne's grey and water, put in deep shadow tones in bed and under figure's feet.

Using warm wash · wet-in-wet · shadow details

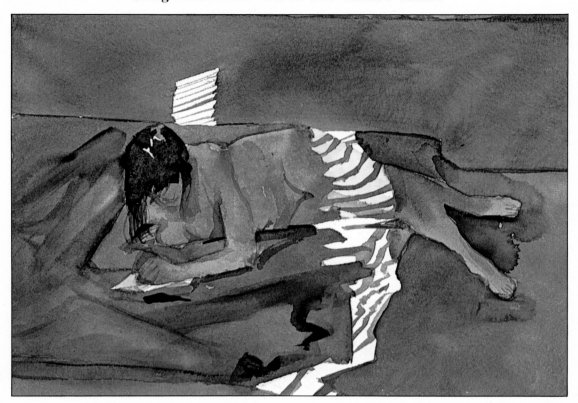

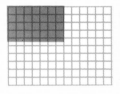

Mixing paint in small dishes which can be held in the hand allows the artist to work quickly. Here the artist is overpainting the initial yellow layer in the figure's legs with a warm red.

Working over the slightly damp underpainting, the artist lays in thin lines of dark paint to describe the shadow over the figure.

One way of working wet-in-wet is to lay down a small area of color (above) and then immediately flood this with a clean brush and water. If too much water is applied, this is easily lifted with a small piece of tissue or cotton. Remember not to rub into the surface, but simply blot up the excess moisture (left).

WORKING QUICKLY WITH only a few colors and brushes, the artist has here created a fascinating picture which fulfills all the requirements of a successful figure study. Using more than one figure is always an interesting exercise. The artist can combine sketches of different poses into one painting, but make sure the lighting is similar to avoid confusion.

Using a grey underpainting to set the mood and tone of the picture, the artist worked from dark to light with wet paint; each layer grew more opaque with the addition of designer's white gouache into the flesh tones. In some areas the wet paint was allowed to bleed and blend into a previous wet area; in other areas a dryish, opaque mixture was put over a dry layer.

Note in particular how the artist has used just a few warm and cool tones to create a variety of shades within the figure. The subtle colours are contrasted with the sharp, intense black areas of the hair and the shadow areas outside of the figures.

Compositionally, the painting presents a balanced and symmetrical image by placing the figures in such a way that the eye is led downward and into the centre of the picture plane.

Materials

Surface
Stretched watercolor paper

Size
20in × 16in (50cm × 40cm)

Tools
Small sponge
Nos 6, 12 sable round watercolor brushes

Colors
Alizarin crimson	Payne's grey
Cadmium red light	White (gouache)
Chrome green	Yellow ochre

Medium
Water

1. Mix a large amount of Payne's grey and water in a mixing dish and with a small sponge work over the painting surface.

2. With a No 12 brush, work back into the underpainting with a darker tone of grey, blocking in dark areas around the figures.

3. While still wet, use a No 12 brush and chrome green and block in the shadow areas of the first figure. Mix white, ochre and red for highlights.

4. Work down the figure with opaque white and yellow ochre mixture.

5. Block in the hair with pure Payne's grey and the highlights with pure white using a No 6 brush.

6. With the same flesh tones, put in the figure on the right with lighter colors made by adding white.

7. Put in dark details of hair and shadow areas, allowing the paint to bleed into previous area.

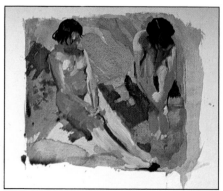

8. Mix Payne's grey and water and block in shadow areas around the figures.

Laying in highlights

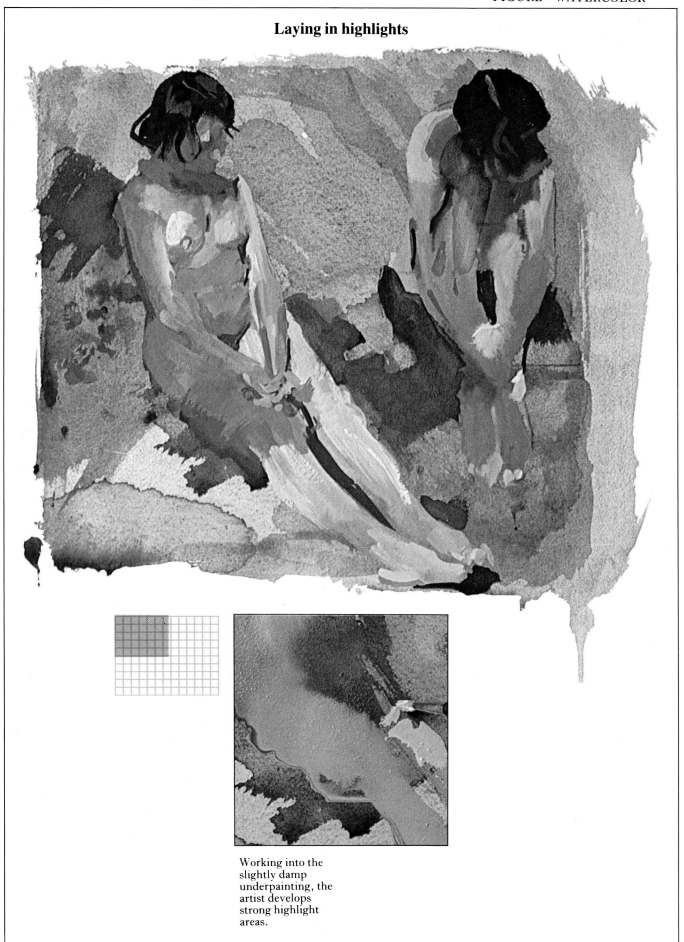

Working into the
slightly damp
underpainting, the
artist develops
strong highlight
areas.

Tempera

WHILE TEMPERA PAINTING has never quite regained the widespread popularity it enjoyed with the artists of medieval times, it is still used by many contemporary painters as a fascinating and challenging alternative to other painting media.

When used as an underpainting for an oil painting, tempera will give a glowing, translucent effect. Once the oil paint layer has dried thoroughly, the artist can return to working with tempera if he chooses.

If dry pigments are used, tempera colors will not necessarily dry as they look when applied to the surface; they may dry lighter or darker depending on the type of pigment used. For this reason it is a good idea to test colors on a separate piece of similar surface before beginning to work.

An important point to note is that tempera cannot be easily corrected or overpainted during the painting process. Thus, this process requires planning and forethought. Small areas should be worked on one at a time, allowing each layer to dry thoroughly before beginning the next.

Materials

Surface
Primed hardboard sized with muslin

Size
24in × 20in (60cm × 50cm)

Tools
No 2 sable brush
Small jar
Piece of flannel
Plate

Colors (dry pigments)
Black Viridian
Cobalt blue White
Light red Yellow ochre
Terre verte

Mediums
Egg yolk
Water

1. Transfer the preliminary sketch on to a board by placing the sketch drawing side down and rubbing over the back with a soft dark pencil.

2. Mix light red with some egg yolk, and with a No 2 brush, put in red areas using very light, fluid strokes.

3. Using terre verte and viridian in varying tones of green, put in figure shadows using the same light touch.

4. Work over the whole picture with these same tones. Mix only the amount needed and change brushes depending on the area to be covered.

5. Darken tones of green by adding a small amount of blue pigment and work over previous areas, intensifying shadows.

6. Continue to strengthen and blend green background tones. Work into the figures with ochre, beginning to put in the various highlight areas.

7. Develop small areas of detail, such as the tree on the left, with a dark blue-green tone. Use only the tip of the brush to touch in colors.

8. Using pure cobalt blue, strengthen outlines and shadows in this same detail area.

Underpainting with terre verte · using white

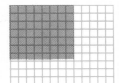

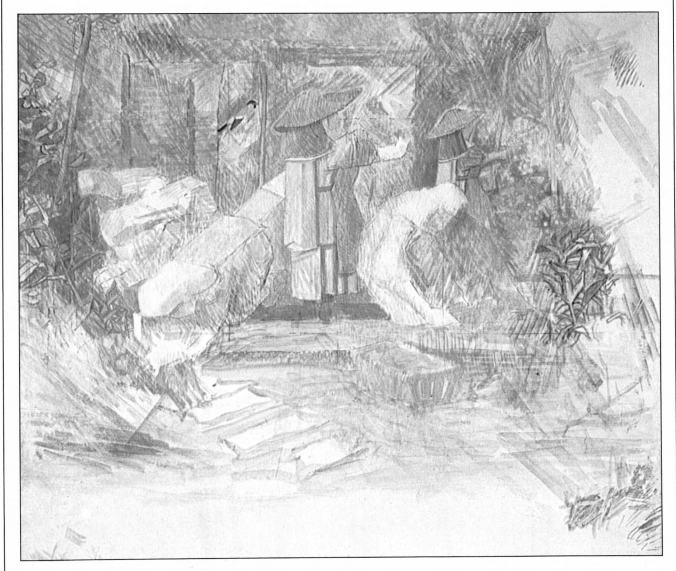

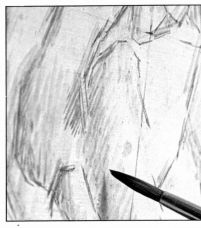

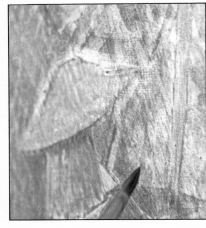

Here the artist is putting in a cool underpainting in terre verte. Note the directional strokes and the light touch required.

At a more advanced stage, white mixed with yolk can be used to tone down previous color areas. White can also be used to correct and rework, but the color laid over this will lose some of its translucence in the process.

Pastel

PASTEL drawing requires a combination of drawing and painting skills. It can be treated either as a linear medium for outlines and loosely hatched textures, or the color may be laid in broad, grainy patches and blended with the fingers or a rag. Pastel color is soft and powdery and, although it is held together by the tooth of the paper, the surface is always unstable. The drawing should be sprayed with fixative frequently to hold the image while further layers are applied.

The rich textures are built up in a series of overlaid marks, carefully manipulated to describe the forms in terms of their component shapes and color relationships. In this drawing, the pastel strokes have a vertical emphasis, but sometimes marks follow the direction of the forms in order to emphasize a particular curve or angle. It is easier to control the overall image if the strokes follow one direction. In the initial stages of the drawing use medium soft pastels, graduating to the soft type to develop texture as the drawing progresses.

Materials

Surface
Tinted rag paper

Size
23in × 30in (57cm × 75cm)

Tools
Fixative

Colors
Black	Light yellow
Cobalt blue	Olive green
Dark brown	Red
Flesh	Venetian red
Grey	Ultramarine blue

1. Mark the position of the head and limbs with a pink pastel tint and roughly block in the structure of the figure with pink, light yellow, brown and grey.

2. Work lightly over the whole figure, weaving colors together so basic shapes and tones begin to emerge. Use grey and blue to suggest dark tones.

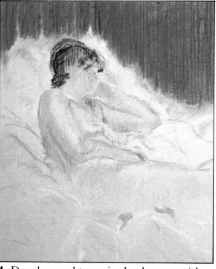

4. Develop cool tones in the drapery with light blue and white and darken the background color with broad vertical strokes of olive green and ultramarine.

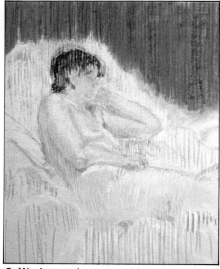

5. Work over the composition with tones of grey to strengthen shadows. Draw into the figure with light yellow and dark red to build up the solidity of the form.

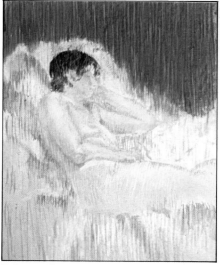

7. Intensify the blues in the background, laying in brown and green to vary the color. Develop the colors over the whole drawing, altering if necessary.

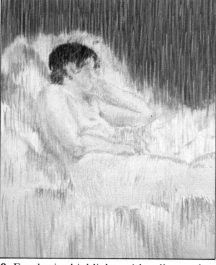

8. Emphasize highlights with yellow and white and lighten the background colour with cobalt blue and white. Add touches of warm pink tones into the drapery.

3. Spray the work lightly with fixative. Start to build up a contrast of cool and warm tones using blue and green in the shadow areas.

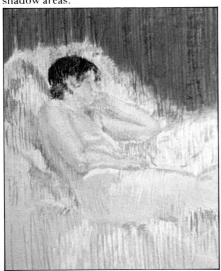

6. Overlay the colors so that the pastel strokes remain visible but the image works as a whole form. Work over the figure to heighten the tonal contrasts.

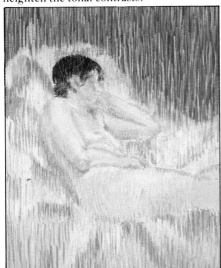

9. Round out the forms of the figure using a dark flesh pink, contrasted with cool green in the shadows. Use pinks and browns to warm the drawing.

Finished picture · blocking in · using pure color

As seen in the finished picture, it is the combination of forceful, vertical strokes used to define a largely horizontal subject which creates a harmonious, stable image.

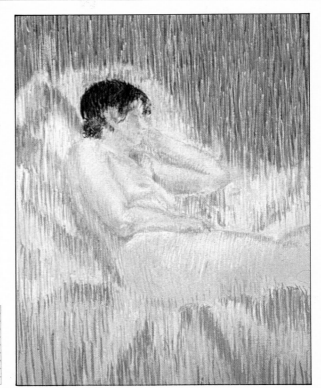

Thin lines of pure color are laid down in directional strokes next to and on top of one another.

In the first few stages of drawing, the artist describes large areas of color using the side of the chalk.

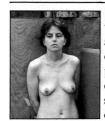

IN COMMON with watercolor, pastels allow the artist to create layers of transparent colour. These can be used either to subtly imply warm or cool tones or to indicate shadow or highlight areas.

The picture here relies basically on the use of warm and cool tones to create the flesh tones and give the picture unity. The artist worked by developing highlights and shadows, constantly adjusting and readjusting these to correct the balance of warm and cool colors.

Note that pastel cannot be easily erased. If you use a light hand throughout the drawing process, however, you will avoid building up a heavy and unworkable surface.

Compositionally, the drawing was planned to focus attention on the head of the model rather tham the complete torso. By leaving the figure relatively untouched except for a few sparse outlines, and working well into the head and background areas, the artist ensured that the viewer's attention would be focused on the head – the most important area of the picture.

Materials

Surface
Cartridge paper

Size
18.5in × 26in (47cm × 65cm)

Tools
Large soft brush
2B pencil
Putty eraser
Fixative

Colors
Light grey
Dark grey
Black
White

1. Reinforce pencil outlines with pastel. Use a deep tone for the hair and shadow areas of the face.

2. Continue to sketch in the figure in loose outline and block in the background and figure using the same tone.

3. Lighten the background area and carry this tone into the face. With a soft brush blend the background and face.

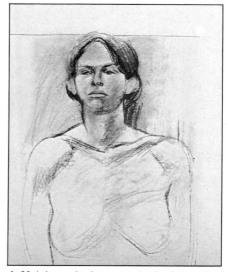

4. Heighten shadow areas in the face with a deeper tone and work into highlights with a lighter tone.

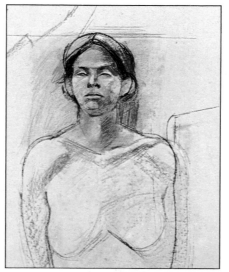

5. Describe background in more detail and carry this tone into the hair area. Blend the face with a large, soft brush.

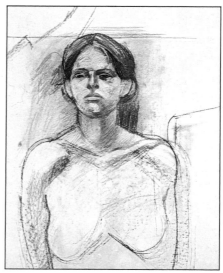

6. Using pure white, cover the face area with directional strokes and blend with the brush.

Using pure white · blending with brush

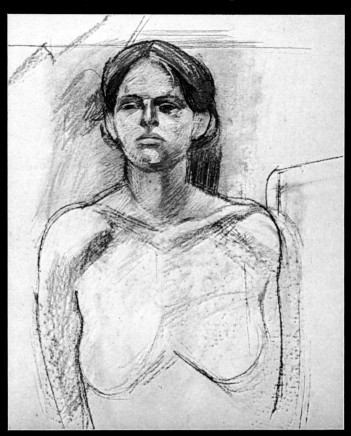

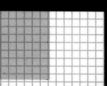

Besides using a rag or fingers to blend, a large, soft sable brush is a useful tool. The artist is here blending strong highlight tones into the darker underlayer.

Using pure white, the artist lays in strong strokes which will be blended and modified by other colors. Note the use of directional strokes to model the face.

Pencil

MUCH LIKE CRAYONS, colored pencils are often overlooked as an exciting drawing medium. As seen in this drawing, they are capable of producing brilliant colors and dramatic tones. The picture is interesting not only for the techniques used in describing the form, but for the unusual and striking composition as well.

In terms of technique, the artist used a combination of heavy, dense shadow areas and lighter, translucent highlights. These play off one another to both heighten and modify the overall effect of the picture. Note that the drawing process is very similar to the traditional oil painting process; thin layers of pure color are laid over one another to build up a shimmering, translucent surface. While it appears that many individual tones and colors have been used, the artist has in fact used only a few warm and cool colors. The flesh tone is used all over the figure and altered for highlight and shadow areas by either overlaying warm red tones for highlights or cool blues for shadows.

Compositionally, the artist has exploited the white of the paper, using it to become part of the drawing as demonstrated in the playing cards and sunglasses. This is extremely effective in creating unity between the image and its environment, as well as strengthening the intensity of colored areas.

Materials

Surface
Cartridge paper

Size
14in14in (35cm × 35cm)

Tools
Putty eraser

Colors
Black	Pale blue
Blue-violet	Purple
Green	Red
Orange	Yellow

1. Sketch in the figure very lightly with a 2B pencil. With heavy strokes, put in the hair in black and light blue outside of the head. Mix black and red in the glasses.

2. Overlay thin layers of purple and blue in the shoulder areas.

3. Work over the shoulder with a thin layer of orange. Move down the arm and breast, again leaving the paper bare to describe white areas. Carry blue shadow down.

4. With cool blue or purple and overlaying warm flesh tones, put in the right shoulder. Very loosely describe the blue shadow at the right of the head.

5. Varying warm tones of orange, red, and yellow, lightly work down the figure. Continue to use cool blue or purple for shadow areas.

6. Work down over the stomach area with the same warm and cool tones. Keep shadow areas dense and clearly defined.

Finished picture · using white of paper

Colored pencil should not be overlooked as a forceful tool, capable of producing effects equal to any painting medium. The clean, pure color areas contrast well with any tinted or pure white drawing surface.

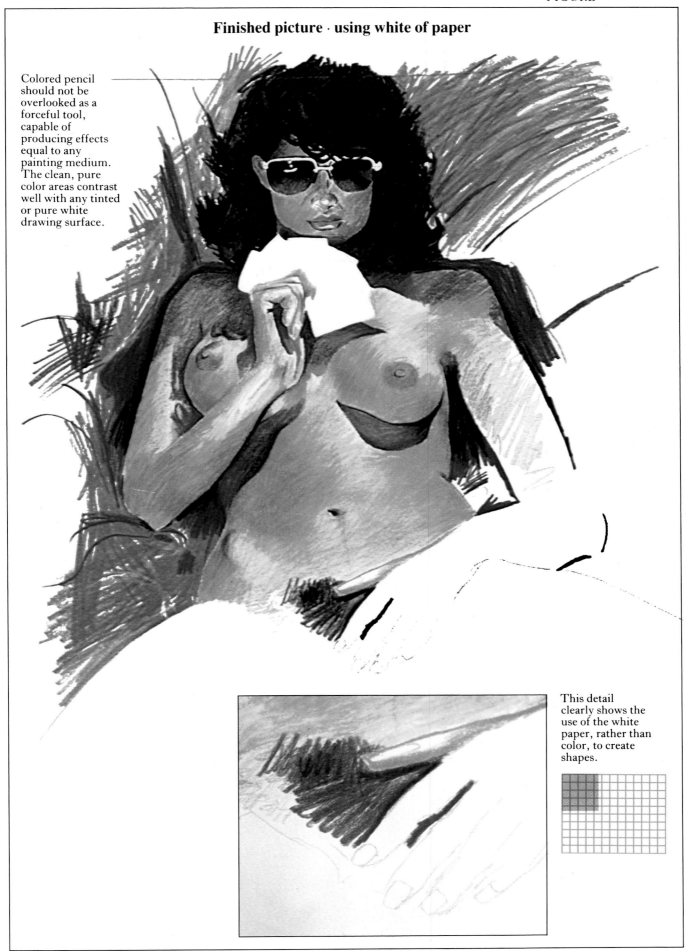

This detail clearly shows the use of the white paper, rather than color, to create shapes.

FIGURE DRAWING IN pencil is one of the most useful skills for artists to acquire and is usually included in the first projects given in art schools.

Interesting variations can be obtained by placing the figure in strong light and shadow. If the effect of the light is to be the main interest of the drawing, the picture must be treated as a tonal study by taking advantage of the patterns of light and shade across the forms.

Large areas of pencil shading can become either boring or messy, so the tones must be developed gradually and the textures varied to define separate forms. The dense grey background area in this drawing is built up with layers of fine, criss-crossed marks, loosely woven together to create an overall tone. The shading on the figure is more solid and close-knit, and the dark tones are contrasted with the bare white paper representing the fall of the light.

Materials

__Surface__
Thick cartridge paper

__Size__
24in × 16in (60cm × 40cm)

__Tools__
HB and 2B pencils
Putty eraser
Fixative

1. To establish the scale, start by making a brief outline sketch of the figure. Work into the shape of the head, laying in the darkest tones.

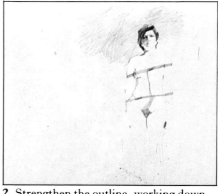

2. Strengthen the outline, working down from the head, and block in dark stripes of shadow cutting across the body. Lay a mid-toned grey behind the head.

Describing tone

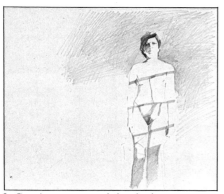 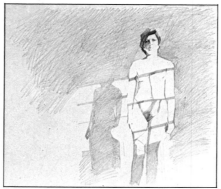 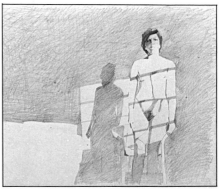

3. Continue to extend the shadow pattern on the figure with dark shading. Develop the background tone, keeping the marks light and loose.

4. Draw into the background behind the figure, lightly outlining shapes with tonal shading.

5. Complete the area of background tone and work back into the shapes of the figure and shadows, building up details in the forms and patterns.

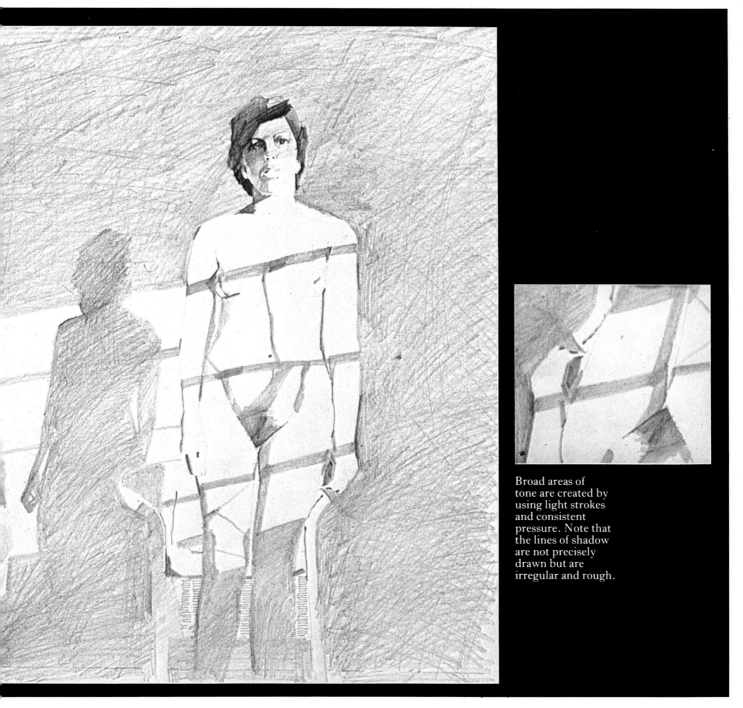

Broad areas of tone are created by using light strokes and consistent pressure. Note that the lines of shadow are not precisely drawn but are irregular and rough.

THE GENERAL impression of this drawing is similar to an old photograph or print due largely to the color of the paper and the soft pencil tones. The picture shows how pencil can be used with a light, subtle touch to create a peaceful, stable atmosphere.

The effect is also similar to the drawings of the French artist Seurat who, by using rough paper and a soft, dark crayon, was able to create tonal areas duplicating the pointillist technique. A rough surface will lessen the linear effect of the pencil and blend tones more evenly than smooth paper.

The artist here depended upon the use of tone to create an illusion of space and depth and, as seen in the head, this can heighten the overall emphasis of the figure within the picture plane. Although most of the page is blank with no indication of the environment, putting the dark shadow area outside the face gives an impression of depth and space.

Materials

Surface
Pumpkin colored pastel paper

Size
16in × 20in (40cm × 50cm)

Tools
2B and 4B pencils
Putty eraser
Tissues
Fixative

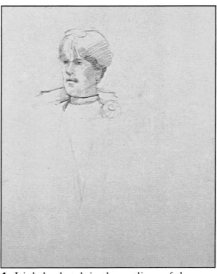

1. Lightly sketch in the outlines of the figure with a 2B pencil.

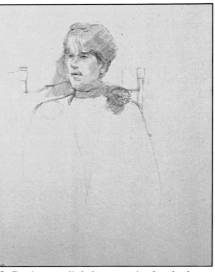

2. Begin very lightly to put in the shadow areas with loose, directional strokes. Add dark details around the neck.

3. Work back into the hair with more pressure, building up darks. Strengthen face and chair outlines.

4. Begin to work outside of the face with very light strokes. Carry this over to the flower shape.

5. Strengthen the shadow areas within the figure. With a 2B pencil, work down the figure, roughing in general outlines and shadow areas.

6. With a 4B pencil, strengthen details of face and flower. With same, darken shadow areas in the dress.

Creating tones with putty eraser

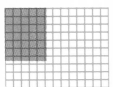

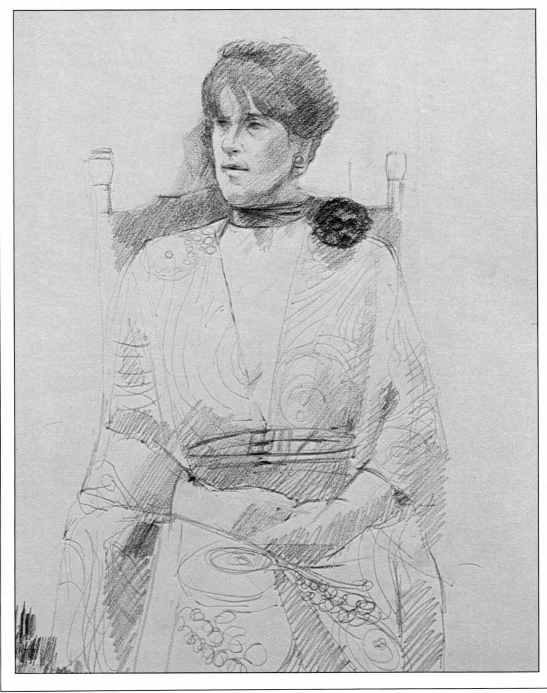

The artist works into the facial details using a combination of grey tones and the clean paper surface to describe shadow and highlight areas.

CHARCOAL IS a most rewarding artistic medium. It gives a characteristic rich, soft black color and a wide variety of textures and tones. However, it is powdery and impermanent, while the drawing may soon become messy and uncontrolled if over elaborated.

Observe the subject carefully as you draw, analysing the shapes and tones, and make your marks decisive and vigorous. Do not attempt to be too precise; a stick of charcoal cannot be as carefully manipulated as the fine point of a pencil, for instance. The best subject is a strong image full of dense tone and calligraphic line. Use a putty eraser both to take out errors and to draw highlights into the loose, black surface. Fix the drawing whenever a stage of the work is successfully completed so that the surface does not become dull and smudgy.

A charcoal drawing on tinted paper can prove particularly effective, especially if white gouache is applied to strengthen the highlights and round out the forms. Use the paint sparingly and keep it free of charcoal dust or it will look dull and grey, deadening the tonal contrasts and producing an opposite effect to the one intended.

Materials

Surface
Tinted drawing paper

Size
16in × 23in (40cm × 57cm)

Tools
No 6 sable round brush
Medium charcoal
Putty eraser
White designers' gouache

Medium
Water

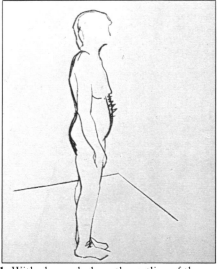

1. With charcoal, draw the outline of the figure with bold, black lines. If necessary, make small corrections or revisions as you work.

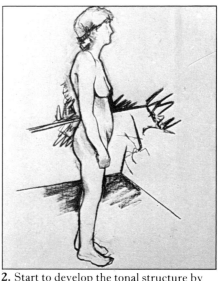

2. Start to develop the tonal structure by spreading the charcoal lightly with your fingers and erasing to make grey tones.

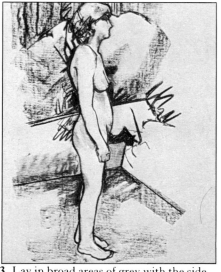

3. Lay in broad areas of grey with the side of the charcoal, using the pointed end to draw into the background shapes with loose, calligraphic marks.

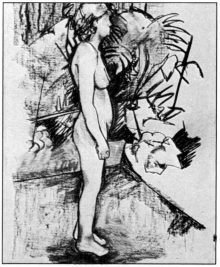

4. Block in small areas of solid black around the figure and strengthen the definition of the shapes and patterns with strong lines.

5. Work over the figure adjusting details and strengthening lines. Use the eraser to lighten greys and bring up white highlights.

6. Apply thin patches of white gouache with a No 6 sable brush to add definition to the highlight areas. Let the paint dry before making finishing touches.

Highlighting with gouache

With a small brush and white designer's gouache, strong highlights are developed in the figure. The gouache is allowed to blend with the charcoal to create subtle grey tones.

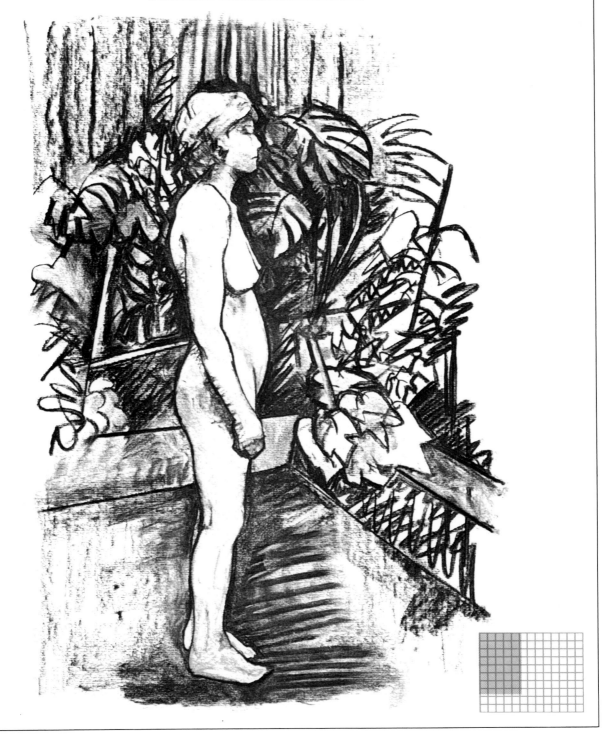

THE OVERALL EFFECT of a drawing executed in pure graphite powder is a subtle, impressionistic one, as if the artist had taken a fleeting glance and quickly described the basic tones and shapes of the subject. Graphite is best used for describing tones, not for creating a highly rendered, detailed drawing. When applied with the fingers, the artist can render the figure in contours and directional strokes which both follow and shape the form.

It is this particular aspect – working in tones rather than line – which gives the medium its unique softness and subtlety. However, pure graphite powder has a slippery quality and, because it is so easily applied to the surface, the artist must avoid losing control of the drawing. If mistakes are made however, they can be easily rubbed out with a rag and turpentine.

When used with turpentine, a range of tones can be created from very pale greys to bold and intense blacks. Coupled with the use of a clean pencil line, the tones of the graphite will lend a soft, atmospheric mood, regardless of subject matter.

Materials

__Surface__
Heavyweight cartridge paper

__Size__
14in × 18in (35cm × 45cm)

__Tools__
4B pencil
Putty eraser
Q-tips
Small rags or tissues

__Colors__
Raw graphite powder
Cerulean blue pastel

__Medium__
Turpentine

1. Dip fingers in bowl of graphite powder and block in general shadow areas. Rubbing harder will create darker tones.

2. With a 4B pencil, rough in figure outlines and further develop shadows within the figure.

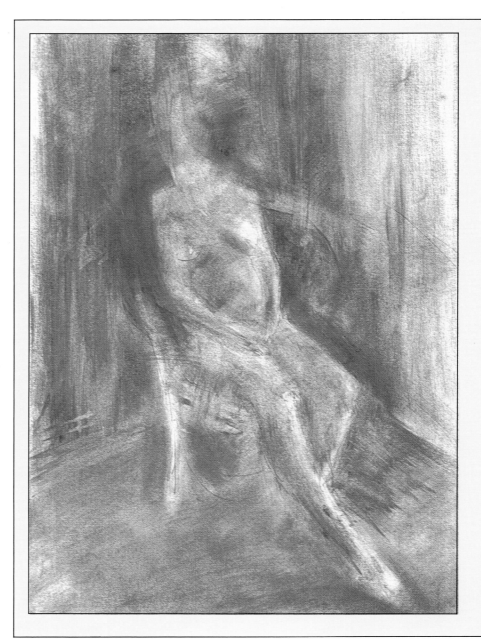

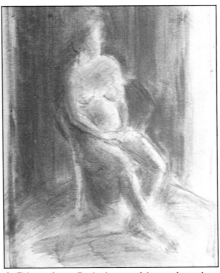

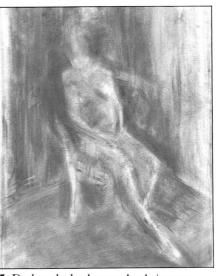

3. Dip a small rag or Q-tip in turpentine and rub on to the surface. Wipe out mistakes or false highlights with a clean rag and turpentine.

4. Dip a clean Q-tip in graphite and work around the figure, darkening the background.

5. Darken the background to bring out light areas. Reinforce figure outlines in pencil. Work around the figure with a rag dipped in turpentine.

Drawing with fingers · blending with turpentine

The fingers are first dipped into the pure graphite powder and then applied directly on to the drawing surface. The pressure and amount of powder will determine the density of tone.

With a small tissue dipped in turpentine, the graphite can be blended and worked to create a variety of tones.

Pen and ink

WHILE PEN AND ink may at first prove uncomfortable and awkward to work with, the artist will soon develop a natural feel for the movement of the pen, the flow of the ink, and which gestures produce which marks. The pen and ink draftsman creates a draw-drawing from the use of the white of the paper, the black of the ink, and the many tones in between these two. These tones are usually created by the use of individual lines of ink which, when laid over one another in various directions, create a mesh-like effect, giving an impression of shadow and depth. Unlike other drawing and painting media, the pen and ink artist is limited to the use of line for developing tone, but, as demonstrated in this drawing, creating a highly modelled, accurate drawing presents no problem despite this limitation.

In this drawing, the artist, with a minimum of detail, has accurately rendered the figure. The simple use of outline and shaded, crosshatched areas alone gives the figure shape, dimension and weight. The tone created by pen and ink can be very subtly varied and need not have a harsh black and white effect, if carefully graduated and controlled. If you look carefully at the area of the hand resting on the knee, you will see that only loose, rough strokes have been used to describe the shadow areas.

Materials

Surface
Smooth cartridge paper

Size
9in × 12in (22cm × 30cm)

Tools
Dip pen
Fine nib
2B pencil

Colors
Black waterproof ink

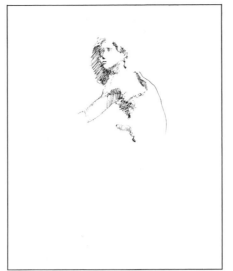

1. Sketch in the figure very roughly with a 2B pencil. Put in general outlines in ink and begin to describe shadow areas.

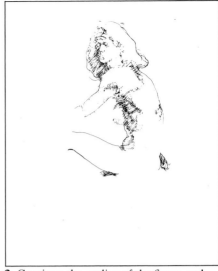

2. Continue the outline of the figure and return to put in shadow areas. Use a hatching stroke to define muscles.

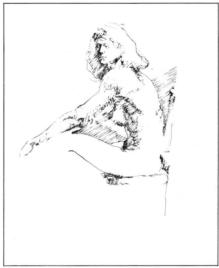

3. Continue outline of the arm. Moving outside of the figure, very loosely put in broad strokes, working in one direction.

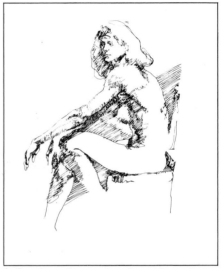

4. Continue down to hands and legs of figure, putting in outlines and then working into shadow areas with light strokes.

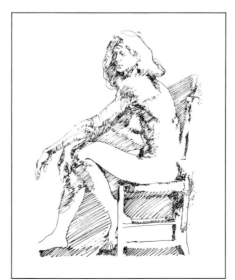

5. Carry background tone down behind the chair using same directional strokes. Leave white of paper bare to define chair shape.

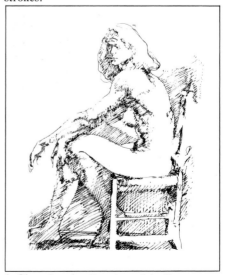

6. Changing the direction of the line, put in general shadow over the leg. Crosshatch over the background shadow to create a denser tone.

Defining shadow areas

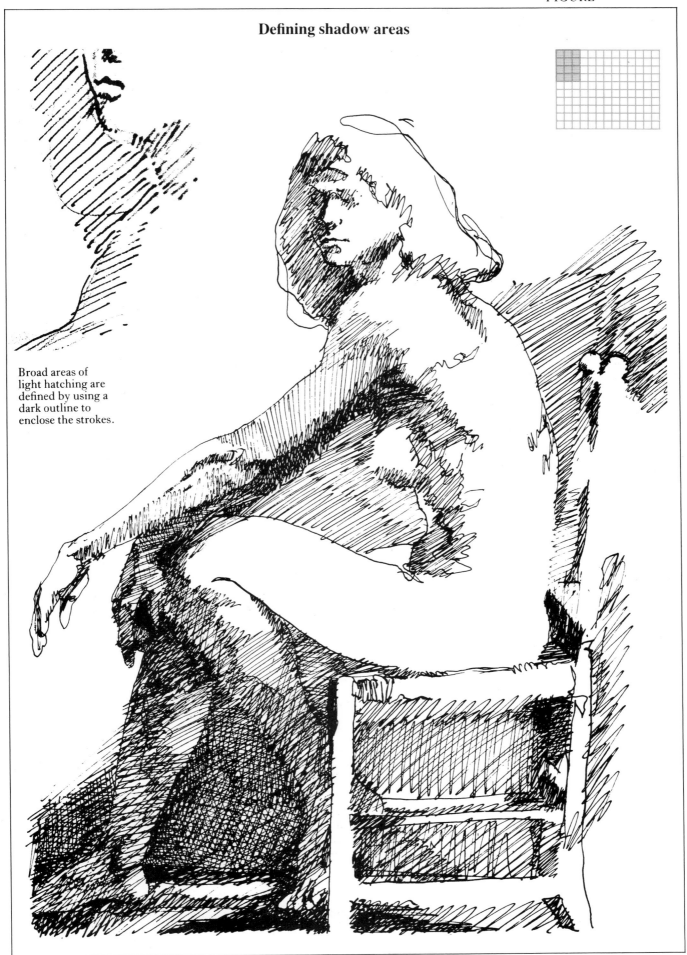

Broad areas of
light hatching are
defined by using a
dark outline to
enclose the strokes.

 WHILE A large variety of commercial pens and nibs are available, it is interesting to experiment with hand-cut pens made from quills or hollow sticks. A thick reed pen is used here to give a bold, fluid line to create a spontaneous image.

Drawing with line will give the basic outlines of the forms; the image is then given volume by loose washes of thin, wet color. A rich surface texture can be built up with this technique so, although only two colors have been used in this picture, a considerable variety of tonal density is achieved.

The intention is not to depict the subject in meticulous detail, but to record a lively impression of the mood and pose which exploits the freedom and diversity of the medium. If the pen is used on dry paper, or over a dry wash it makes a strong, sharp line. When line is applied into wet layers they will spread and feather. Be careful when drawing into a wet area not to tear the damp paper with the point of the pen. Vary the shapes and tones of the washes to provide a contrast between hard-edged shapes and subtly blended tones so that the full versatility of the medium contributes to the overall effect.

Materials

__Surface__
Stretched cartridge paper

__Size__
18in × 22in (45cm × 55cm)

__Tools__
Hollow piece of reed or willow
Knife or scalpel
No 8 round sable brush

__Colors__
Brown ink
Black waterproof India ink

__Medium__
Water

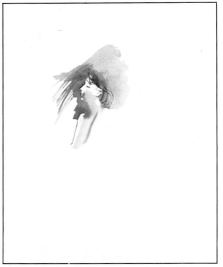
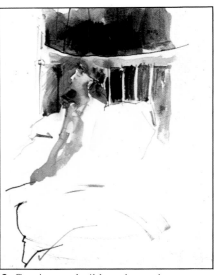

1. Dip the pen in black ink diluted with water and draw the profile of the head. Using a small sable brush, apply thin washes of brown ink.

2. Continue to build up the washes, preserving areas of white. Use the pen to define the linear shapes in the foreground and background.

Making the reed pen · the pen line

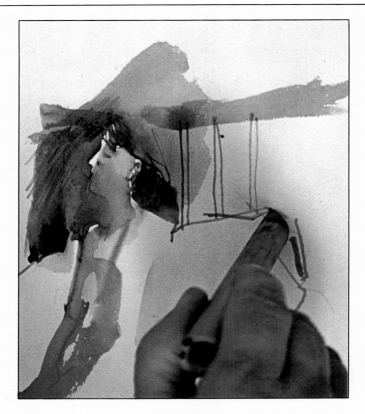

A reed pen can be made from any type of hollow wood. Once roughly shaped, the point is refined with a small knife. The line created by a reed pen is irregular yet soft and produces an effect very suitable for figure work.

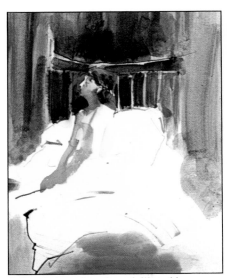

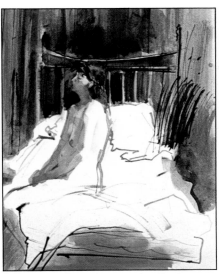

3. Lay in broad washes of diluted brown and black inks, working across the entire picture.

4. Draw the figure in more detail using bold, fluid lines. Enrich the shadows with additional washes of brown and black ink.

5. Strengthen linear detail and dark tones with the pen and brush in black.

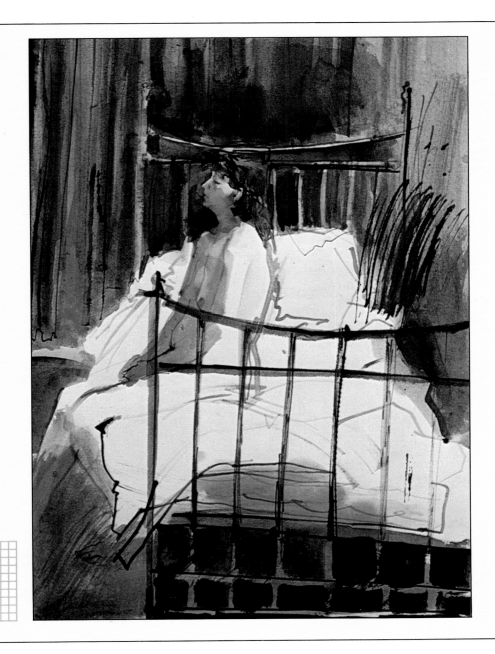

A rapidograph was used for this drawing rather than the traditional pen, nib, and ink as it gives a more consistent line. Thus the artist could develop fine areas of crosshatching without fear of dripping. By leaving the white paper untouched for highlight areas and using hatching and crosshatching to describe shadow areas, the artist has created an interesting drawing.

The rapidograph is a sensitive and temperamental tool. The artist must have a light touch and hold the pen nearly upright to keep the ink flowing. The pen should be shaken frequently in this position to make sure the nib does not clog. The paper used with a rapidograph should have a very smooth surface, otherwise the fine hairs of the paper will rip and clog the nib.

Until familiar with the rapidograph, it is worthwhile to experiment with the various textural effects available. Note that in this drawing the artist has used small areas of crosshatching to build up the shadow area, changing the direction of the line to avoid building it up too densely. A huge variety of textures can be created by simply varying the direction and thickness of the line.

Materials

Surface
Cartridge paper

Size
12in × 23in (30cm × 57.5cm)

Tools
Rapidograph
02 nib

Colors
Black rapidograph ink

1. Carry the outline down the figure with the same consistent pressure.

3. Work over the figure and hair developing shadow areas. Watch the balance of light and dark carefully and move back to judge tones.

5. Work into the face, and with a very light stroke, put in the shadow areas.

2. Begin to develop the shadow area in the elbow by lightly hatching and crosshatching in small areas, working the line in different directions.

4. Put in dark areas of the chair seat with dense crosshatching.

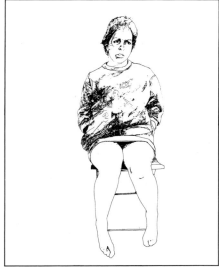

6. Continue to work on the shirt and head, heightening dark areas by overlaying strokes in different directions.

Crosshatching to create tone

Whether a
rapidograph or
traditional dip type,
the pen relies on the
use of line to create
tone and texture.
Here the use of fine
lines of hatching and
crosshatching are
being used to create
subtle tones and
shadow areas.

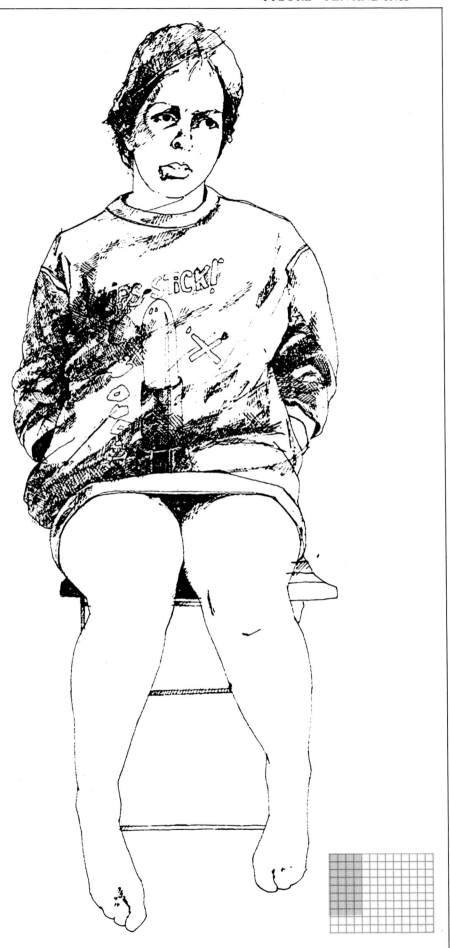

Portrait

IN SPITE OF the old adage that the face reflects the soul, the foibles, failings, and weaknesses of man are not usually shown openly in the portrait. The reason for this, of course, is that the sitter, or whoever commissions the portrait, invariably wishes to present his or her best appearances, as the actor will insist on the camera catching his 'good side'. In spite of this, the true portrait artist – as opposed to the photocopyist – will often show depths of character and shades of cunning or synthetic emotions better than any other means of making a likeness of the sitter.

Likeness is an indispensable part of portraiture, but by no means the whole story: qualities of color can aid the feeling of the spirit of the sitter; intelligent composition can render frailty or pompous bulk.

The self portrait

Because the history of portraiture is studded with so many fine gems, to find one's own language, to avoid the pitfalls of sentimentality and deadness, is often difficult. Many artists use the self portrait as a way to guarantee a consistent model and to allow a subject for experiment, both with descriptions of form and the way

of approaching problems.

Throughout the centuries man has ventured to create images of himself, often using the self portrait as a background figure or as a character in animation. The self portrait as an art form, in its own right, was taken to very high levels of achievement by Rembrandt, Van Gogh, and Cézanne, all of whom used it to discover their personal means of picture making. It remains an extremely useful way to gain knowledge and will give aspiring portraitists valuable opportunities to experiment and risk making mistakes.

The support

When setting out to make a portrait, it is important to consider the shape of the support upon which the picture will be made. A subject painted full length does not necessarily demand a tall, thin canvas for it may be that the figure will be better seen or the character better expressed by putting it alongside other objects. This is a way to increase interest in the composition; the tendency to place the sitter in the middle of the picture and fill in the background often creates boring images. A study of the portrait paintings of old and modern masters from this point of view will reveal a good

Bone structure. Left: to right: The female skull is smaller than the male with less pronounced forehead and chin. The male skull has a strong jawline and forehead. The child's head is largely undeveloped. With age, bone deteriorates.

Expressions. Expression is created by the tensing and relaxing of muscles. Left: A worried expression is altered by an overhead light source. Right: The smile creates a turning upward of all features, most notably the eyes and forehead; the frown causes the opposite.

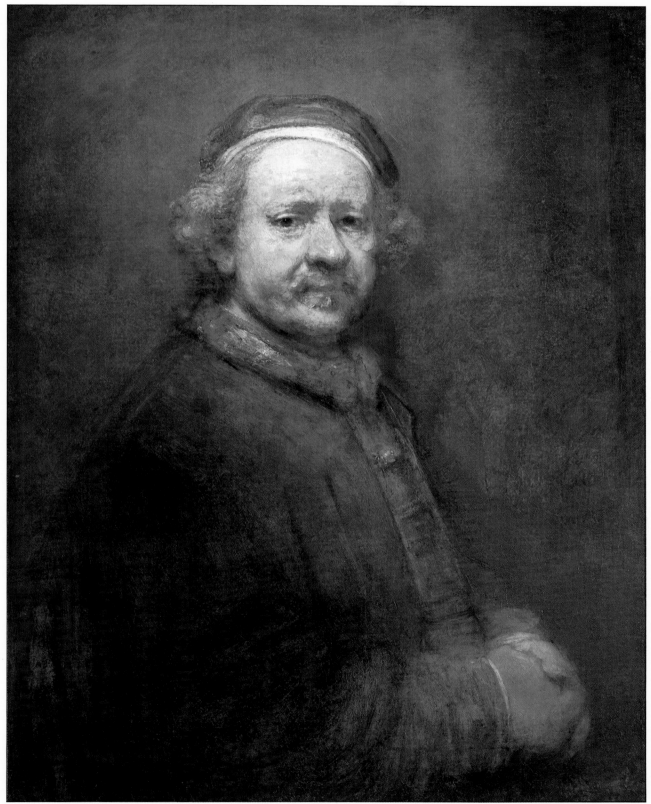

Rembrandt van Rijn, 'Self Portrait'. Rembrandt's series of self portraits are renowned for their technical skill and ability to depict a sombre and intense atmosphere.

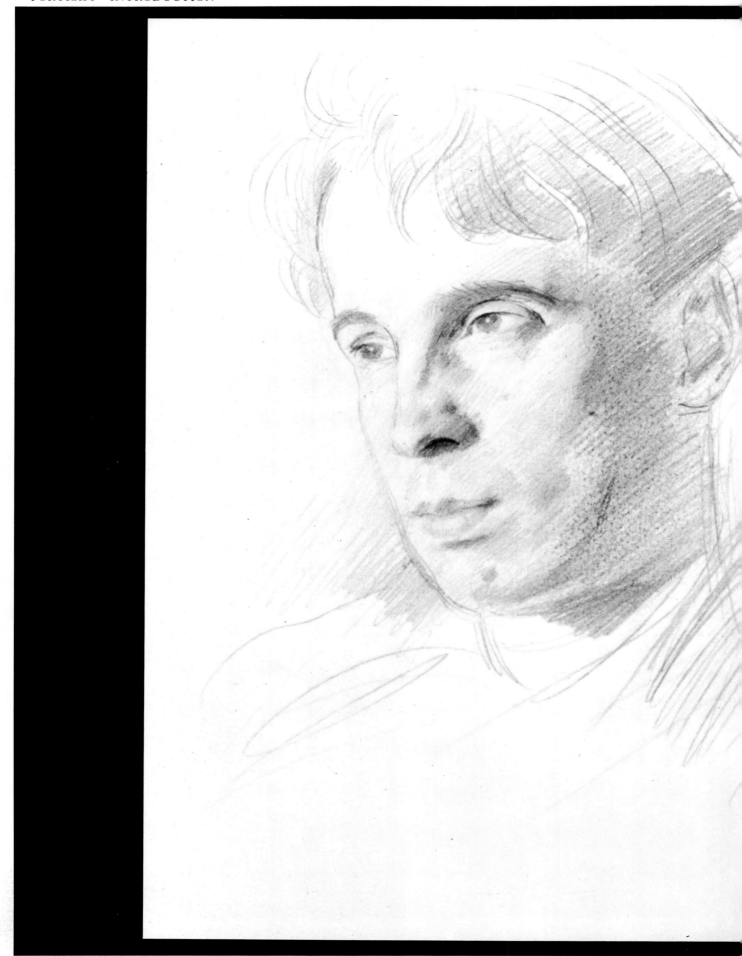

A successful portrait can be achieved with either a quick, informal sketch, or an elaborate oil painting. Left: In this pencil sketch by Augustus John, we see how the skilled handling of tone and line capture the mood and personality of the sitter. Above: The 'Laughing Cavalier' by Franz Hals, although elaborate in the use of detail and ornamentation is nonetheless successful in portraying the personality of the sitter.

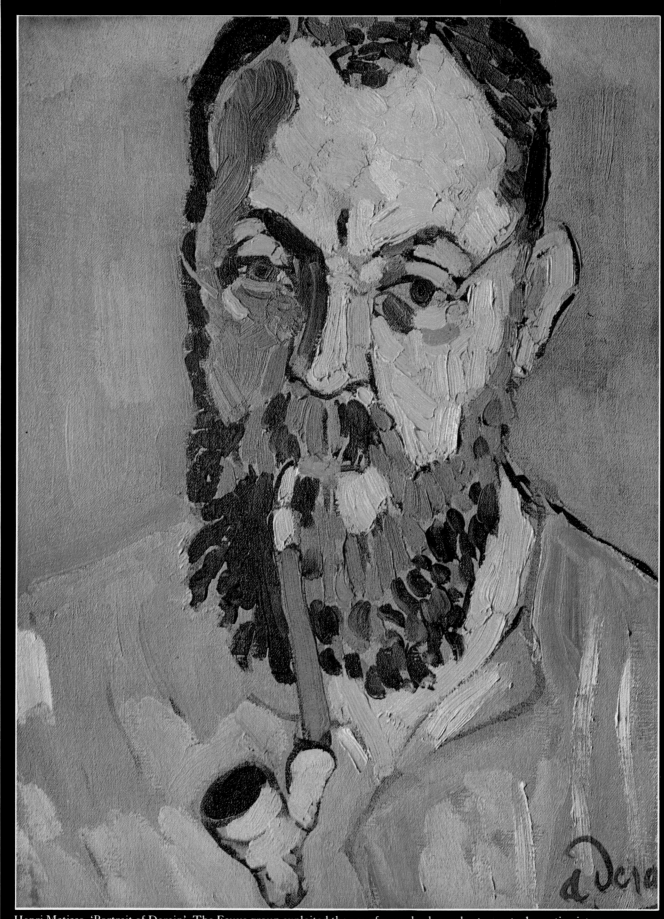

<u>Henri Matisse,</u> 'Portrait of Derain'. The Fauve group exploited the use of pure, broken color to create dramatic pictures.

deal of the mechanics of picture construction.

Color

Color will always be a challenge to the portraitist. At first sight it would appear that a portrait would be dominated by flesh tones. This, though, is not always the case as witnessed in the portraits by Derain, Matisse, and the candle-lit flesh tints of a de la Tour. By deciding upon a color idea – that is, a scheme of color that both harmonizes and reflects the feelings one has towards the subject – the picture will get off to a good start. An elegant lady with jewellery and silks will need a different color idea than that used in painting a baby or the noble head of an old man. Flesh itself varies in color a great deal from the pink blush in a Fragonard (1732–1806) to the dry tints in a Wyeth, or the modulated tones in a Franz Hals (1585–1666).

To experiment with the mixtures that might result in descriptive flesh tones is essential, and to use a mixture of techniques desirable. Limited palettes for flesh painting have always proved most successful. A good, general palette that will mix in several ways would consist of yellow ochre, light red, terre verte, cobalt blue, and flake white. By mixing the yellow and red with perhaps a touch of terre verte or blue, a good general tint will be achieved. By using this limited palette discoveries will be made as to how red and blue, or blue and green, or any other multi-mixtures, will correspond to the colors seen.

Shadows should be carefully analysed so that when painted in they are never simply a darkened version of the general color in the lighter areas; each each shadow has its own color and tone. The shadows in the face and hands or any other flesh areas will be affected by external colors being reflected into them. Thus, the shadow on a nose might well have a green cast to the color whereas the darker, warmer tones beneath the eyebrows might contain a purplish-brown. By experimenting with both the 'reflected' shadow colors and the local, lighter colors, one will discover the value of understanding and using the various color theories.

Drawing media

The pencil has long been regarded as excellent for portrait drawing. Ingres was an artist who demonstrated consummate skills in this medium, able at once to describe character, clothing, and often bring the whole picture into context with the briefest description of background. As an alternative to this, the hatching method has much to commend it. By using a hard pencil to sketch in the basic shapes and proportions, and using progressively softer leads to mass in the shadows and tones and describe details, control can be sustained throughout the drawing process.

With pen and ink, using diluted ink and gradually strenthening the density of tones to build up the face and costume is a useful method of tackling portraits. Charles Keene, a contemporary artist, makes use of a wide range of marks with great subtlety, whereas Phil May, another 20th century artist, used the pen line in a more direct, linear way, involving a thrilling calligraphic line. This means requires practice and experience. Try using solid areas of ink to suggest 'color' as in hair mass or boots, contrasted with a smooth, flowing line.

Positioning. Placement of the figure is important in all picture making. Here the figure has been dropped below the center-line bringing the observer's eye into the subject.

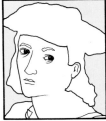

Classic view. The three-quarter view is the traditional pose for portraiture. This has been used extensively because it incorporates as much of the full face and profile of a figure as possible

The profile. The profile was more common in the past than today. It can be a difficult pose to capture and care is required to avoid flatness. It is useful to include some of the figure as well.

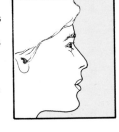

Direction. This too is a very important factor in all painting and drawing. Notice how the downward glance of the figure tends to lead the observer's eye downward as well.

Background. The background of a portrait can add a great deal to what the artist is attempting to say about the sitter.

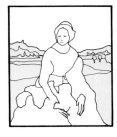

A new element. Introducing another element into a portrait – in this case the sitter's hand – can often enliven a picture. Note how the hand supports the head giving a feeling of stability.

Oil

IN ART HISTORICAL terms, the technique of working on a stark, white canvas is a recent development made popular by the Impressionists of the last century. Before that time it was customary to work on a colored ground, made either by mixing pigment into the priming coat or laying a thin wash of color over a white base. The purpose of this was to establish a middle tone over which to work with light and dark colors and to give the image a warm or cool cast.

The red priming used in this painting is a powerful color which radically affects the whole character of the painting. The forms are constructed with a variety of greys; those which tend toward blue or green are emphasized on the strong red ground, and pink and yellow flesh tones pick up the warm glow of red which breaks through. Although the palette is limited, the relationships of the colors are vibrant and active. You will need to pay close attention to both the subject and the painting to achieve a lively but controlled result.

Use thick, dry paint and keep the brushwork loose and open so the red is seen through the broken color. Stiff bristle brushes are effective for this if handled lightly and vigorously. Keep the paint dry, adding only a small amount of turpentine, or the colors will flood the surface and deaden as they dry out.

Materials

Surface
Canvas primed with red oil-based primer

Size
30in × 26in (75cm × 65cm)

Tools
Nos 3, 6, flat bristle brushes
Palette

Colors
Black
Chrome yellow
Cobalt blue
Foundation white
Oxide of chromium
Permanent rose

Medium
Turpentine

1. Use a No 6 bristle brush to block in the basic shape of the figure in white. With a No 3 brush, sketch in the outline and lay areas of light tone.

2. Mix two tones of grey from cobalt blue, black and white. Work over the whole canvas in thin patches of color.

3. Develop the dark tones around the hat, shoulders and neck. Add a little yellow to the greys and block in the tones behind the head and in the hat.

4. Work into the face and neck with a light greenish-grey, roughly mapping out the features. Build up the structure of the image, with detail in the hat and collar.

5. Develop the color in the face using cool blue-grey contrasted with a warm flesh tone mixed from yellow, rose, and white. Indicate features with light marks.

6. Draw into the features with dark red, black and white. Block in light tones on the shirt with solid grey and white.

7. Work over the whole image with thick paint developing the tonal structure with warm greys in the foreground and light grey-green in the background.

8. Work over the figure with a No 3 brush, dabbing in color to refine details and add definition to the features.

Finished picture · outlining in white · scratching back

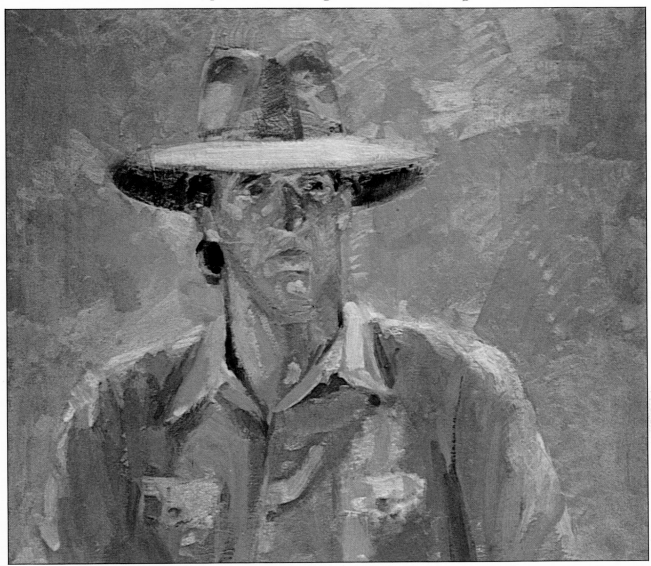

By completion of the painting, (<u>above</u>) the strong red underpainting is almost completely obscured, yet its subtle influence can be seen in the warm cast of the image.

Using the end of the brush, the artist is here scratching back through the wet paint layer to allow the underpainting to break through to the surface.

Using undiluted white paint, the artist roughs in the general composition and figure outlines over the dry red underpainting.

ONE OF THE most interesting aspects of this painting is how few colors were used to effectively render the subject and its environment. The artist has relied only upon tones of burnt umber, burnt sienna, ochre, and white for almost the entire painting. This stresses the wisdom of the artist familiarizing himself with the many color mixes that can be attained from using a limited palette. The knowledge gained from working in this way is greater than using a variety of colors as the same principles apply to using many colors as to using a few. Thus the knowledge and experienced gained by using a limited palette can later be used with any number of colors.

The strength of the picture comes not only from the simplicity of the palette, but from the composition as well. This is – as any successful composition should be – not obvious, but has the subtle effect of directing the viewer's attention where the artist intends it to go. The artist intentionally left a great deal of space around the figure. Coupled with the pale strip down the right hand side and the off-centre placement of the subject, the viewer's eyes are drawn directly into the figure.

Materials

Surface
Primed cotton duck

Size
23in × 30in (57cm × 75cm)

Tools
HB pencil
Nos 2 and 4 flat bristle brushes
No 5 sable round watercolor brush
1½in (3.75cm) housepainting brush
Fixative
Palette

Colors

Black	Raw sienna
Burnt sienna	Scarlet lake
Burnt umber	White
Cobalt blue	Yellow ochre

Medium
Turpentine

1 Begin to block in shadow areas in burnt and raw sienna with a No 5 sable brush. Add white to the sienna and work into the eye area in detail with a No 2 brush.

2 Continue to block in the shadows of the face with a thinned mixture of burnt umber and white.

3. Continue to block in highlight areas with white and ochre. Add a touch of scarlet lake to warm the flesh tones.

4. Put in mouth details with the No 2 brush and scarlet lake, yellow ochre and white. Add touches of highlight in the ear. Blend again with a clean, large brush.

5. Begin to lay in the pattern of the jacket with loose strokes of burnt umber with a No 4 brush. Rough in the outline of the arm and scrub in the shadow area.

6. Next block in lighter jacket areas in yellow ochre. With a 1½in (3.75cm) housepainting brush, blend tones together. *(continued overleaf)*

Initial drawing · modelling face · blending highlights

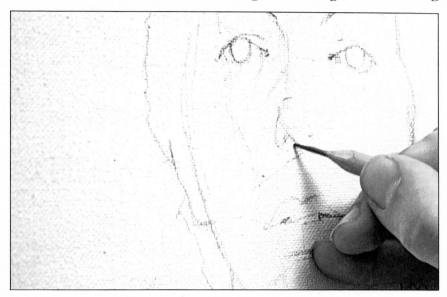

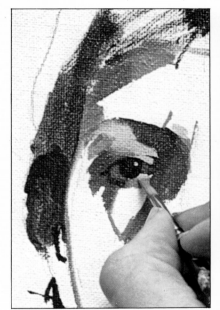

The figure is first drawn in with light pencil strokes (top) including as much detail as possible. Using a small sable brush and warm and cool flesh tones, the artist begins to model the face of the figure (above) working from one point outwards. Moving downwards, larger areas of highlights are blocked in and then blended into surrounding areas with a dry, clean brush (right).

Coat pattern · working inside and outside the figure

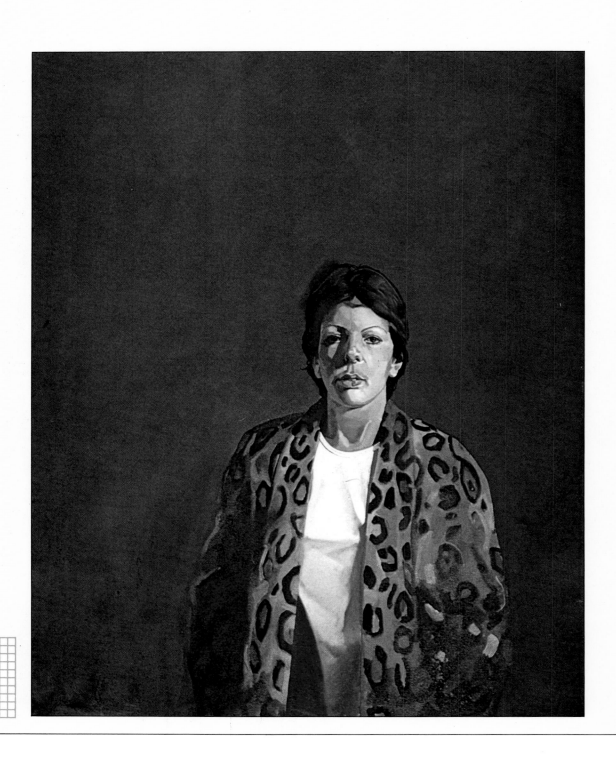

Coat pattern · working inside and outside the figure

To create the pattern of the coat, the artist first describes the lighter pattern and fills in the white areas with a darker tone. Then, with a clean, dry decorators' brush, the colors are blended together with a feathering motion, the brush just lightly touching the surface.

Working outside the figure (above), the background is roughed in with the decorators' brush. A clean edge between background and figure is obtained by using a smaller brush and background color. Moving into the figure (left), the shirt is carefully described in tones of grey and white.

7. Continue to define the pattern in burnt umber and fill in with yellow ochre. Darken shadow area around collar. Block in the right side with burnt sienna.

9. With a No 4 brush and grey paint, block in the shirt. With burnt sienna, raw umber, and the housepainting brush, cover the background area.

11 Work back into the right side of the jacket with gold ochre, scrubbing in highlight areas.

8. Continue to put in the pattern in burnt umber and yellow ochre. Mix scarlet lake and yellow ochre for the highlight areas. Rough in the shirt shadow in grey.

10. Smooth out the background with the housepainting brush and a lighter brown made from burnt umber and white.

12. Block in the pattern with the no 4 brush and burnt umber.

THE PORTRAIT shown was executed quickly. However, because a very rich mixture of paint and oil medium was used, the painting had to be allowed to dry thoroughly between stages to avoid muddying the colors and surface.

The artist was chiefly concerned with the fine details of the painting – for example the model's features – until the final steps. In these last few steps broad, general areas of the figure were tightened up and the final detailed touches – those which turned the work from a figure painting into a portrait – were put into the painting.

The subject was never treated as a series of parts – face, torso, legs and arms – but was always considered as a complete unit throughout the painting process. Thus, if the artist applied a highlight in the face, he might very well use this same color in the dress and hands. This method of painting unifies the image by the use of similar colors placed throughout the figure. As well, it prevents the artist from seeing the subject as a number of parts, but as a whole unit in which every area – no matter how small – directly affects every other area.

Materials

Surface
Prepared canvas board

Size
14in × 18in (35cm × 45cm)

Tools
No 6 flat bristle brush
No 4 sable round brush
Palette

Colors
Alizarin crimson	Cobalt blue
Black	Terre verte
Burnt umber	White
Cadmium red light	Yellow ochre

Mediums
Turpentine
Linseed oil

Blending with fingers · describing hands

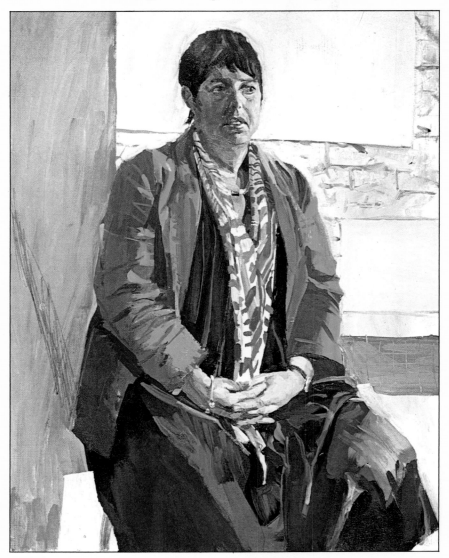

The artist has purposely avoided using small areas of detail except in the face of the model. Details are not always needed to accurately and effectively render a subject, as seen in the sitter's hands.

1. With red, yellow ochre, and a mixture of blue and alizarin crimson, block in the general color areas of the figure in a thinnish wash with a No 6 brush.

2. Add white to these colors and block in the lighter areas of the figure with long strokes. Using the color of the skirt highlight, put in the strip on the left side.

3. Block in the hair with burnt umber and a No 4 sable brush. Mix terre verte, white, and linseed oil and loosely put in general facial features. Blend left side of coat.

4. Using cobalt blue and black, work into the dark shadow areas of the skirt. With the same tone, loosely block in shadows on the left side of the shirt.

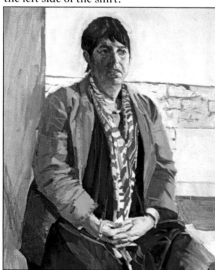

5. Mix white, terre verte, and a small amount of cobalt blue and block in grey area to left. Work into the left side of the face with terre verte and white.

6. Put in scarf details in blue and white. mix grey tone and put in brick details behind figure. Touch in dark details of face and skirt highlights.

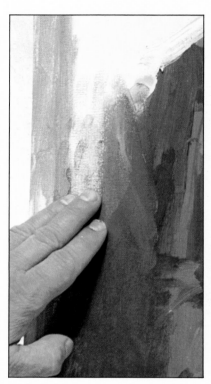

Rather than using a brush or rag, the artist is here using his fingers to blend the figure's shoulder into the background. Blending with the fingers produces a subtle, smudged effect unobtainable by other means.

WHILE A SUCCESSFUL portrait is never an easy thing to achieve, there are certain techniques which will facilitate the process.

In terms of capturing a likeness, the key to a successful portrait is to make sure that the first basic step – the preliminary drawing – is as accurate as possible. If the features are not correctly positioned and described at the outset, there is little chance of success and the artist will find himself repeatedly laying down paint, scraping it off, and reworking in an attempt to correct the original drawing.

Once the preliminary work is as accurate as possible, do not be over-concerned with details. The most important thing at this stage is to check and recheck the positioning of the features while you work. A face is not made up of a series of individual parts; always judge distance and relative size by comparing one feature to another.

If you work in thin rather than thick washes of color, there is less danger of building up the paint surface too quickly. It is easier to correct and revise thin layers of paint then thick. Work in light-dark and warm-cool tones and keep the palette as simple as possible. The artist here used a minimum of colors, with the addition of white, to successfully capture the subject of the portrait.

Materials

Surface
Prepared canvas board

Size
9in × 10in (22.5cm × 25cm)

Tools
No 6 flat bristle brush
No 4 round sable brush
Palette

Colors
Burnt sienna
Burnt umber
Cadmium red deep
Gold ochre
White

Mediums
Turpentine
Linseed oil

1. With a No 4 sable brush and a wash of turpentine and burnt umber, block in outlines, facial features and the start of the background.

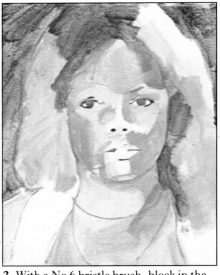

2. With a No 6 bristle brush, block in the hair in gold ochre and background in thinned umber. Use burnt sienna and white for the face tones.

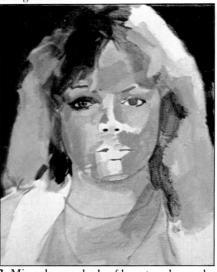

3. Mix a deeper shade of burnt umber and paint over background. Work into the hair. With burnt sienna and white put in shadow areas on right.

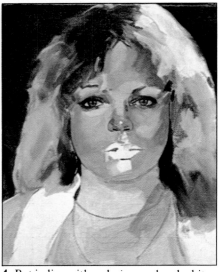

4. Put in lips with cadmium red and white mixture. Put in touches of dark shadow with the sable brush and burnt umber.

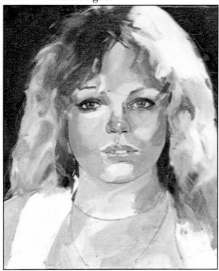

5. With pure cadmium red, paint in the necklace. Mix warmish tones of burnt sienna, red and white and work over the face, blending in the paint.

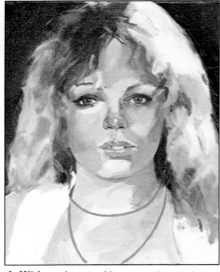

6. With a mixture of burnt umber and white, re-define the facial planes with even strokes. Mix white, cadmium green and yellow ochre and cover in the background.

Hair shadows

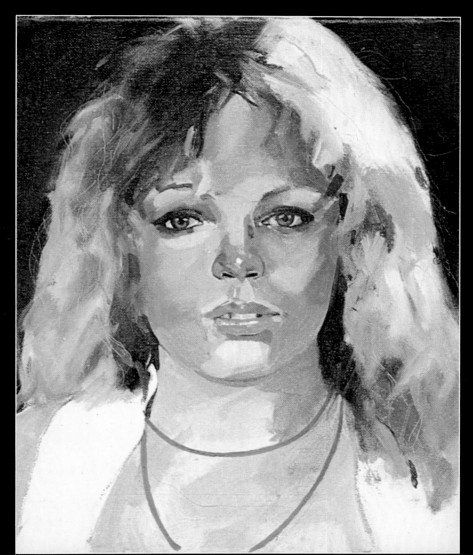

Shadow areas in the hair are put in with fluid brushstrokes and a neutral, mid-toned grey.

THE TECHNIQUES USED for this portrait demonstrate an oil painting method which is essentially direct and spontaneous both in the drawing and application of color. As the painting was completed in only two sittings, the paint had no time to dry. For this reason the artist would occasionally blot the painting surface with a rag or sheet of paper to lift excess moisture.

A color photograph rather than live subject was used for the painting, but the information supplied was used only for the groundwork of the painting and the end result is not a straight-forward copy. Photographs tend to flatten subtleties of tone and color, so it is necessary to add to the image by strengthening or even exaggerating certain elements. In this example, the background color and patterns in the clothes were altered as the painting progressed.

Work rapidly with stiff bristle brushes to block in the overall impression of the image, using the brushmarks to indicate the structure and texture of the forms. Small sable brushes are more suitable for adding fine points of detail. Experiment with colour mixes on a separate piece of paper or board to find the right tones for subtle flesh colours and shadows.

Materials

Surface
Primed hardboard

Size
12in × 18in (30cm × 45cm)

Tools
No 3 flat bristle brush
No 5 sable round brush
Newspaper
Palette

Colors
Alizarin crimson	Ultramarine blue
Black	Vermilion
Cadmium yellow	Van Dyke brown
Chrome oxide	White
Cobalt blue	Yellow ochre

Mediums
Turpentine
Linseed oil

Face shadows · eye details · blotting

While the paint is still wet, the artist cleans up the facial area where background color has run over with a small piece of rag and turpentine.

If the paint surface becomes too wet to work on, a piece of newspaper or absorbent towelling can be laid over it, lightly pressed, and lifted off. Be sure not to press too hard or to move the paper on the surface.

With a small brush and a middle flesh tone, the artist begins to work into the details of the eye over the dry underpainting. Note how the underpainting shows through the paint.

1. Use brown and blue to make a neutral color and outline the basic shape of the face and features with a No 3 bristle brush.

2. Start to define warm and cool color areas with flesh tones, dark yellow and brown. Strengthen the background color and cover the entire background area.

3. Spread the paint in the background and lighten highlight areas with a dry rag. Use dark colors and flesh tones in the face, using the No 3 bristle brush.

4. Paint shadows on the head and neck with dark red and work over the hair and beard with greenish-brown.

5. Build up shadows and highlights in the face and hair using small dabbing strokes to blend the colors. Darken the left side of the background.

6. Blot off the excess paint from the whole surface with a sheet of newspaper. Applying the paint more thickly, build up the dark tones.

7. Use a No 5 sable to apply highlights of light yellow and pink. Paint the jacket with a thick layer of light color.

8. Work over the whole image, blending the colors and redefining the forms. Give the shadows a slightly cooler cast with thin overlays of yellow ochre and brown.

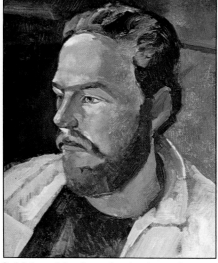

9. Make a thin glaze of red paint, using an oil medium, and work over the flesh tones. Strengthen the highlights with thick dabs of white paint. *(continued overleaf)*

261

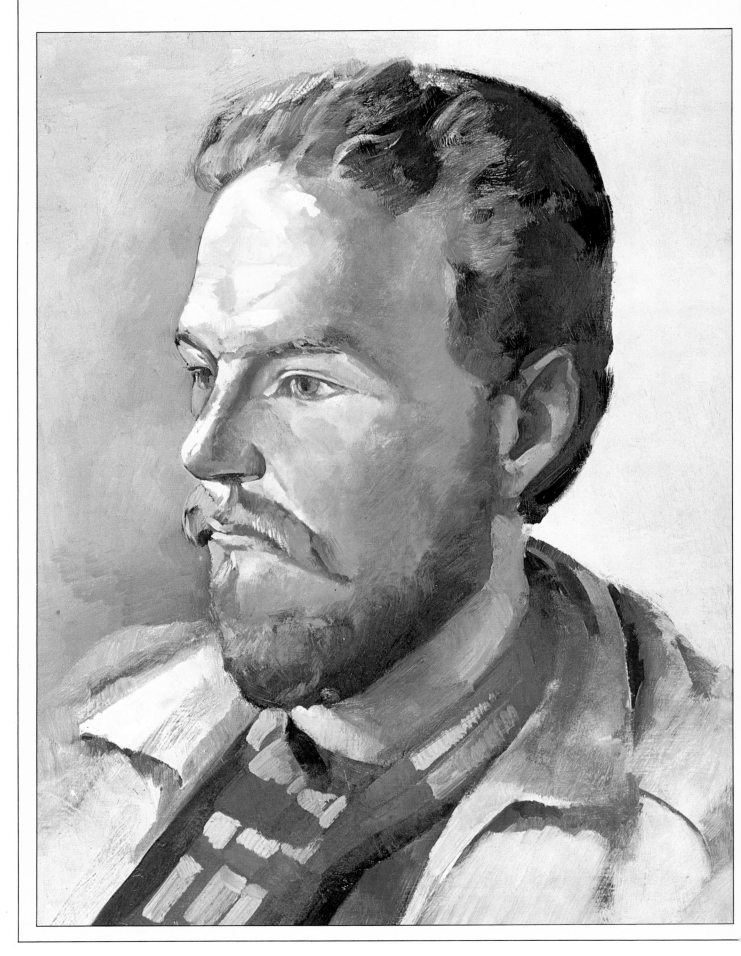

Finished picture · shadows and highlights

As a final step, the artist decided to put a scarf around the man's neck (left). This provides an interesting contrast to the face and liveliness of the image.

With a fine sable brush, the artist develops the shadow and highlight areas around the eye.

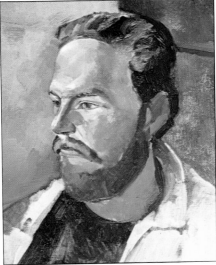

10. Lighten the color of the background, at the same time correcting the outlines.

Small touches of highlight and shadow are put in with a small brush in the final stages of the painting. Here the artist defines the model's ear.

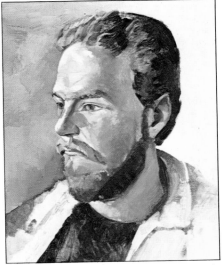

11. Alter the tone of the whole background area, leaving a darker shadow at one side of the face.

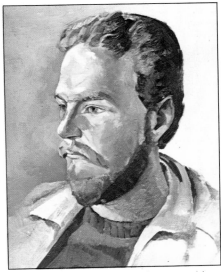

12. Using the background color as a guide, make adjustments to the tone and color over the entire image, blending the paint with light strokes of the brush.

PAINTING A PORTRAIT in profile, as opposed to the traditional full-faced approach, can yield interesting results. When working in this way, however, there is a danger of producing a flat and predictable picture. A bare profile against a plain background can easily become simplistic and uninteresting to look at.

In this painting, the artist has avoided this in two ways. The face has been modelled with a textural and tonal complexity which overrides the simplicity of its shape and position on the canvas. The details of the hair, being the only part of the picture to incorporate fine lines of color, serve to bring the observer's eyes into the face. Curving downward and to the right, these details bring the eyes repeatedly into the subject area.

The artist has also exploited the dark blue background to heighten the lighter, warmer tones of the face and set off the profile in sharp contrast. The sitter appears to be cast in a strong, direct light, the source of which is unknown, and therefore the painting becomes more interesting to the viewer.

Materials

Surface
Prepared canvas board

Size
12in × 15in (30cm × 37.5cm)

Tools
Nos 2 and 4 flat bristle brushes
Palette
Palette knife

Colors

Black	Scarlet lake
Burnt sienna	Ultramarine
Burnt umber	White
Cadmium red medium	Yellow ochre

Mediums
Turpentine
Linseed oil

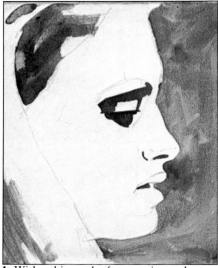

1. With a thin wash of turpentine and burnt umber, block in the shadow areas in hair and background. With a No 2 brush, establish facial features.

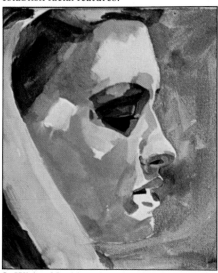

2. With a No 4 brush, mix a loose wash of cadmium red, umber and white and block in the red tones of the face. With yellow ochre and white, define highlight areas.

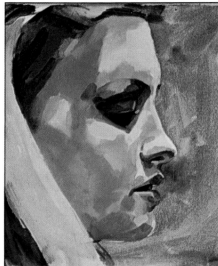

3. Mix black, white and a touch of burnt umber and put in the shadows around the eyes with the No 2 brush.

Finished picture

A profile can produce a strong, vibrant portrait as seen in the finished painting. Care must be taken to balance the bold outline of the profile with the background.

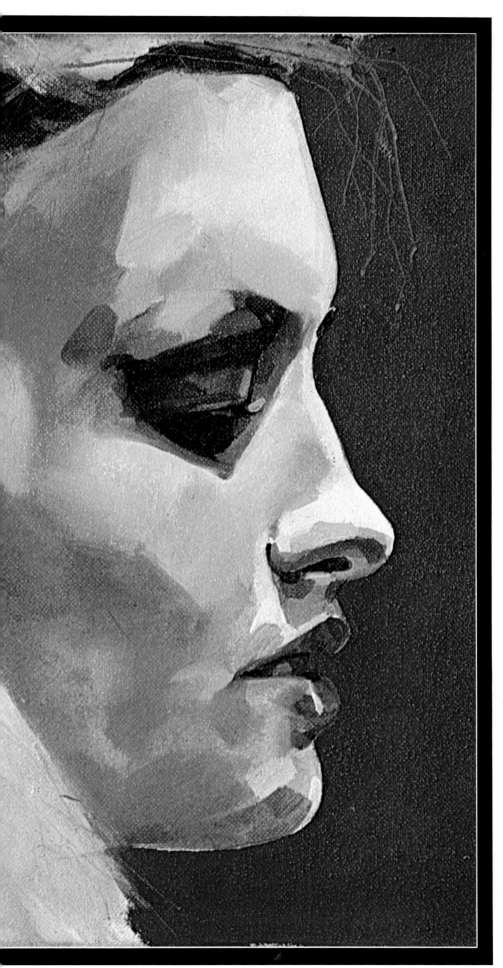

4. With white and a small amount of red, blend in warm highlights on cheek bones, forehead, and nose. Lay down color and blend with a clean, dry brush.

5. Mix umber and white and, with a No 4 brush, model in shadow areas of the chin, blending the edges into the previous layer.

6. Mix a wash of blue and black and, with a large brush, cover background area. With a small brush and white and yellow ochre, put in hair details.

265

A CLASSICAL technique was used to create this painting. The artist began by loosely blocking in the general warm and cool areas and building them up, constantly modifying and adjusting the tones to create a harmonious color balance. Note that the warm tones are contrasted with small touches of green, and the finished painting has an overall atmosphere of coolness.

The composition also follows classical lines, with the traditional triangle placed firmly in the centre of the picture plane. The figure is heavy and immovable and has a solidity which allows the artist to indulge in fine, delicate details within the face.

It is worth noting the various changes and alterations which took place during the painting process. Note in particular that the artist altered the tone of the background from a greenish white to a darker green, and then back again to the original color. Such a change of mind is not unusual in the painting process and it is rare for an artist to keep the first colors or shapes decided upon. The only way to find out if a color is right is to put it into the picture confidently, and then modify or change it to suit the painting as a whole, if necessary. This process of modifying and altering should take place continuously as the painting develops.

Materials

Surface
Prepared canvas board

Size
18in × 14in (45 × 35cm)

Tools
No 2 sable brush
No 3 and 5 flat bristle brush
Palette

Colors

Black	Cadmium red
Burnt umber	Cobalt blue
Cadmium green	White
Cadmium red light	Yellow ochre

Mediums
Turpentine
Polysaturated linseed oil

Finished picture · blocking in highlight areas · correcting

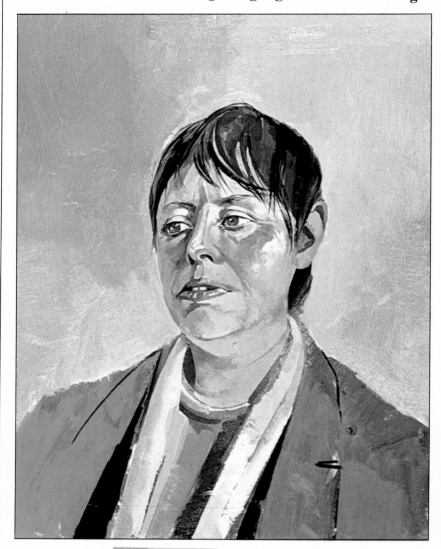

With a clean, dry rag, the artist wipes back an unwanted area. This can then be cleaned with cotton dipped in turpentine and immediately reworked.

When the underpainting has dried, the artist blocks in strong highlight areas with shades of white. These areas are then toned down and modified by subsequent colors blended into the white.

1. With red, ochre and white, create general color areas of the face. Scrub in pure white around the head and draw the features in black with a No 5 brush.

2. Lighten the background area with white, black, and pale grey. With white and yellow ochre define general highlight areas of the face with a No 3 brush.

3. With cadmium red medium, block in the shirt. Using the same tone, develop warm color areas of the face, blending into the previous paint layer

4. Work back into the face with cadmium red, yellow ochre and white, painting over previous white areas and blending.

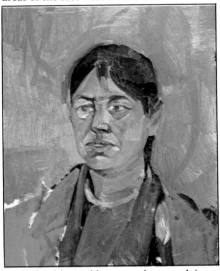

5. With white and burnt umber, work into shadow and dark detail areas. Mix cobalt blue, white, and black and block in the background with a No 5 brush.

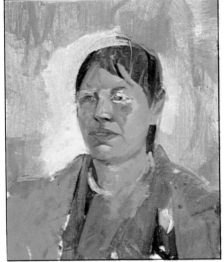

6. With a warmer, lighter shade of white and cadmium red, blend features and details of face. Smooth out background with white and large brush.

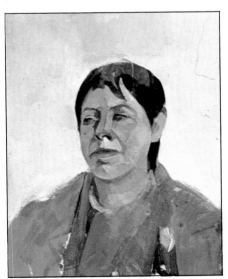

7. With burnt umber and white, redefine planes of face with even strokes. Mix white, cadmium green and yellow ochre and thickly cover the background.

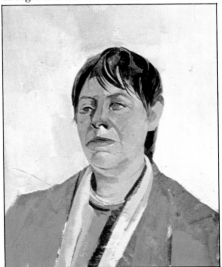

8. With a No 3 sable brush and white paint, put highlights in hair and face. Carry greenish tone of background into the scarf.

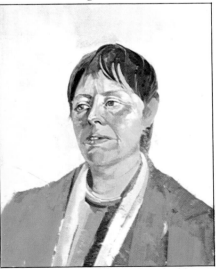

9. With the small sable brush and white, touch up highlights within the face.

Acrylic

PAINTING A portrait makes demands on the power of visual observation above and beyond those used in everyday contact. In creating a likeness, observation must be disciplined and critical. Every feature of the head and face must be carefully analysed in terms of color, shape, and tone in order to understand the relationships existing between them. Because the character of the image is dependent upon this detailed analysis, small adjustments at any stage of the painting can make all the difference between success and failure.

The nature of acrylic paints may help to overcome some of the problems of portrait painting. The basic form can be built up quickly with thin layers of paint which dry almost immediately. Fine details can then be painted over this mixture with no danger of the layers mixing and making the colors muddy. The shapes tend to be more distinct than in oil paint, which remains wet for a long period. Acrylic colors are vivid and opaque, so light and dark tones can be overlaid and mistakes covered completely.

Materials

Surface
Primed and stretched cotton duck

Size
18in × 20in (45cm × 50cm)

Tools
No 6 flat bristle brush
No 4 sable round brush
Palette
Stencil for making small dots

Colors
Black	Cobalt blue
Burnt sienna	Vermilion
Burnt umber	White
Cadmium yellow	Yellow ochre

Medium
Water

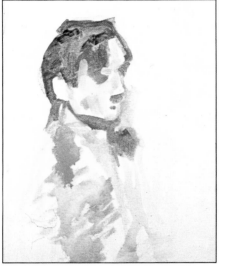

1. Working with black, white, vermilion and burnt sienna and a No 6 brush, block in an overall impression of the figure.

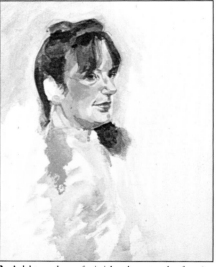

3. Add touches of vivid colour to the face by using rich reds and browns to define the mouth and lighten flesh tones with pale pinks and yellows.

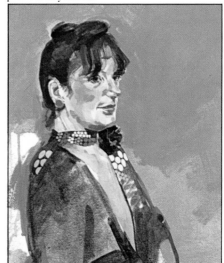

5. Start to paint the pattern details on the dress using vivid colors. Draw the tiny shapes with the point of a brush, keeping the color thick and opaque.

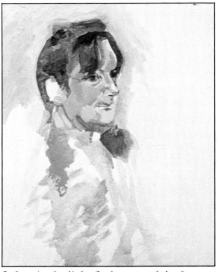

2. Lay in the light flesh tones of the face. Put a blue cast into the shadows with cobalt and grey, drawing small, precise shapes with the brush.

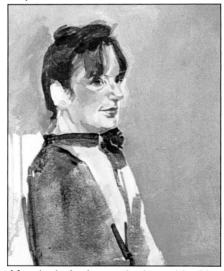

4 Lay in the background colour with a No 6 brush and apply a thin wash of black. Adjust the contours of the figure with a smaller brush

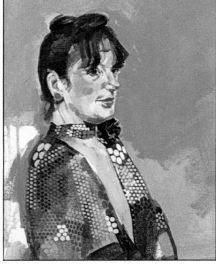

6. Use a stencil to apply small pattern areas. Angle the dots to describe the directions of the form. Combine this with larger shapes painted by hand.

Stencilling in details

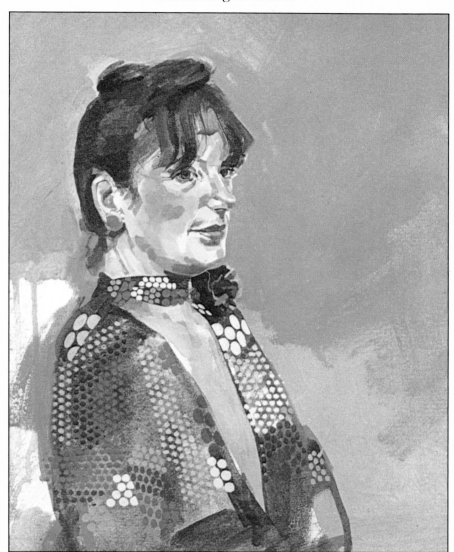

Using a stencil,
the artist blocks in
dots of yellow over
the dry paint
surface. These dots
are then modified by
further applications
of color to vary their
shape and size.

THE STYLE AND character of a person is expressed not only by the face, but also by clothes, posture, and the environment in which they live and work. A full-length portrait, will catch the viewer's attention if it include all of these aspects of the subject's individuality. A portrait should try to capture the mood of the sitter; for example, whether he or she is relaxed and confident, or presenting a formal, calculated pose. Such aspects should all be taken into consideration by all artists and will, to a large extent, determine the techniques chosen by them.

Here the artist has used acrylic paints on paper rather than canvas to make a quick, but detailed, study. This does not mean any special techniques or methods were used, but as the finished work is more easy to damage than one on canvas or board, it should be protected by glass.

A photograph was used for reference. This does away with the necessity of long, tiring sittings for the model but, since the range of information given by a photograph is limited, the artist therefore must be confident and inventive in his handling of the subject and the medium.

The colors of the painting are muted but warm and glowing. Areas of neutral brown are enlivened with touches of green and dark red in the shadows. The effect of bright, artificial lighting is enhanced by a strong cast of yellow in the highlights.

Materials

Surface
Stretched cartridge paper

Size
14.5in × 21in (36cm × 52.5cm)

Tools
No 6 sable round brush
No 5 flat bristle brush
Palette

Colors
Black	Pthalo crimson
Burnt sienna	Ultramarine blue
Burnt umber	Vermilion
Cadmium orange	White
Cadmium yellow	Yellow ochre

Medium
Water

1. Block in the basic image in thin color washes with a No 6 brush.

3. Thicken the paint and use the No 6 brush to lay in light flesh tones and blue-grey shadows. Work over the suit with grey and ultramarine.

5. Work up the details of face and hands with strong contrasts of light and dark flesh tones.

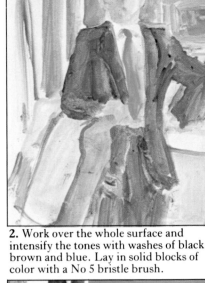

2. Work over the whole surface and intensify the tones with washes of black, brown and blue. Lay in solid blocks of color with a No 5 bristle brush.

4. Strengthen the background colour and block in the shape of the chair with yellow ochre and burnt sienna. Show folds in the suit with blue and grey draw tie pattern.

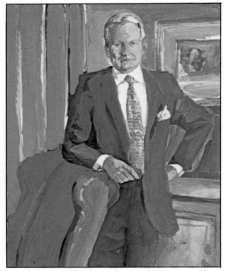

6. Move across the painting laying small dabs of thick color to redefine details and add strong white highlights. Lighten the tones in the background.

Developing shadows · using the brushstroke

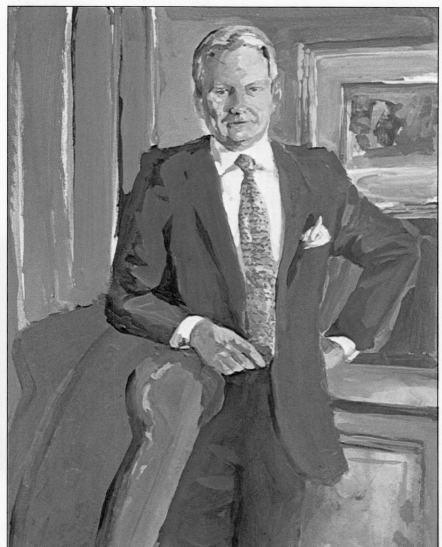

The stroke of the brush is used to create the form of the arm and fabric texture.

After the predominant flesh tones have been established, the artist develops subtle shadow areas with a warm, light brown.

THE CHIEF GOAL of the portrait artist to capture a likeness of the sitter, but the problems and pleasures of controlling the paint and developing color and texture also add another dimension to the challenge. Unlike a photograph, which duplicates almost exactly what the lens of the camera sees, the portraitist has the freedom to create not only a likeness, but an interesting painting as well.

A layered technique has been used here to keep the surface active and develop a wide tonal range. The dry-brush technique was used, which involves laying dry, broken color across the canvas weave by spreading the bristles of the brush. An alternative is to apply thin glazes of color, made more transparent by the addition of a glazing medium. By using these techniques, the colors and tones are successively modified to build up the form of the head. Thick dabs of opaque paint are overlaid to emphasize dark tones and vivid highlights.

The basic structure and proportions of the image are freely reworked throughout the process. There is no need to cover up all corrections and alterations; stray lines and patches of unexpected color may enliven the painting and give weight to the overall structure.

Materials

__Surface__
Prepared canvas board

__Size__
16in × 14in (40cm × 50cm)

__Tools__
No 5 flat bristle brushes
No 8 round sable brush
Palette

__Colors__

Black	Pthalo crimson
Burnt sienna	Prussian blue
Cadmium red light	Violet
Cadmium yellow	Yellow ochre

Quick-drying acrylics allow the artist to alter and correct his painting without interrupting the painting process. Here the artist is moving the entire face of the subject over by blocking in new highlight areas.

Shadow areas around the eyes are described with thick, opaque paint and a small brush. Note the strong contrast created between the bright highlight area of the nose and the shadow of the eyes.

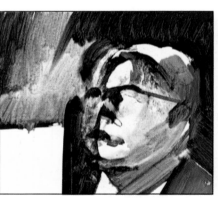

1. Draw up the outline of the head and features in black with a No 5 bristle brush. Block in areas of tone with Prussian blue and burnt sienna.

2. Mix warm flesh tones from red, yellow, black and white. Work over the face with patches of solid color. Lay in the background with greenish-greys.

6. Draw back into the features with black and lighten shadows with an overlay of yellow ochre. Lighten the background tone behind the head.

7. Once dry, put another thin red glaze over the flesh tones rubbing the paint in with a rag. Darken the background with a thick layer of black.

Finished picture · altering face · dark and light contrasts

Radical changes made during the painting process can often yield interesting results, especially if the original design is left only partly obscured. In this case, the artist chose to alter the face to correct anatomical features (<u>right</u>) and heighten compositional interest.

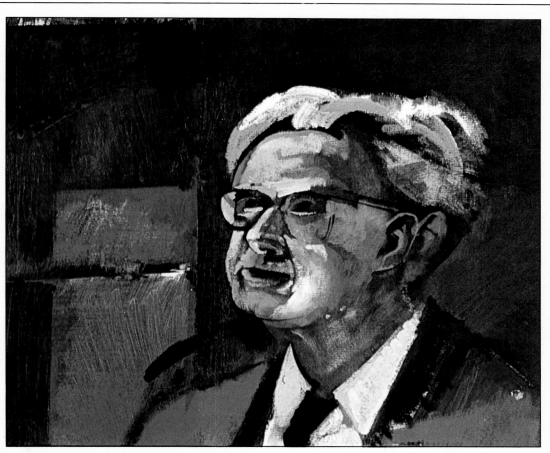

3. Highlight the face and hair with light pink and white and scumble a warm orange over the background to the left. Work loosely, laying broad, grainy marks.

4. Brush in dark tones in black defining the shape of the head and detailing features with a No 8 brush. Dry brush dark shadows across the flesh tones.

5. Lay a thin glaze of wet red paint over the whole face and heighten light tones with heavy dabs of pink and yellow.

8. Work over the background with hot reds and violet. Adjust the flesh tones with layers of broken color, blending the colors with a rag.

9. Rework the shapes in the face with fine black lines and dark shadows under the nose and behind the head. Block in strong white and light pink highlights.

10. Continue to model the form of the face and hair with light pink, yellow, and mauve tones. Dab in shadows with dark brown and violet.

273

ACRYLICS ARE time savers. While this painting could have been executed in oil, it would have taken much longer to complete. To achieve the changes shown, each stage would have to be thoroughly dry before alterations could be made. With acrylics, because of their fast drying time, the artist was able to work from start to finish without stopping and starting.

Examination of the first and last steps of the painting shows that, with the sole exception of the figure, the artist has almost completely re-arranged the picture. The changes were made largely for the sake of creating a more interesting composition. The original picture, while strong in its use of horizontals and verticals, was too complex and overpowered the figure. In removing the various squares and rectangles, the artist redirected the emphasis of the painting on to the figure. The addition of the bed and canvas on the same horizontal plane as the figure brings the viewer's eyes into the centre and, thus, concentrates them on the subject.

Materials

Surface
Stretched, primed canvas

Size
20in × 15in (50cm × 37cm)

Tools
No 4 flat bristle brush
Assorted palette knives
Soft pencil or charcoal sticks
Palette

Colors

Black	Chrome green
Burnt umber	Flake white
Cadmium yellow	Gold ochre
Cerulean blue	Prussian blue

Medium
Turpentine

Painting with knife and brush

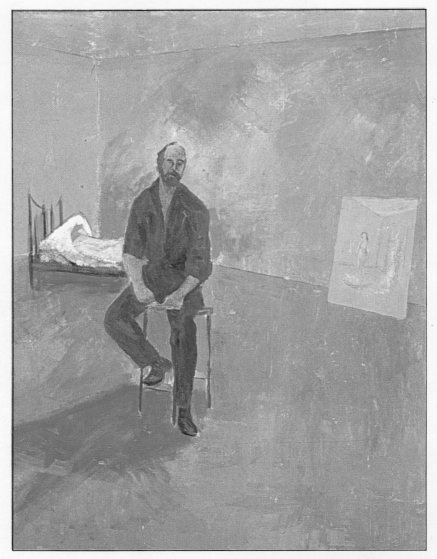

Broad areas of this painting were described with thick paint and palette knives. Smaller detail areas were created with a No 2 brush and thinner washes of color.

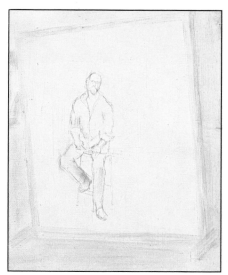

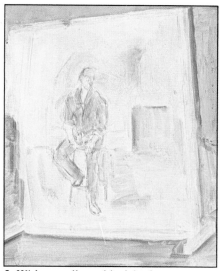

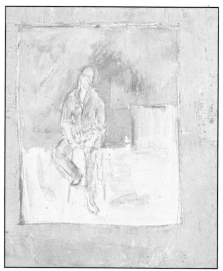

1. With a soft pencil or willow charcoal, very lightly draw in the main horizontals and verticals of the compositon.

2. With a small rag, block in the background with a thin wash of cerulean blue. Do the same for the floor with cobalt blue and gold ochre.

3. Using a palette knife, mix a thick mixture of white and cerulean blue and cover the entire background and fore-ground areas.

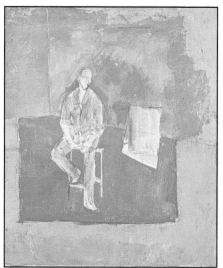

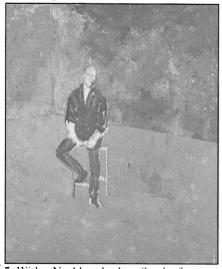

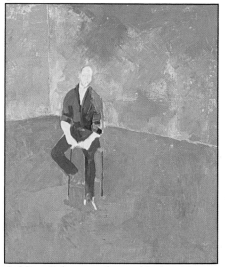

4. Mix cerulean blue, a touch of black and white and block in the area around the floor with a palette knife. Add more blue and work into the background.

5. With a No 4 brush, describe the figure in black and white. Cover over the entire floor surface with cerulean blue and white on a palette knife .

6. Mix a light tone of grey, black, white and a touch of cerulean blue and cover the floor color. Lighten the background area with white and cerulean blue.

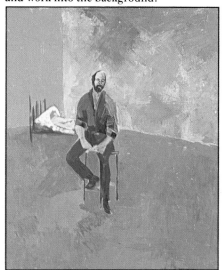

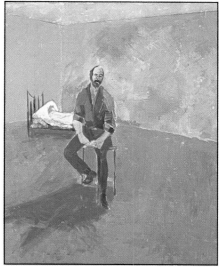

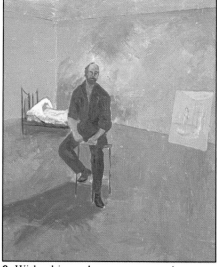

7. With a small brush and grey, put in the bed. Cover area directly behind in blue-grey tone using a knife. Put in flesh tone with ochre and white.

8. With a dark grey mixture made from cerulean blue, black and white, describe the shadow under the chair with a knife.

9. With white and terre verte, put in canvas to right of figure. Warm the flesh tones of the figure by glazing over with yellow ochre, umber, and linseed oil.

275

MANY ARTISTS will use acrylics for an underpainting and then finish off the work in oil paint. Note, however, that this process cannot be reversed, with an oil underpainting used for an acrylic painting, as a water-based paint will not adhere to an oil-based paint. This would also defeat the purpose of using an acrylic underpainting as the aim is to shorten the drying time and oils take much longer to dry than acrylics.

The painting develops as a series of steps in which the artist modelled the figure out of warm and cool tones, constantly watching their effect on one another and on the painting as a whole. Using a thin wash, a warm tone for the flesh would be put down and then overlaid with a cooler, lighter shade. Outlines and feature details would then be reinforced, and the process would begin again.

The warmth of the colors used in the figure are set off and heightened by the cool background. A similarly cool, light color has been used for highlight details in the face which link the sitter and the environment.

It is interesting to note that the various areas of the painting have been treated differently – the torso and background are not as highly developed as the head, for instance. This is effective in portraiture, since a generalized area around the sitter will draw the viewer's eyes to the face – the most important area.

Materials

Surface
Prepared canvas board

Size
18in × 24in (45cm × 60cm)

Tools
No 6 flat bristle brushes
No 4 sable round brush
Palette

Colors

Burnt sienna	Cobalt blue
Burnt umber	Pthalo crimson
Cadmium green	Pthalo violet
Cadmium red light	White
Cerulean blue	Yellow ochre

Medium
Water

1. Using thin wash and a No 6 brush, block in main color areas with pthalo crimson, burnt sienna, yellow ochre, white and cerulean blue.

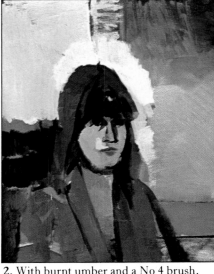

2. With burnt umber and a No 4 brush, define dark areas draw in the features. Block in shadow areas behind head and with pure white put in light area.

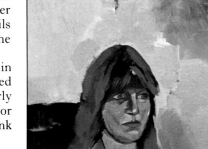

3. Mix lighter flesh tone of yellow ochre and white and work over previous layer to emphasize highlights. Mix yellow ochre and red to create hair highlights.

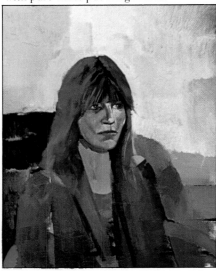

4. With a No 6 brush, mix a pale tone of white and pthalo violet and block in the background with large strokes, blending the paint well into the surface.

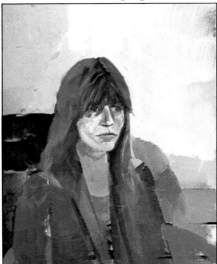

5. When dry, work back over face, glazing in strong highlight areas with thin wash of white and water

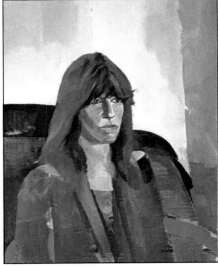

6. Mix white, yellow ochre and a little red. With a No 4 brush, put in warm color areas of the face. Mix pthalo violet and white and rework background.

Blocking in hair

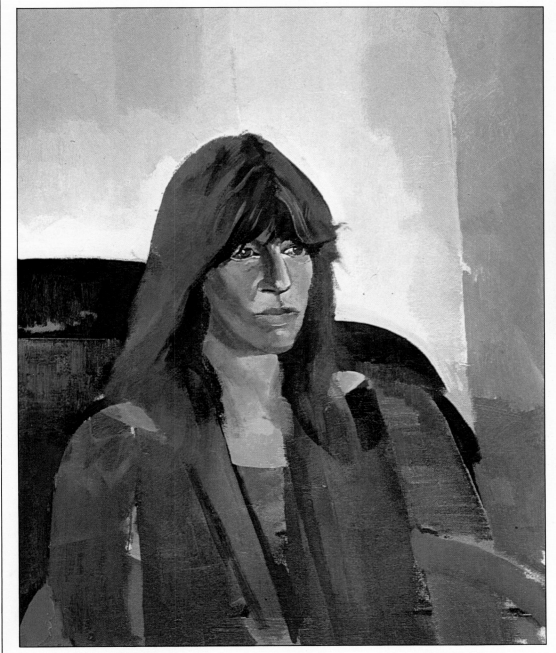

The dark shadow area in the hair is blocked in with black paint. This is used basically as an underpainting to be modified and toned down by later overpainting with warmer, lighter shades.

Watercolor

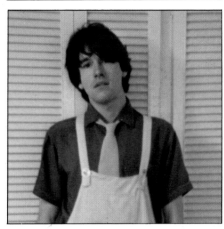

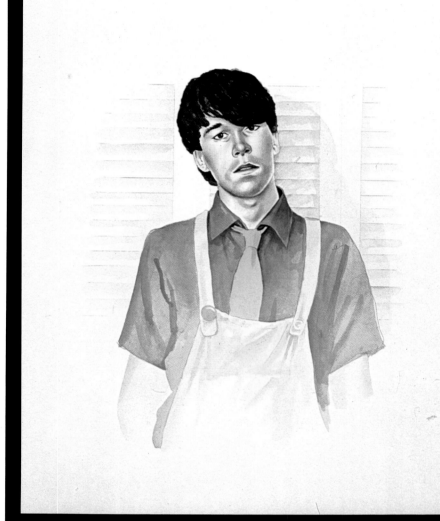

IN THIS PAINTING, thin, transparent layers of watercolor have been laid one on top of another giving the flesh a truly 'flesh-like' feeling and texture. Few other painting media are capable of this effect.

This painting exemplifies many of the more sophisticated ways in which watercolor may be used to create a strong but subtle portrait. The methods used require a steady hand, and familiarity with and confident use of the various watercolor techniques.

The flesh tones of the face, which, from a distance, merge into a continuous area of light and dark, were individually laid down and then blended with a clean, wet brush. Yellow and green were used to render the warm and cool tones of the flesh. The very dark details of the face were described in a strong burnt umber which contrasts with the pale flesh tone and emphasizes their importance.

Materials

Surface
Smooth board

Size
16in × 23in (40cm × 57.5cm)

Tools
Nos 00, 1 and 2 sable watercolor brushes
2B pencil
Colored pencils

Colors
Watercolor:

Burnt umber	Chrome green
Cadmium red	Ultramarine blue
Cadmium yellow	Yellow ochre

Colored pencils:
Grey
Red

Medium
Water

Watercolor is especially well-suited for portraiture. Because of the inherent transparency of the medium, it is important that the overall image has a strong composition. In this picture, the artist has surrounded the figure with almost empty space to draw the observer's eye into the figure.

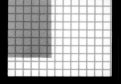

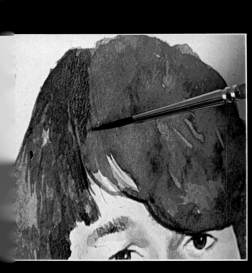

The entire painting progresses from light to dark. Here the artist is putting another wash of color over the hair to create a darker tone.

Using a strong blue and small sable brush, shadow areas are created in the shirt. Notice how the paint naturally bleeds into the damp surface, creating a gradated tone.

Once the paint surface is thoroughly dry, the artist works back into the face and detail areas with colored pencil, strengthening outlines and shadow areas with light hatching strokes.

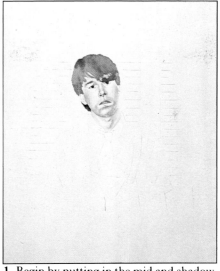

1. Begin by putting in the mid and shadow tones with a thin wash of burnt sienna and green. With a small sable brush and pure umber, add eye details.

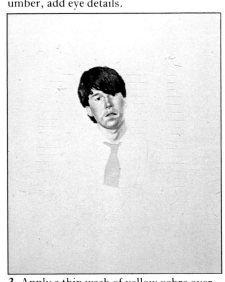

3. Apply a thin wash of yellow ochre over the face and work wet-in-wet with a light wash of green in the shadow area.

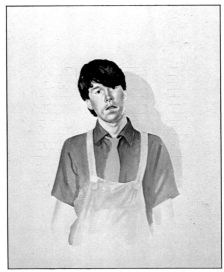

5. Darken hair color with burnt umber and a fine brush.

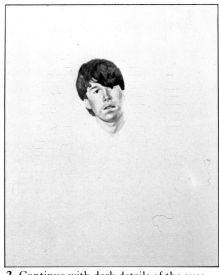

2. Continue with dark details of the eyes, nose and mouth. If the paint becomes too wet, blot with a tissue and then rework.

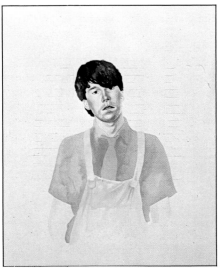

4. Block in the shirt with a thin wash of ultramarine blue. Carry yellow ochre tone into pants leaving white of paper for highlight areas.

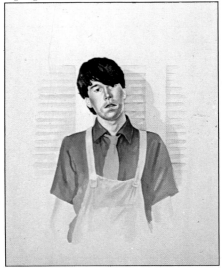

6. With red pencil, work into the face with very light, diagonal strokes, heightening warm areas. With a grey pencil, strengthen horizontal lines of door.

A QUICK WATERCOLOR portrait may result in an interesting finished picture or may be used as reference for a larger work. This painting shows a lively impression of the overall form of face and figure, lightly modelled with color and tone.

The essence of the technique is to lay the color in watery pools which give the surface a loose, rippling texture. The painting must be allowed to dry frequently to get the full effect of overlaid washes and liquid shapes. It is important to keep the colors bright and true; you need to use plenty of clean water and rinse out the brushes thoroughly after each color application. Start by picking out small shapes of strong tone and color and develop the form in more detail as the painting progresses, drawing separate elements together to construct the entire image.

Since the painting is quite small you need only one brush to lay in the washes, and a finer point to draw up small linear details in the features. Make a brief pencil sketch to establish a guideline at the start but allow the painting to develop freely drawing over the pencil lines with the brush.

Materials

Surface
Stretched cartridge paper

Size
12in × 16in (30cm × 40cm)

Tools
Nos 3 and 7 sable watercolor brushes
Plate or palette

Colors

Black	Gamboge yellow
Burnt sienna	Scarlet lake
Burnt umber	Ultramarine blue
Cobalt blue	

Medium
Water

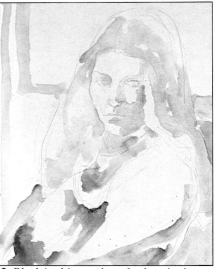

1. Work over the hair and face with wet pools of color – scarlet, yellow and burnt sienna – letting the tones blend. Drop light touches of cobalt blue into the shadows.

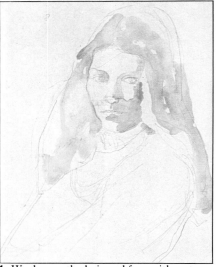

3. Strengthen the color over the whole image, developing the structure of the forms. Keep the paint fluid and allow the colors to merge on the surface.

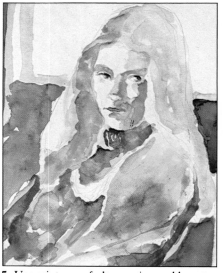

5. Use mixtures of ultramarine and burnt umber to darken the shadows. Redefine the shapes in eyes and mouth.

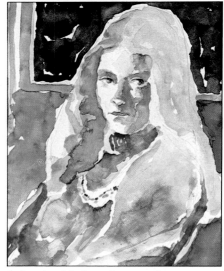

2. Block in thin patches of colour in the background and heavy washes of ultramarine to show the folds in the clothes.

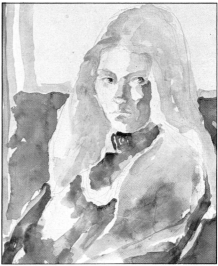

4. Model the face with heavy patches of red and brown, drawing in detail around the eyes with the point of a brush. Extend the background color.

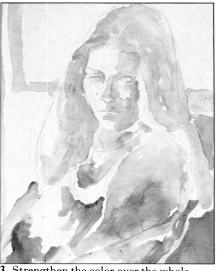

6. Lay in a black wash across the background to bring the shape of the head forward. Add detail to the forms and strengthen the colors.

Using paper tone

To create face details, the artist runs loose washes of color into one another leaving the paper tone to define highlights.

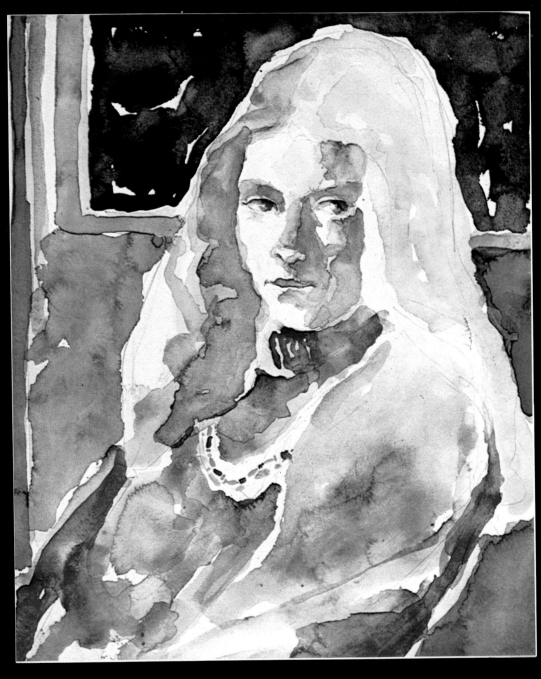

Using paper tone

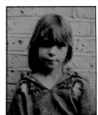

WATERCOLOR IS an excellent medium for painting children. It is delicate and subtle, with light flesh tones and soft shadows evolving gradually through layers of thin, pale washes applied over details.

When painting children, the temptation is often to make them look like small adults. For this reason, details of the pose which are characteristically childlike, such as the roundness of unformed features and smooth skin, must be captured exactly. It is usually easier to work from a photograph as lengthy sittings may be boring for a child. Take several photographs and choose the one which best suits the purpose, or use several in combination as reference.

The range of colors here is limited to shades of red, grey and brown. Blue was added to the browns and greys in the shadow areas to contrast with the overall warm tone of the colors. The image is drawn with the brush over a light pencil outline, first establishing the shapes and tones in the head and moving down to block in the entire body. Details in face and hair are drawn in fine lines with the point of the brush and then overlaid with washes of color. Dry-brush is used to create soft textures by loading a brush with dryish paint and, with the bristles spread between finger and thumb, drawing the brush across the paper to form light, broken strands of color.

Materials

Surface
Watercolor paper

Size
16in × 22.5in (40cm × 56cm)

Tools
No 3 round sable watercolor brush
Palette or plate

Colors
Black
Burnt sienna Payne's grey
Burnt umber Scarlet lake
Cobalt blue Yellow ochre

Medium
Water

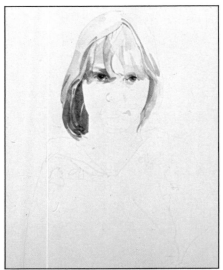

1. Work up detail around the eyes with light red, grey and burnt umber using a No 3 brush. Put in strands of hair.

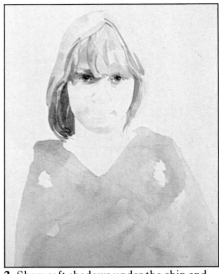

2. Show soft shadows under the chin and mouth with light red and Payne's grey. Block in the body with a light wash of grey.

Using the same tone as for the shirt, made lighter by adding water, the artist puts in very pale shadow areas on the face.

To create a dry-brush effect, dip a brush in paint and blot on a towel or rag. Press the brush hairs between thumb and finger to spread the hairs and brush on to the surface with light, feathering strokes using only the tips of the hairs.

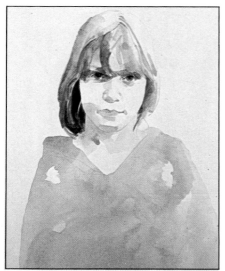

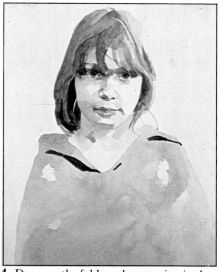

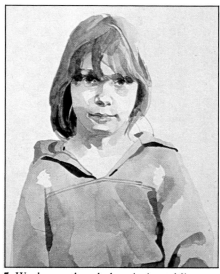

3. Model the features more clearly with grey and brown washes. Lay in a strong black shadow to one side of the face.

4. Draw up the folds and patterning in the blouse with lines and washes of dark grey, drawing with the tip of the No 3 brush.

5. Work over the whole painting adding small touches of tone and color, elaborating details with the same brush.

Finished picture · facial shadows · using dry-brush

The full-faced centred portrait is perhaps the most direct way for the artist to present his subject. If the media and techniques used are handled carefully and thoughtfully, the overall effect can be both strong yet subtle.

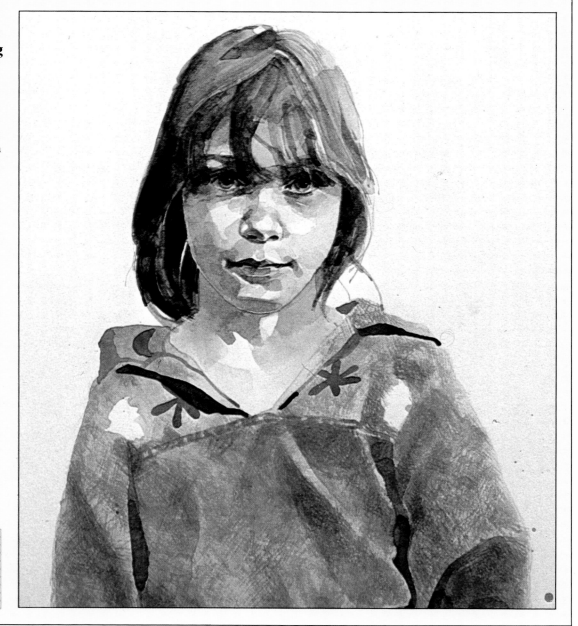

THE PAINTING technique used here is loose and fluid and thus suited to the relaxed, informal attitude of the subject. This is basically a simple color study, as the forms are suggested in the brushwork rather than through accurate drawing and meticulous modelling. The figure is emphasized by the strong dark tones of clothes and hair and broad areas of black are enlivened with touches of vivid dark blue, violet and warm browns.

The whole composition is built up by laying in small local shapes and colors, gradually drawing them together into a coherent image. The vitality of this type of study depends upon working quickly, letting the eye travel across the subject to pick out color relationships, and translating them on to the paper with fluid and vigorous brushwork. Keep the brushes well loaded with paint so that each line and shape flows freely on to the paper and the liquid colors merge gently together.

Let the painting dry out completely from time to time so that subsequent color washes are fresh and sharp. If the painting is still wet the fine lines will spread and lose definition.

Small linear details such as the eyes and mouth should be drawn over a dry wash with the tip of a brush.

Materials

Surface
Stretched cartridge paper

Size
15in × 18in (38cm × 45cm

Tools
HB pencil
Nos 3 and 7 round sable watercolor brushes
Plate or palette

Colors
Black	Scarlet lake
Burnt sienna	Ultramarine blue
Cadmium yellow	Violet
Prussian blue	

Medium
Water

1. Draw the basic shapes in the figure and background with an HB pencil. Wash in patches of strong wet color – black, burnt sienna, violet, Prussian blue and yellow.

2. Work into the flesh tones with washes of light red using a No 7 brush. Loosely apply colored shapes over the whole painting to indicate the forms.

3. Strengthen the blacks and draw into the pattern of the skirt with a No 3 brush. Bring together the background shapes with blocks of solid color.

4. Put in dark shadows on the face and arms with burnt umber and violet. Lay in light washes of blue and green across the background letting the colors run.

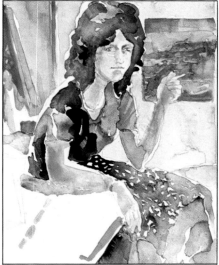

5. Work on the modelling of the figure with dark tones, defining the details of face and hands. Use muted tones in the background to draw the figure forward.

6. Continue to work on the figure gradually developing the tonal contrasts. Draw the features more finely with the point of the brush.

Finished picture · wet underpainting

The full length portrait presents the artist with a number of options and challenges and is often more difficult than the head-only variety. Included in the decisions to be made are where and how to place the figure, and how much of the background area to include.

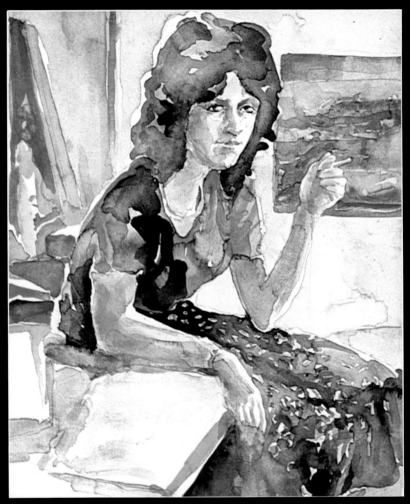

In the initial stages, thin washes of color are laid down to describe shape and form. Note in the figure's hair how the paint has bled outward to create a natural outline.

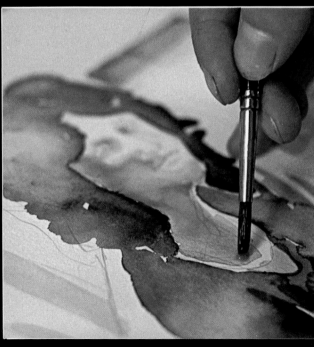

WHILE THIS painting may prove difficult to think of as a serious watercolor portrait, it expresses some of the most attractive attributes of the medium for the artist.

Despite its humorous aspect, the techniques and composition should not be overlooked. It is largely through the unique placement of the figure and the use of the clean, white space around it which forces the viewer's eye into the face of the subject. The strong darks of the hat and beard contrast boldly with the white of the paper making it impossible for the observer not to look directly into the face. This, coupled with the meticulous control of the medium and light, informal rendering of the shirt, serve to emphasize the focus of the painting.

Materials

Surface
Watercolor paper

Size
16in × 23in (40cm × 57.5cm)

Tools
2B pencil
No 4 sable watercolor brush
Palette or plate

Colors
Alizarin crimson
Black
Burnt sienna
Payne's grey

Medium
Water

1. With a No 4 brush, describe the hat and beard in Payne's grey. Keep the paint very wet and draw in outlines carefully, using only the tip of the brush.

2. With same color, define the eyes, nose and mouth. Describe detail of hat in red.

3. Work over the face and neck with a darker wash of burnt umber and a touch of red to build up the picture.

4. With a thin wash of Payne's grey, lay in shadow area of neck and chest.

5. Wet area of shirt with a clean brush and water. Very quickly lay down a wash of light Payne's grey, letting the tones run into the paper and one another.

6. While still wet, work back into the shirt with a thin wash of burnt umber, allowing drops to fall from the brush.

Blocking in color · tones and textures

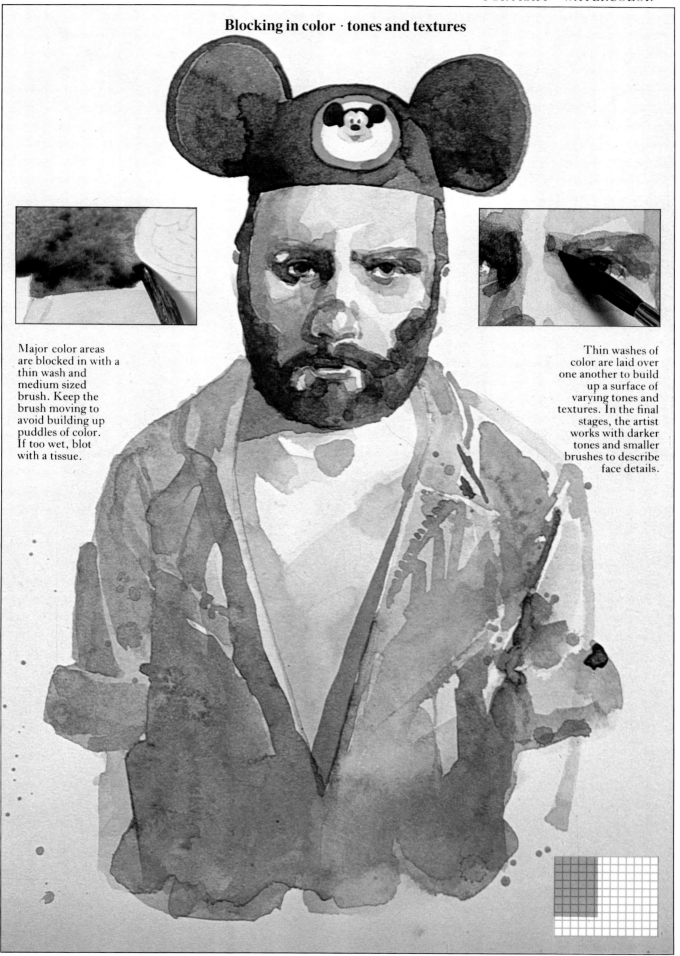

Major color areas are blocked in with a thin wash and medium sized brush. Keep the brush moving to avoid building up puddles of color. If too wet, blot with a tissue.

Thin washes of color are laid over one another to build up a surface of varying tones and textures. In the final stages, the artist works with darker tones and smaller brushes to describe face details.

Gouache

GOUACHE IS a convenient medium for doing quick color studies. It is cleaner to work with than oils and is also more opaque and matt than watercolors or acrylics. The colors are clear and intense. When mixed with white, they form a wide range of bright pastel tints suitable for the skin tones in a portrait. Because the paint is opaque you can work light over dark or vice versa, adjusting the tonal scale of the painting at any stage. The paint is reasonably stable when dry and thin washes of color can be laid over without damaging previous layers.

By studying the head in this painting carefully, the relationships between form and color become apparent. Work in small shapes of color, drawing with the brush to model curves and angles. A loose charcoal drawing is a helpful guideline at the start and can later be used to redefine outlines if the paint is not too thick. Adding black to make shadow areas may dull a color; shadows on the skin usually have a subtle cast of color such as green, blue or purple which can be used instead of black. Contrast these shadows with red and yellow within the lighter tones

Materials

Surface
Stretched cartridge paper

Size
16in × 20in (40cm × 50cm)

Tools
Medium willow charcoal
Nos 3 and 6 sable round brushes
Plate or palette

Colors

Alizarin crimson	Cobalt blue
Black	Flame red
Burnt sienna	Violet
Burnt umber	White
Cadmium yellow	Yellow ochre

Medium
Water

1. Draw the outline of head and shoulders with charcoal, indicating eyes, nose and mouth. Lay thin washes of red and brown to indicate shadows with a No. 6 brush.

2. Identify basic colors in the face and neck. Draw out contrasts by exaggerating the tones slightly, overlaying patches of each color to build up the form.

3. Draw into face with charcoal and paint in linear details with the point of a No 3 brush in dark brown. Work up the color in and around the features.

4. Alter the shape of the head and lay in dark tones of the hair. Paint the stripe pattern on the scarf in cobalt blue and strengthen the red of the jacket.

5. Develop the structure and colour of the face, drawing into the features with the No 3 brush and adding thick white and pink highlights with brown shadows in the flesh.

6. Block in the hair with a thin wash of yellow ochre and delineate separate strands with burnt umber. Reinforce the shapes of eyes and mouth with small color details.

Modelling with tone

Gouache is especially
well suited for
building up opaque
layers of paint. Due
to its excellent
covering powers, the
artist is free to alter
the image as much as
he chooses. Here the
artist is building up
highlights over a
darker paint layer.

Pencil

TO CREATE a quick, informal portrait, any artist needs to be familiar with the chosen medium and techniques. Naturally, a sound knowledge of human anatomy is beneficial for all figure and portrait artists. Regardless of a person's distinguishing features, what lies beneath the surface – muscles, tendons, bones and cartilage – are the building blocks for all portrait and figure work. If the artist knows, for example, why an eye looks like it does – where it bulges and where it recedes – he will be that much closer to creating an accurate likeness.

This is especially true when doing a quick sketch, as the goal is to capture only the essential and outstanding characteristics of the model as quickly as possible. A labored and detailed drawing would allow the artist to study, correct, and change the drawing; but a quick sketch demands that the artist be able to accurately render the subject, since he will not be able to correct and revise.

Note, for example, how the artist has created the nose of the model and used directional lines to give form and depth. Through constant observation, studying and practice, the artist is able to quickly and effectively capture a likeness of the model.

Materials

Surface
Smooth, heavy weight drawing paper

Size
24in × 30in (60cm × 75cm)

Tools
2B and 4B drawing pencils
Eraser
Tissues or torchon
Fixative

1. With a 2B pencil, sketch in the general shape of the head. Position features in relation to one another, using very light strokes.

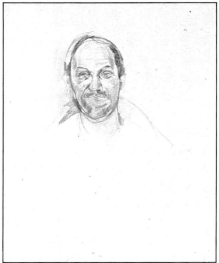

3. To bring the nose forward, crosshatch in shadow areas. Develop structure of face with light, widely spaced strokes. Refer to the subject to check the drawing.

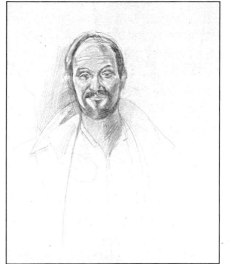

5. Draw in the neck and shirt collar. Darken all detailed areas with contour strokes.

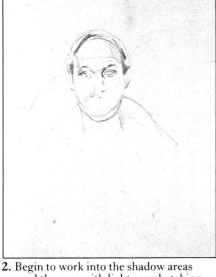

2. Begin to work into the shadow areas around the eyes with light crosshatching. Develop the hair with strokes which follow general contours.

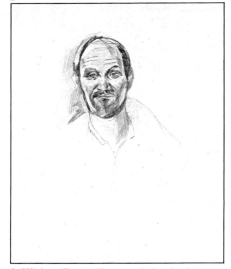

4. With a 4B pencil, rework the shadow areas to darken tone. Work back into shadow areas with a putty eraser to erase highlights or lighten tones.

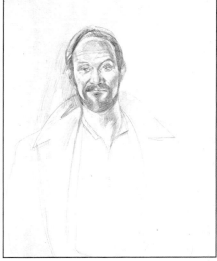

6. Blend in shadow area in neck with tissue or torchon. Put in shadow area outside of the face and blend. Erase back into highlights within the face.

Final details and crosshatching tones

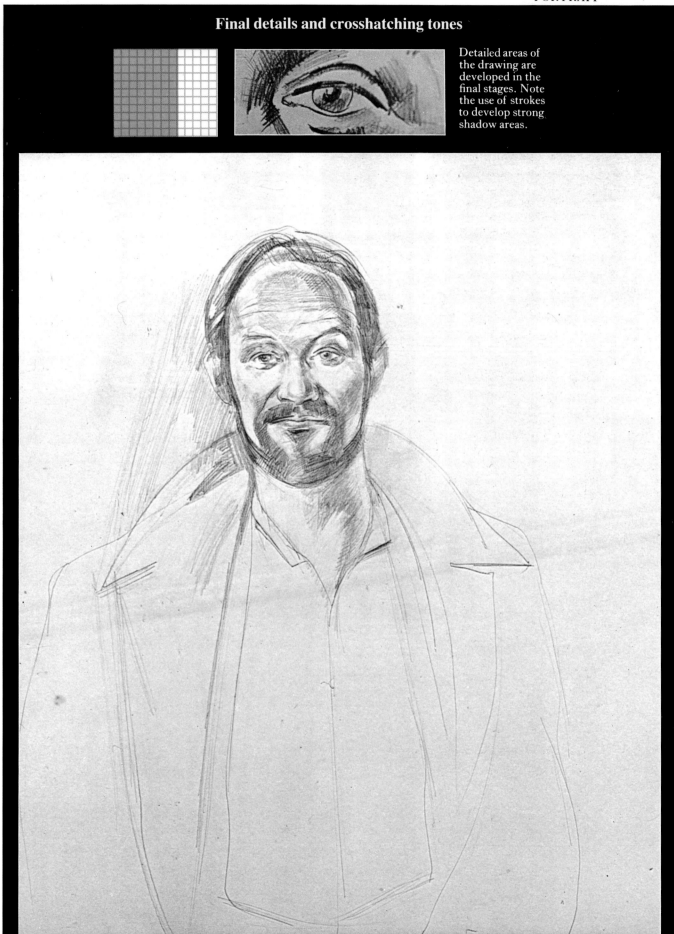

Detailed areas of the drawing are developed in the final stages. Note the use of strokes to develop strong shadow areas.

THIS PICTURE is a good example of the effective use of colored pencils in portraiture, especially when combined with the color of the clean white surface.

Although the artist has used line to develop tonal areas, the method of drawing is similar to the classic oil painting technique of laying down colors one over another to 'mix' new colors. This requires a confident use of color, as once put down, colored pencils are not easily erased. This, combined with subtle or strongly directed strokes which follow or exaggerate the planes of the figure, creates a powerful image.

An interesting feature of the composition is the use of the white paper within the figure to describe the face, hands, and hair highlights. In the model's left hand, one simple line is all that is needed to separate the figure from its environment. The nearly bare areas of the face and hands are heightened by the surrounding dark area, which, in turn, plays off against the white of the paper.

Materials

<u>Surface</u>
White drawing paper

<u>Size</u>
12in × 16in (30cm × 40cm)

<u>Colors</u>

Dark red	Raw umber
Light green	Ultramarine blue
Magenta	Yellow ochre

Initial color areas · dark details

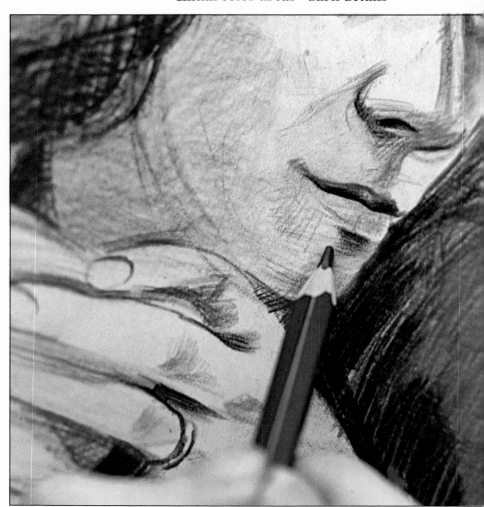

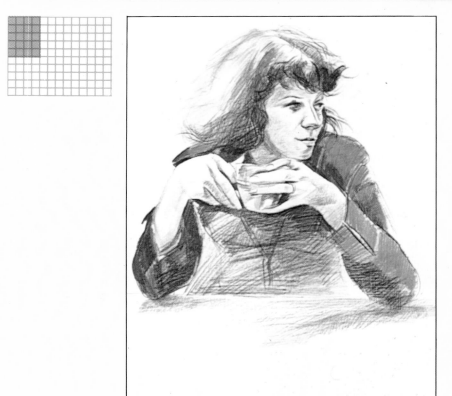

In the final stages of drawing, the artist reworks dark detail areas with a strong blue pencil.

The outlines of the figure are first sketched in with a warm brown. The artist then blocks in shadow areas with a cool blue. Here he is working back into the face with light strokes of orange to begin to build up flesh tones. Note the use of loose strokes.

1. Sketch in the outline of the face in raw umber. Use ultramarine blue for shadows and hair and very light strokes of the same color in the blouse.

3. With red and yellow, put in loose strokes to define hair tone. Strengthen outlines of face with ultramarine blue. Put in dark shadow area to right of face

5. Overlay magenta area with red. Create stronger shadow areas with ultramarine blue.

2. With pale green, begin to define shadow areas of the face with very light hatching and crosshatching. With dark blue, put in the eye details.

4. Work into the hair with directional strokes of red. Overlay light strokes of blue and red in the blouse with loose, scratching strokes.

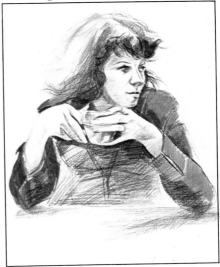

6. Work back into hair with burnt umber. Use pale green to put in highlights in the cup.

THIS DRAWING RELIES largely on the use of loose, flowing lines and areas of tone to create the image. The drawing was executed rapidly with just essential shapes and tones used to describe the sitter. The emphasis of the drawing is on the face and hands, making the figure a self-contained, stable unit.

A high contrast is developed in the face of the model which, with the use of the pure white paper and very dark details, focuses the viewer's attention on the head area. The relaxed line work and shading within the torso lend the figure both weight and movement. While solid and stable, the impression is that the figure could get up or change his position at any moment. The value of using a quick, informal approach to drawings of this type becomes evident especially when the pose is difficult or uncomfortable for the model and he or she is apt to move or tire easily.

Materials

Surface
Smooth white drawing paper

Size
15in × 16.5in (37.5cm × 41cm)

Tools
2B and 4B drawing pencils
Putty eraser
Fixative
Tissues

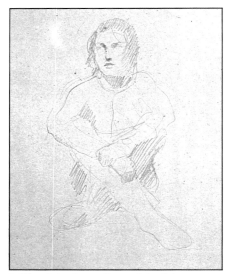

1. Sketch in the outlines of the figure very loosely with a 2B pencil. Rough in the eyes, nose, and mouth.

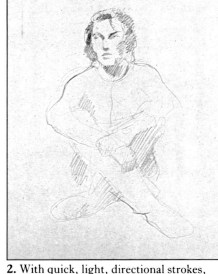

2. With quick, light, directional strokes, put the shadow areas of the hair and figure into the drawing.

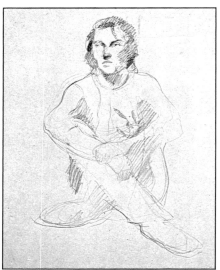

3. Work back into the head of the figure with a 4B pencil strengthening dark areas. With the same, outline shoulder and neck.

4. With a 2B pencil work back into the shadow areas. Redefine leg and feet outlines as necessary.

5. With the 4B pencil, go over the lower half of torso with quick, light strokes building up shadow tones. Work back into the head to heighten darks.

6. With the 2B pencil, define fingers and hands. Put in shadow area beneath them.

Using tone and stroke to develop the figure

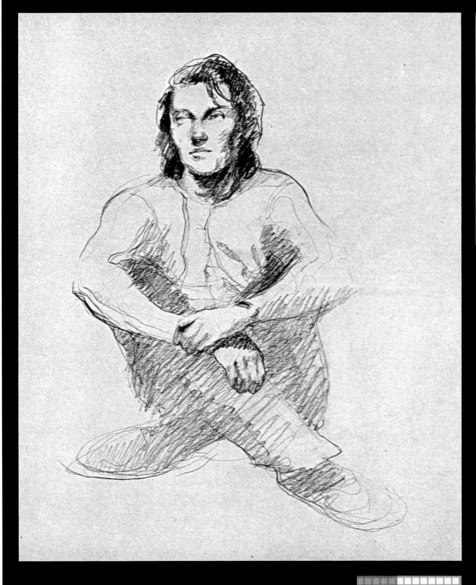

The shadow areas on the face are developed with diagonal strokes of soft grey tone. Both the tone of the pencil and the direction of the strokes help give the impression of depth and form.

Pastel

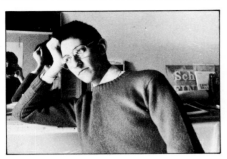

THERE IS A long history of pastel portrait drawing and some of these drawings, with their finished surface of subtly blended color, are nearly indistinguishable from an oil painting. In fact, the term 'pastel painting' has become as common as 'pastel drawing'. While the early pastellists most likely spent as much time on their work as a painter would on an elaborate portrait, contemporary artists have developed techniques of drawing which are flexible and less time-consuming than these early drawing methods.

The basic structure of this drawing is built upon woven lines and hatched blocks of tone using a limited range of colour. Once the fundamental shapes and tones are established, the subject is rendered with layers of bright color.

Pastel is powdery and difficult to work with if the surface becomes too densely covered. Thus, it is worthwhile to spray the drawing with fixative frequently to keep the color fresh and stable.

Materials

Surface
Beige pastel paper

Size
25in × 18in (62.5cm × 45cm)

Tools
Soft, large brush for blending
Pastles
Putty eraser
Fixative

Colors
Apple green	Scarlet
Black	Ultramarine blue
Light blue	Venetian red
Pink	White
Prussian blue	Yellow

1. Draw up the basic shapes of the image in Prussian blue, sketching in rough outlines and a brief indication of tones.

3. Refine details of the features with strong lines of dark blue and flesh out the face with solid blocks of white and red.

5. Block in light tones in the face with pink and pale blue. Lay in broad areas of dark tone with black and Prussian blue, working out from the figure.

7. Lay in dark background tones to emphasize the form of the figure. Overlay and blend the colors to mix the tones, working over the whole image.

2. Build up the linear and tonal structure with Venetian red, developing the loose modelling of the forms. Strengthen the drawing with fine black lines.

4. Spray the work with fixative and let it dry. Draw into the figure with blue and black correcting the outlines and adding extra details in line and tone.

6. Develop the intensity of color, using strong, bright hues to lift the overall tone. Link vivid yellow highlights on the face with the same color in the background.

8. Bring out the form with strong white highlights. Apply the pastel thickly and blend the color softly with a dry brush. Strengthen light tones in the background.

Strengthening background and face with black

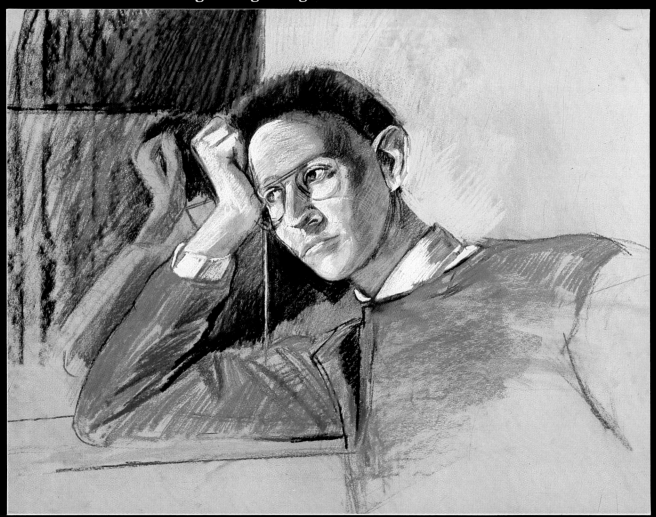

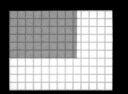

Once general shadow and highlight areas have been blocked in, the artist works back into the picture with a black pastel to develop facial details. Here he is outlining the shape of the glasses.

With a black pastel, the artist darkens the shadow area beside the face. This has the effect of forcing the flesh tones of the face to stand out in bold relief.

THERE ARE good reasons for the fact that many pastel artists prefer to work on tinted paper. In this case, the flesh-toned paper has been used as part of the figure. As well as being a solid, neutral tone, it works to emphasize the strong colours used in the face and dress.

A minimum of blending has been used thus the technique of overlaying colors may be clearly seen. The hands reveal how the artist has used directional strokes of pure color to give them form and tone; throughout the figure the artist has changed the direction of the strokes to describe planes within the face and hands.

Materials

Surface
Pumpkin coloured pastel paper

Size
22in × 30in (55cm × 75cm)

Tools
Tissues or rags
Large, soft brush for blending
Fixative

Colors
Light grey
Dark grey
Black
White

1. Roughly describe the dark areas of the head and torso with loose strokes.

2. Put in hair highlights and eye details. With white, put in strong face highlights and strengthen outlines.

3. Fill in hair area describing shadow and highlights. Rough in chair and flower and draw in the hands.

4. Develop the shadow areas of the hands. If a part of the drawing proves difficult, use the rest of the page to do a detailed study.

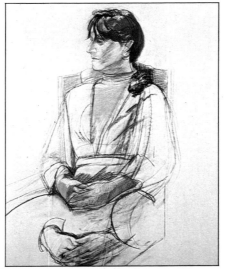

5. Block in the lighter area of the chair. Work into shadow areas and blend and lay in the shadow areas in the dress.

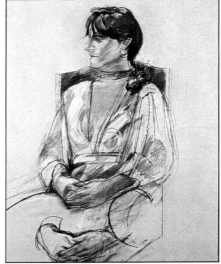

6. Roughly describe the dress pattern with a mixture of tones.

Overlaying light tones · doing a detailed study

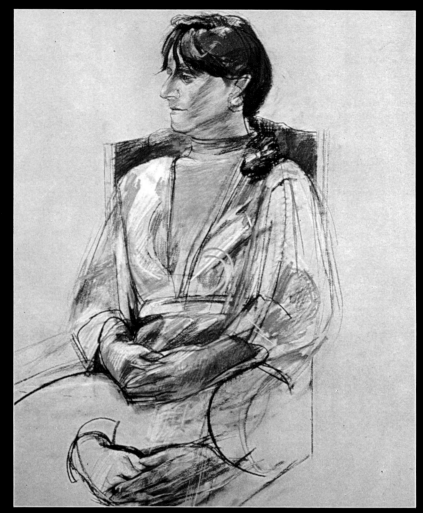

Here the artist overlays very dark shadow areas in the hair with a lighter, softer shade of brown.

If a part of the drawing proves difficult, a study can be done elsewhere on the page which can later be cropped from the finished picture.

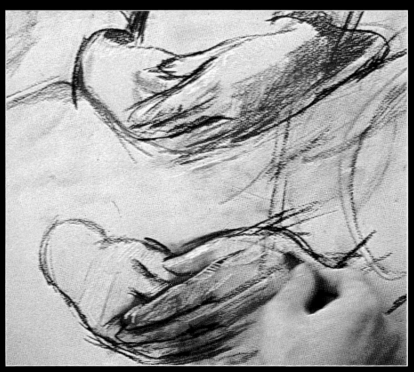

Overlaying light tones · doing a detailed study

IN CAPTURING THE character of a subject, a quick sketch is often more successful than a carefully worked painting. The loose, vibrant colors of pastels are particularly suited for quick sketches using a vigorous, calligraphic style, as shape and texture can be shown through the activity of the color rather than the meticulous delineation of forms.

In this drawing, pastel strokes are multidirectional and the colors warm and bright, giving an impression of a fleeting image; the model is frozen in a split second of time, not carefully posed for a long sitting. This is a quality which photographers often capture, and thus photographs are often a good source of reference material for this type of portrait.

Tonal contrasts are skillfully manipulated with black used sparingly for dark tones and outlines. Facial shadows are created with mauve and a vivid dark red, and thick white highlights give an impression of light across the face. The movement and texture of the hair is represented by heavily scribbled strokes of bright orange.

Materials

Surface
Blue-grey pastel paper

Size
11in × 15in (27.5cm × 37.5cm)

Tools
Fixative

Colors
Black	Pink
Burnt sienna	Ultramarine blue
Mauve	White
Orange	Yellow

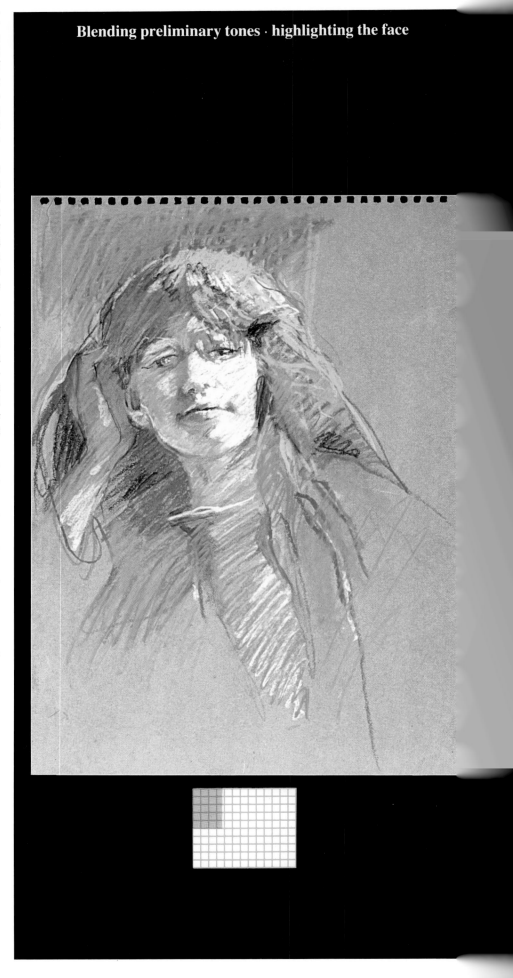

Blending preliminary tones · highlighting the face

After the outlines of the head are sketched in, the artist lays in very thin strokes of warm and cool tones, blending them with his fingers.

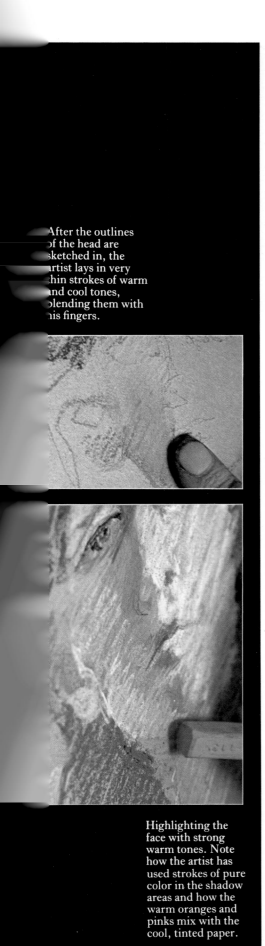

Highlighting the face with strong warm tones. Note how the artist has used strokes of pure color in the shadow areas and how the warm oranges and pinks mix with the cool, tinted paper.

1. Sketch in the outline of the figure in burnt sienna. Work into the face with lines of bright orange, ultramarine and pink against dark shadows in the hair.

3. Accentuate the shapes in the face with fine black lines and patches of strong colour. Heighten light tones with pink and mauve against warm dark red shadows.

5. Outline the hand and arm with black and block in dark flesh tones with orange and mauve. Lay in a dark blue background tone.

2. Hatch in light tones down one side of the figure with broad, grainy strokes of white. Move across the whole figure putting in orange, yellow and blue.

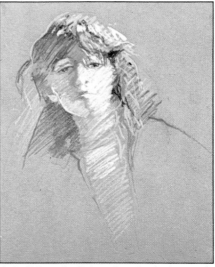

4. Build up the light colour in the face and work over the hair with heavy strokes of black, white and orange.

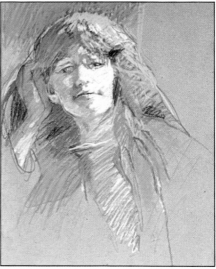

6. Draw vigorously into all the shapes with strong color, developing the tones and texture and highlighting the face and hand.

301

Pen and ink

A PROFILE CAN be as successful in capturing a person's likeness as the traditional full-faced portrait because it clearly shows the contours of the individual's features. In this painting, the structure of the form is broken into a pattern of shapes by extremes of light and shadow. A strong image is constructed by using the basic techniques of hatching and stippling. The drawing uses high tonal contrasts, but note that there are no solid black areas; the darkest tones consist of layers of dense crosshatching built up in patterns of parallel lines. Details of texture and shadow in the face are stippled with the point of the nib. The vigorous activity in the drawing is offset by broad patches of plain white paper indicating the fall of light over the form.

Observe the subject carefully as you work, moving the pen swiftly over the paper. Pen strokes should be loose and lively or the result can all too easily look stiff and studied.

Materials

Surface
White cartridge paper

Size
10in × 11.5in (25cm × 29cm)

Tools
HB pencil
Dip pen with medium nib

Colors
Black waterproof India ink

1. Hatch in a dark tone down one side of the head to throw the profile into relief. Continue to build up detail in the face.

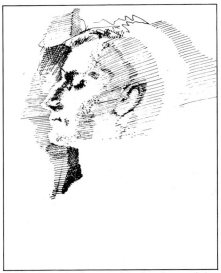

2. Work on shadows inside the shape of the head with fine parallel lines slanted across the paper. Work outwards into the background in the same way.

3. Broaden out the shadows and crosshatch areas of the background behind the head to darken the tones.

4. Vary the tones in the background gradually covering more of the paper. Work into the head and clothes with small, detailed patterns.

5. Draw in patches of dark tone to show folds in the clothing. Define the hairline and shape of the ear with crosshatching.

6. Work over the whole image intensifying the tones with hatching and stippling. Develop a high contrast of light and dark down the face and body.

Using paper to model the face

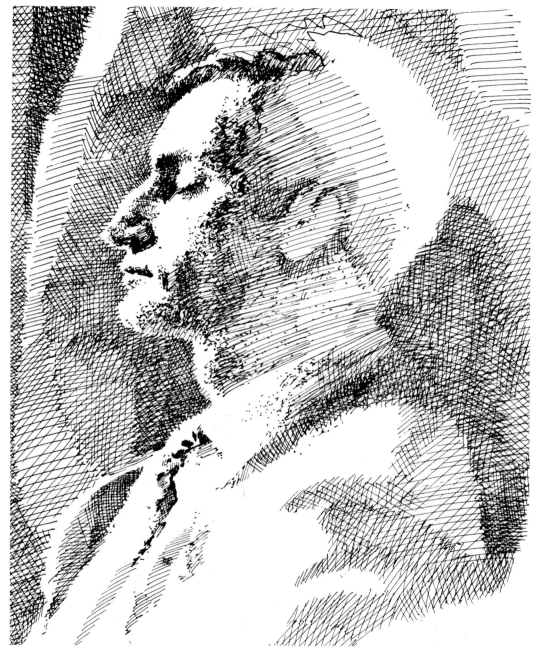

The initial pencil sketch of the head is used only as a reference for developing shadow and highlight areas. Note in particular how the shadows within the face and in the background create the profile of the head.

Artists' biographies

Numerals following a biography indicate pages
on which work may be seen.

John Devane
Attended Blackpool College of Art, Liverpool College of Art, and the Royal College of Art. In 1978 he was commissioned by the Imperial War Museum to travel to Cyprus and record military life. Mr Devane has exhibited extensively with major shows at the Ruskin School of Drawing and Fine Art, the Imperial War Museum, and a one-man show at Hammersmith Riverside Studios. He is presently teaching at Falmouth School of Art. 72, 122, 138, 188, 206, 210, 226, 260, 272, 276, 290, 292, 296, 298.

Judy Martin
Attended the Waltham Forest School of Art, Maidstone College of Art, and Reading University. She has been an Associate Lecturer of art and design at the North East London Polytechnic and St Martin's School of Art as well as a lecturer in painting and drawing at the Falmouth School of Art. Ms Martin has exhibited in a number of open and private shows and has had a one-woman show in London. 48, 80, 96, 102, 114, 124, 150, 176, 208, 232, 288.

Mike Pope
Is a well known painter, lecturer, and tutor and writer on art. He is presently a Senior Lecturer at the London College of Printing and a regular exhibitor in London and Venice. 40, 70, 98, 162, 192, 236, 274

Marc Winer
Studied at Skowhegan School of Painting and Sculpture, Harvard University Graduate School, and the School of the Boston Museum of Fine Arts. He has taught at Harvard University and is currently Visiting Artist at the Ruskin School of Drawing and Fine Art, Oxford. He has exhibited in ten one-man shows, most recently at the Thackeray Gallery, London. His publications include the book *Drawing: The Creative Process*. 60, 66, 74, 82, 180, 214, 238, 270, 280, 284, 294, 300.

Tom Evans
Is an artist, photographer and writer with wide experience and a great interest in techniques and materials. He has exhibited and published widely. 224.

Terence Clarke
Studied at the Coventry School of Art and the Royal College of Art. He has participated in group shows and had a one-man exhibit in London. 50, 56.

Clive Hayball
Studied at Torquay School of Art and has been working as a freelance illustrator with work published in a number of books, magazines, and educational material. He has taught arts and crafts in the U.S. and continues to work as a designer in London. 228.

Clive Hayball

Mike Pope

Judy Martin and Marc Winer

John Devane

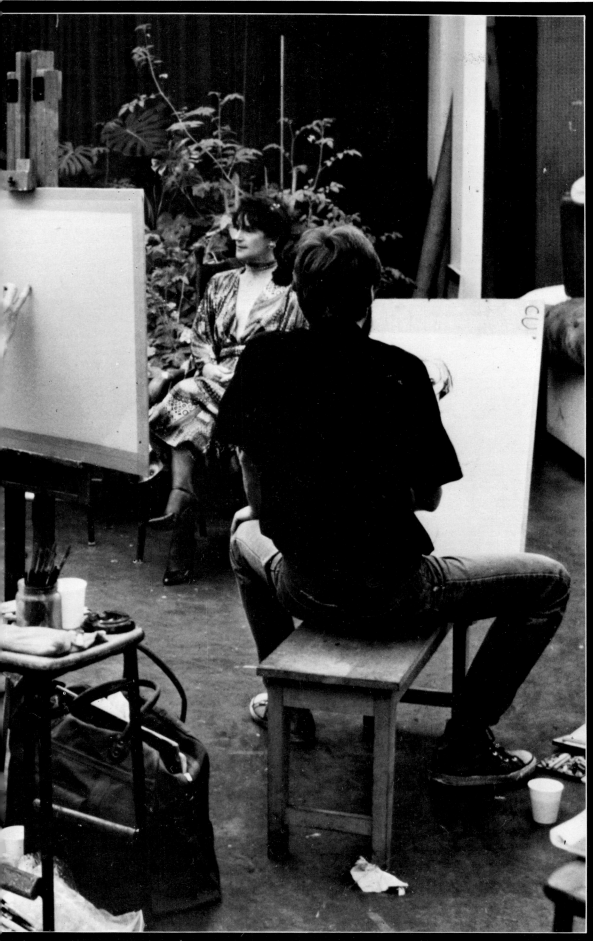

The artists at work
(left to right): Mike
Pope, Terence Clark,
Ian Sidaway,
Mark Churchill, and
John Devane.

Ian Sidaway

Kate Gwynn

Mark Churchill

Victoria Funk

Bill Dare

Ian Sidaway
Studied at the Nuneton School of Art and Richmond College. After pursuing a career in graphic design, he began painting in 1971. Mr Sidaway has exhibited in the Royal Academy Summer Exhibition, has had four one-man shows and various group shows. His work is included in private collections in the U.K., Sweden, France, Germany, Canada, and the U.S. 36, 58, 76, 90, 106, 136, 154, 170, 198, 202, 216, 230, 232, 242, 252, 258, 264, 268, 286.

Mark Churchill
Studied at the Chelsea School of Art and The Polytechnic, London. He has exhibited with the National Society and Cambridge Arts Centre and carried out commissions for murals, sculptures, and inscriptions for architects and buildings. He has exhibited with the London Group, the Ash Barn Gallery, EP Galerie (Dusseldorf), St Edmunds gallery, Salisbury, and the Linfield Gallery. Mr Churchill has taught at Twickenham College. 52, 94, 100, 118, 126, 142, 148, 152, 234, 250.

Kate Gwynn
Is an artist and designer who studied at the London College of Printing and Newcastle University. Her range of work includes illustration and typographic design in addition to drawing and painting. 166, 172.

Jane Greenham
Attended the Slade and Ruskin School, Byanshaw, and The Central School of Art and Design. She has taught at Maidstone School of Art, the Royal Academy, and the Ruskin School of Drawing and Fine Art. She is presently teaching painting and drawing at the Royal Academy and the Ruskin School of Drawing and Fine Art. She has exhibited extensively and was chosen for the Royal Academy Summer Exhibition. She is married to the artist Peter Greenham and has two children. 156, 158, 196, 222.

Bill Dare
Attended Twickenham College where he studied art and design gaining the LSIA Certificate and Surrey Diploma with honours. On leaving college, he worked in publishing and advertising in London. In 1974 he began freelance work and concentrated on illustration supplying work for advertising, editorial, the music industry, and publishing. He is presently teaching illustration at Richmond-upon-Thames College. 278.

Victoria Funk
Studied at Silvermine College of Art, U.S. where she studied drawing and painting. She has exhibited in group and one-woman shows in the U.S. 38, 68, 116, 164, 168.

Glossary

A

Acrylic. A painting medium created by dispersing pigment in an acrylic emulsion. Dries quickly to a permanent, tough surface.

Alla prima. A technique in which the artist works directly without preliminary underpainting or drawing.

B

Binder. Any medium which, when added to a pigment, forms what is commonly referred to as 'paint'. The type of binder will determine the type of paint, for example, oil binders create oil paint, etc.

Block-in, to. An underpainting technique by which the artist roughly describes the forms and composition of the painting.

Broken color. When colors are used in their pure state rather than blending or mixing. When dragged across the surface, this allows previous layers to show through.

C

Chiaroscuro. Meaning 'light-dark', this term is usually associated with oil paintings depicting a high contrast of highlight and shadow.

Complementary colors. The three primary colors – red, yellow, and blue – create what is known as complementary colors by a mixture of the other two. Thus, the complementary color of red is green, a mixture of yellow and blue. The Impressionists believed that shadows were created by a color's complement – i.e., a blue object would cast an orange shadow.

Crosshatching. The use of criss-crossing strokes to create depth and form.

D

Dry brush. Mainly used in watercolour, this involves applying paint with a dry or slightly damp brush. The hairs are sometimes held with the fingers to give a feathering effect.

E

Emulsion. Commonly used in association with different tempera techniques, an emulsion is any mixture which involves the suspension of one material in another. For example, milk is an emulsion with particles of fat suspended in liquid; egg tempera is an emulsion of egg suspended in oil.

F

Fixative. A thin varnish sprayed onto drawings and pastels to adhere the chalk to the surface and prevent rubbing and blurring.

Fugitive color. A phrase used to describe a pigment's impermanence and tendency to fade or change color, especially due to natural effects such as sunlight.

G

Gesso. A white, absorbent ground used for priming painting surfaces.

Glazing. A painting technique by which thin, transparent layers of paint are placed over an opaque layer to modify that layer's colour.

Gouache. An opaque, water-based paint also known as poster paint.

Grain. This generally refers to the texture of the surface to be painted or drawn on. With canvas, it refers to the thickness and density of the weave and with papers, the amount of tooth or roughness of the surface.

Graphite. A form of carbon. When mixed with clay and compressed, makes the common pencil. The amount of graphite/clay mixture will determine the pencil's hardness and darkness.

Ground. A ground is used to prevent the paint from being absorbed into the surface. In oil painting, the ground is usually an oil-based mixture or, more commonly, gesso. Grounds may also be tinted to add colour to a painting.

H

Half-tones. Those tones of color between the lightest and darkest shades.

Hatching. The placing of fine, parallel lines over one another to create darkness and density.

I

Impasto. A painting technique in which the paint is applied very thickly. When the paint is thick enough to create lumps or distinct brush strokes, it is said to be heavily impasted.

L

Local color. The inherent color hue of an object or surface without the influence of light, atmospheric conditions or nearby colors. For example, the local color of a lemon is yellow.

Linseed oil. The oil is derived from the flax plant and is chiefly used in the grinding of oil colors, as a painting medium, and in tempera emulsions. Linseed oil gives a smooth effect to the paint.

tions and is less susceptible to damage.

Support. Used synonymously with 'surface' meaning any material used to paint or draw upon.

T

Tempera. This word actually means a type of binder added to powdered pigment but usually refers to egg tempera painting which was popular until the late fifteenth century. Tempera painting, being a quick-drying media, is difficult to work with but dries to an almost impenetrable surface.

Torchon. A rolled paper stump used in drawing with pencil and charcoal. Can be used for blending and toning.

Transfer paper. Paper coated with a thin layer of powder used in transferring one drawing to another surface.

Transparency. In terms of painting this means the last opacity, in paint application. Transparency is usually acquired by the use of glazes which allow previous layers of paint to show through changing the color and creating depth in the paint surface.

Turpentine. This is the most common diluent in oil painting. It has no binding properties and if too much is used, tends to absorb the colors creating a dusty, dull effect. If used in quantities, the rapid evaporation will cause deterioration of the paint surface.

U

Underdrawing, underpainting. The technique of laying-in or blocking-in the drawing, composition, and often the tonal values of a painting. While color may be involved in underpainting, generally it is used to lay down the basic structure of the picture before the more complex aspects are worked on.

M

Medium. Any substance mixed with pigment to create paint. For example oil to make oil paint and gum arabic to make watercolor. Also refers to substances added to media while painting or drawing such as turpentine and linseed oil.

N

Negative space. The space surrounding the subject. For example, the background or the area around, say a model.

P

Picture plane. The region of the painting which lies directly behind the frame and separates the viewer's world from that of the picture.

Pigment. Any substance which, when mixed with a liquid, creates a color which, in this case, is used for painting. Pigments are generally organic (earth colours) or inorganic (minerals and chemicals).

S

Scumbling. A painting technique in which dry, thickish paint is applied to a surface in a loose and direct manner often creating areas of broken color allowing previous layers to show through.

Size. A mixture of pigment and hot glue applied to the painting surface to ensure against corrosion.

Stretcher. The wooden frame on which canvas is stretched. Stretched canvas is less apt to change with atmospheric varia-

V

Value. The tone of a color ranging from white to black.

W

Wash. A technique generally used with water-based paints. Mixing a large amount of water with the paint and applying it loosely to a surface.

Wet-in-wet. A painting technique which involves the application of wet paint to an already wet surface creating a subtle blending of color and tone.

White space. The color of the surface when used as a color in addition to the paint color. Also refers to the area of the surface left uncovered or untouched.

Index

Italicized page numbers indicate illustrations.

Acknowledgments

Reproductions
7, Lascarex: Colorphoto Hans Hinz, Basel/Mappae Clavicula; Rubens, National Gallery, London; 9, Van Eyck, National Gallery, London; 10, Botticelli, National Gallery, London; 11, Michelangelo, National Gallery, London; 13, Ingres, Ashmolean Museum, Oxford; 14, Degas, National Gallery of Scotland, Edinburgh; 15, Daumier, Cooper Bridgeman Library, London; 16, Michelangelo, Ashmolean Museum, Oxford; 21, Bruegel, Musée Royaux-Brussels; 35, Turner, Tate Gallery, London; 84, Cosimo, Ashmolean Museum, Oxford; 87, Dürer, Albertina, Vienna; 88, Hunt, Ashmolean Museum, Oxford; 130, Velazquez, National Gallery, London; 132, Cézanne, Museum of Wales; 135, Van Gogh, Tate Gallery, London; 185, Keene, Tate Gallery, London; 186, Kennington, Tate Gallery, London; 244, Rembrandt, National Gallery, London; 246, John, Tate Gallery, London; 247, Hals, The Wallace Collection, London; 248, Matisse, Tate Gallery, London.

Illustrations
QED: 18
Roger Twinn: 19, 20, 34, 86, 88, 134, 182, 187, 244, 249
John Woodcock: 24, 25, 28, 29

Photography
All original photography by David Strickland

With special thanks to: David Strickland for the use of his studio; James Campus for his patience; The London College of Printing; Langford and Hill Ltd for the use of their materials; Gill Pettitt, Yvonne Vimall.